Belgian Art: 1880-1914

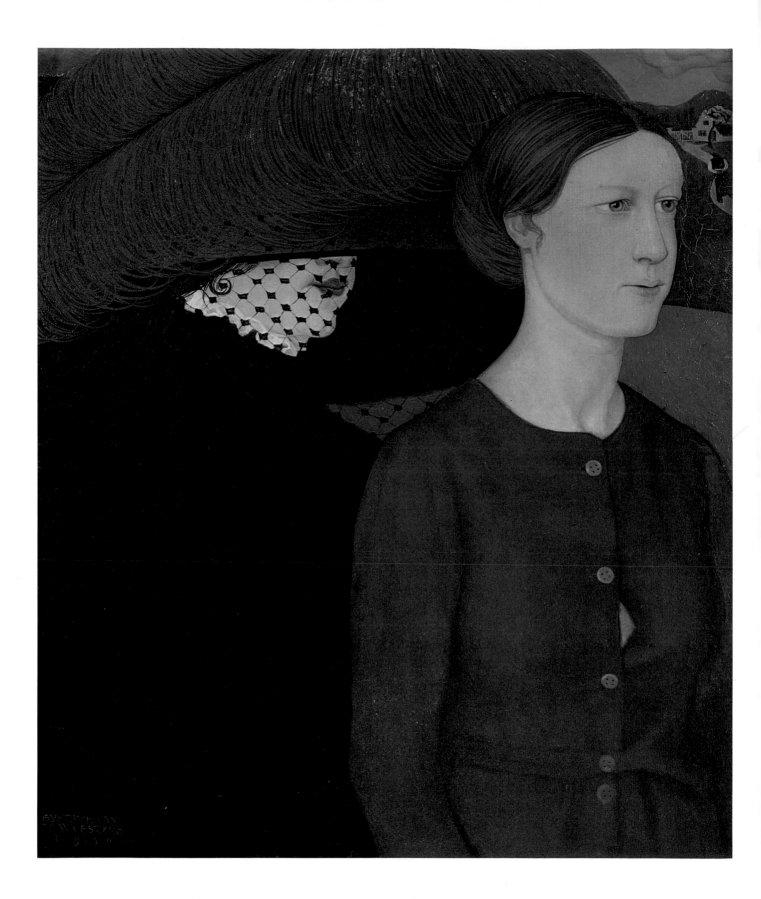

Belgische Kunst **Belgian Art** L'Art Belge
1880 – 1914

THE BROOKLYN MUSEUM

The Brooklyn Museum and the Ministries of Communities of the Government of Belgium

Published for the exhibition
Belgian Art: 1880–1914
The Brooklyn Museum, New York
April 23–June 29, 1980

Belgian Art: 1880–1914 *was organized jointly by The Brooklyn Museum and the Ministries of Communities of the Government of Belgium. It was made possible with the aid of grants from Count René Boël, Brussels, Belgium, and the National Endowment for the Humanities in Washington, D. C., a Federal agency, and was supported by a Federal indemnity from the Federal Council on the Arts and the Humanities.*

This exhibition was part of Belgium Today, *a United States commemoration of the 150th anniversary of Belgian independence through exhibitions, symposia, performing arts, films, and courses on contemporary Belgium made possible by grants from the National Endowment for the Humanities and the National Endowment for the Arts and sponsored by the Belgian American Educational Foundation, Smithsonian Resident Associate Program, and the World Affairs Council of Northern California.* Belgium Today *was organized with the cooperation of the Government of Belgium.*

Library of Congress Cataloging in Publication Data
Main entry under title:

Belgian art, 1880–1914.

Exhibition held at The Brooklyn Museum
Apr. 23–June 29, 1980.
Bibliography: p.
Includes indexes.
1. Art, Belgian — Exhibitions. 2. Art, Modern —
19th century — Belgium — Exhibitions. 3. Art, Modern —
20th century — Belgium — Exhibitions. I. Brooklyn
Institute of Arts and Sciences.
N6967.B44 709'.9493'074014723 80–12527
ISBN 0–87273–078–6

Designed and published by The Brooklyn Museum, Division of Publications and Marketing Services, Eastern Parkway, Brooklyn, New York 11238. Printed in the U.S.A. by Thomas Todd Company, Boston.

© 1980 The Brooklyn Museum, a department of the Brooklyn Institute of Arts and Sciences.

Cover:
Théo van Rysselberghe
Famille dans le Verger 1890 (detail; cat. no. 89)
Family in the Orchard
Oil on canvas
115.0 x 163.5 cm. (45½ x 64½ in.)
Collection: Rijksmuseum Kröller-Müller, Otterlo

Frontispiece:
Gustave van de Woestijne
De Twee Lentes 1910 (cat. no. 109)
The Two Springs
Oil on canvas
73.0 x 63.0 cm. (28¾ x 24¾ in.)
Collection: Koninklijk Museum voor Schone Kunsten, Antwerp

Back cover:
Privat Livemont
La Vague 1897 (cat. no. 120)
The Wave
Lithograph in four colors and gold
39.0 x 56.0 cm. (15½ x 22 in.)
Collection: Wittamer-De Camps, Brussels

Contents

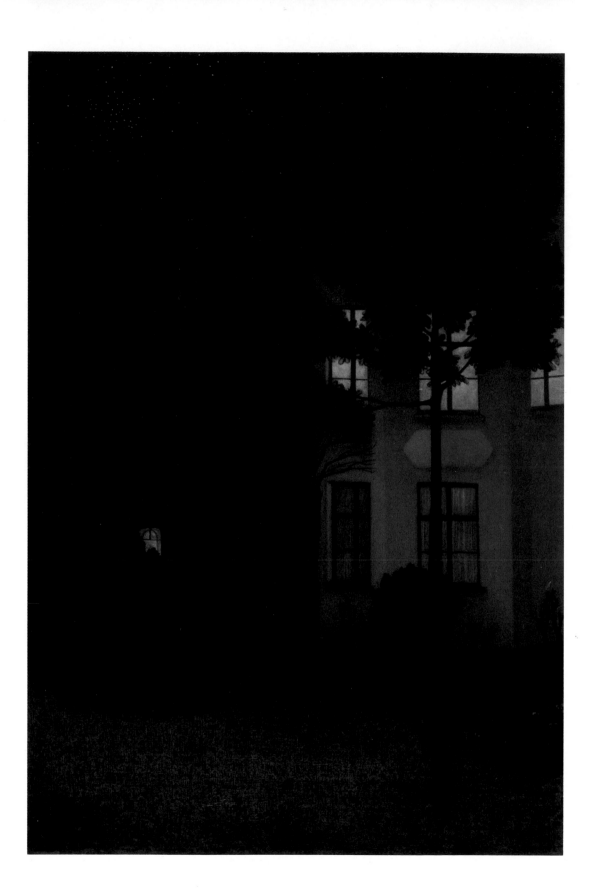

William Degouve de Nuncques
La Maison Rose (La Maison du Mystère) 1892 (cat. no. 7)
The Pink House (The House of Mystery)
Oil on canvas
63.0 x 42.0 cm. (24³/₄ x 16¹/₂ in.)
Collection: Rijksmuseum Kröller-Müller, Otterlo

Foreword

Michael Botwinick

Director
The Brooklyn Museum
New York

La Belle Époque — the end of the nineteenth and the beginning of the twentieth century — was a period of great paradox. Even as strong forces were finally controlling the growth of the industrial revolution, moving Europe steadily out of the agricultural age, these same urges gave rise to new philosophies such as socialism, that would irreversibly change the relationship of people, one to another. It was a period that saw an extraordinary, almost breathtaking expansion of European hegemony in world trade, side-by-side with the growth of the most petty and stifling bureaucracies. It was an age of continuous and repressive curbing of political, artistic, and emotional expression — even as it presided over the most wonderful and heartening array of groups and journals dedicated to the promulgation of an intellectual ferment as diverse as we can imagine. And above all, as we can only see with the perspective of history, it was an age that moved toward a final confrontation. So abrupt, so catastrophic was the break of the First World War that even now we do not completely understand how thoroughly it marked the end of an era. The Belgium of 1880–1914 was richly expressive of its time. Just fifty years old — the delicate balance of three centuries in which several empires and two cultural hearts contested — it was a fragile new political reality on a map of Europe on the verge of even greater flux.

As democratic intellectual roots were laid down in the new nation, movement after movement arose to test the aesthetic and political waters. We can trace much of the artistic history of the period in the groups and journals that grew out of one another: La Société Libre des Beaux-Arts, La Chrysalide, L'Essor, Les XX, La Libre Esthétique. What is so refreshing and remarkable about the Belgian experience of this era is that it tends to be inclusionary rather than exclusionary in its nature. Les XX typified this attitude of openness. Its binding force was the desire to explore all aesthetics, rather than holding a philosophical commitment to one; it welcomed outsiders instead of defining their differences. And the spirit of this group perhaps best expresses the spirit of the age. We are enriched with the fusion of all the arts — of the visual with music and poetry. We are struck by the ease with which we can move from a bitter and cold Realism to

the graceful flights of Art Nouveau to the sometimes troubling introspection of Symbolism. And yet the period does not come apart in a chaotic split of personalities. This geopolitical newcomer had, in fact, deep roots in all of these cultural currents, and was therefore able to provide a remarkably fertile environment.

The realization of this project has been a most complex affair. It had its genesis in the idea of a series of international symposia proposed jointly by the National Endowment for the Arts and the National Endowment for the Humanities some years ago. This evolved into *Belgium Today*. In 1930 The Brooklyn Museum presented the Centennial exhibition of the founding of modern Belgium, so it seemed natural that we host the Sesquicentennial. Under the gentle guidance and firm support of James Kraft, now Dean at the New School, and Lucie de Mytennaere, Cultural Counselor, Embassy of Belgium, Washington, D. C., we tried to establish an exhibition that would play a central role in the celebration.

We are deeply grateful to the museums and private collectors in Europe and America who have generously lent works to the exhibition.

We greatly appreciate the cooperation of our colleagues, Philippe Roberts-Jones, Director, and Francine-Claire Legrand, Curator-in-Chief for Modern Art, Royal Museums of Fine Arts, Brussels; Gilberte Gepts-Buysaert, Director, and Jean F. Buyck, Curator, Royal Museum of Fine Arts, Antwerp; Lieven Daenens, Director, Museum of Decorative Arts, Ghent; Maurice Culot, Director, Archives of Modern Architecture, Brussels; and Jacques-Grégoire Watelet, Brussels, all of whom collaborated in the selecting of the objects and the shaping of the exhibition.

On the official side we were greatly helped by the efforts of many people: Diane Verstraeten, Paul Delmotte, and Ben Millet of the Ministry of the Dutch Community; Catherine de Croës, Francis de Lulle, and Marie de Briey of the Ministry of the French Community; Ambassador Frans Herpin and Ambassador Michel van Ussel, Coordinators of *Belgium Today* in Belgium; and Grand Marshall of the Court Herman Liebaers.

Patricia Farmer was responsible for translating the French and Flemish contributions to English for the catalogue and worked as an effective liaison throughout the transatlantic phase of this show. She must also be thanked for originally proposing to The Brooklyn Museum the idea of an historical survey exhibition in celebration of Belgium's 150th Anniversary, out of which this show grew. Brooke Lappin, National Program Director for *Belgium Today*, was an invaluable ally.

We are grateful to the Federal Council on the Arts and the Humanities for granting the indemnity which helped make this show possible, and to Marsha Semmel, who, working as an intern, coordinated those complex documents. We are also grateful to the National Endowment for the Humanities and the Government of Belgium for their support of the exhibition and to Count René Boël, Brussels, for his generous gift which helped make this project possible.

Finally we would like to thank Sarah Faunce, Curator of Paintings and Sculpture, and John R. Lane, Administrator for Curatorial Affairs, The Brooklyn Museum, for their efforts on behalf of this project.

Belgium as a Crossroads

Philippe Roberts-Jones

Director
Musées Royaux des Beaux-Arts de Belgique
Brussels

For the history of Western art, the turn of the century was a feverish time, richly divergent and challenging — a true period of emancipation. Form and color were liberated from convention and academism, and important ideas were fused. But at the heart of the visual image, freedom of form was sometimes in conflict with the intent of the message. This is not the place to speak of French painting — Monet and Cézanne, Redon and Seurat — or the Pre-Raphaelites; nor of Lautrec or Van Gogh, Whistler or Gauguin, the Secessionists of Vienna or of Munich; nor of Japonisme, the Style Moderne, Wagner or Mallarmé — although none of these were unknown in Belgian art between 1880 and 1914. Does that awareness seem astonishing? In principle, certainly not; but the degree of Belgian participation may come as an agreeable surprise.

The tradition of innovation and creation is deeply rooted in the history of the Belgian provinces. It is expressed in Mosan metalwork, in the tapestries of Brussels, and through an exceptional school of painting. Van Eyck, Breughel, and Rubens all demonstrated, in their own time, a universal genius that was never imprisoned by regionalism, yet drew as much strength from its local origins as from the spirit of humanism. The works of Van der Weyden, Van der Goes, Memling, Gossart, Patinir, Van Dyck, Brouwer, and Teniers enriched all major collections, belonging to royalty or to the bourgeoisie between the fifteenth and seventeenth centuries, and are among the most important artists represented in the great museums of today. The eighteenth century in this country saw a less innovative art than the preceding period: while its artisans were considered important both at home and abroad,[1] the brilliance, and wide-ranging, vigorous originality, were gone.

A strong creative force did not occur again until the mid-nineteenth century. Jean-François Navez exhibited a neoclassical style of high quality, and the Romanticism of Antoine Wiertz — while never attaining greatness — was striking in the dimensions of its vision.[2] But it is Realism — not that of Gustave Courbet, but rather of the brothers Joseph and Alfred Stevens — that must be credited with giving new impetus to the art of painting in Belgium.[3] The movement was affirmed in 1868 by the organization of the Société Libre des

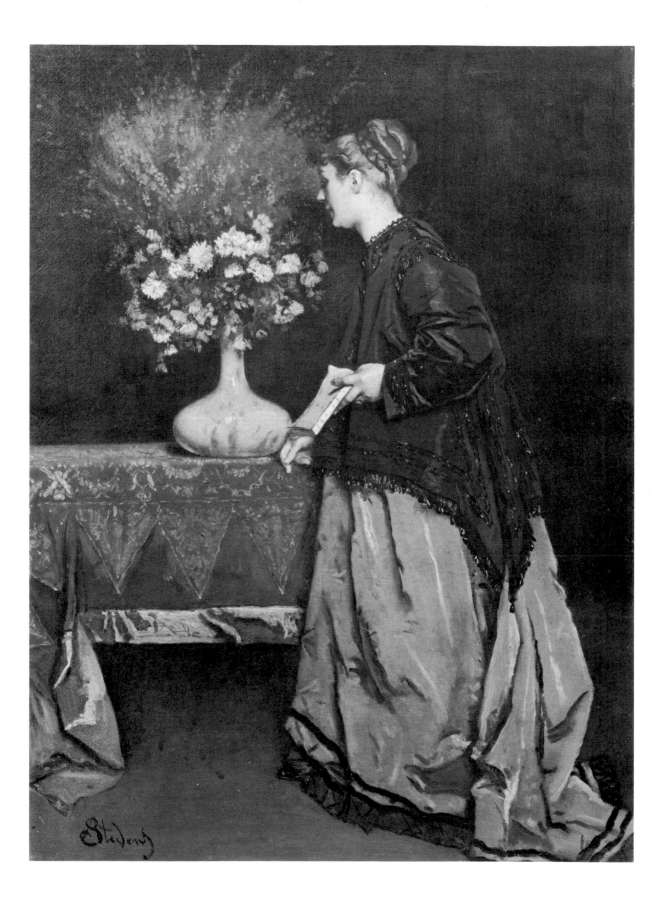

Facing page:
Alfred Stevens
Fleurs d'Automne 1867
Autumn Flowers
Oil on canvas
74.5 x 55.0 cm. (29³/₈ x 21³/₄ in.)
Collection: Musées Royaux des Beaux-Arts de Belgique, Brussels

Above:
Hippolyte Boulenger
L'Inondation *circa* 1870
The Flood
Oil on canvas
103.0 x 144.0 cm. (40¹/₂ x 56³/₄ in.)
Collection: Musées Royaux des Beaux-Arts de Belgique, Brussels

Beaux-Arts in Brussels, whose goal was the "free and individual interpretation of nature."[4] The chief founders of the Société were Charles de Groux, Alfred Verwee, Constantin Meunier, Louis Dubois, Félicien Rops, and Louis Artan, but one other name must be added — that of an independent artist, who was nevertheless close to the members of this group in his point of view — the landscape painter, Hippolyte Boulenger. The novelist and critic, Camille Lemonnier, was the group's ardent champion against the hostilities of the official world. His argument in their favor was: "Make painting healthy and strong, without striving for effect or using recipes; return to the true meaning of painting, loved not for its subject but for its material elements, rich like some precious substance, like a living organism."[5] This pictorial quality, so characteristic of older Flemish painting, was completely recaptured and given new life through the diversity of approach and talent — even of genius — that also enriched the creative process.

The wealth and variety of artistic life in Brussels developed out of the many young and dynamic art circles such as La Chrysalide and L'Essor, and the literary and artistic journals of the avant-garde such as La Jeune Belgique and L'Art Moderne, which were produced and supported by men like Georges Rodenbach, Émile Verhaeren, Edmond Picard, and Octave Maus. The key date of this period for the world of art was undoubtedly the foundation of the group called Les XX on October 28, 1883, at the Guillaume Taverne on the rue du Musée in Brussels. The artists who formed Les XX — to be led by the cultured lawyer Maus — represented no particular school of painting, nor were they unified by a manifesto or constitution. Their confraternity was the result of a common interest, a desire to experience the creative adventure to its utmost limits. They imposed no aesthetic on one another; traditional works were shown side-by-side with the avant-garde, with no conditions imposed on either art or artist.

Les XX was not limited to Belgian artists, for in addition to full-time members from other countries, the group invited new guests each year, welcoming the innovative spirits of contemporary art to all their exhibitions. Thanks to them, Brussels became a point of cultural convergence: from 1884 to 1893, Les XX's international exhibitions, enlivened with recitals and conferences, created one of the most exciting centers of confrontation that the history of art had ever known — an ambience that was prolonged until the eve of the First World War by the activities of its successor, La Libre Esthétique. It was thus that a continually changing mixture of works covered the walls of the Brussels museum: Vogels, Khnopff, Ensor, Van Rysselberghe, Monet, Whistler, Van Gogh, Seurat, Rodin, Signac, Gauguin, Redon, Lautrec, Munch, Renoir, Bonnard, Sargent. Seemingly endless innovations confronted one another, kindling passionate debates between the new talent and the old guard. Impressionism, Symbolism, Pointillism, Expressionism — all demanded the right to speak in their own language during this fascinating period.[6]

What was Belgium's own position in the context of these exhibitions? Some Belgian artists had already made a name and a place for themselves. Constantin Meunier had manifested his personal vision of the dignity of work and the proletarian universe in painting as well as in sculpture; Félicien Rops, who conquered Paris with his audacious engraving, created a scandal with his Temptation of St. Anthony and then with Pornocrates. Henri de Braekeleer also appeared at Les XX, in 1887, one year before his death. This makes clear that the Brussels group recognized Antwerp's importance in welcoming one of its greatest artists — a Realist, certainly, but one whose profound introspection conferred a deeply evocative character upon his work. Ernest Verlant, one of the first to note this, wrote in 1892, paraphrasing Novalis: "For Braekeleer, painting was the art of expressing the invisible through the visible."[7] In that respect, he is close to Xavier Mellery, a guest of Les XX from 1885 on, who would later use the phrase, "the soul of things," to describe his own poetic drawings of extreme subtlety. Mellery, who was Fernand Khnopff's teacher, also said: "Whoever subordinates color and form to emotion will achieve the highest goal."[8] Realism and intimacy were already closely allied.

But essentially, the generation that formed Les XX produced four major artists: James Ensor, Fernand Khnopff, Théo van Rysselberghe, and Guillaume Vogels. Although they shared certain qualities inherent to the renaissance of Belgian painting, they were also

strongly differentiated by their aspirations. Khnopff and Van Rysselberghe both reacted decisively to influences from other countries but were diametrically opposed in their choice of styles — the first fascinated by esoteric form and content, the second by Pointillism. The other two remained firmly rooted in their native land; Vogels contributing with sensitivity to the creative passage between Realism and Expressionism, while Ensor, in his wild independence, would be recognized as the essential pioneer of the twentieth century. Each one brought a personal genius to his chosen direction.

Fernand Khnopff, whose style is composed from many sources and shows numerous affinities — to Xavier Mellery, Gustave Moreau, Pre-Raphaelitism, the Rosicrucians, and the Secession — produced imagery that was sometimes *fin-de-siècle*, sometimes curiously prophetic of Surrealism, and suggested a secretive personality, dreamy and troubled. His motto, "On n'a que soi" (One has only oneself), was entirely appropriate. Much appreciated during his lifetime, forgotten the day after he died, he has reappeared today as one of the most interesting figures in international Symbolism.

Van Rysselberghe, who made himself indispensable to Octave Maus in the search for new talent,[9] became recognized as a remarkable portraitist very early in his career, and when he discovered, with Verhaeren, Seurat's painting of *La Grande Jatte,* he was carried away by this most revolutionary technique of Neo-Impressionism and became its unwavering disciple. But if he borrowed the technique, he also brought to it his immense gifts as a portraitist, and was to be the only Pointillist who practiced this genre so that the life of his model radiated from within.

Guillaume Vogels was self-taught; emerging from the working-class world, he was both crude and jovial. He left very little in the way of letters or anecdotes about his life but, instead, provided a legacy of numerous important oil paintings, sketches, watercolors, and drawings — all having great freedom, considerable wisdom and, often, astonishing poetry. In the company of Louis Artan and Hippolyte Boulenger, he had not only "led Impressionism, in a single bound, to the limits of its possibilities," as Paul Colin said,[10] but freed landscape from the necessities of topographical identification, in order to better express its emotional qualities through pictorial materials, in color and line alone. Today, Vogels is a little-known painter.

Obscurity was not the fate of James Ensor, Vogels' junior by twenty-four years, but the genius of the Ostend painter is both more universal and more tormented. In less then ten years, Ensor passed from painting the oppressive atmosphere of bourgeois salons to creating glittering and hallucinatory visions of color and light, of masks and unreality. Innovator that he was, he remained an isolated and troubled genius during the entire period of his greatest creativity, from 1880 to 1900 — but survived this turbulence to live on for nearly half a century longer. His importance as an artist can be no better articulated than in this quotation from Alfred H. Barr writing about Ensor's painting of 1887, *The Tribulations of St. Anthony:* ". . . at this moment in his career, Ensor was possibly the boldest living painter. Gauguin was still painting semi-Impressionist pictures and only in the following year, 1888, was Van Gogh, under the burning sun of Arles, able to free himself from Impressionism."[11]

These four artists are like signposts of the diversity and, at the same time, the unity in quality that characterized painting in Belgium of this period. Both Khnopff and Symbolism reinforced a tendency toward the unreal in art, that has been constant in painting from Breughel to Magritte. In this same area, but with his own particular interests, we find William Degouve de Nuncques, recognized by critics from 1890 on as "the inventor of strange landscapes."[12] During the last ten years of the century, these landscapes seemed to be manifestations of dreams, or free interpretations of the imagination, achieved through linear rhythms and subtle coloring.

It was the idea — the spiritual and aesthetic conception — that dominated Jean Delville's work. Searching for beauty in the soul, Delville mixed conventional images with good or bad moral personifications surrounded by nimbuses of vaporous and astral light. As a disciple of Sâr Péladan, he exhibited at the Rosicrucian Salons in Paris from 1892 to 1895 and, with Émile Fabry and Xavier Mellery, founded the circle Pour l'Art (1892) and the Salon d'Art Idéaliste (1896), where Constant Montald and Léon Frédéric were among the artists who exhibited. The intense activity apparent in

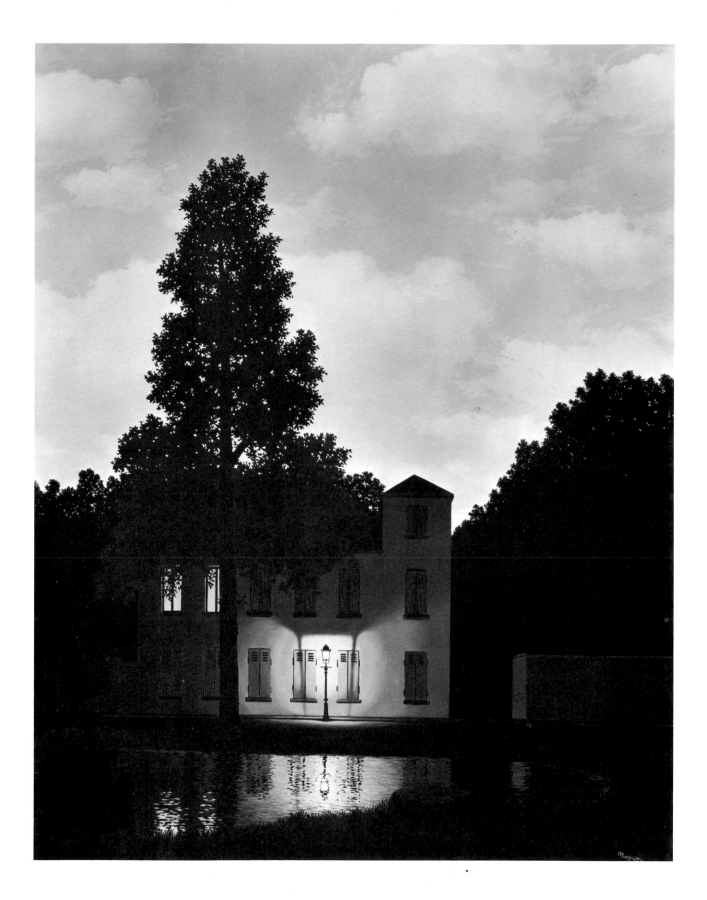

René Magritte
L'Empire des Lumières 1954
The Empire of Light
Oil on canvas
146.0 x 114.0 cm. (57½ x 44⅞ in.)
Collection: Musées Royaux des Beaux-Arts de Belgique, Brussels

14

the Symbolist works of these artists is strongly charged with esoteric imagery, but excludes neither naive nor sophisticated allegory, nor mythological dreams, nor the temptations of decorative art, nor literature. Fabry was associated with both Maeterlinck and Verhaeren,[13] who was a friend of Montald — in turn the future teacher of Paul Delvaux. It was in several similar cases that painters and writers formed a closely overlapping milieu.

Léon Frédéric was a careful worker, attentive to detail and the perfection of his rendering, whether he found his subject in mysticism or reality. He treated his love of nature and his interest in peasant life with the same careful precision. Today, our attention is held by the super-real quality of his work. There is often a very thin line between the real and the imaginary in Belgian art. Expression ranges from the most precise treatment to an audacious lyricism, if one thinks, for instance, of James Ensor. And many bridges cross this deep current which we called non-reality and which coursed through all nineteenth-century painting — particularly in the Belgian provinces.[14]

The work of Léon Spilliaert provides a striking example of this complexity, touching the extremes of anguish and eccentricity, being sometimes impulsive and sometimes dream-like, alternating between the compelling quality of human presence and the silence of an empty dining room. Astride both Symbolism and Expressionism, working between 1902 and 1912 in both pastel and watercolor, he could give the impression of being entirely isolated or equally at home with his fellow man. Strength and subtlety, the suppleness of line and force of color, made this artist — whose originality we are only beginning to assess today — an eloquent witness of the Expressionist style.

Two other artists, who were never aesthetically affiliated with either a group or a movement but who amplified the original Realist tendencies in Belgium, making extraordinary contributions to the emotional impact of art, were Jakob Smits and Eugène Laermans. The plains of the Campine and its humble peasants, as well as the reign of light and the presence of Christ, were the means by which Smits joined the quotidian to the exceptional. Laermans was also very interested in the physical traits of the working people, and inter-

preted the social tensions of industrialized life during the 1880s and 1890s in a poignant manner, against a background of Brabantine sites still marked by a Breughelian spirit. Jakob Smits undoubtedly inherited his veneration of luminous matter from his Dutch ancestors of the seventeenth century — and from Rembrandt, in particular — although it was more toward the South and the lesson of the Impressionists that others had looked for these subtle nuances.

The impact of Seurat on Van Rysselberghe is well known, though he was not the only convert to Pointillism. Vogels' friend Willy Finch joined the movement in 1888; Georges Lemmen and Henry van de Velde, members of Les XX, followed in 1889. The importance of all three to Neo-Impressionism is far from being negligible, and it is also true that the Belgian contribution was once again second only to that of the French. But for none of these artists was Pointillism the final goal. Decorative art and the curving lines of Art Nouveau seduced them: Finch became a ceramicist, Lemmen found his true power in the arabesque of the poster, Van de Velde, together with Horta and Hanker, became a leader of the modern style in architecture and design. Both architect and theoretician, he directed the Institute of Decorative Arts in Weimar from 1902 to 1914.

Émile Claus who, when he was about forty, saturated himself with Parisian Impressionism, had proposed his own version, in which the picturesque borders of the River Lys would replace the better-known banks of the River Seine. The lights of Flanders were also capable of charm, and he extracted a certain gaiety from them: "I was born on the day of Kermesse," said the artist.[15] In 1904 Claus formed the Brussels group Vie et Lumière. If the artistic activity in Brussels attracted painters to the capital, there were also those, like Claus, who were no less aware of the poetry in the countryside, of the special qualities of a regional area or of another city.

But while the light of France had opened the way to Claus relatively late in life, it illuminated the art of Henri Evenepoel precociously early. At age twenty, he was a pupil of Gustave Moreau — with Matisse and Rouault as his fellow students — and he had only seven years left to live. He showed himself to be an exceptional painter, with an ability to transfer scenes

of Parisian life instantly to canvas, and to reproduce the facial expressions of his friends, of the woman he loved, and especially of children, playing or day-dreaming. He was always looking, as he himself wrote, for the "special characteristic, the particular expression, [the] unexpected."[16] One of the most talented figures in Belgian art, and the most sensitive children's portraitist that the nineteenth century knew, Evenepoel made use of his creative gifts at some distance from Brussels. On a smaller scale, the same is true of the Antwerp artist, Charles Mertens; François Maréchal of Liège; and Georges Le Brun of Verviers, who, according to their own temperaments, were especially drawn to scenes of daily life in familiar locations. A more profound example occurred, again on the banks of the River Lys, in the village of Laethem-St.-Martin, where the group of Flemish Expressionists — to whom history has given the name of this village — found their creative home.

The several forces that produced the first group at Laethem after 1905 were strongly anti-Impressionist: Symbolist poetry, for which Ghent was one of the chief centers; the rediscovery of the Flemish Primitives at the Bruges Exhibition of 1902; a deep religious sense; and, finally, the renaissance of Flemish letters. George Minne evoked the image of the kneeling adolescent, which he used with rhythmic repetition for his splendid fountain of 1898. Minne's work had a great influence on German sculpture; that of Lehmbruck, in particular. The qualities of his sculpture, like those of his drawings, are monumental, and its basic themes are introspection and introversion. Mysticism and symbolic values are also seen in the work of Gustave van de Woestyne — suggesting torment as well as hope — and cut across the apparent serenity of Valerius de Saedeleer's landscapes.

These were the multiple faces of painting in Belgium between 1880 and 1914, which passed from reality to dream and from the imaginary to the ordinary with the greatest ease of expressive power. These are the incontestable strengths of this art — its particular character created by craftsmanlike qualities, in which daring and perfection are balanced. The human presence, in dramatic or intimate setting, crying out or searching for an ideal, is rarely absent from a work of art of this period. Landscapes secrete an evocative presence, as in works of Degouves de Nuncques or Spilliaert, or are profoundly communicative under the brush of Vogels or Laermans. And intimacy was often dominant, as seen in De Braekeleer's and Mellery's interiors and sensitive descriptions of objects, as well as in the grand portrait tradition as illustrated by the works of Van Rysselberghe, Evenepoel, and Frédéric. This art, known to be built on an exceptionally rich past, did not end in 1914 with the dissolution of La Libre Esthétique or the beginning of the First World War, but rather, having left behind some of the great artists like Ensor, went on perpetuating itself through Rik Wouters and Brabantine Fauvism, Permeke and Flemish Expressionism, and the Surrealism of Magritte and Delvaux.

1. Denis Coekelberghs, "Les peintres belges à Rome de 1700 à 1830," Études d'Histoire de l'Art de l'Institut Historique Belge de Rome 3 (Brussels, Rome, 1976).
2. Philippe Roberts-Jones, "L'image irréaliste chez Antoine Wiertz," Bulletin de la Classe des Beaux-Arts, Académie Royale de Belgique 59, nos. 2–4 (Brussels, 1977), pp. 55–63.
3. Philippe Roberts-Jones, From Realism to Surrealism: Painting in Belgium from Joseph Stevens to Paul Delvaux (Brussels: Laconti, 1972).
4. H. H., in: Brussels, Journal des Beaux-Arts et de la Littérature, January 31, 1869, p. 9.
5. Camille Lemonnier, L'École Belge de Peinture, 1830–1905 (Brussels: G. Van Oest, 1906), p. 124.
6. Madeleine Octave Maus, Trente années de lutte pour l'Art, 1884–1914 (Brussels: L'Oiseau bleu, 1926) and Brussels, Musées Royaux des Beaux-Arts de Belgique, Le Groupe des XX et son temps, by Francine-Claire Legrand, 1962, pp. 17–35.
7. Ernest Verlant, "Henri de Braekeleer," La Jeune Belgique, 1892, p. 108.
8. Paul Fierens, L'Art en Belgique, La Renaissance du Livre, 4th ed. (Brussels, n.d.), p. 487.
9. Marie-Jeanne Chartrain-Hebbelinck, ed., "Les Lettres de Van Rysselberghe à Octave Maus," Bulletin des Musées Royaux des Beaux-Arts de Belgique 15 (1966), pp. 55–112.
10. Paul Colin, La peinture belge depuis 1830 (Brussels: Cahiers de Belgique, 1930), p. 311.
11. New York, The Museum of Modern Art, Masters of Modern Art, by Alfred H. Barr, 1954, p. 34.
12. Georges Destrée, "Le Salon éternal," La Jeune Belgique 9 (1890), p. 375.
13. Francine-Claire Legrand, Symbolism in Belgium (Brussels: Laconti, 1972), pp. 96–97.
14. Philippe Roberts-Jones, Beyond Time and Place: Non-Realist Painting in the Nineteenth Century (Oxford, New York, Melbourne: Oxford University Press, 1978).
15. Théo Hannon, "Émile Claus au Cercle artistique de Bruxelles," Antwerp, Revue Artistique, April 10, 1880, p. 371.
16. Paul Lambotte, Henri Evenepoel (Brussels: G. Van Oest, 1908), p. 66.

Les XX: Forum of the Avant-Garde

Jane Block

Curator of Visual Services
Frances Loeb Library
Harvard University
Cambridge

Les XX, or the Group of Twenty, was the name adopted by a group of antiacademic artists who joined together to exhibit their work annually in Brussels during the years 1884-1893.[1] During the course of that decade, Les XX became the most important group of its kind in Belgium and achieved international significance. One element of this achievement was its bringing the arts together through lectures, readings of new poetry, and musical performances — all held in the exhibition rooms. Another, and even more significant and distinguishing feature of Les XX was its practice of inviting foreign artists to participate in its annual exhibitions. The group was perceptive in its selection, among whom were Seurat, Gauguin, Lautrec, and Van Gogh, artists who at that time were either controversial or little known. And the interaction between the Vingtistes and their *invités* turned Les XX into a forum of avant-garde art so important that a number of foreign artists, including Raffaëlli, Whistler, Rodin, and Gauguin actually lobbied to become either members of the group or *invités*.

The formation and development of Les XX grew out of an ideal set of political and social conditions. Under the liberal policies of Kings Leopold I and II, Brussels had served as a refuge for political exiles from France. The proximity of the country, a common language, and a press constitutionally protected from government censorship appealed to many of these exiles, and artists and writers such as Jacques-Louis David, Victor Hugo, Charles Baudelaire, Gustave Courbet, and Jules Vallès had fled from France to Brussels. In this relatively liberal context, Belgium was undergoing a period of great social unrest. Recessions, unemployment, and an influx of radical ideas from France led to a series of strikes and demands from the working class for better working conditions, universal suffrage, and compulsory education.

It was in this atmosphere of social and economic turbulence that Les XX arose, and the joining of the artistic with the political struggle in Belgium was noted by the Symbolist poet Émile Verhaeren. A close friend and colleague of several Vingtistes, he wrote in 1884, "[Les XX's struggle] is ardent, youthful, bitter, violent: it encounters the same attitudes, the same enemies, the same hopes, the same goal, the same obstacles."[2]

Just as the working class challenged the social order, Les XX sought to unshackle art from an antiquated system of Salons and juries.

The Origins of Les XX

In Belgium, as in the rest of Europe, art during the nineteenth century was regulated by the government-sponsored Academies and Salons. Artists who deviated from the artistic norm — embodied in precepts taught by the Academy — were either rejected by the juries of placement for the annual Salon or admitted and their works hung in obscure corners. This had serious consequences for artists since the Salon was almost the only place to market works and establish a reputation.

An anonymous member of the 1884 Brussels Salon jury is generally credited with provoking the formation of Les XX by exclaiming, "Let them show at their own place."[3] This popular notion, first offered in a 1918 lecture in Lausanne by Octave Maus, Secretary and guiding spirit of Les XX, would have us believe that the group was formed in defiance of this "quip tossed off by a member of the official jury . . ."[4] But the 1885 catalogue of Les XX makes clear that the remark was made at the Brussels Salon of September 1884, months after the group's first exhibition. It therefore had nothing to do with the founding of Les XX, but by telling the story this way years later, Maus was — whether consciously or not — dramatizing the conflict between the Salon and the avant-garde spirit.

The actual inception of the group was both more prosaic and more personal. Spiritually, it was the heir of the Société Libre des Beaux-Arts (*circa* 1868–*circa* 1876) and La Chrysalide (1876–1881),[5] both groups of forward-looking artists who received no official support or patronage. But Les XX's immediate roots were in another group — L'Essor, founded in 1876, which had more official support and financial success than the others. Among the many patrons its first year was King Leopold, who remained an avid supporter throughout its existence. The critic for *L'Artiste,* Théo Hannon, alias Marc Véry and member of La Chrysalide, found this official patronage objectionable. ". . . we are perhaps in the presence of the academicians of tomorrow. There prevails there a vague mustiness of official

commissions, academic rewards, decorations, ribbons, and medals . . ."[6] Thus Hannon saw from the outset the conservative tendencies of L'Essor.

But Hannon makes his argument more extreme than the facts would warrant. Coexisting with this conservative element was a progressive faction that included several members of La Chrysalide. The very fact that these Chrysalidiens were members of L'Essor indicated a receptivity to all types of art; it was this eclecticism that was L'Essor's greatest strength and allowed it to survive until 1891.

With L'Essor's fifth exhibition, in 1881, *L'Art Moderne* came out with its opinion of the group. This periodical, founded in that year and published every week until 1914, had a particular importance since it was later to become the principal defender of Les XX. In its very first issue of March 6, *L'Art Moderne* professed to see in L'Essor "Many efforts in various directions. Sometimes old hat, more often the new . . ."[7] The artist Léon Herbo is singled out with adverse criticism on account of the similarity of his figures to those of the "machines" of the 1830s,[8] and again, in 1883, *L'Art Moderne* denounced his *Psyche* of 1882 in the strongest terms as "false taste, horribly pretentious . . . a travesty of life."[9]

Herbo also became a subject of controversy within L'Essor itself. Frantz Charlet, one of the leaders of the liberal faction, proposed at a meeting of L'Essor in 1883 that Herbo refrain from participating in the next exhibition. Charlet was then censured and he, along with ten other Essoriens (Charles Goethals, James Ensor, Willy Finch, Fernand Khnopff, Théo van Rysselberghe, Guillaume van Strydonck, Paul Dubois, Willy Schlobach, Rodolphe Wytsman and Dario de Regoyos), withdrew to form Les XX. Though they numbered only eleven, the renegades of L'Essor chose "Les XX" as the name of their group because L'Essor itself had been founded by twenty artists and their exhibitions organized by a twenty-member jury. Thus in its very name, Les XX was implicitly rejecting the conservative values embodied in L'Essor and asserting its determination to establish a new group of twenty.

While recruiting nine more artists (see pages 36–38 for list of founding members), the group also sought a secretary who would organize the annual exhibitions. The

Léon Herbo
Psyche 1882
Oil on canvas
141.0 x 70.0 cm. (53½ x 27½ in.)
Collection: Musée des Beaux-Arts, Tournai

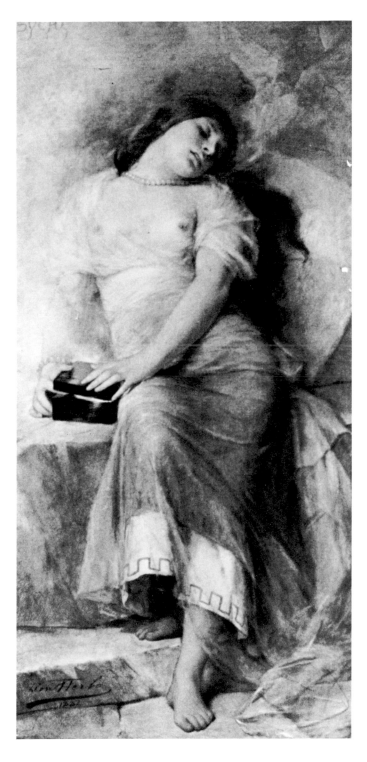

Vingtistes first offered the position to the art critic Lucien Solvay. Solvay told the story of his selection in his autobiography, *Une Vie de Journaliste.*[10]

Charlet, Van Rysselberghe, and Van Strydonck met with Solvay upon his return from Spain and Morocco in 1883 to inform him of their plan to organize Les XX. Unlike L'Essor, they would have no president or jury; only a secretary charged with the task of preparing yearly exhibitions, and it was at this meeting that Solvay was offered the Secretariat. At first, Solvay admits, the position appealed to him — and it was probably his initial enthusiasm that led to the announcement of his appointment in *L'Art Moderne* of October 7, 1883. But Solvay later rejected the offer, believing that his independence as a critic would be compromised if he became associated with Les XX.

A scrap of paper dated October 28 of the same year, and signed by thirteen Vingtistes, first links Octave Maus with Les XX. Four days later, Maus revealed in a letter to his artist cousin, Eugène Boch, that he had announced the constitution of Les XX in *L'Art Moderne* and that ". . .they offered me the function of Secretary and I accepted."[11] He further elaborated on the resignation of Solvay, saying, "Solvay had refused, fearing to compromise himself, because in fact it was a question of a great uprising against everything that is academic, conventional, old-fashioned. It is a proud and independent art that they want to make, and as it's a matter of turning everything upside down and doing battle, I'm for it." Maus lamented the condition of art in Belgium: "Everything that is beautiful, free, and sincere is stifled by a coterie of octopuses, who suck up all the money, esteem, and reputation for themselves." At the close of this letter, Maus revealed for the first time the truly combative nature he saw embodied in Les XX: "Finally, we propose to topple everything, and put our poor bourgeois country back on the map."

On November 11, 1883, *L'Art Moderne* announced that the group's first exhibition would open on the first of February, 1884 and that the group would be devoted to "an independent art, detached from all official connections. . . ."[12] With this announcement, *L'Art Moderne* became the official defender of Les XX. *L'Art Moderne* clearly delineated the battle lines, identifying Les XX's

19

enemies as the bourgeois public, the press, and the Salon. It championed the group not only by explaining and exhalting its aesthetic platform, but by discrediting its critics. *L'Art Moderne* transformed this association into a cohesive group with a consistent aesthetic doctrine, and the men responsible for this policy were two of its founding editors, Edmond Picard and Octave Maus.

Edmond Picard (1836–1924) was a well-known lawyer, art collector, critic, and man of letters.[13] As a patron of the arts, his splendid house on the Toison d'Or served as a cultural center where artists, members of the bar, politicians, and musicians mingled. Picard was also a militant socialist and passionate defender of the working man. In 1865, he had co-founded the newspaper *La Liberté,* which campaigned for universal suffrage, and on January 18 of the following year, he was asked by the worker's committee to assist in preparing a manifesto for electoral reform. After the violent strikes of 1886, the government called on Picard to be a member of a commission to study industrial conditions, but when workers' delegates were barred, he resigned in protest. In 1888, Picard served as counsel to the participants of the May 1887 and December 1888 strikes. He was repeatedly defeated in his bid for a Senate seat until 1894, when he was elected on the Parti Ouvrier Belge (Belgian Worker's party) platform.

Picard's social views, often expressed in *L'Art Moderne,* clearly shaped his artistic and literary philosophy; he believed that literature and art were effective agents in achieving a transformation of society. For him, a work of art was truly great only if it reflected the society and time in which it was produced. His viewpoint eventually collided with the "art for art's sake" philosophy held by *La Jeune Belgique,* another major literary and artistic periodical in Brussels at this period. For the collaborators of *La Jeune Belgique,* beauty — not subject matter — was the sole criterion determining the value of a work of art; they were repelled by Picard's vulgar concept of "l'art social."

The interests of Octave Maus (1856–1919) complemented those of his mentor Edmond Picard. Like Picard, Maus was a lawyer, patron of the arts, man of letters, and a socialist. He was also an amateur musician and loyal devotee of Richard Wagner.[14] Maus is there-

fore almost certainly the author of the musical reviews, while he and Picard (and later Verhaeren) shared in writing the art criticism. Unlike Picard, Maus did not run for public office, and in fact seems to have avoided the political limelight. Since Picard was such a powerful and well-known figure and since he gave the opening lecture at Les XX in 1884, contemporary critics such as Gustave Lagye incorrectly identified the group as "la bande à Picard." But the main driving force behind Les XX once it was founded was Octave Maus.

After becoming the official secretary, Maus contributed much of his energy and administrative genius to Les XX and its successor, La Libre Esthétique. From 1884, the date of the first exhibition of Les XX, until 1914, with the demise of La Libre Esthétique, Maus was the undisputed artistic impresario in Belgium. He supervised not only the yearly artistic exhibitions, but the lectures and concerts which were held with them and which made up an important part of Les XX's contribution to avant-garde culture. In fact, Maus has in modern times become so identified with Les XX that he is often considered its founder and *raison d'être.*

The Avant-Garde: Theory and Practice

Maus and Picard used *L'Art Moderne* as a platform to fashion Les XX into one of the most avant-garde groups in Europe. But the members of Les XX were not unanimous in their acceptance of *L'Art Moderne's* definition of the group, and ex-Vingtiste Achille Chainaye was in fact quite bitter about the role it played: ". . . little by little, it has imposed its will on the Vingtistes."[15] From the beginning, the ultra-radical stance of Les XX's ideals as set forth in *L'Art Moderne* collided with the more conservative views of some of its members.

The controversy over the annual lecture series illustrates the rift that quickly developed. By deliberately bringing together writers and artists and taking up subjects in all the arts, this program of lectures was a significant part of the activity of Les XX, and in 1884, the opening year, the lectures set a tone of defiance by ridiculing the press and repudiating all official art. Edmond Picard's talk on the art of the new generation of artists was especially inflammatory. In addition, lectures were given that year by Albert Giraud on the Belgian press, by Catulle Mendès on Richard Wagner,

and by the poet Georges Rodenbach on the unity of avant-garde artistic and literary movements. The more conservative members of Les XX, disturbed by the outspokenness of these lectures, tried to end the series altogether.

The painter Willy Finch vehemently objected to this proposal in a letter to Maus. "Who is the pea-brain who has proposed the suppression of the lecture series? So we are invaded once more by *officialdom . . .* must we not only fight officialdom outside the group but within it, on our own ground as well? . . ."[16] The "pea-brain" who suggested the abolition of the lecture series was fellow Vingtiste Jean Delvin. But on December 7, 1884, by a vote of ten to five,[17] the lecture series was retained. Like the exhibitions and the musical programs, these lectures were given by important figures from other countries as well as Belgium, and thus provided another aspect of the cosmopolitan attitude fostered by the leading members of the group.

Although the debate over the lecture series was not publicized at the time, critics recognized divergent artistic styles within Les XX, including "an extreme left, conservative left, and even a right."[18] This contradiction was a constant embarrassment that led Maus and Picard to launch a campaign to purge the group of its more conservative members. Between 1884 and 1886, articles in *L'Art Moderne* and its allies in the press had the desired result of forcing the resignation of five of the most conservative members — Verhaert in 1884, Verstraete and Simons in 1885, and Delvin and Vanaise in 1886. Thus, though proclaiming full artistic liberty, the leaders of Les XX were impelled to act in non-libertarian ways in order to enforce a greater consistency between the art shown at Les XX and *L'Art Moderne's* theory of avant-gardism.

At the same time, Les XX's radical image was somewhat tarnished by the pragmatic need to accommodate certain social realities. In the early years especially, it was considered advantageous to include certain members and *invités* who were well thought of by the establishment. And in practice, although Les XX made a point of rejecting the jury system, the group itself operated as a jury. On a few occasions, works submitted by members were refused. This first occurred in 1886, when a painting by Jean Delvin was rejected.

In this case, the motive was to bring about the resignation of an embarrassingly academic artist; but in the case of the conflicts between Maus and Ensor, the problem arose in the opposite quarter. In 1888, press reports indicate that a drawing of Ensor's, *The Temptation of St. Anthony*, was refused for indecency. Hannon of *La Chronique* wrote, ". . . You . . . have thus brought into your so-called intransigent and revolutionary organization those detestable misjudgments made by the official juries you scoff at so!"[19]

In 1891, according to Ensor, several Vingtistes tried to persuade him not to exhibit *The Good Judges*. As it turned out, it was shown; but Ensor, in writing to Maus before the 1893 exhibition, felt it necessary to lecture him on artistic freedom: "Let us give freedom to everyone. An artist does not decide lightly what he wants to show. He is aware of his responsibility and his judgment must be respected."[20]

Maus explained some years later that Ensor's works at Les XX caused public outrage: "There were bursts of laughter and sometimes scuffles. Impossible to exhibit such paintings. The Prosecutor would descend on us! The government would close the exhibition. . . ."[21] From Maus' point of view, compromises were necessary to attain a degree of acceptance from the government and the art-viewing public.

In trying to live up to *L'Art Moderne's* theoretical principles, Les XX continuously struggled to balance idealism with pragmatism. And by purging its most conservative members, the group's art did become more avant-garde. But this very act violated the libertarian spirit that Les XX claimed to uphold. A similar dilemma was presented by the provocative art of Ensor: while Les XX could be accused of hypocrisy, the striking of a balance between the desire for acceptance and the impulse for unending experimentation was crucial to the group's success.

Organization of Les XX

The organization of Les XX centered on the office of the Secretary — rejecting L'Essor's form of government by a constitution, a president, and a jury of placement — and the group viewed the absence of a hierarchy as an expression of its anarchistic tendencies, considering the lack of doctrines and rules proof of its avant-gardism.

Below:
James Ensor
La Tentation de St. Antoine 1887
The Temptation of St. Anthony
Pencil on paper
170.0 x 150.0 cm. (67 x 59 in.)
Collection: Frédéric Speth, Kapellen

Facing page:
James Ensor
Les Bons Juges 1891
The Good Judges
Oil on panel
38.0 x 46.0 cm. (15 x 18⅛ in.)
Collection: P. de Weissenbruch, Brussels

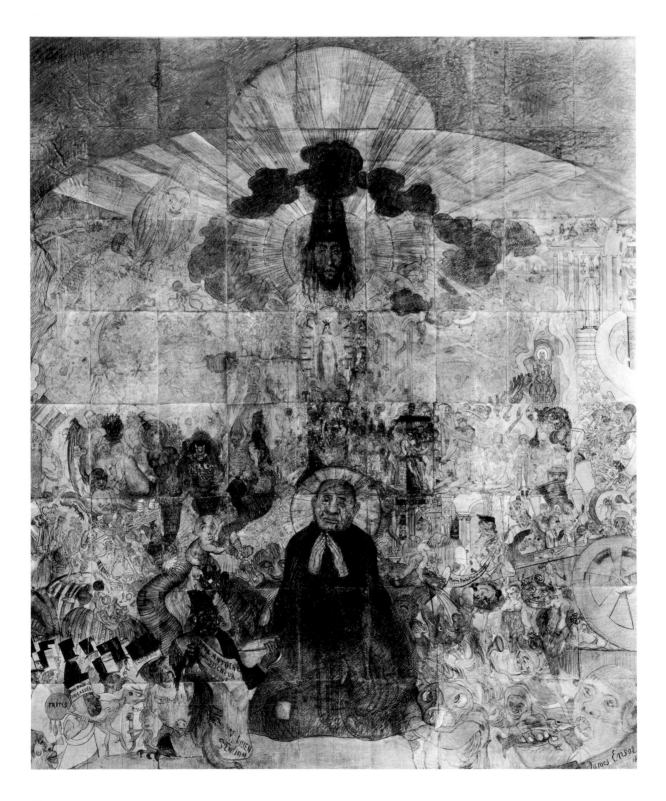

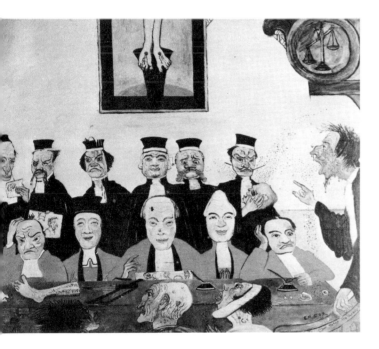

The Secretary, Octave Maus, and a committee of three members were responsible for organizing the annual exhibitions. Membership of the committee was to change annually and was selected by lot. That first year, the committee was composed of Fernand Khnopff, Jef Lambeaux, and Guillaume van Strydonck. It is not clear from the evidence whether the committee role was eventually abandoned, but as Les XX evolved, Maus acquired more power, and his influence on the group became more extensive.

One of Maus' tasks was to secure exhibition space. Although it was government policy to reserve several rooms for temporary exhibitions sponsored by artistic groups, Maus met with some difficulty in obtaining space for Les XX's second show. He requested exhibition space from Auguste Beernaert, Ministre des Beaux-Arts, but was denied permission. Then, despite governmental resistance, Maus' request was subsequently honored; in fact, in 1885, he managed to secure even larger quarters than had been provided the previous year. Whatever the reasons, it is clear that the political and social contacts of Maus and Picard, along with the role played by L'Art Moderne in publishing Les XX's difficulties, were crucial in obtaining the exhibition space.

Throughout Les XX's existence, conservative critics protested this official — if indirect — support given the group. Le Courrier Belge of February 5, 1888, wondered how the government could lend space to "an exhibition of jokers who make fun of the public, of art, of good taste, and morality . . ."[22] The question of granting the group space was even raised in the Belgian parliament: on March 28, 1889, Armand Anspach, the representative from Thuin, demanded that the government cease giving asylum to Les XX.[23]

The group held its exhibitions for one month each year, usually during February and March.[24] It was open daily from ten o'clock to five o'clock and the entrance fee was fifty centimes. Days on which concerts or lectures were given, the rate was increased to two francs,[25] and admission opening night was five francs.[26] In 1886, Les XX began offering an exhibition pass that sold for ten francs (the price was raised to fifteen in 1891) and entitled the bearer to unlimited admission. This was largely a revenue–raising device aimed at those who

could afford to make a modest contribution. Additional funds were raised by charging each member of Les XX twenty-five francs, which would be refunded at the close of the show.

In keeping with the group's desire to avoid the favoritism associated with Salon exhibitions, placement of works was by lot and grouped according to artist. Once assigned a space, the artist was free to arrange his works as he chose. Also unlike the Salon practice, all the paintings — insofar as possible — were arranged in one row at eye level so that the works could be examined without fatigue.

Due to Maus' organizational genius, the publicity supplied by *L'Art Moderne,* and the contrast to the staid Salon, opening day at Les XX was always packed. Attending the exhibitions became a major social event: "It is *le Tout-Bruxelles* of the art world, the people who know painters, who love Wagner and who put on their parlor table the latest novel from Paris."[27]

Les XX was a success from a financial point of view as well. From the outset, *invités* as well as members sold works at the exhibitions.[28] In addition, the group averaged over its ten-year period receipts of four thousand five hundred francs per year. Receipts rose quickly from 1884–1888, reflecting the interest in the group generated by *L'Art Moderne*'s attacks on the press and in the controversial art shown in the exhibitions. Thereafter, receipts remained fairly stable, declining somewhat in Les XX's last two years.

The relative success and popularity of Les XX can be measured by comparing its paid attendance with that of the Brussels Triennial Salon. From 1884 to 1890, attendance at the Salon declined by 43 percent from 54,700 to 31,300.[29] During the same years, attendance at Les XX increased by 45 percent from 4,300 to almost 6,300.

L'Art Moderne concluded from these statistics that Les XX had successfully educated the art-viewing public. Since the Salon of 1890 differed little from that of 1884, *L'Art Moderne* claimed that, because of Les XX, "the public eye . . . [was beginning] to see clearly."[30] By providing an alternative and exciting exhibition ground, the group had diminished the power of the Salon, exposed the public to the most avant-garde art of the day, and still managed to turn a profit.

Selection of Members

Even before the opening of Les XX's first exhibition of February 2, 1884, Les XX became "Les XIX" with the death of Périclès Pantazis. During this exhibition, two other members, Jef Lambeaux and Piet Verhaert, resigned. *L'Art Moderne,* undoubtedly referring to Lambeaux, commented, "We remember too, alas!, some cowards who were scared off and quit the ranks before the battle began."[31]

In order to fill vacancies created by deaths and resignations, Vingtistes proposed the names of candidates and held elections. (See pages 36–38 for list of members.) In 1886, for example, the vacancy created by the death of Charles Goethals was filled by Henry de Groux, a member of L'Essor since 1884 and son of the Realist painter, Charles de Groux. But the suggestion that James Whistler fill one of the two remaining vacancies caused considerable controversy.

Whistler, who had previously exhibited at Les XX in 1884 and 1886 and who was enthusiastic about the organization, was proposed by Willy Finch, an ardent admirer and friend of Whistler. In a letter to Maus, Finch stated: "I have seen Whistler again, and he wants very much to be a part of Les XX."[32] Finch's enthusiasm for Whistler's candidacy was not shared by Maus. Although he admired Whistler, Maus replied that he could not support Whistler's election: "He both *is* a foreigner and *lives* in a foreign country."[33] Maus proposed that the two remaining vacancies be set aside for young Belgian artists, adding, "Nothing would be more stimulating for their productivity than the eventual prize of being able to join Les XX."

James Ensor, echoing Maus' concerns, argued vehemently that Whistler was already an established artist: "Why admit Whistler? His painting already smells moldy and musty, he is known and recognized, what new art or principle can he bring to us? . . ."[34] Ensor felt that Les XX should exist only for young artists and, like Maus, opposed Whistler's candidacy because of his nationality. In the same letter, he said: "Why admit foreigners? Are there no more young artists in Belgium? Are we the last of the young? . . ."

The results of the election were publicly announced in *L'Art Moderne* of December 5, 1886. The Vingtistes

by a vote of ten to seven accepted Maus' idea of reserving the two slots for young Belgian artists. By 1889, however, due to the rapid changes in the artistic climate, a more cosmopolitan spirit had emerged and Rodin was made a member, followed by Signac in 1891.

The extent to which Maus controlled Les XX is further revealed in his successful campaign to elect Robert Picard a member in 1890. The three candidates for election were William Degouve de Nuncques, Frantz Melchers, and Picard. Maus enclosed a letter with Rodin's ballot suggesting that he vote for Robert Picard, the son of Edmond Picard.[35] Melchers and Degouve de Nuncques could wait, Maus continued, since they were young. In actuality, Picard — at the age of twenty — was younger than either Melchers or Degouve de Nuncques.

Henry van de Velde received a similar letter. In his reply, he not only cast his vote for Picard without any knowledge of his work, but suggested that Maus be the sole judge in selecting new members — "Why don't you decide alone on these occasions . . ."[36] Picard was the only member elected in 1890.

The Invités

Les XX always stressed the international nature of its movement by inviting foreign artists to exhibit at the annual exhibitions. In 1884, well-known artists such as Whistler, Rodin, Liebermann, and the older generation of Belgian artists — Artan, Heymans, and Rops — were invited to the first exhibition. These artists provided the newborn organization with a credibility and support it needed to survive. Names of invités, both Belgian and foreign, were proposed and decided upon by the Vingtistes themselves.

Maus was always aware that a major problem lay in securing the willingness of invités to participate in Les XX exhibitions. In a letter to Van Strydonck, he wrote, "The question now is to know whether these artists will accept."[37] Some invités, such as Jules Dalou and Puvis de Chavannes, declined Les XX's invitation, claiming either that they had nothing available to exhibit or were too busy working on other projects. Frederic Leighton declined because he was opposed to the Impressionist movement at Les XX. But it is doubtful

we will ever know all the reasons why certain artists were asked to show at Les XX and why some declined and others accepted. In the latter category is Cézanne, who was persuaded to show at Les XX in 1890. Teodor de Wyzewa wrote to Maus on the difficulty of securing him: "Cézanne is a sort of madman who is convinced that his painting is rubbish, and who would respond no more to your invitation than to that of collectors who want to buy or to just look at his painting. . . ."[38]

One way Maus hoped to increase the acceptance rate of invités was to develop a network of contacts (diverses influences) who could intercede on behalf of Les XX. The recruitment efforts of Boch, de Wyzewa, Van Rysselberghe, Signac, Lautrec, Verhaeren, and Maus helped to foster closer ties between Paris and Brussels and also greatly contributed to the group's success.

In 1885, Maus went to Paris and personally invited Monet, Renoir, and Carriès to show with Les XX. Verhaeren was instrumental in suggesting that Seurat exhibit with the group in 1887, the year after Verhaeren had seen and praised La Grande Jatte in Paris. In 1889, de Wyzewa's influence was crucial in persuading Renoir, who at first declined to participate because of his opposition to the divisionist painting of Seurat and his followers. That same year, Maus enlisted the aid of Eugène Boch to convince Sisley to exhibit at Les XX. Maus feared that Jacques-Émile Blanche had turned the Impressionists against Les XX by claiming that Neo-Impressionism had completely taken it over.[39] The fear proved groundless and Sisley showed with the group in 1891.

Van Rysselberghe was a particularly able agent for Maus. In 1887 he sought out Guillaumin, Helleu, Dubois-Pillet, and Anquetin. Two years later, he contacted Hayet, Signac, Gausson, Van Gogh, and again Dubois-Pillet. Not only did Van Rysselberghe eventually persuade all of these artists to exhibit with Les XX, but he could justifiably claim to have discovered Lautrec, whose first exhibition was with the group in 1888. Van Rysselberghe wrote Maus that Lautrec not only had talent but that he would be of use to Les XX, being "well-acquainted with a lot of people."[40]

During its ten years, 126 invités exhibited at Les XX. Although the group invited relative unknowns such as

Lautrec, Van Gogh, Anquetin, Gauguin, and Filliger, it also invited artists of considerable current repute: Bracquemond, Fantin-Latour, Gervex, and Frémiet. By inviting artists of diverse schools, Les XX broadened its appeal and increased attendance at the exhibitions. Describing his recruitment efforts for the 1887 show, Maus wrote Eugène Boch in a humorous vein: "There will be something for every taste, the 'tight' and the 'loose,' the 'impressionists' and the 'intentionists' and the 'impossibilists.'. . ."[41]

There are two important conclusions to be drawn about the *invités*. First, there is an overall similarity in the diversity of artistic styles represented by both the *invités* and members of Les XX. For instance, in 1892, when decorative arts took hold at Les XX, the *invités* included Cassatt and Meunier representing Impressionism and Realism; Luce, Gausson and a Seurat memorial representing Neo-Impressionism; Denis and Mellery representing Symbolism; and Delaherche, Horne, Image, and Lautrec representing the decorative arts. Les XX deliberately invited artists representing the different avant-garde styles of its members. Second, this very diversity of style among the *invités* made Brussels a marketplace of avant-garde art — where the latest and most controversial styles could be seen by artists and critics. In a relatively short time, through the interaction of the Vingtistes and their *invités*, Brussels became one of the leading artistic capitals of Europe.

The Artistic Phases of Les XX

Throughout Les XX's ten-year existence, *L'Art Moderne* proclaimed the group's artistic independence and eclecticism. *Le Journal des Beaux-Arts* summed up critical opinion of the group with the ominous phrase, "the monster that is called Vingtisme."[42] *L'Art Moderne* denied that there was such a thing as Vingtisme. It claimed that the one unifying feature of all Les XX's exhibitors was their rejection of "the formulas passed on from generation to generation by the dubious ateliers of the academies . . ."[43]

This is born out by Les XX's receptivity to several artistic movements, which confirmed the avant-garde principles of novelty, exploration, and discovery. Four distinct movements — Impressionism, Neo-Impression-

ism, Symbolism, and the decorative arts — were at different times endorsed by *L'Art Moderne*. Each in turn tended to dominate the works shown at Les XX.

Impressionism

As early as the 1885 exhibition, critics were citing Ensor and his followers Vogels, Finch, and Toorop as the true revolutionaries within Les XX. They were often referred to as "tachistes" or "les Impressionnistes," generally implying unfinished or scribbled work. But in 1886, with the presence of Monet and Renoir at Les XX, the term 'Impressionist' is applied consistently to Ensor and his following. This label is somewhat misleading because the artists concerned were inspired more by their own tradition of Flemish Realism as practiced by Artan and De Braekeleer than by French Impressionism.

The critics of the 1886 exhibition decried the unfinished look of Impressionist works and the reviewer for *La Gazette* declared that he longed to see a polished work and not merely an embryo.[44] *Le Journal des Beaux-Arts* accused Ensor's group of simply copying Monet and Renoir.[45] An article in *Le Nord* claimed disgustedly that Les XX was "the sanctuary of Impressionism."[46]

L'Art Moderne responded to these criticisms by asserting that the Vingtistes had not formed a school with any one distinct style. It saw Impressionism as an inevitable phase in the aesthetic evolution of the history of art. Quoting from Raffaëlli's lecture given at Les XX in 1885, *L'Art Moderne* continued, "These words ending in ism . . . are rallying cries thrown into circulation, and which help artists to recognize one another, to count on one another, and to unite for the defense of art. Nothing more!"[47]

Ensor's artistic influence within Les XX culminated in 1887. In that year, the critics and the Vingtistes began to turn their attention to Seurat, whose Neo-Impressionist works were shown in Brussels for the first time, and by 1888, Impressionism at Les XX was no longer seen as a progressive movement. *L'Art Moderne* stated, "These works, which were perhaps bold in those distant days of the first flowering of art, today appear almost timid."[48] Although many of the Vingtistes quickly adopted Neo-Impressionism, artists such as

Théo van Rysselberghe
Poster for 1889 Exhibition of Les XX
24.0 x 14.0 cm. (9¹/₂ x 5¹/₂ in.)
*Collection: Musées Royaux des Beaux-Arts de Belgique,
Archives de l'Art contemporain*

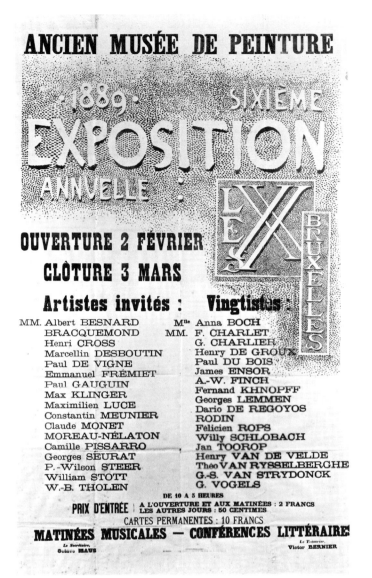

Vogels and Van Strydonck remained extremely individualistic in content and style. Thus a form of Belgian Impressionism, although viewed as passé by *L'Art Moderne*, continued to coexist with Neo-Impressionism at Les XX.

Neo-Impressionism

It was Octave Maus who wrote the anonymous article in *L'Art Moderne* of June 27, 1886, entitled "Les Vingtistes Parisiens," which analyzed the 1886 Impressionist exhibition in Paris. In this review, Maus referred to Seurat as "this Messiah of a new art" and stated that if *La Grande Jatte* were to be shown in Brussels it would create a scandal: "If it were to be exhibited, there would be sudden cases of mental breakdown and terrible cases of apoplexy."[49] A postscript appended to this article by Picard urged Maus to therefore and by all means exhibit Seurat's work in Brussels.

Fully aware that *La Grande Jatte* was greeted with derision in Paris, *L'Art Moderne* tried to prepare the public for its appearance in Brussels. It published on September 19, 1886 an article by Félix Fénéon — Paris correspondent for *L'Art Moderne* and the first critic to admire and defend Seurat's work — which attempted to explain the theories of optics and color that lay behind Seurat's painting. On February 6, 1887, in its discussion of the exhibition of Les XX in which *La Grande Jatte* was shown, *L'Art Moderne* reviewed the major principles previously set forth by Fénéon and praised the luminosity Seurat achieved in *La Grande Jatte* through use of the divisionist technique.

In addition, the week previous to this review *L'Art Moderne* published an excerpt from Zola's *L'Oeuvre*.[50] The passage dealt with the outrage of an unenlightened crowd before works of avant-garde painters at the Salon des Refusés. By anticipating public reaction, *L'Art Moderne* hoped to temper the critics' vehemence and thus sway public opinion.

As it turned out, the Belgian critics greeted the works of Seurat with surprising calm. While there were those who dismissed the works as having no merit whatsoever and ridiculed the dot-like brush strokes as "wafers" (*pains à cacheter*),[51] the overall response was reserved, and can be attributed to *L'Art Moderne's* insistence that *La Grande Jatte* would scandalize Brussels. The critics, not wishing to fulfill the periodical's prophecy, restrained their attacks — though only until the following year when the Belgians began adopting the same technique.

The first Belgian convert to Neo-Impressionism was Willy Finch, who was already experimenting with it by July, 1887.[52] Finch submitted some Pointillist paintings along with a Pointillist drawing for the 1888 catalogue, and expressed to Maus the fear that "inexperienced eyes will not see the differences in technique between us and our friends in Paris."[53] Indeed, the critics condemned him for his pastiche of the French. In 1889 and in subsequent years, other Vingtistes, such as Van Rysselberghe, Anna Boch, Lemmen, Van de Velde, and Toorop executed Neo-Impressionist works. The new school of Neo-Impressionism was referred to as "les Bubonistes" (a reference to the spots accompanying the Bubonic Plague), and was seen by the critics as an epidemic from Paris that threatened to subvert the true personalities of all these artists. *La Fédération*

Artistique in particular felt that Van Rysselberghe's conversion to Pointillism destroyed his art: "Pointillism kills everything strong and original in him, and even takes away his passion for the beautiful."[54] Even the poster for the 1889 exhibition, executed in the Neo-Impressionist style, and probably by Van Rysselberghe, was attacked. "The poster itself has not escaped. The smallpox has horribly blotched it."[55] This motif of Les XX having been invaded by a disease continued in the 1890s.

For the 1892 show, Maus mounted a memorial exhibition for Seurat, and *L'Art Moderne* of February 7 had as its lead article a review that eloquently defended the artist's genius and originality against his critics. But Seurat's death actually coincided with some slackening of interest in Neo-Impressionism by the Vingtistes. Finch, Lemmen, and Van Rysselberghe continued to produce Neo-Impressionist works in the 1890s, but their interests were increasingly diverted to the decorative arts. By 1894, Van de Velde had given up painting entirely and devoted himself to applied arts and architecture. And while Toorop, too, continued painting Neo-Impressionist works in the 1890s, he ultimately became more absorbed in Symbolism.

Symbolism

Although discussion of Symbolism in Belgium began in 1885 in *La Basoche* and *L'Élan Littéraire* (later to become *La Wallonie*), it did not receive extensive consideration until Jean Moréas' manifesto appeared on September 18, 1886 in the Parisian *Le Figaro*. At first, Belgian reaction to the manifesto was harsh. *La Jeune Belgique* said that it was "a singular case of artistic aberration, scorn of the language, deformation of the word, a tendency to gibberish where simple good sense would satisfy."[56]

Similarly, *L'Art Moderne* found the manifesto composed of "murky statements and incomprehensible works . . . which appear to us like cases of literary pathology."[57] Given Picard's belief that art should be a direct reflection of society and thus comprehensible to the greatest number of people, this view is not surprising. In 1887, the Symbolist poets Émile Verhaeren, Georges Khnopff, and Georges Rodenbach left *La Jeune Belgique* to join the staff of *L'Art Moderne*. These

writers won Picard over to the merits of Symbolism and made *L'Art Moderne* a principal defender of the movement. In fact, in 1890 Picard gave a lecture at Les XX praising the Symbolist poetry of Verhaeren, Maurice Maeterlinck, and Charles van Lerberghe. In the same year, Mallarmé lectured at Les XX on Villiers de l'Isle Adam.

For *L'Art Moderne*, the Belgian artist who came closest to expressing literary Symbolism was Fernand Khnopff. Khnopff had studied in Paris and was a great admirer of Gustave Moreau, Burne-Jones, and Rossetti. Khnopff exhibited at four of the six Rose + Croix Salons between 1892 and 1897 and collaborated with Joséphin Péladan on several literary projects.

Among the works Khnopff exhibited at the first Les XX exhibition was *The Temptation of Saint Anthony according to Flaubert*. *La Jeune Belgique* did not fail to notice Moreau's influence and called Khnopff "the most thoughtful, the most analytic, the most searching of Les XX."[58] Khnopff's concern with psychological interpretation and probing beyond the surface of things was already evident.

In 1888, *L'Art Moderne* identified a group of painters exhibiting with Les XX who, unlike the Neo-Impressionists, were not interested in seeking and rendering light and color."[59] This contingent, composed of De Groux, Rops, Khnopff, and the *invité* Mellery, was later enlarged with the addition of Vingtistes Robert Picard, Jan Toorop, George Minne, and Willy Schlobach. All these artists tended to rely on literary sources for their works and strove to depict *un état d'âme* as opposed to a faithful reproduction of reality.

By 1892, Symbolism had become firmly entrenched at Les XX. Its prevalence led Émile Verhaeren to write at that time, "Already in recent years, an orientation toward literature made itself felt among certain painters of Les XX. Today, that orientation has grown to the point where it is dominant. Furthermore, for the past five years, in all the arts, but especially in painting, idealism has made an enormous comeback, whether it's called Symbolism, intellectualism, or esotericism."[60]

Decorative Arts

Discontent with the social and artistic conditions in Belgium gave impetus to the growth of the decorative

Fernand Khnopff
La Tentation de St. Antoine, d'après Flaubert 1883
The Temptation of St. Anthony according to Flaubert
Oil on paper
85.0 x 85.0 cm. (33½ x 33½ in.)
Collection: Gillion-Crowet, Brussels

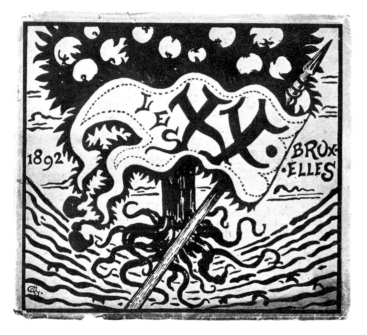

arts movement. The Parti Ouvrier Belge, formed in 1885, recognized the importance of art for attaining its goal of social equality. However, the party did not officially develop a program to achieve this end. Instead, it was content to turn to aestheticians like Verhaeren, Maus, and Picard. For these men, the decorative arts epitomized an art that would belong to all the people. The artist — by concerning himself with the most common objects — could infuse beauty into everyday life and thus improve the environment for all. In part, the idealism that was at the base of the Symbolist movement also fueled the belief in the power of art to transform ordinary life.

Beginning in 1891, the decorative arts became a major focus of exhibitions at Les XX. To the 1891 show, Willy Finch sent ceramic panels along with several of his paintings and drawings; Lemmen designed the covers for the exhibition catalogues of 1891, 1892, and 1893. Chéret sent a series of posters; Walter Crane agreed to exhibit two pastels and gave permission to exhibit his children's books, which Lemmen owned.

In 1892, even greater prominence was given to the decorative arts. Auguste Delaherche, whose work —

along with that of Émile Gallé and Chapelet — had been exhibited in 1889 in the ceramic section of the Champ de Mars Salon, accepted Les XX's invitation. Selwyn Image displayed drawings for his stained glass and embroidery; Herbert Horne showed frontispieces for books; and Toulouse-Lautrec exhibited several posters. As for the Vingtistes, Finch displayed more of his ceramic tiles, and Van de Velde showed a project for an embroidery.

In 1893, two entire rooms were reserved for the decorative arts at Les XX. Van de Velde, influenced by Gauguin's painting of *Jacob Wrestling with the Angel* — shown at Les XX in 1889 — exhibited the embroidery for his *Vigil of Angels*. Willy Finch exhibited a tea table, and Anna Boch a screen that complemented one she owned by Émile Bernard. Delaherche reappeared at Les XX with his plates.

The interest in decorative arts continued on a greater scale in the years after 1893, in the exhibitions of La Libre Esthétique, the successor organization to Les XX. In 1894, Gustave Serrurier-Bovy prepared an entire furnished room for this first exhibition. He created a study with wall paper, draperies, and furniture, and even installed a false window. Also shown were: the posters of Lautrec, Cheret, and Grasset; tapestries by Maillol; William Morris' Kelmscott Press books; the jewelry of Charles Ashbee; and Beardsley's illustrations for Oscar Wilde's *Salome*.

Through Les XX and La Libre Esthétique, Brussels became an important center for the exhibition and dissemination of the decorative arts. Before the 1880s, Belgium often looked to France for its artistic inspiration. It is a fitting tribute to Les XX and La Libre Esthétique that by the 1890s the situation had changed drastically. The Parisian *Revue des Arts Décoratifs*, fearful of being overwhelmed by English and Belgian importations in 1897, urged its artists: "Let us be French! . . . Is it not the moment to publish this appeal to artists, now when after several years of servitude to English art and its derivatives, an invasion of Belgian art is being attempted?"[61]

Art and Politics

Throughout Les XX's existence, a basically hostile press labeled the group as *anarchiste* and attacked it for its

stylistic innovations. Because Edmond Picard's socialist credentials were so indisputable, his close association with Les XX left it tainted in the eyes of the conservative artistic community. In 1888, the orange-colored catalogue sold in red wrappers was seen as a symbol of rebellion. "The catalogue is red, the red of blood, the red of combat and carnage."[62]

That some critics equated avant-garde art with socialism can be seen in the caricatural illustrations from *Le Patriote Illustré*. Delaherche's pottery is presumed filled with revolutionary ideas, and Seurat's *Young Woman Powdering Herself* is transformed into an old hag powdering her face with "la rouge socialiste." Even Paul Dubois' portrait busts are inexplicably linked with socialism.

That Les XX considered itself anarchistic is reflected in Maus' letter to Verheyden upon his election: "You are hailed as a member of the anarchist society."[63] The label *anarchiste* referred not only to the avant-garde styles of painting of the Vingtistes, but also to the political and social philosophy of the group.

In 1886, Picard published in *L'Art Moderne* a three part article on "L'Art et la Révolution" in which he praised Peter Kropotkin's *Paroles d'un Révolté* and *L'Insurgé* of Jules Vallès.[64] Ostensibly, Picard treated these as literary works, but actually he viewed them as models for the artist. Picard declared that instead of taking refuge from contemporary society, poets should be made aware that "The hour is at hand to dip one's pen into red ink."[65]

Picard, like Proudhon, Marx, and Kropotkin, believed in the artist's ability to transform society. This would be accomplished by depicting contemporary society, dissolving the barriers between men, and thereby uniting them in a state of harmony. An integral part of this goal was the international nature of the struggle. Only if artists of all countries united could the struggle to reform society succeed. Progress toward the inevitable victory was marked by a succession of artistic movements. Picard, in his defense of Impressionism, stated: "It is the latest turn of the wheel of this vast system, which is always in motion and whose functioning no human power could impede; which it is as foolish to attack as it is absurd to deny."[66] As Marx exhorted the working class, Picard exhorted the artist.

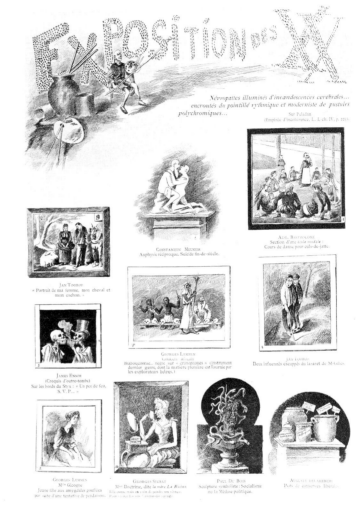

Ensor's 1885 drawing, the *Entry of Christ into Jerusalem,* conforms with Picard's exhortation. This work contains several banners — "Liberté, Égalité, Fraternité;"[67] "Vive la Sociale;" "Amnistie;" and "Le Mouvement Flamand" — all popular slogans of the day. By including "Les XX" and "les Impressionnistes belges" alongside these slogans, Ensor explicitly links the artistic struggle with the political.

The social message of Ensor's work was recognized by contemporary critics. A.–J. Wauters of *La Gazette* claimed that the crowd in Ensor's work contained heads "deformed by physical labor, convulsed by the fatigue of the procession, distorted by rancor, vengeance and craving. . . ."[68]

Despite this example, explicit references to political and social issues are rare among works exhibited at Les XX. Ensor showed *Massacre of the Fishermen at Ostend* in 1889 and *Belgium in the XIX Century* in 1891, and Toorop's *After the Strike* of 1889 was clearly intended as a comment on a social issue of the day. But far more typical were the Symbolist works of Khnopff and Degouve de Nuncques, the Neo-Impressionist works of Van Rysselberghe and Signac, the Realist works of Vogels and Van Strydonck, and Ensor's macabre masks and skeletons.

This general absence of overt socialist themes in Les XX's art did not undermine its personal allegiance to socialism. Throughout its existence, Les XX's support for the most avant-garde styles of the day, such as Impressionism and Neo-Impressionism, reflected its antiestablishment tendencies. As *L'Art Moderne* made clear, and as the Vingtistes quickly realized, membership in the group itself was a revolutionary act. This may well have had the effect of lessening the pressure on the Vingtistes to depict purely social themes in their art, and allowing them to pursue whatever styles and subject matter they cared to.

With the advent of the decorative arts movement, Les XX's socialist leanings became more apparent. For several Vingtistes — especially Lemmen, Finch, and Van de Velde — the writings of William Morris and Walter Crane had a major impact on their careers. Morris denounced the evils of the Industrial Revolution and called for a return to craftsmanship that would create an art for all the people — not just an elite.

For Morris, the making of beautiful and useful objects would enrich the lives of all men. This explicit link between art, morality, and religion inspired several Vingtistes to turn to the decorative arts; in the case of Van de Velde, as has been mentioned, the break with painting was complete.

In 1891, *L'Art Moderne* published an article entitled "L'Art et le Socialisme," which argued that the bourgeoisie would eventually crumble despite its financial and military power. Art, however, would be resurrected and infused into everyday life: "We will see art, as in the past, recommitted to the details of life, to adorning the tool of the worker, the furnishings of simple houses, the national costumes. The dish, the pot, the sign board, the door, the lock will again become objects which the artist will believe to be worthy of his attention. . . ."[69] *L'Art Moderne* strongly believed in the power of the decorative arts to bridge the gap between all the classes.

In 1893, when Les XX devoted two exhibition rooms to the decorative arts, Émile Vandervelde, the socialist leader of the Parti Ouvrier Belge, brought sixty members of the Section d'Art to the exhibition. The Section d'Art, founded in 1891, was the artistic arm of the Maison du Peuple, headquarters of the Parti Ouvrier Belge. The purpose of the Section d'Art was to educate the working class through art, literature, and music. Instrumental in the founding and running of the Section d'Art were Picard, Maus, Verhaeren, and Khnopff. The link between Les XX, *L'Art Moderne,* and socialism was now made explicit.

The Dissolution of Les XX

It is difficult to ascertain exactly when Octave Maus conceived the notion to disband Les XX and form its successor, La Libre Esthétique. We do know that Maus considered Les XX's tenth annual exhibition of 1893 an

important event. Distressed at the prospect of Toorop not exhibiting, Maus wrote, "It seems to me that this abstention is very vexing, particularly in view of the rumors which are going around Brussels on the subject of the splitting up of our Circle."[70]

A laudatory article by Verhaeren in *La Nation* of February 26, 1893, provided the first public suggestion that Les XX should disband. "The influence of Les XX has been so profound and so successful that they could cease to be a group tomorrow, with no great harm done, since their goal seems to be attained."[71] Van de Velde echoed Verhaeren's sentiments and urged that the group disband at the peak of its success rather than risk becoming outdated.[72]

On April 9, 1893, *L'Art Moderne* published a compilation of all artists, lecturers, and musicians who had participated in Les XX's annual Salons.[73] Interestingly, no mention is made of the future of the group; the entire emphasis is on Les XX's accomplishments. Maus probably knew at this time that this was to be its last exhibition. In the place of Les XX, Maus envisaged a new group, managed by himself and supervised by an organizing committee of critics and patrons of the arts rather than artists. Maus most likely shared this idea first with Théo van Rysselberghe, who endorsed Maus' suggestion primarily because he felt that "artists are . . . not gifted at working together and managing 'affairs.' . . ."[74]

On October 29, 1893, the program of Les XX's successor, La Libre Esthétique, was set forth in *L'Art Moderne*. La Libre Esthétique would devote an important place to the decorative arts, and had but one rule: to support "new art in all its expressions."[75] It would consist of one hundred members from all parts of Belgium who would each contribute a sum of twenty francs. None of these supporters would be artists, because La Libre Esthétique wanted to avoid the unpleasant consequences that followed from the aesthetic rivalries and personal alignments that inevitably occurred in a group of them.[76]

Despite this announcement, the question of Les XX's dissolution was not put to a vote until November 1893. The final count was twelve affirmatives (including the votes of Maus and Victor Bernier, the treasurer), three abstentions, six failures to respond, and only one negative vote — that of James Ensor. Ensor complained bitterly that he had not even received notification of the two meetings that were held to discuss the dissolution.[77]

From 1894 to 1914, La Libre Esthétique continued to devote itself to the avant-garde cause, though over the years, the once revolutionary figures became established and the tradition of inviting the young and unknown from abroad tended to decline. Heavy emphasis was placed on the decorative arts. Artists such as Aubrey Beardsley, William Morris, William H. Bradley, Aristide Maillol, Gisbert Combaz, and Victor Horta exhibited. An important difference between Les XX and La Libre Esthétique was in its organization. Maus was now free to invite whom he wished. Referring to Les XX as the "anarchist period," Maus confessed that "the exhibitors squabbled among themselves."[78] Ensor, embittered by the dissolution of Les XX and his exclusion from La Libre Esthétique's inner circle, depicted Maus as his executioner in his painting of 1896, *Dangerous Cooks*.

The Salons for La Libre Esthétique were much larger than those for Les XX. Compared to the thirty-two artists who exhibited at Les XX in 1893, eighty-five artists exhibited at La Libre Esthétique in 1894. By creating a larger exhibition, it seems, Maus intended to actually replace the Salon — not simply to offer an alternative outlet.

During its ten-year existence, Les XX succeeded in introducing into Belgium the most avant-garde art movements: Impressionism, Neo-Impressionism, Symbolism, and the decorative arts. Les XX provided an alternative exhibition ground to the Salon and established a climate of artistic freedom. The group, as a model of a jury-free, independent society, helped to galvanize artistic forces both at home and abroad. Inside and outside its borders, Les XX spawned imitators who adopted its organization. By doing so, Les XX expanded the narrow definition of art that was upheld by the Academy, and ultimately helped contribute to the Salon's demise.

James Ensor
Les Cuisiniers Dangereux 1896
Dangerous Cooks
Oil on panel
38.0 x 46.0 cm. (15 x 18⅛ in.)
Collection: P. Leten, Ghent

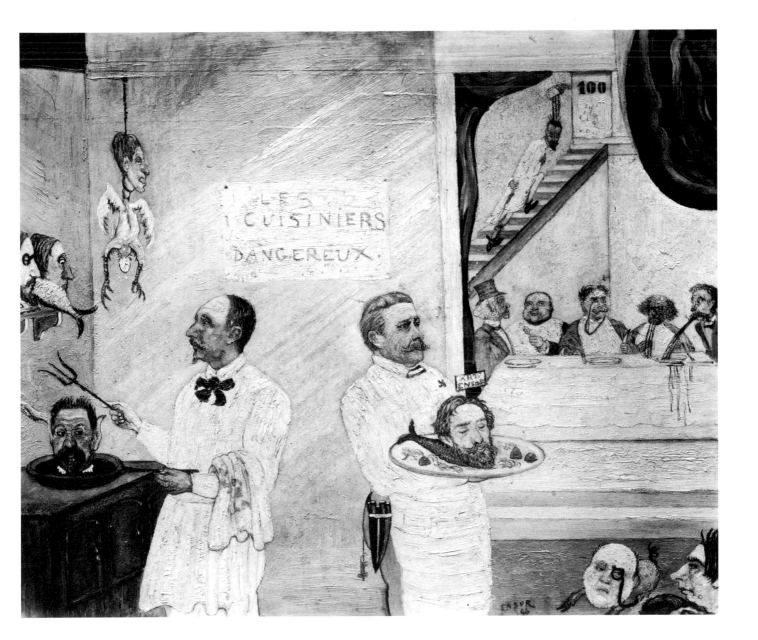

Vingtistes

Artist		Member	Exhibited									
Boch, Anna	B	1886-1893	–	–	1886	1887	1888	1889	1890	1891	1892	1893
Chainaye, Achille	B	**1884-1888**	1884	1885	1886	–	–	–	–	–	–	–
Charlet, Frantz	B	**1884-1893**	1884	1885	1886	1887	–	1889	–	–	–	–
Charlier, Guillaume	B	1885-1893	–	1885	1886	1887	1888	1889	1890	1891	–	1893
Delvin, Jean	B	**1884-1886**	1884	1885	–	–	–	–	–	–	–	–
Dubois, Paul	B	**1884-1893**	1884	1885	1886	1887	1888	1889	1890	1891	1892	1893
Ensor, James	B	**1884-1893**	1884	1885	1886	1887	1888	1889	1890	1891	1892	1893
Finch, Willy	B	**1884-1893**	1884	1885	1886	1887	1888	–	1890	1891	1892	1893
Goethals, Charles	B	**1884-1885**	1884	1885	*1886*	–	–	–	–	–	–	–
Groux, Henry de	B	1887-1890	–	–	–	1887	1888	1889	–	–	–	–
Khnopff, Fernand	B	**1884-1893**	1884	1885	1886	–	1888	–	1890	1891	1892	–
Lambeaux, Jef	B	**1884**	1884	–	–	–	–	–	–	–	–	–
Lemmen, Georges	B	1889-1893	–	–	–	–	–	1889	1890	1891	1892	1893
Minne, George	B	1891-1893	–	–	–	–	–	–	1890*	1891	1892	–
Pantazis, Périclès	GR	**1884**	*1884*	–	–	–	–	–	–	–	–	–
Picard, Robert	B	1890-1893	–	–	–	–	–	–	1890	–	–	–
Regoyos, Dario de	SP	**1884-1893**	1884	1885	1886	1887	1888	1889	1890	–	1892	1893
Rodin, Auguste	F	1889-1893	1884*	–	–	1887*	–	1889	1890	–	–	1893
Rops, Félicien	B	1886-1893	1884*	–	1886	1887	1888	1889	–	–	–	1893
Rysselberghe, Théo van	B	**1884-1893**	1884	1885	1886	1887	–	1889	1890	1891	1892	1893
Schlobach, Willy	B	**1884-1893**	1884	1885	1886	1887	1888	1889	1890	–	–	–
Signac, Paul	F	1891-1893	–	–	–	–	1888*	–	1890*	1891	1892	1893
Simons, Frans	B	**1884-1885**	1884	1885	–	–	–	–	–	–	–	–
Strydonck, Guillaume van	B	**1884-1893**	1884	1885	1886	1887	1888	1889	1890	1891	1892	1893
Toorop, Jan	H	1885-1893	–	1885	1886	1887	1888	1889	1890	1891	1892	1893
Vanaise, Guillaume	B	**1884-1886**	1884	–	1886	–	–	–	–	–	–	–
Velde, Henry van de	B	1889-1893	–	–	–	–	–	1889	1890	1891	1892	1893
Verhaert, Piet	B	**1884**	1884	–	–	–	–	–	–	–	–	–
Verheyden, Isidore	B	1885-1887	–	1885	1886	1887	–	–	–	–	–	–
Verstraete, Théodore	B	**1884-1885**	1884	1885	–	–	–	–	–	–	–	–
Vogels, Guillaume	B	**1884-1893**	1884	1885	1886	1887	1888	–	1890	–	1892	1893
Wytsman, Rodolphe	B	**1884-1887**	1884	1885	1886	1887	–	–	–	–	–	–

Invités

Artist		Exhibited									
Angrand, Charles	F	–	–	–	–	–	–	–	1891	–	–
Anquetin, Louis	F	–	–	–	–	1888	–	–	–	–	–
Artan de Saint-Martin, Louis	B	1884	–	–	1887	–	–	–	–	–	–
Baffier, Jean	F	–	–	–	–	–	–	–	1891	–	–
Bartholmé, Albert	F	–	–	–	–	–	–	–	–	1892	–
Bauer, Marius	H	–	–	–	–	–	–	–	1891	–	–
Bergh, Sven Richard	S	1884	–	–	–	–	–	–	–	–	–
Bernard, Émile	F	–	–	–	–	–	–	–	–	–	1893
Besnard, Charlotte Gabrielle	F	–	–	–	–	1888	–	–	–	–	–
Besnard, Paul Albert	F	–	–	1886	–	–	1889	–	[1891]	–	1893
Blanche, Jacques-Émile	F	–	–	–	–	1888	–	–	–	–	–
Boch, Eugène	B	–	–	–	–	–	–	1890	–	–	–
Bracquemond, Félix	F	–	1885	–	–	–	1889	–	–	–	–
Braekeleer, Henri de	B	–	–	–	1887	–	–	–	–	–	–
Breitner, George Hendrik	H	–	–	1886	–	–	–	–	–	–	–
Breslau, Marie Louise	SWI	–	1885	–	–	–	–	–	–	–	–
Brown, Ford Madox	GB	–	–	–	–	–	–	–	–	–	1893
Caillebotte, Gustave	F	–	–	–	–	1888	–	–	–	–	–

Artist		1884	1885	1886	1887	1888	1889	1890	1891	1892	1893
						Exhibited					
Carriès, Jean-Joseph-Marie	F	—	—	1886	—	—	—	—	—	—	—
Cassatt, Mary	F	—	—	—	—	—	—	—	—	1892	—
Cazin, Jean-Charles	F	—	1885	—	—	—	—	—	—	—	—
Cazin, Marie	F	—	—	—	1887	—	—	—	—	—	—
Cézanne, Paul	F	—	—	—	—	—	—	1890	—	—	—
Chaplain, Jules-Clémont	F	—	—	—	—	1888	—	—	—	—	—
Charpentier, Alexandre	F	—	—	—	—	—	—	1890	—	—	1893
Chase, William Merritt	USA	1884	--	[1886]	—	—	—	—	—	—	—
Chéret, Jules	F	—	—	—	—	—	—	—	1891	—	—
Crane, Walter	GB	—	—	—	—	—	—	—	1091	—	—
Cros, César Isidore Henri	F	—	—	—	—	1888	—	—	—	—	1893
Cross, Henri Edmond	F	—	—	—	—	—	1889	—	—	—	1893
Danse, Auguste	B	—	—	1886	—	—	—	—	—	—	—
Degouve de Nuncques, William	B	—	—	—	—	—	—	—	—	—	1893
Delaherche, Auguste	F	—	—	—	—	—	—	—	—	1892	1893
Denis, Maurice	F	—	—	—	—	—	—	—	—	1892	—
Desboutin, Marcellin	F	—	—	—	—	—	1889	—	—	—	—
Devillez, Louis-Henry	B	—	1885	—	—	—	—	—	—	—	—
Doudelet, Charles	B	—	—	—	—	—	—	—	—	—	1893
Dubois-Pillet, Albert	F	—	—	—	—	1888	—	1890	—	—	—
Fantin-Latour, Ignace Henri	F	—	1885	—	—	—	—	—	—	—	—
Filliger, Charles	F	—	—	—	—	—	—	—	1891	—	—
Fisher, Mark	GB	—	1885	—	—	—	—	—	—	—	—
Forain, Jean-Louis	F	—	—	—	—	[1888]	—	—	—	—	—
Frédéric, Léon	B	—	—	—	—	—	—	—	—	—	1893
Frémiet, Emmanual	F	—	—	—	—	—	1889	—	—	—	—
Gaillard, Claude Ferdinand	F	—	—	1886	—	—	—	—	—	—	—
Gaspar, Jean	B	—	—	—	—	—	—	—	—	—	1893
Gauguin, Paul	F	—	—	—	—	—	1889	—	1891	—	—
Gausson, Léo	F	—	—	—	—	—	—	—	—	1892	—
Gervex, Henri	F	1884	—	—	—	—	—	—	—	—	—
Gogh, Vincent van	H	—	—	—	—	—	—	1890	1891†	—	—
Guérard, Henri	F	—	—	1886	—	—	—	—	—	—	—
Guérard-Gonzalès, Jeanne	F	—	—	—	—	1888	—	—	—	—	—
Guillaumin, Jean-Baptiste-Armand	F	—	—	—	—	1888	—	—	1891	—	—
Hayet, Louis	F	—	—	—	—	—	—	1890	—	—	—
Helleu, Paul César	F	—	—	—	—	1888	—	—	—	—	—
Hermans, Charles	B	—	—	1886	—	—	—	—	—	—	—
Heymans, Adrien-Joseph	B	1884	—	—	—	—	—	—	—	—	—
Holeman, Marguerite	B	—	—	—	—	—	—	—	—	—	1893
Horne, Herbert	GB	—	—	—	—	—	—	—	—	1892	—
Hornel, Edward Atkinson	GB	—	—	—	—	—	—	—	—	—	1893
Image, Selwyn	GB	—	—	—	—	—	—	—	—	1892	—
Injalbert, Jean-Antoine	F	1884	—	—	—	—	—	—	—	—	—
Israels, Jozef	H	1884	—	[1886]	—	—	—	—	—	—	—
Jacquemin, Jeanne	F	—	—	—	—	—	—	—	—	—	1893
Klinger, Max	G	—	—	—	—	—	1889	—	—	—	—
Kölsto, Fredrik	N	—	—	1886	—	—	—	—	—	—	—
Krohg, Christian	N	—	—	1886	—	—	—	—	—	—	—
Kröyer, Peter Severin	D	—	1885	—	—	—	—	—	—	—	—
Lanson, Alfred	F	—	1885	—	—	—	—	—	—	—	—
Larsson, Carl	S	—	—	—	—	—	—	—	1891	—	—
Lebourg, Albert	F	—	—	—	1887	—	—	—	—	—	—
Le Nain, Louis	B	—	1885	—	—	—	—	—	—	—	—
Liebermann, Max	G	1884	—	—	—	—	—	—	—	—	—

Artist		Exhibited									
		1884	1885	1886	1887	1888	1889	1890	1891	1892	1893
Luce, Maximilien	F	—	—	—	—	—	1889	—	—	1892	—
Maarel, Marinus van der	H	—	—	—	1887	—	—	—	—	—	—
Mancini, Antonio	I	—	1885	—	—	—	—	—	—	—	—
Maris, Jacob	H	1884	—	—	—	—	—	—	—	—	—
Maris, Matthijs	H	—	—	—	1887	—	—	—	—	—	—
Maris, Willem	H	—	—	—	1887	—	—	—	—	—	—
Mauve, Anton	H	1884	—	—	—	—	—	—	—	—	—
Mellery, Xavier	B	—	1885	—	—	1888	—	1890	—	1892	—
Mesdag, Hendrik Willem	H	—	1885	—	—	—	—	—	—	—	—
Meunier, Constantin	B	—	1885	—	1887	—	1889	—	—	1892	—
Meunier, Karl	B	—	—	—	—	—	—	—	—	—	1893
Michetti, Francesco-Paulo	I	—	1885	—	—	—	—	—	—	—	—
Monet, Claude	F	—	—	1886	—	—	1889	—	—	—	—
Montalba, Clara	GB	—	—	1886	—	—	—	—	—	—	—
Monticelli, Adolphe	F	—	—	1886	—	—	—	—	—	—	—
Moreau-Nélaton, Etienne	F	—	—	—	—	—	1889	—	—	—	—
Morisot, Berthe	F	—	—	—	1887	—	—	—	—	—	—
Oberländer, Adam Adolf	G	—	—	—	—	—	—	—	1891	—	—
Petitjean, Hippolyte	F	—	—	—	—	—	—	—	—	—	1893
Pissarro, Camille	F	—	—	—	1887	—	1889	—	1891	—	—
Pissarro, Lucien	F	—	—	—	—	—	—	1890	—	1892	—
Raffaëlli, Jean-François	F	—	1885	—	1887	—	—	—	—	—	—
Redon, Odilon	F	—	—	1886	—	—	—	1890	—	—	—
Renan, Ary	F	—	—	—	1887	—	—	—	—	—	—
Renoir, Pierre-Auguste	F	—	—	1886	—	—	—	1890	—	—	—
Roty, Louis Oscar	F	1884	—	1886	—	—	—	1890	—	—	—
Sargent, John Singer	USA	1884	—	—	—	—	—	—	—	—	—
Segantini, Giovanni	I	—	—	—	—	—	—	1890	—	—	—
Serret, Charles	F	—	—	—	—	—	—	—	—	1892	—
Seurat, Georges	F	—	—	—	1887	—	1889	—	1891	1892†	—
Sickert, Walter	GB	—	—	—	1887	—	—	—	—	—	—
Sisley, Alfred	F	—	—	—	—	—	—	[1890]	1891	—	—
Smits, Eugène	B	—	—	—	1887	—	—	—	1891	—	—
Speekaert, Léopold	B	—	—	1886	—	—	—	—	—	—	—
Stappen, Charles van der	B	1884	—	—	—	1888	—	—	1891	—	—
Steer, Philip Wilson	GB	—	—	—	—	—	1889	—	1891	—	1893
Stobbaerts, Jan	B	1884	—	—	—	—	—	—	—	—	—
Storm van S'Gravensande, Charles	H	—	—	—	—	—	—	1890	—	—	—
Stott, William (of Oldham)	GB	1884	—	—	—	—	1889	—	—	—	—
Swan, John	GB	—	1885	—	—	—	—	—	—	—	—
TerLinden, Félix	B	—	1885	—	—	—	—	—	—	—	—
Thaulow, Fritz	N	—	—	—	1887	—	—	—	—	—	—
Tholen, Willem Bastiaan	H	—	—	—	—	—	1889	—	—	—	—
Thorn Prikker, Johan	H	—	—	—	—	—	—	—	—	—	1893
Thornley, Georges-William	GB	—	—	—	—	—	—	1890	—	—	—
Toulouse-Lautrec, Henri de	F	—	—	—	—	1888	—	1890	—	1892	1893
Uhde, Fritz von	G	—	1885	—	—	—	—	—	—	—	—
Ulrich, Charles Frederic	USA	—	[1885]	—	—	—	—	—	—	—	—
Verhaeren, Alfred	B	—	—	—	1887	—	—	—	—	—	—
Verster, Floris	H	—	—	—	—	—	—	—	1891	—	—
Vigne, Paul de	B	1884	—	—	—	—	1889	—	—	—	—
Vinçotte, Thomas	B	1884	—	—	—	—	—	—	—	—	—
Whistler, James Abbott McNeill	USA	1884	—	1886	—	1888	—	—	—	—	—
Zandomeneghi, Federico	I	—	—	1886	—	—	—	—	—	—	—
Zilcken, Charles-Louis Philippe	H	—	—	—	1887	—	—	—	—	—	—

1. The principal works on Les XX are: Brussels, Musées Royaux des Beaux-Arts de Belgique, and Otterlo, Rijksmuseum Kröller-Müller, *Le Groupe des XX et son temps*, by Francine-Claire Legrand, 1962; and Madeleine Octave Maus, *Trente années de lutte pour l'Art, 1884-1914* (Brussels: L'Oiseau bleu, 1926).
2. Émile Verhaeren, "La lutte pour l'Art," *Le National Belge*, February 10, 1884.
3. M. O. Maus, *Trente années*, p. 16; and Bruce Laughton, "The British and the American Contribution to Les XX, 1884-1893," *Apollo* 69 (November 1967), p. 372.
4. Octave Maus, "Conférence pour la Lanterne Magique," reprinted in *Revue des Belles Lettres*, 1927, no. 25, p. 206.
5. For additional information on the Société Libre des Beaux-Arts see the periodical *L'Art Libre*, 1871-1872; Oscar Roelandts, *Étude sur la Société Libre des Beaux-Arts de Bruxelles*, Académie Royale de Belgique, Classe des Beaux-Arts, Mémoires, vol. 4, no. 1 (Brussels: Palais des Académies, 1935); and Marie-Jeanne Chartrain-Hebbelinck, "Quelques maîtres de la 'Société Libre des Beaux-Arts' dans les Archives de l'Art contemporain," *Bulletin des Musées Royaux des Beaux-Arts de Belgique*, 1964, no. 1-2, pp. 11-26. For details on La Chrysalide see: Jules Du Jardin, *L'Art flamand*, 6 vols. (Brussels: Arthur Boitte, 1900), 6: pp. 17-26; and Jules Destrée, "La Chrysalide," *L'Art Moderne*, December 10, 1899, p. 413.
6. Marc Véry [Théo Hannon], "Exposition du Cercle d'élèves et anciens élèves des Académies des Beaux-Arts," *L'Artiste*, January 14, 1877, p. 10.
7. "Exposition de L'Essor," *L'Art Moderne*, March 6, 1881, p. 5.
8. "Exposition de L'Essor," p. 5.
9. "Septième Exposition de L'Essor," *L'Art Moderne*, January 28, 1883, p. 29.
10. Lucien Solvay, *Une Vie de Journaliste* (Brussels: Office de Publicité, 1934), pp. 109-111.
11. Maus to Boch, November 1, 1883, Fonds Bouquelle, #3900, Archives de l'Art contemporain, Musées Royaux des Beaux-Arts de Belgique, Brussels.
12. "Les Vingt," *L'Art Moderne*, November 11, 1883, p. 361.
13. For further details on Picard's accomplishments, see: François Vermeulen, *Edmond Picard et le Réveil des Lettres Belges 1881-1888*, Mémoires, vol. 9 (Brussels: Académie Royale de Langue et de Littérature françaises de Belgique, 1935); and Alex Pasquier, *Edmond Picard* (Brussels: Office de Publicité, 1945).
14. For further information on Maus' interest in music, see: Albert van der Linden, *Octave Maus et la Vie musicale belge 1875-1914*, Académie Royale de Belgique, Classe des Beaux-Arts, Mémoires, vol. 6, no. 2 (Brussels: Palais des Académies, 1950). For additional biographical material, see: A. Guislain, "Octave Maus," *Le Soir*, November 4, 1961; and A. Guislain, "En parlant d'Octave Maus avec Albert van der Linden," *Le Soir*, June 4, 1966.
15. Champal [Achille Chainaye], "Chez Les XX," *La Réforme*, February 18, 1891.
16. Finch to Maus, December 1884, #4691, Archives de l'Art contemporain, Musées Royaux des Beaux-Arts de Belgique, Brussels.
17. Election results of December 7, 1884, #4658, Archives de l'Art contemporain, Musées Royaux des Beaux-Arts de Belgique, Brussels. The five who voted for the abolition of the lectures were the three conservatives, Delvin, Vanaise, and Verstraete and — surprisingly — the moderates Wytsman and Van Rysselberghe.
18. H. Vigoureux, "Les XX," *L'Étudiant*, February 5, 1885.
19. Théo Hannon, "Le Salon des Vingt," *La Chronique*, February 20, 1888.
20. Francine-Claire Legrand, ed., "Les Lettres de James Ensor à Octave Maus," *Bulletin des Musées Royaux des Beaux-Arts de Belgique*, 1966, no. 1-2, p. 39.
21. Octave Maus, "James Ensor" in *James Ensor, peintre et graveur*, special issue of *La Plume* (Paris, 1899), pp. 31-33.
22. "Arts, Sciences et Lettres," *Le Courrier Belge*, February 5, 1888.
23. "Chambre des Représentants," *Journal de Gand*, March 29, 1889. See also, "Doctrinaires et Artistes," *L'Art Moderne*, March 31, 1889, p. 101.
24. The dates for Les XX exhibitions in Brussels were: 1884: February 2-March 2; 1885: February 1-March 3; 1886: February 6-March 14; 1887: February 5-March 6; 1888: February 4-March 4; 1889: February 2-March 5; 1890: January 18-February 23; 1891: February 7-March 8; 1892: February 6-March 6; 1893: February 18-March 26.
25. However, the price in 1885-1887 was one franc.
26. Invitations were issued free to friends of the Vingtistes, *invités*, artists, musicians, men of letters, and the press.
27. Georges Rodenbach, "Têtes de Vingtistes," *Le Progrès*, February 10, 1887.
28. Many of these artists were the most revolutionary: Ensor, Gauguin, Seurat, Luce, and Toorop. See "Petite Chronique," *L'Art Moderne*, March 10, 1889, p. 79.
29. "Le Salon Défunt," *L'Art Moderne*, November 23, 1890, p. 369.
30. "Le Salon Défunt," p. 370.
31. "L'Art Jeune et Les XX," *L'Art Moderne*, February 1, 1885, p. 34.
32. Finch to Maus, November 17, 1886, #4786, Archives de l'Art contemporain, Musées Royaux des Beaux-Arts de Belgique, Brussels.
33. Maus to Finch, November 21, 1886, Whistler Archives, Glasgow University Library, Glasgow.
34. Legrand, ed., "Lettres d'Ensor à Maus," p. 26.
35. Maus to Rodin, November 23, 1889, Rodin Archives, Musée Rodin, Paris.
36. Van de Velde to Maus, November 1889, #5334, Archives de l'Art contemporain, Musées Royaux des Beaux-Arts de Belgique, Brussels.
37. Maus to Van Strydonck, November 26, 1887, Fonds Van Strydonck, #33, Archives de l'Art contemporain, Musées Royaux des Beaux-Arts de Belgique, Brussels.
38. De Wyzewa to Maus, n.d. [late 1889-early 1890], #5356, Archives de l'Art contemporain, Musées Royaux des Beaux-Arts de Belgique, Brussels.
39. Maus to Boch, January 1890, Fonds Bouquelle, #3919, Archives de l'Art contemporain, Musées Royaux des Beaux-Arts de Belgique, Brussels. However, as Sisley explained, it was his dealer, Georges Petit, who refused to lend his works to the Les XX show. (Sisley to Maus, January 23, 1890, #5300, Archives de l'Art contemporain, Musées Royaux des Beaux-Arts de Belgique, Brussels.)
40. Marie-Jeanne Chartrain-Hebbelinck, ed., "Les Lettres de Van Rysselberghe à Octave Maus," *Bulletin des Musées Royaux des Beaux-Arts de Belgique*, 1966, no. 1-2, p. 65. Van Rysselberghe spent the summer of 1887 visiting Eugène Boch in Paris. It was undoubtedly Boch who introduced Théo van Rysselberghe to Toulouse-Lautrec. Both Lautrec and Boch had been fellow students at the Atelier Cormon in Paris.
41. Maus to Boch, December 29, 1886, Fonds Bouquelle, #3914, Archives de l'Art contemporain, Musées Royaux des Beaux-Arts de Belgique, Brussels.
42. "Les XX," *Le Journal des Beaux-Arts*, February 15, 1886, p. 21.
43. "À Propos du Salon des XX: l'Impressionnisme," *L'Art Moderne*, February 21, 1886, p. 58.
44. A.-J. Wauters, "Aux XX," *La Gazette*, March 14, 1886.
45. "Les XX," *Le Journal des Beaux-Arts*, February 15, 1886, p. 20.
46. "L'Exposition du Cercle des XX," *Le Nord*, February 13, 1886.
47. "À Propos du Salon des XX: l'Impressionnisme," *L'Art Moderne*, February 21, 1886, p. 58.
48. "Le Salon des XX: l'ancien et le nouvel Impressionnisme," *L'Art Moderne*, February 5, 1888, p. 42.
49. [Octave Maus], "Les Vingtistes Parisiens," *L'Art Moderne*, June 27, 1886, pp. 201-204.
50. "Ouverture du Salon des XX," *L'Art Moderne*, January 30, 1887, pp. 37-38.
51. Mécoenas [Théo Hannon], "Les Apporteurs de Neuf," *La Chronique*, February 27, 1887.

52. "Petite Chronique," *L'Art Moderne,* July 24, 1887, p. 239.
53. Finch to Maus, January 6, 1888, #5044, Archives de l'Art contemporain, Musées Royaux des Beaux-Arts de Belgique, Brussels.
54. Georges Verdavainne, "L'Exposition des XX," *La Fédération Artistique,* January 26, 1890, p. 163.
55. *La Chronique,* February 2, 1889.
56. "Chronique Littéraire," *La Jeune Belgique,* October 1886, p. 435.
57. "Le Symbolisme," *L'Art Moderne,* October 3, 1886, p. 314.
58. Émile Verhaeren, "Exposition des XX," *La Jeune Belgique,* 1884, p. 201.
59. "Le Salon des XX," *L'Art Moderne,* February 12, 1888, p. 52.
60. Émile Verhaeren, "Les XX," *La Nation,* February 15, 1892.
61. Ch. Genuys, "À Propos de l'Art nouveau, Soyons Français!" *Revue des Arts Décoratifs,* 1897, p. 1.
62. "Chronique de la Ville," *L'Étoile Belge,* February 5, 1888.
63. Maus to Verheyden, (postmarked November 20, 1884), #7248, Archives de l'Art contemporain, Musées Royaux des Beaux-Arts de Belgique, Brussels.
64. Edmond Picard, "L'Art et la Révolution," *L'Art Moderne,* July 18, 1886, pp. 225-227; July 25, 1886, pp. 233-236; August 1, 1886, pp. 241-244.
65. Picard, "L'Art et la Révolution," p. 225 (of July 18, 1886 issue).
66. "À Propos du Salon des XX: l'Impressionnisme," *L'Art Moderne,* February 21, 1886, p. 57.
67. Aside from its revolutionary implications, Ensor's slogan, "Liberté, Égalité, Fraternité," was an important Freemason motto. The Vingtistes were acutely aware of Freemason ideals. Félicien Rops was a Freemason, as was Edmond Picard's father. Freemasons favored compulsory education, betterment of the laboring class, and in 1834 founded the Free University of Brussels. The relationship between Freemasonry and the avant-garde movements in Belgium merits further investigation.
68. A.-J. Wauters, "Aux XX," *La Gazette,* February 10, 1887.
69. "L'Art et le Socialisme," *L'Art Moderne,* August 30, 1891, p. 276.
70. Maus to Toorop, February 1, 1893, Hague Royal Library, The Hague.
71. Émile Verhaeren, "Les XX," *La Nation,* February 26, 1893.
72. Henry van de Velde, "Les XX," *Floréal,* April 1, 1893, p. 51.
73. "Les XX: Dix Années de Campagne," *L'Art Moderne,* April 9, 1893, pp. 115-117.
74. Marie-Jeanne Chartrain-Hebbelinck, ed., "Les Lettres de Van Rysselberghe à Octave Maus," *Bulletin des Musées Royaux des Beaux-Arts de Belgique,* 1966, no. 1-2, p. 77.
75–76. "La Libre Esthétique," *L'Art Moderne,* October 29, 1893, p. 345.
77. Francine-Claire Legrand, ed., "Les Lettres de James Ensor à Octave Maus," *Bulletin des Musées Royaux des Beaux-Arts de Belgique,* 1966, no. 1-2, p. 41.
78. Octave Maus, "Conférence pour la Lanterne Magique," reprinted in *Revue des Belles Lettres,* 1927, no. 25, p. 210.

Seurat and "the Soul of Things"

Sarah Faunce

Curator of Paintings and Sculpture
The Brooklyn Museum
New York

"Absolute newness, sudden clarity, unheard-of translucence! The most celestial and the most contemplative poetry expressed by means of the utmost precision; painting washed clean of all untruth, resistant to all trickery; so much nobility, so much sweetness, and the genius of the painter at the service — not in any way restrictive to himself — of a principle: we were only a few for whom these landscapes marked an indescribable moment. In front of *La Grande Jatte* . . . it was a revolution."[1]

Thus wrote Madeleine Maus, in her memoir published nearly forty years after the event she so eloquently describes: the first exhibition at Les XX in Brussels, in 1887, of the work of Seurat. The title of her book, *Trente années de lutte pour l'Art, 1884–1914*, expresses succinctly the stance which she and her husband, Octave Maus — Secretary first of Les XX and then of La Libre Esthétique — took toward the official culture and conventional criticism of that period in which they worked to foster a genuinely avant-garde art in their capital city of Belgium. And in a small way, these words about Seurat convey something of the flavor of what was a specifically Belgian response to the work of this great and innovative artist.

During the years when he was invited to exhibit with Les XX, Seurat's most important work was consistently shown. *La Grande Jatte* in 1887, *Les Poseuses* in 1889, and *Le Chahut* in 1891 were each accompanied by the finest of his paintings done at Grandcamp, Honfleur, Port-en-Bessin, and Gravelines; and in 1892, the memorial exhibition at Les XX included nineteen paintings, some seen previously and others new — such as *La Parade, Young Woman Powdering Herself* and *The Circus* — as well as twelve small oil studies and ten of his incomparable drawings.[2] It has also been revealed, through such an exhibition as Robert Herbert's *Neo-Impressionism* of 1968,[3] to what degree the Belgian Vingtistes — in particular, Willy Finch, Henry van de Velde, Théo van Rysselberghe, and Georges Lemmen — responded to the work of Seurat and developed their own distinctive styles, using the method for which Félix Fénéon coined the term "Neo-Impressionism." Professor Herbert has written, too, about the ways in which the qualities of Seurat's art find affinities with

the ideas of the Symbolist poets and critics who were his friends in Paris: Gustave Kahn, Paul Adam, Jules Christophe and others who, with such writers as Félix Fénéon and Charles Henry, formed what we might call the "new generation" of the later 1880s in Paris.[4] Seurat's inherent classicism, his ability to synthesize, to grasp the essentials of form rather than the accidents of the surface of life, appealed greatly to those Symbolists who were sufficiently visual-minded not to require a literary subject matter in order to perceive an art that was asserting the supremacy of mind over the multifarious details of nature. As Rewald observes, La Grande Jatte and the first "Symbolist Manifesto" of Jean Moréas both appeared in 1886.[5] Though the calm order of the one contrasts greatly with the verbal fireworks of the other, and though their conjunction in time is coincidental, both find support in the aesthetic theory of Charles Henry and the critical acumen of Fénéon, and both express the need to go beyond Naturalism and Impressionism.

It is, of course, true that the links between Seurat and Belgian Symbolist thought cannot be entirely separated from the movement in Paris; to a certain extent they are both part of the same cultural phenomenon. Octave Maus not only put on annual exhibitions in Brussels, but was co-editor of the major weekly journal, L'Art Moderne, which published the art criticism of Fénéon, Kahn, Lecomte and other Parisians, as well as that of Belgian writers. The poet Émile Verhaeren, whose work was published in Paris from the mid-1880s, was a colleague both of the French Symbolists and of his fellow countrymen Maurice Maeterlinck, Grégoire Le Roy, and Georges Rodenbach. Both Verhaeren and Maus wrote criticism for French as well as Belgian journals. Indeed, as Mary Anne Stevens has recently pointed out,[6] one aspect of the Vingtiste movement was an opposition to the official French culture of the Brussels Salon and Academy in the name of an independent Belgian culture — an opposition that led naturally to affinities with the French artists and writers of the avant-garde, who had themselves cut loose from their own official institutions. The young, forward-looking artists of both countries were "anti-French" even while they used the French language and responded to the traditions and innovations of French painting. But despite these links and despite the naturally cosmopolitan attitude of the majority of the Vingtistes, Belgium retained a distinctive culture and tradition, and therefore had a distinctive response to the art that was exhibited each year by members of Les XX and their invités.

As one of the most important artists to exhibit with Les XX, Seurat was widely written about, but there is one body of criticism — published in Belgium from the time of the first exhibition of La Grande Jatte in 1887 to the memorial exhibition at Les XX in 1892 — that interprets his work in such a way as to link its meanings to some of the central ideas of Belgian Symbolism. Of particular significance are the writings of Émile Verhaeren, who was, with Maeterlinck, the leading Symbolist poet of Belgium, and who was unmatched there as a critic of painting; and Henry van de Velde, then a young artist of great gifts, for whom Seurat's work was among the first major aesthetic milestones of his long and productive life. Both men drew direct parallels, both intellectual and intuitive, between Seurat's Neo-Impressionism and Symbolist ideas. To examine these parallels is interesting, not only from the point of view of cultural history, but also because they provide an original and valuable contribution to a critical understanding of one of the great masters of European painting.

The story begins not in Brussels in 1887, but in Paris the previous year, and it begins appropriately enough with Octave Maus. It was he who was on hand to review, in June of 1886, the eighth and last Impressionist exhibition, where Seurat showed La Grande Jatte for the first time. And it was he, who in his review of the exhibition in L'Art Moderne, published the first critical mention of Seurat in the Belgian press.[7] More luminist than Symbolist, more animateur than critic, Maus nonetheless had an eye for originality, and he knew he had seen something astonishing. While candidly admitting that the figures in La Grande Jatte looked to him like so many wooden toy soldiers from Germany, and that he couldn't take the artist seriously on the basis of that picture alone, he nevertheless could see, in the landscapes and even in La Grande Jatte, an extraordinary "depth . . . exactitude of atmosphere . . . [and] radiance of light."[8]

Georges Seurat
Un dimanche, l'après-midi, à l'île de la Grande Jatte 1884–1886
Sunday Afternoon on the Island of La Grande Jatte
Oil on canvas
190.0 x 283.0 cm. (81 x 120⅜ in.)
*Collection: The Art Institute of Chicago, Helen Buch Bartlett
Memorial Collection*

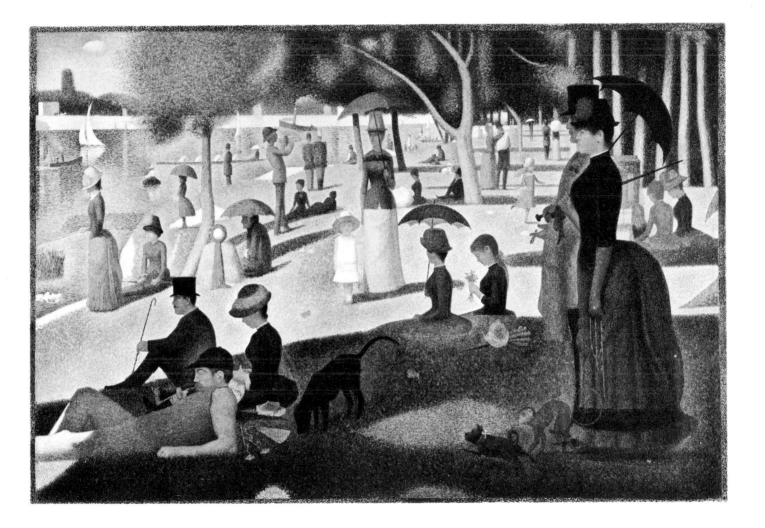

He also — and with a vocabulary which, like that of his wife's forty years later, borrows from that of religion — calls Seurat a painter who is "open-hearted, deliberative, observant," and refers to him as "this Messiah of a new art."[9] And he is sure that *La Grande Jatte* will create a scandal in Brussels, as indeed it had in Paris;[10] thus the invitation was extended in November of that year for the annual February exhibition of Les XX. Seurat replied to Maus with a brief, polite note of acceptance dated November 20, 1886.[11] Along with *La Grande Jatte,* he sent two paintings done in Grandcamp in the summer of 1885, and four from Honfleur, done in 1886.[12]

For the review of the exhibition in *L'Art Moderne,* the editors turned to Félix Fénéon, who had already published in their journal, in the previous fall, an account of the second Indépendants exhibition in Paris. In that piece, he lucidly analyzed the ways in which the art of Seurat and his friends arose out of Impressionism and created something new — which he called Neo-Impressionism.[13] Knowing that *La Grande Jatte* would be the main center of attention and outrage, the *L'Art Moderne* review consisted of a long excerpt from Fénéon's review of the eighth Impressionist exhibition in June 1886, devoted to explaining the theory of decomposition and retinal mixture of colors, with particular reference to this painting. These articles, as well as a further piece entitled "Le Neo-Impressionisme" which appeared in *L'Art Moderne* on May 1, 1887, are three of the major critical texts in Fénéon's oeuvre and have ever since provided the point of departure for an understanding of the style that Seurat initiated. Fénéon's authority, conceived in his aesthetic response to Seurat's painting and born of detailed conversations with Seurat, Signac, Pissarro and the other divisionists, asserted itself all the more since he was the first to both accurately describe and convincingly defend the method of Neo-Impressionism. Inevitably, all subsequent favorable criticism, both Belgian and French, was based on Fénéon's writings. Octave Maus, for whom "la recherche de la lumière" was one of the most important aspects of the new art that he sought to foster,[14] learned not to use the term "pointillé" as he had done in 1886 — a term disliked by the artists and used for the most part only by ill-informed or hostile critics —

and to speak instead of the "division of tones" that permits a totally new creation of light and atmosphere in painting.[15] From 1887 on, in addition to critical reviews of the exhibitions of new art in Brussels and Paris, *L'Art Moderne* published a number of articles on aspects of Neo-Impressionism, including articles by Ogden Rood, discussions of Chevreul's color theory, and reviews of the newly published work on aesthetic psychology by Charles Henry.

It need hardly be said that all this effort to educate the public in the principles of Neo-Impressionism went on in the face of a continuing stream of hostile commentary and ridicule from most other quarters. Even such advanced journals as *La Jeune Belgique* and *La Wallonie,* which came in the course of time to publish some perceptive criticism of Seurat, began in resistance or ignorance; *La Wallonie's* anonymous reviewer of the 1887 Les XX exhibition was capable of devoting two and one-half pages to the show without even mentioning Seurat's name.[16] The typical epithets for the new technique were "pains à cacheter" (wafers: thus permitting subtle implications of blasphemy to float about), and the whole vocabulary of dermatological disease: smallpox, leprosy, the Bubonic plague. One particularly vitriolic review by Achille Chainaye, a disaffected former member of Les XX, devoted a paragraph to an extended metaphor of "Vingtisme" as a body afflicted with a chronic disease that involves permanent disfigurement by blotches.[17] But my personal prize for critical acumen goes to the writer in *L'Indépendance Belge* of February 4, 1889, who describes the shocking situation in *Les Poseuses,* in which three young ladies are undressing in front of an open door at the left of the picture, with no concern for all those people walking about who can look in at them![18]

But hostile criticism of great works of art is seldom as amusing as this is; the pleasures it provides are largely self-flattering, and the insights are, to say the least, fitful. Of greater interest is the variety of attitudes brought to bear by perceptive critics who thereby illuminate the work of art — or oeuvre — in different ways, as well as inform us, as historians, about their own minds and cultural milieus. It was Fénéon's genius to be able to interpret with great objectivity and precision the theoretical basis of Seurat's art and

Théo van Rysselberghe
Portrait of Émile Verhaeren 1892
Conté crayon on paper
55.0 x 42.0 cm. (21⅝ x 16½ in.)
Private Collection, Paris

to elucidate some of the connections between the method of painting and the aesthetic qualities of the work — always understanding that, far from being a uniform and readily transferable method, it was a way of painting which required "an exceptional delicacy of eye . . . [and was] only accessible to *painters.*"[19] At the same time, by pointing out the priority, in this new style, of vision over manual virtuosity, of deliberativeness over improvisation, of the essential over the accidental and transitory, he draws by implication certain parallels between Neo-Impressionism and the ideas taking shape in the Symbolist milieu of which both he and Seurat were formative members. Additionally, Fénéon has the striking distinction, in that milieu, of maintaining a purely visual, formal approach, and of seeing the intellectual importance of Seurat's painting when many of those about him tended to think that the only route away from Naturalism and Impressionism was that of the literal "idea-picture," the painting of legend, allegory or specifically evocative image. Above all, he is objective and restrained, seldom permitting himself words expressive of feeling beyond such a brief phrase as the following, about Seurat's Honfleur paintings of 1886: "a style of inexpressible breadth, serenity and distinction."[20]

When, in 1887, Émile Verhaeren joined *L'Art Moderne* as the third co-editor, with Maus and Edmond Picard, that influential journal gained a writer who had the mind of a productive poet and the eye of a sensitive, visually informed critic of art. He was not a theoretician in the style of Fénéon — and in any case, the task of analyzing the theoretical basis of Seurat's art had been done — but rather was a close observer of the qualities of works of art and an interpreter who, while never subjective or merely personal, nonetheless responded to a work in a direct and concrete way.

Born in 1854 in a village on the Scheldt River in Flanders, Verhaeren had published by the mid-1880s two volumes of poetry — *Les Flamandes* in 1883 and *Les Moines* in 1885 — and had begun to write art criticism — studies of the Belgian landscape painter Joseph Heymans (1885) and the rising Symbolist artist Fernand Khnopff (1886), as well as shorter reviews. He had undergone a rigorous Jesuit education in Ghent, where Maeterlinck and Rodenbach were schoolmates;

then, deciding against the confining career of the priesthood, he studied law at Louvain University and practiced for a short time before committing himself — to the distress of his orthodox family but with the encouragement of Edmond Picard and Camille Lemonnier — to the vocation of poet. His first book, *Les Flamandes,* caused shock waves among the respectable on account of its explicit celebration of the earthy, Rabelaisian life of the Flemish countryside. These poems, drawn from the spirit of Breughel and Jordaens but also based on his own youthful observations, expressed a feeling for his Flemish heritage that he never lost. *Les Moines,* a collection of poems full of the imagery of cloister, ritual and candlelight was also a psychological examination of the varieties of monastic temperament, and represents the poet's coming to terms with his own orthodox upbringing.

From early in his writing career, Verhaeren was interested in art. Painters trusted his eye, and he had many artist friends — among them Xavier Mellery, Constantin Meunier, William Degouves de Nunques (who married his wife's sister in 1894), and Théo van

Georges Seurat
La Phare et l'Hospice à Honfleur 1886
The Lighthouse at Honfleur
Oil on canvas
65.0 x 81.0 cm. (25⅝ x 31⅞ in.)
*Collection: The National Gallery of Art, Washington, D. C., Collection
of Mr. and Mrs. Paul Mellon (loan)*

Rysselberghe. Van Rysselberghe wrote him long letters from his travels in Morocco in 1888,[21] and between 1893 and 1900, designed and/or illustrated no less than eight of his books. He had friends in Paris, as well, and during the 1880s became increasingly interested in the new developments in painting; indeed, it may have been in part because of his positive attitude toward Les XX that he was attracted away from the more literary journal, La Jeune Belgique, to L'Art Moderne, which was to some extent the voice of Les XX. In his short criticisms, Verhaeren wrote perceptively about Khnopff, Rops, Ensor, De Braekeleer and other artists, as well as about the Neo-Impressionists; he later published a book on Ensor (1906), and as early as 1890 was giving a course of lectures on Japanese art.[22]

Verhaeren's first discussion of Seurat was not in L'Art Moderne, but was a review of the Les XX exhibition in La Vie Moderne of February 26, 1887. By this time he had met Seurat, probably sometime during the previous winter; certainly they were acquainted by the time of the Indépendants exhibition in the late summer of 1886.[23] Verhaeren had first seen Seurat's work at the eighth Impressionist exhibition in the spring of that year. In the memoir he published a month after Seurat's death, he wrote of the first impact upon him of La Grande Jatte: . . . "not for a minute did I doubt the complete genuineness and the profound innovation which were manifest there before me."[24] When he talked about it that evening with some of his artist friends in Paris, they scoffed at him; for the partisans of Monet and Renoir, Seurat's work in the show they had boycotted was anathema. Verhaeren returned the next day, and was overcome by the experience of light; La Grande Jatte remained the most significant picture in the exhibition. When the painting was exhibited in Brussels the following February, he was able to see it from a better distance and to study it carefully and patiently. In the process, any lingering resistance he might have had to its novelty disappeared: "For me, La Grande Jatte was a battle both given up and won."[25]

In addition, by the time of Verhaeren's first public mention of Seurat, he had so far committed himself as to acquire two paintings: The Dock at Honfleur (Rijks-

museum Kröller-Müller), which Seurat had probably given to him the previous fall, and The Lighthouse at Honfleur (Mellon Collection) which he bought from Seurat during the exhibition in Brussels for a "prix d'ami." He had evidently written to Seurat of his preference for the latter painting, for Seurat agrees in his reply that he considers the former to be a "large sketch," worked on for only eight days, while The Lighthouse took him two and one-half months.[26]

In his defense of Seurat in La Vie Moderne — for this is what was required — Verhaeren immediately disposes of the attack on Seurat as a scientist, or mere technician, as expressed, for instance, by Jules d'Estrée in La Jeune Belgique: "These are experiments, not paintings."[27] It was thought by many then — and assumed by many since — that Seurat's method, because of his interest in the theory of color and line, was completely scientific. Verhaeren knows that "to see the tones before being able to combine them, and to see them with the eye of a painter, is something no scholar, no theoretician, no chemist will ever be able to do, unless he is himself an artist."[28] More than that, he knows that whatever the theoretical basis of the method, the actual work of art convinces by its aesthetic qualities alone, and that these must be seen in relation not to science but to other works of art. He relates the figures of La Grande Jatte — which he admitted, in 1891, had at first seemed almost wooden to him[29] — to the art most familiar and at that time closest to him in spirit: the painters of the late Middle Ages. "La Grande Jatte is painted with a primitive naïveté and honesty. In front of it we think of the Primitives. Just as the old masters hieratized their figures at the risk of a certain stiffness, M. Seurat synthesizes manners, poses and ways of walking. What they did to express their age, he attempts to do for his own with the same solicitude for exactness, concentration and sincerity. He does not repeat their work, he uses only their profound method in order to sum up modern life."[30]

Even as he relates the qualities of Seurat's art to the iconic, hieratic art of the past, Verhaeren does not lose sight of the fact that Seurat is unequivocally a

Alfred William Finch
Untitled (Harbor View) 1888
Pen and ink on paper

Drawn for and reproduced in the Les XX catalogue of 1888; present whereabouts unknown.

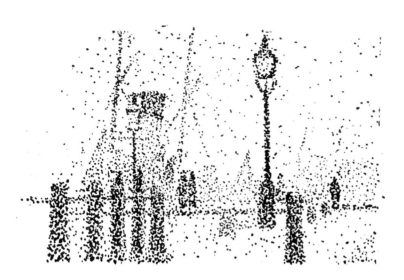

"painter of modern life" with all that is implied in Baudelaire's pregnant phrase. There is no nostalgia here, nor any turning away from the contemporary reality which was of concern both to the painter and the poet. At the same time, Verhaeren recognizes that more is involved in Seurat's painting than the pleasures of spectatorship.

A related theme occurs in Verhaeren's lead review of the Les XX exhibition written for *L'Art Moderne* of February 5, 1888.[31] Here he speaks of Neo-Impressionism as a growing movement, exemplified that year by the work of Signac, Dubois-Pillet, and the Belgian painter Willy Finch — who was the first in Brussels to adopt the new technique. (For the hand-designed catalogue of that year, Finch made a charming and delicate drawing "par points," as he put it in a letter to Maus.)[32] Verhaeren contrasts the nineteenth-century "dirty and bituminous chiaroscuros" with the clear, fresh, transparent colors of the Primitives such as Angelico and Metsys: "Certain blonde and clear canvases of the Neo-Impressionists . . . make one think of these early triptychs. It is the same genuine harmony, made of light. Of course, the moderns work with more certainty and intention: they base themselves on the findings of an established and recent science."[33] Again, in interpreting this new art, his vision fuses the mystical purity of the Primitives with the sense of modernity, and indeed of the future. Once the initial furor over *La Grande Jatte* had subsided, he writes, "several artists not brutalized by prejudice were persuaded that through this window newly opened into art one could usefully look at the future."[34] He then goes on to discuss critically each of the three artists' work — in the course of which he contradicts the conventional view that all paintings "au pointillé" looked just alike.

In February of 1889, it was again Verhaeren who wrote the lead article on Les XX in *L'Art Moderne*, and again he concentrates on the Neo-Impressionist painters, and specifically on Seurat, who was exhibiting in Brussels for the second time.[35] As in 1887, Seurat showed a new, large figure painting — *Les Poseuses* — together with eight landscapes, six of them from Port-en-Bessin; and, for the first time, three drawings — *M. Paul Alexis* (whereabouts unknown),

Au concert Européen (Museum of Modern Art), and
À la Gaieté Rochehouart (according to De Hauke, the
Rhode Island Museum version).[36] In this article, Ver-
haeren explores more fully than he has previously the
nature of Seurat's art, as he sees it.

To begin with, he is not entirely happy with the
term "Neo-Impressionism" because it is valid only in
an evolutionary sense: for Verhaeren, nothing is less
like Impressionism — with its emphasis on capturing
the fugitive moment of light — than the "patient,
reflective, sure" art of Seurat. Where Impressionism
rejoices in the the sensation of the immediate experi-
ence, and concentrates all its virtuosity of hand and
subtlety of vision on capturing it on canvas, Seurat's
is an art of intention, "slow, careful, reflective, with-
out transport or virtuosity, the art of an artist who
wants to be in possession of himself until the last
touch of the brush." From this judgment, the critic
draws some important consequences (as he rightly
remarks, nothing is so mysterious as the way in which,
with works of art, the smallest premises may end in
large consequences). The first of these is formulated in
a way that links Seurat directly with one of the central
concepts of Belgian Symbolist thought. "The will to
work surely and coolly means that one penetrates
more deeply into the intimacy and as it were into the
soul of things; one analyzes them, one connects with
what is permanent in them much more than with what
is accidental; one isolates from them the transitory, the
individual, the ephemeral, and without necessarily
setting out to, one ends in a synthesis."[37] Fénéon, too,
had emphasized Seurat's powers of synthesis and his
concentration on the essential over the transitory; but
Verhaeren approaches this idea not so much intellec-
tually as spiritually. He sees in Seurat's way of paint-
ing — of building form slowly from an infinite number
of delicately calculated small touches, an infinite num-
ber of subtle variations of tone — a depth of vision
that penetrates into the very heart of reality, into "the
soul of things." For him, Seurat is what Meyer Schapiro
in our own day has called him: "the visionary of the
seen."[38]

From the point of view of Belgian Symbolism, it is
striking that Verhaeren here uses the phrase "l'âme
des choses" (the soul of things). The artist Xavier

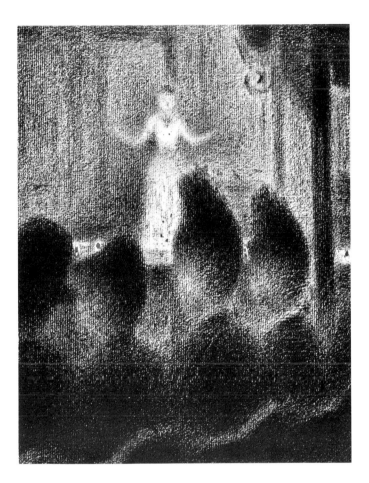

Mellery, whom Verhaeren knew, would use this phrase as a generic title for the series of drawings that he showed at La Libre Esthétique in 1895. These were tonal drawings of silent interiors, sometimes empty of all but objects, sometimes occupied by a single figure or by a group of nuns — at prayer or on the staircase, which is frequently a feature of the drawings. The subject of the drawings is the interior of the artist's house[39] — he was called the "solitary of Laeken" — or of that unique institution of the Low Countries, the Beguinage. This is a place of religious retreat and care for the aged, a place where even today, where they exist (as, for example, in Bruges), an extraordinary silence — a silence which is far from being simply the absence of noise — pervades the air. The content of the drawings is the life of inanimate objects and the silence of half-lit, empty rooms, or that of contemplation and prayer. Mellery, who was known in his time for allegorical works, began to show these drawings — for which he is most appreciated today — in 1889 at the Aquarellistes in Brussels; in 1890 he showed a group of them at Les XX. In these years, however, he used the title, "La Vie des Choses" (The Life of Things). When, in 1895, he submitted for these drawings the title "Emotions d'Art, l'âme des choses," he wrote to Maus asking him to seek Verhaeren's opinion about it — the poet had seen them and would be able to judge whether the title was suitable.[40]

Thus Verhaeren's use of the phrase in 1889 does not originate with Mellery, but rather the contrary. The most likely source for both is the long prose poem published in La Jeune Belgique in 1887 by the young poet of Liège, Hector Chainaye, called "L'Âme des Choses." [41] This and other prose poems by Chainaye were collected and published with the title L'Âme des Choses in 1890 — a volume which appears to have been the poet's first and last.[42] Not only because of Verhaeren's former association with La Jeune Belgique but also because he was a cultivated Belgian poet, one must assume that he read the leading literary journal regularly and would not overlook the work of new young poets such as Chainaye. One can only speculate as to what he might have thought of the work itself, which in its fantasy and medievalism is much closer to Maeterlinck's sensibility than to his

own, though to a modern reader the element of the bizarre — in this and in the other prose poems by Chainaye — makes the poet something of a proto-Surrealist. In this tale in which a young princess, brought to the brink of death by the death of her husband, is returned to life not by God or human care but by the voices of the things about her, there is a sense of the independent life in non-human things, and of the mysterious connections between things and the inner life of dream and delirium that comes very close to Surrealist thought. Verhaeren does not see Seurat in these terms (though it is perhaps worth noting here the suggestive fact that André Breton, in his First Surrealist Manifesto of 1929, lists Seurat as the first among the modern forerunners of Surrealism in the art of painting).[43] But Chainaye's title had begun to pass into poetic currency and to assume the nature of a Symbolist concept, and it is striking that Verhaeren should have used it in interpreting Seurat. With its mystical overtones, the phrase would find a more obvious application to the works of the Symbolist artists who dealt in the realm of the dreamlike, the imaginary — the image which formed an equivalent for a state of the soul. Thus Maus, writing of the Symbolist group at the Les XX exhibition of 1890 — Khnopff, Minne, Redon, and others — refers to them as "those for whom the soul mingles with things" (chez qui l'âme se mêle aux choses).[44]

Mellery's own choice of the phrase as a title for his drawings was not an obvious one either, in that these works had nothing to do with the symbolism of dreams or literature, but rather with the mysterious inner life of everyday objects and interior spaces. Yet his subject matter and the reclusive nature of his art, together with his traditional technique, link him more closely with that aspect of Symbolism which found expression in the imagery and feeling of the past, of remoteness from the actual, evolving world. Seurat was not remote, but went out to encounter the world in some of its least prepossessing places: the industrial suburbs, the docks and jetties, the resorts and places of entertainment of ordinary people. These subjects he transposed into paintings and drawings which fuse a grand austerity of structure with the most tender, most open and unprotected

Xavier Mellery
L'Escalier *circa* 1889
The Staircase
(cat. no. 55)
Black chalk and
sanguine on paper
57.0 x 45.0 cm.
(22$^{1}/_{2}$ x 17$^{3}/_{4}$ in.)
Collection:
Koninklijk Museum
voor Schone Kunsten,
Antwerp

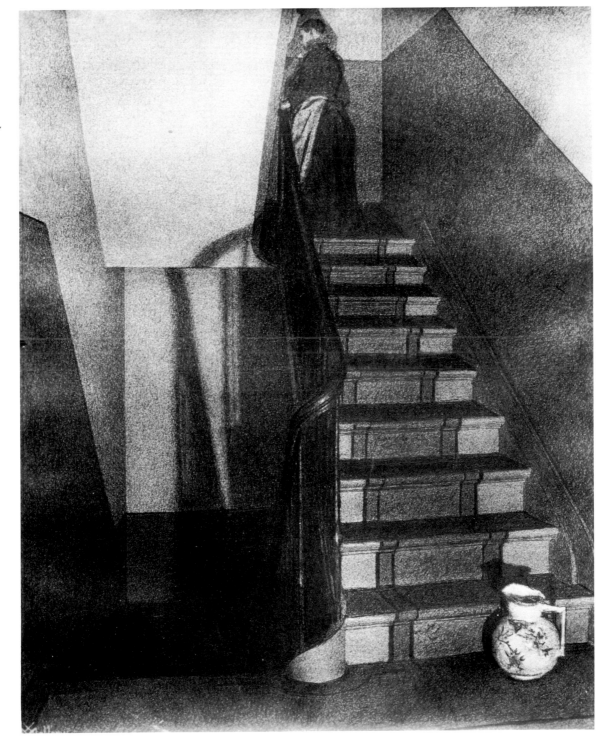

Henry van de Velde
La Ravadeuse 1889 (cat. no. 103)
Girl Darning
Oil on canvas
78.0 x 101.5 cm. (30³/₄ x 40 in.)
Collection: Musées Royaux des Beaux-Arts de Belgique, Brussels

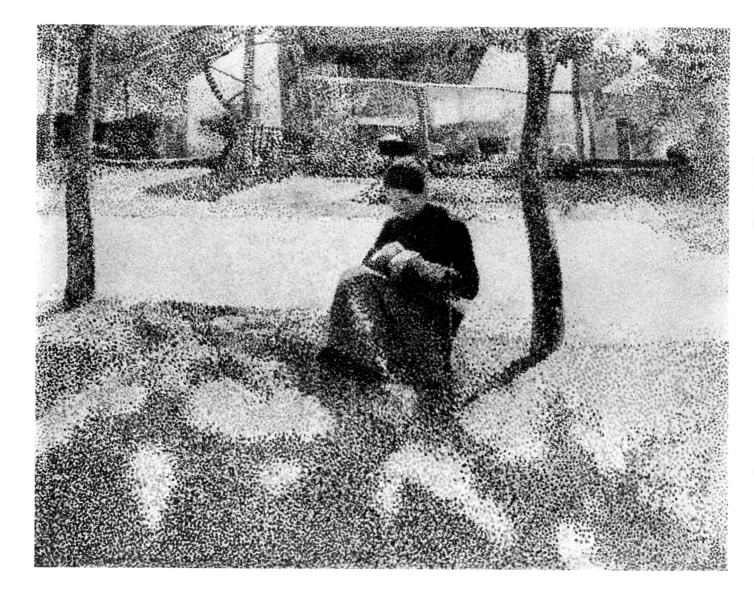

sensibility to the nuances of value, color, and shape. He invented a way of painting which by its very process was able to fully express a sense of divination, not into any transcendental world, but into the inner structure of the world we see. In saying that Seurat penetrated into "the soul of things," the writer made a statement that for his time was as original as it was true.

Verhaeren wrote again at some length about Seurat in a review of the Les XX exhibition a month before his death in 1891, and also the month after, in the memoir referred to earlier. On both occasions, he drew distinct parallels between Seurat's work and that of the Symbolist artists, whom he refers to as "the painters of mind."[45] He sees Seurat's work as becoming increasingly one in which reality, far from being recorded in its details, is transformed in the Idea. Had he lived, he would surely have come to create works of art which achieved "beauty independent of everything, beauty by and for itself."[46] But even when dealing with these large abstractions, Verhaeren never sees them as divorced either from the nature of the painter he knows, or from the act of painting: comparing him to Chéret, whose posters he recognizes as being related to Le Chahut,[47] he says, "His [Chéret's] pencil lives and is content to live; M. Seurat's brush thinks and reflects in touching the canvas."[48]

The last time the poet wrote about the painter was in 1909, some years after he had ceased to be a regular contributor to L'Art Moderne — or indeed to be an art critic in the journalistic sense. A large Seurat exhibition was held at the Bernheim Jeune Gallery in Paris in that year, and Verhaeren wrote a short summing up of his belief that time had confirmed his original faith in the fact that Seurat was a great master. For him, Seurat inspires the kind of total respect and confidence in his viewers that can only come from the artist's own possession of profound respect for what he saw. "There are certain of his landscapes which give as it were a new meaning to the idea that we have of purity, of fluidity and of freshness. His figures . . . seem to us to move with gestures so definitive and so expressive of their character, that they seem to fix, not a moment in time, but the very function of mankind in its daily existence. Thus,

as soon as one begins to talk about such an art, immediately one arrives at the essential."[49]

When we turn to the articles on art contributed in 1890 to 1891 by Henry van de Velde to La Wallonie, the Symbolist journal of Liège, we find a very different sort of mind at work, but one which reaches some similar conclusions. Van de Velde at this time was just twenty-seven years old, and had been a member of Les XX only since 1888. The revelation of Seurat had been momentous for him. His own genius had enabled him already in the summer of 1888 to paint the beautiful Bathhouse at Blankenberghe (now in Zurich), in which the divisionist way of painting is completely assimilated to his own bold sense of design. From early in his life, Van de Velde was very involved with social thought — in the early nineties, he would abandon painting for decorative arts and architecture as a means of more directly redeeming the life of the people — and, as Herbert points out, it may have been a release for him to learn that Seurat and the other Neo-Impressionists were themselves concerned with social ideals.[50] In any case, though he became more critical later in his life, he was at this time a fervent disciple of Seurat and Neo-Impressionism. And though he did not follow Seurat in his conception of the figure, he was the only one of the Belgian Neo-Impressionists who truly incorporated the figure into the divisionist pictorial structure — as in Girl Darning (cat. no. 103), in which the figure is conceived in a continuum with the surrounding space.

Van de Velde was not a Symbolist, but he understood the need for art to surpass Realism and reach a higher plane of significance. Neo-Impressionism, whose color harmonies he saw as analogous to music, was for him, in 1890, the way to achieve this transcendence. In his characteristically gnomic style, he wrote, "Different states of soul in the Largo, Andante or Allegretto of color! . . . Color! This unformulated and changing significance with which Things are clothed!" He argues against the literary concept of painting: "Is it necessary, in order to escape vulgarity, in order to arrive at the Dream, to evoke apparitions, ghosts, to fall back into Symbols?"[51]

Théo van Rysselberghe
Voilier sur L'Escaut 1892 (cat. no. 90)
Sailboat on the Escaut
Oil on canvas
66.7 x 90.2 cm. (26¹/₄ x 35¹/₂ in.)
Collection: Arthur G. Altschul, New York

He admires the work of Khnopff and Rops — artists who can truly imagine "new monsters," who are original artists even while using literary texts — but he looks to "a future less anguished, less unquiet," finding its possibility in such works as La Vie des Choses (he is writing about the 1890 Les XX exhibition, at which the Mellery drawings were shown) and "those unforgettable landscapes of the First (le Premier) of the Neo-Impressionists."[52] Thus Van de Velde, too, links Mellery with Seurat, as artists who seek to find inner meaning through the contemplation of realities close at hand.

It is perhaps not surprising that, when Seurat died at thirty-one, such an ardent spirit as Van de Velde would respond by writing of him with Christian imagery. At the head of his essay in La Wallonie of April, 1891, he placed a quotation from Flaubert: "Il faut des Christs de l'art pour guérir les lepreux." (We must have Christs of art to cure the lepers.) He writes of Seurat's art in the light of that only too prophetic phrase of Octave Maus, who had hailed him as "this Messiah of a new art." The subject of the essay is Seurat's painting, but the writer tells us more of himself when he says, ". . . those who call themselves His disciples ask themselves today with anxious uncertainty what will be the destiny of the Art which they will create after Him."[53] But even setting aside the extreme effects of shock and sorrow, there remains a tendency to see Seurat in quasi-mystical terms that is not confined to Van de Velde. Verhaeren, who knew him well enough to have broken the ice of shyness and become friends, and who could describe quite exactly what it was like to listen to his calm, modest, but always very serious and determined conversation about painting,[54] wrote of him a year after his death: "When one approached Seurat, one might have said that one was speaking to a kind of silent and reflective monk."[55] And for Verhaeren, monks were no metaphorical fancy, but men among whom he had lived and whom he knew. Much later, in 1903, Georges Lemmen in a letter to his friend Willy Finch referred to "the benedictine temperament of Seurat."[56] Rewald and others have referred to the aloofness and sense of superiority in Seurat, that sometimes irritated his Parisian fellow artists. That intense dedication, which

made it possible for a man in his twenties to create a master oeuvre within a decade, may have made him difficult at times; but it would seem that his Belgian advocates, even as they responded to his art in spiritual terms, were also able to place his character in a context where this kind of dedication was a source not of irritation but of respect. The last word I leave to an unnamed writer in L'Art Moderne of March 2, 1890, who provided us with this description of the artist who, even in his most self-protective moods, never hesitated to send his best work to Brussels or to salute his Belgian colleagues: ". . . he works, six days a week, like a laborer, from nine o'clock in the morning till seven o'clock at night, in that modest well-lit studio on the Boulevard de Clichy which is stripped of all bric-a-brac, where alone radiate in their white frames the studies brought back from a stay by the sea or in the fields — visits not of rest or vacation, but of intense work. . . . As to looks: a simple man, correct, thoughtful, measured and precise of speech, whom you can have met now and then, clothed in black, mingling with the crowd at an exhibition opening, and not distinguished from the first passerby except by the energy of a calm face animated by a look of implacable decision."[57]

1. Madeleine Octave Maus, Trente années de lutte pour l'Art 1884–1914 (Brussels: L'Oiseau bleu, 1926), p. 52.
2. C. M. de Hauke, Seurat et Son Oeuvre, 2 vols. (Paris, 1961), 1, provides reproductions of the Seurat catalogue pages of the Les XX exhibitions, together with identification of all of the works save three of the drawings shown in 1892.
3. New York, Guggenheim Museum, Neo-Impressionism, by Robert L. Herbert, 1968.
4. Robert L. Herbert, Seurat's Drawings (New York, 1962), pp. 108 and following. See also Herbert's essay in Jean Sutter, ed., The Neo-Impressionists (New York Graphic Society, 1970), pp. 23–42; and Sven Loevgren, The Genesis of Modernism: Seurat, Gauguin, Van Gogh and French Symbolism in the 1880s (Indiana University Press, 1971).
5. John Rewald, Post-Impressionism: from Van Gogh to Gauguin (New York, 1978), p. 133.
6. London, The Royal Academy of Arts, Post-Impressionism: Cross-Currents in European Painting, (November 17, 1979–March 16, 1980), p. 253.
7. "Les Vingtistes Parisiens," L'Art Moderne, June 27, 1886, pp. 201–204.

8–9. "Les Vingtistes Parisiens," p. 204.

10. The story is told (Rewald, *Post-Impressionism*, 1962 edition, pp. 90–91) by Signac that it was the Belgian artist Alfred Stevens, long part of the Paris establishment, who led the crowd in mocking *La Grande Jatte* by steadily bringing over groups of friends from the nearby Café Tortoni, solely for the purpose of amusement.

11. Archives de l'Art contemporain, Musées Royaux des Beaux-Arts de Belgique, Brussels.

12. See De Hauke, *Seurat*, 1: p. 220, for complete listing.

13. "Correspondance particulière de l'Art Moderne, l'impressionisme aux Tuileries," *L'Art Moderne*, September 19, 1886. This and the two other articles cited are reprinted in full in Françoise Cachin, ed., *Félix Fénéon, au delà de l'impressionisme (Paris, 1966),* pp. 58-95.

14. See Maus' preface to the 1888 catalogue of Les XX, in Archives de l'Art contemporain, Musées Royaux des Beaux-Arts de Belgique, Brussels.

15. *L'Art Moderne*, January 26, 1890, p. 26.

16. *La Wallonie* 2 (February 15, 1887).

17. Quoted in *L'Art Moderne*, February 15, 1891, p. 55.

18. Archives de l'Art contemporain, Musées Royaux des Beaux-Arts de Belgique, Brussels.

19. *L'Art Moderne*, September 19, 1886; and Cachin, ed., *Fénéon*, p. 80.

20. *L'Emancipation Sociale* (Narbonne), April 3, 1887; and Cachin, ed., *Fénéon*, p. 86.

21. Fonds Verhaeren, Bibliothèque Royale, Brussels.

22. I am grateful to M. Warmoes of the Bibliothèque Royale, Brussels, for this information.

23. Robert L. Herbert, "Seurat and Émile Verhaeren: Unpublished Letters," *Gazette des Beaux-Arts* 54 (1959), p. 315.

24. "Georges Seurat," *Société Nouvelle*, April 1891, p. 430.

25. "Georges Seurat," p. 432.

26. Herbert, "Unpublished Letters," p. 322.

27. "Chronique Artistique," *La Jeune Belgique* 6 (1887), p. 133.

28. "Le Salon des XX," *La Vie Moderne* 9 (February 26, 1887), p. 138.

29. "Georges Seurat," *Société Nouvelle*, April 1891, p. 431.

30. "Le Salon des XX," *La Vie Moderne* 9 (February 26, 1887), p. 138. The translation I have used here is that of Herbert, "Unpublished Letters," p. 322.

31. 'L'Ancien et le nouvel impressionisme," *L'Art Moderne*, February 5, 1888, pp. 41–42. Listed in Dorra-Rewald (*Seurat* [Paris, 1959]) and other bibliographies as anonymous, this article is included in the full bibliography of Verhaeren's writings compiled by André Fontaine, *Verhaeren et Son Oeuvre* (Paris: Mercure de France, 1929). I have not been able to independently verify this attribution, so it remains an attribution; but I have accepted it on the grounds of the consistency of its critical viewpoint with Verhaeren's signed writings about Seurat and on the basis of the fact that the unsigned reviews in *L'Art Moderne* were written by the editors.

32. Finch to Maus, January 6, 1888, Archives de l'Art contemporain, Musées Royaux des Beaux-Arts de Belgique, Brussels.

33–34. "L'Ancien et le nouvel impressionisme," *L'Art Moderne*, February 5, 1888, p. 42.

35. "Aux XX," *L'Art Moderne*, February 3, 1889, pp. 33–34. This piece, too, is published anonymously and has been listed in Fontaine's bibliography of Verhaeren's writings. See note 31.

36. See the argument in favor of the Fogg version in J. H. Rubin, "Seurat and Theory: The Near Identical Drawings of the Café-Concert," *Gazette des Beaux-Arts* 76 (October 1970), pp. 237–246.

37. "Aux XX," *L'Art Moderne*, February 3, 1889, p. 34.

38. Meyer Schapiro, "Seurat" (1958), in *Modern Art: Selected Papers* (New York, 1978), p. 104.

39. Suzanne Houbart-Wilkin, "La Maison de Mellery," *Bulletin des Musées Royaux des Beaux-Arts de Belgique* 13 (1964), p. 29.

40. M. O. Maus, *Trente années*, p. 194.

41. *La Jeune Belgique* 6 (1887), pp. 335–344.

42. Paris, Bibliothèque Nationale, *Cinquintenaire du Symbolisme*, 1936, p. 94. *L'Âme des Choses* is called "l'unique receuil du poète Liègeois" and no biographical information is given except his birthdate (1864). The obscurity of Chainaye I find puzzling in view of the quite remarkably hallucinatory character of the work published between 1887 and 1890.

43. André Breton, *Les Manifestes du Surréalisme* (Paris, 1955), p. 25, note 1. I am grateful to Mr. David Carritt for directing me to this reference.

44. *L'Art Moderne*, January 26, 1890, p. 26.

45. *Société Nouvelle*, February 1891, p. 251.

46. "Georges Seurat," *Société Nouvelle*, April 1891, p. 437.

47. See R. L. Herbert, "Seurat and Chéret," *The Art Bulletin*, June, 1958, pp. 156–158.

48. *Société Nouvelle*, February 1891, p. 249.

49. *La Nouvelle Revue Française*, no. 1, (February 1, 1909), p. 92.

50. New York, The Guggenheim Museum, *Neo-Impressionism*, 1968, p. 188, cat. no. 140.

51. "Notes d'Art," *La Wallonie* 5 (1890), p. 91.

52. "Notes d'Art," p. 92.

53. "Georges Seurat," *La Wallonie* 6 (April 1891), p. 167.

54. "Georges Seurat," *Société Nouvelle*, April 1891, p. 432-444. See the extensive extract translated in R. L. Herbert, "Unpublished Letters," pp. 325–326.

55. *La Nation*, February 12, 1892.

56. Lemmen to Finch, March 26, 1903, Archives de l'Art contemporain, Musées Royaux des Beaux-Arts de Belgique, Brussels.

57. *L'Art Moderne*, March 2, 1890, p. 66.

The Symbolist Movement

Francine-Claire Legrand

Curator-in-Chief
Musée d'Art Moderne
Musées Royaux des Beaux-Arts de Belgique
Brussels

It is difficult to assign a birthdate to Symbolism since its birth does not coincide with the baptism performed by the poet Jean Moréas.[1] Furthermore, it was neither a style nor a school that came into existence at a precise moment in the history of the visual arts, but was rather a contagious mood and a particular approach that already existed among certain romantics which, through literature, entered the visual arts as well.

The German poet Novalis gave the idea a definition of considerable resonance when he said, "All that is visible is joined to all that is invisible, that which can be understood to that which cannot be understood, everything perceived to everything imperceptible. Perhaps all that is believable to all that is unbelievable."[2] It would be a little like an entomologist murdering a butterfly if one tried to pin down this notion too firmly, and it is really easier to understand when glimpsed through the veils of imagery provided by poetry. It was with this in mind that Mallarmé, replying to a question, defined his own position and, at the same time, the principal objectives of Symbolism:

> Contemplation of objects, the image which takes flight from the dreams it nourishes, that is the song: the Parnassians took a complete idea and displayed it as such: in that way they destroyed the mystery; they lost the delicious sensation of believing in their own ability to create. To name an object is to suppress three-quarters of the pleasure in a poem, which is made to be discovered little by little: to suggest, that is the dream. It is the perfect use of this mystery which is the symbol: to evoke a thing little by little, in order to reveal its soul or, conversely, to choose an object and through gradual deciphering, release its spirit.[3]

In 1886, the Belgian poet Émile Verhaeren analyzed the work of the most perfect of the Belgian Symbolists, Fernand Khnopff, saying:

> Modern imagination is strongly drawn toward the past, [undertaking] an enormous scientific inquiry into unfamiliar passions over a vague and as yet unidentified supernatural, which has urged us to reincarnate our dreams and even our fear and trembling before the new unknown of this strange Symbolism which interprets the contemporary soul as

antique symbolism did for the soul of ancient times. But it is not our faith and our beliefs that we put forward; on the contrary, it is our doubts, our anxiety, our problems, our vices, our despair and probably our agony.[4]

This particular approach is accompanied by certain characteristics which commonly motivate poets and painters. First of all, melancholy, sometimes elevated to a veritable complacency where sorrow is concerned, seems to be the leavening for this art. It is also based on a rejection of the modern world, particularly of industrialization and the pressure of the proletariat. Symbolism is tearful and nostalgic; it is aristocratic and faded — although it was sympathetic to anarchists because of their position as revolutionaries and individualists. Finally, mysticism, aspiring toward some undefined "beyond," united the Symbolists and justified their reservations toward Impressionism, which they found commonplace — like naturalist literature, unbearably crude and vulgar in their eyes.

It was less a matter of returning to the Christian faith than of gaining a new, deep sense of that mystery which seemed to prolong visible and perceptible reality. The esoteric mode seemed appropriate. In France, the Rosicrucian movement, led by the seer Sâr Mérodack Péladan, nicknamed by his detractors "the sandwich man of the hereafter," was the object of unprecedented infatuation. Péladan had strong ties to Belgium, where he had disciples and often visited. His attitude toward the visual arts reveals his complicity; he put everything in terms of increasing his own notoriety. In the beginning, he groveled before Rops, who was then at the height of fashion: "I am a maybug, dancing according to your whim," he wrote.[5] A few years later, he invented an incantation that was likely to give his disciples a sense of superiority: "Artist, you are a priest: art is the great mystery and when your efforts become masterpieces, a divine ray of light descends as if onto an altar . . . Artist, you are king: art is the true empire . . ."[6] This time it was Khnopff whom he transported to the clouds.

At the instant when the intuition transcends reason, everyone believes himself in touch with the hereafter. Tables move beneath the fingers of initiates; the voice from beyond the tomb has never been heard more distinctly. Another mystic quest was expressed in the love of exoticism, and of unknown lands, where strangeness could be drunk like a potion and man could communicate with nature, dissolving in it. The need for escape, so pressing today, was already in evidence, and hero worship was only one aspect of it. Exceptional people were seen as totally free beings through whom the rest of the world could live out its dreams. Such heroes were often Wagnerian — Lohengrin, Tristan, Parsifal — for the musical and literary atmosphere was strongly influenced by Wagner, although antique myths were also revived in the figures of Oedipus, Jason, and Perseus, while medieval superstition was represented by the four sons of Aymon. As for woman, she had two faces. Sometimes she is an angel coming to help man, who has been dragged down by his desire; sister and friend, she frees him from his bondage and reveals the way to true ecstasy. Sometimes she is a temptress, a *femme fatale,* whose wicked powers strip man of all his will to achieve the ideal and chain him to the sins of the flesh. Unknowable and enigmatic, eluding the grasp, she belongs to the region of the imagination.

If Impressionism is full of sunshine, Symbolism, on the contrary, haunts the night and is haunted by it. Shadows, even when they hide nothing but themselves, generate emotion. An undecoded message palpitates in the moonlit chiaroscuro or the demi-obscurity of empty interiors. Silence is the complement of night, its mystery a casket for the opalescence of dreams. Solitude, the companion of silence, is also celebrated by painters and poets. Sometimes it is displayed proudly — "On n'a que soi" (One has only oneself) is one of Khnopff's devices which echoes the egocentric sentiment of his other *ex libris* "Mihi" (to me); sometimes, with resignation, solitude submits itself to fate. The motif of the solitary person seen from the back, watching the horizon, also belongs to Symbolist iconography. And other kinds of figures are equally charged with emotion: the sower of seeds, a rustic magician; the blind man, out of one of Maeterlinck's plays, whose eyelids conceal his visions; the spinners, sisters of the Three Fates. Contemplation of death, an inheritance from romanticism, connects all these motivations. But drama, tumult, and violence, its ubiquitous romantic accompaniments, are now blurred by a new familiarity with death which dresses skeletons with the attitudes of life.

Painters and poets became fellow travelers to the interior of these morbid dreams. The literary character of Symbolism has frequently been remarked upon, but while it is true that many pictorial works referred to texts, they did not illustrate them. The common artistic heritage of the various cultural disciplines often manifested itself on a shared scale of half-tones, and Maeterlinck played an important role in this sense — abroad as well as in Belgium. If they could speak, the creations of Minne, Khnopff, Spilliaert, Fabry, and Doudelet would be the plaintive voices of Maeterlinck's theatrical heroes. One cannot speak so much of influence here as of complicity; between word and image there ensued a dialogue emanating from the depths. Maeterlinck became a catalyst among his contemporaries, because his work embodied sensations common to many *fin-de-siècle* creative personalities, who were bent together beneath the yoke of morbid decadence. He gave voice to their innermost thoughts; his interpretation of their own thoughts subsequently became a major source for their art. He asked the same troubled questions that a whole generation of artists wished to ask, questions whose answers had to be carefully guarded under pain of breaking the enchantment. Speaking of Maeterlinck's *Serres Chaudes,* Émile Verhaeren wrote in 1889:

> This work glides in the crevices between that which comes and that which goes. It changes, melts, is a chameleon lighted on both sides by contradictory reflections which blend in enchanted iridescence. The thought undulates there like a serpent; withdraws, clings, disappears, and returns with the fantasy of the Vine, with hesitation, regret, rapture and the vicissitudes of uncertainty. Poetry, which is no more, which has never been. In order to describe it, one must not identify these fluid images; precision would be an error, harmful to its disintegrating contours and vertiginous, airy forms . . .[7]

The relationship between Maeterlinck and Fabry is particularly interesting. Though we know of nothing by Fabry that relates directly to Maeterlinck, he worked at one time almost entirely in a Maeterlinckian spirit

59

Émile Fabry
L'Offrande *circa* 1884–1886 (cat. no. 22)
The Offering
Oil on canvas
45.0 x 100.0 cm. (17³/₄ x 39³/₈ in.)
Collection: Musées Royaux des Beaux-Arts de Belgique, Brussels

of suffering and sorrow, and under the same adherence to fatalism. Fabry's women during this period, which he called "my nightmare epoch," could have been invented for the stage. Their faces are strangely alike, anxious and attenuated, with hallucinatory eyes, deformed profiles — flattened noses, concave mouths, pinched lips, and prominent chins. Enigmatic as the sphinx, drawn toward death, these women hold funereal flowers in their abnormally long hands. The massive forms and hieratic attitudes, placed under a stormy sky, in front of mountains flattened by the mist or beside some solitary lake, all contribute a dramatic quality. Fabry explained: "It is probably Wagner to whom we have all submitted. He brought us a new form of expression and I have looked for the means by which he arrived at it. It was the same for the writers."[8] And he cited Maeterlinck among others. So it was through Wagner that Fabry became associated with Maeterlinck. He laid no claim to following this poet, but he recognized a common source of illumination for his and the others' work.

Even beyond this justifiable connection, one could ask if the Symbolist climate was not associated with the evanescent character of words, their freedom of association, and with the difficulty of assigning limitations for their definitions when they were effected by the context of other words. Is it possible to introduce such a situation in the immobility of the drawn or painted image? It is Van Lerberghe who gives us a reply: "I see in images, in symbols . . ."[9] Thus the image is associated with the symbol: its power of suggestion seems to surpass even that of words and seems to reside precisely in the fact that it can neither be translated nor converted except into those other images which it evokes in languid thought. For the French critic Albert Aurier, theoretician of Symbolist painting, image is the symbol incarnate, for art is the representation by image of all that is most elevated in the world, that which is fundamentally real, the knowledge behind the idea.[10] However, the term "idea" here does not mean a group of concepts ordered by reason. The sense and power of the symbol lies outside that which is rational.

James McNeil Whistler
The Little White Girl: Symphony in White Number 2 1864
Oil on canvas
76.5 x 51.0 cm. (30⅛ x 20⅛ in.)
Collection: The Tate Gallery, London

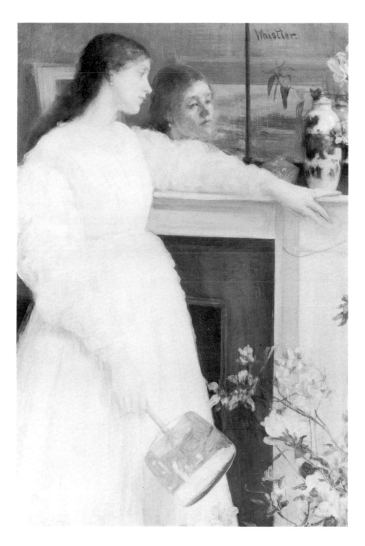

It is a kind of privileged communication with the essence of the world, varying according to the nature of the artist, but which, in any case, is related to emotions and sensations provoked by music, the most extreme expression of the soul. Imagery must lead the spectator toward a state analogous to that manifested by music, the Symbolist art *par excellence* which, far from imprisoning sounds, allowed them to dissolve in space, charged with their vibrations.

However, it is generally admitted that theatre, painting, and sculpture serve a common ideal and react to the correspondences existing among them, for "the true basis of the symbol is the correspondence that exists among all orders of reality, that joins them one to the other and extends by consequence from the natural order, taken as a whole, to the supernatural order itself."[11] This definition *a posteriori*, with its essence of authentic mysticism, is very demanding and few artists could live up to it. Out of all the possible effects of imagery, its commitment to the imaginary became the most compelling. Without altering their legibility, figures and landscapes could be drenched in unreal light resembling reflections from another world. Even better than literature, the visual arts were able to bring alive again a past rich with treasure. This collective past, which was apt to be recognized only by initiates, could nevertheless awaken vague memories in many spectators, connected perhaps to some previous lives — a confused mass of legends, mythical creatures, and archetypes reinvented from age to age. Everything that ever resembled an apparition or recalled cult ceremonies became an emanation of the past. Certain flowers, certain animals (the lily, the rose, the waterlily, the swan, the peacock, and the panther) took on emblematic qualities. Certain hours of the day — or more often of the night — seemed invented especially for the rarest of perceptions. The rapturous light of the moon, and its sad caress, erased all differences between various methods of expression. Through the representation of these beings, these moments of magic resonance, painting and drawing took priority over that which was more immediately accessible. "The visual image learned to represent the inexpressible."[12]

Still, it could fulfill this role only for a certain social class — that of the bourgeoisie, fatigued by pleasure but immobilized by its privileges. It was necessary to have a great deal of money in order to enjoy the luxury of being tired and disenchanted. Others, the "disinherited," as they were called, had no access to this exalted state, nor could they understand the sophistication of its visual or verbal language. The leftist tendencies of certain Symbolists did nothing to prevent the disciples of the movement from becoming reactionaries by instinct. Additionally, the artist discovered that elitist narcissism suited him: one studied oneself, wrapped oneself in one's individualism, tormented one's own heart to extract tears. Despite being the property of a special milieu, Symbolism spread throughout Europe. Where the influence of music and poetry were to be found, especially, Symbolist centers were created, emanating from the powerful artistic personalities who fought for the movement.

Twenty years before the phenomenon was to be named or defined, signs of its impending arrival were apparent in the visual arts. In England, the Pre-Raphaelites, formed in 1848, were looking to nature as a way

61

Below:
Edward Burne-Jones
Le cortège nuptial de Psyché 1895
Psyche's Marriage Procession
Oil on canvas
119.0 x 215.5 cm. (46³/₄ x 84³/₄ in.)
Collection: *Musées Royaux des Beaux-Arts de Belgique, Brussels*

Bottom:
Odilon Redon
Christ Aux Épines *circa* 1889
Christ Crowned with Thorns
Charcoal and black chalk on paper
34.0 x 27.0 cm. (13¹/₂ x 10⅝ in.)
Collection: *Musées Royaux des Beaux-Arts de Belgique, Brussels*

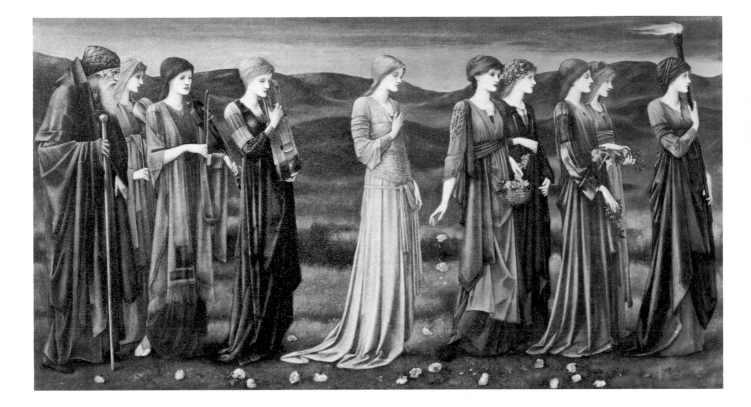

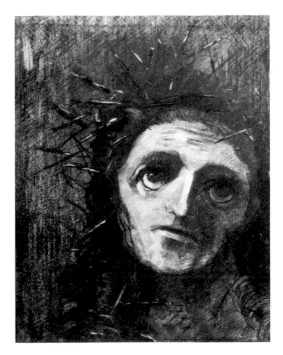

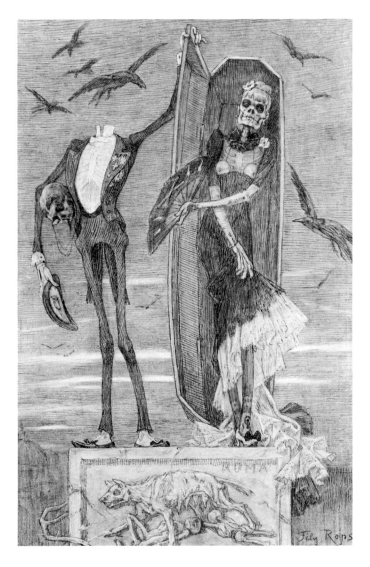

of contacting the divine principle. Around 1865, Rossetti and, later, Burne-Jones, devised the heroine *fatale* with her languorous air, who became so fashionable. After them came Beardsley, saturated in unwholesome artifice. English culture and art awoke a greater response in Belgium in this period than anywhere else.[13] But it was Whistler — even more than the Pre-Raphaelites — and his interest in the occult, occasioned by his visits to séances with Rossetti, who most deeply affected the Belgians. Whistler's portraits often resembled something spectral, due to the extreme refinement of their color harmonies. His nocturnes were already Symbolist works, even before the style was comprehended as such. Verhaeren, writing on the subject in 1883, said, "We readily accept the superb unreality of this artist, convinced that the artist must not be subject to reproducing exactly what he sees, but rather should draw [the vision] across his brain, coloring it with his senses and imagination."[14] The Belgian press used the adjective "Whistlerian" to designate something elegant, refined, and a bit mysterious.

The French contribution to Symbolism was also very powerful, providing a guiding light for the quest. Gustave Moreau, Puvis de Chavannes, and Odilon Redon are its chronological precursors. None was better than Redon at 'joining the visible to the invisible.' He was well known in Belgium where he exhibited with Les XX and made frontispieces for Verhaeren's books. A Belgian publisher brought out his lithographs and another Belgian, Jules Destrée, edited the catalogue of his graphic work. The role of the Rosicrucian Salons in France and of Les XX's exhibitions in Belgium was taken on in Germany and Austria around 1892 by two groups who, wishing to break away from the establishment, both took the name "Secession." Sustained by international emulation, certain artists grew famous: in Austria, it was Klimt and Kubin; in Germany, Stuck and Klinger; in Russia, Vroubel; in Italy, Previati, Segantini, and Pelliza da Volpedo; in Finland, Gallen Kallela and Simberg; in the Netherlands, Toorop and Thorn Prikker; in Switzerland, Böcklin and Hodler; and in Norway, Munch.

Belgium's most talented artists created Symbolist works before the style was identified. Rops, whose roots were in Naturalism, was inspired to develop his

Xavier Mellery
L'Entrée de l'atelier *circa* 1889 (cat. no. 54)
Entrance to the Studio
Black chalk and ink wash on paper
54.0 x 75.0 cm. (21¼ x 29½ in.)
Collection: Hilda Vanderhaegen, Ghent

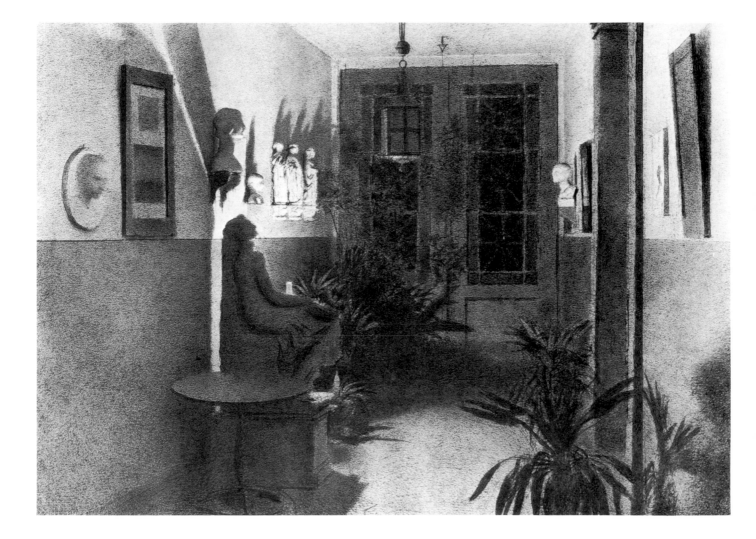

Symbolist style from the works of those authors he
most admired: Baudelaire, the discovery of whom
flooded his world with a strange new light; Barbey
d'Aurevilly, for whom Rops illustrated *Les Diaboliques*
(cat. nos. 79–84); Péladan, whose frontispieces he
often composed, most notably for *Le Vice suprême*
(cat. no. 85) — a title more suggestive than the con-
tents warrant; and Mallarmé, who inspired *La grande
Lyre.* Mellery, another precursor, came to Symbolism
through contemplation. Two aspects of Symbolism
coexist in his work: the idealism of his allegorical
works on gold backgrounds, and the intimacy of his
deserted interiors or veiled nuns meeting in the fading
twilight. Even before Munch, Mellery had gone far
toward expressing fear in his work. Despite its unre-
vealing title, *Effect of Light* gives the first taste of those
sensations that Munch would produce some years later
in *The Cry,* with its unique sonority.

But it was Khnopff, as Péladan clearly understood,
who was the real embodiment of the movement, not
only because of the melancholy enigma that bathed
his work, but because of his dandified life-style, his
house — a veritable temple of *fin-de-siècle* narcissism
— and his motto, "On n'a que soi," an ironic echo of
the title given by Redon to his personal journal, "À soi-
même."[15] "Perfect Symbolist,"[16] cultivated man, so-
phisticated in the extreme, he made multiple allusions
to Belgian, French, and English poetry in his work. *I
Lock My Door Upon Myself* was inspired by a sonnet
of Christina Rossetti, sister of the Pre-Raphaelite
painter, but it exploits a narcissistic theme: love of self
carried to a point of self-hatred within the rigid circle
of solitude. Several drawings and pastels refer to
Mallarmé; others are accompaniments to Rodenbach's
poetry; still others belong to the texts of Péladan. The
conjunction "with," which this artist often uses —
"With Joséphin Péladan," "With Georges Rodenbach"
— indicates a sense of companionship. But it is not an
illustration of their work he produces so much as the
recollection of a meeting between poet and painter,
who shared similar ideas — a kind of emblematic
image, an icon to their spiritual communion. The
frontispiece for *Istar,* a novel which appeared in 1888,
was conceived by Péladan, the magician who con-
demned physical contact, and is of such violent and

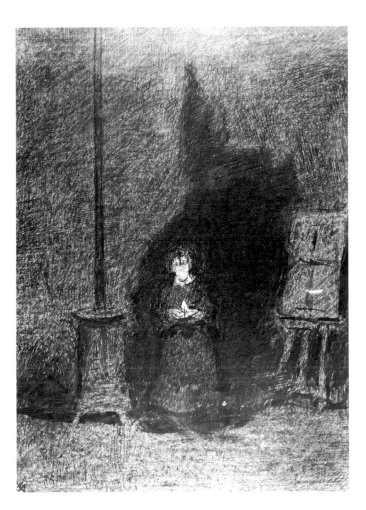

Fernand Khnopff
Avec Grégoire Le Roy — Mon coeur pleure d'autrefois 1888–1889
Weeping for Other Days
Colored pencil, heightened in white, on paper
25.0 x 14.2 cm. (9³/₄ x 5¹/₂ in.)
Private Collection, Paris

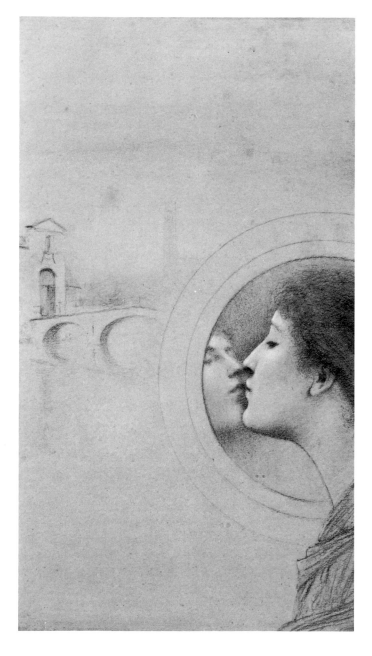

unhealthy eroticism that it surpasses even Félicien Rops.[17] One of the most beautiful compositions from Khnopff's hand is *Weeping for the Other Days,* which is known in a number of versions and was originally created as the frontispiece for a book of poems by Grégoire Le Roy. According to Lesley Morrissey:

> It indicates the artist's pursuit of some ideal or psychological state of mind which can be found only in the past. In this image of a woman kissing her own reflection one can read an attempt to reach across time into the past through the self, in an effort to discover the real self in the past, as if by a narcissist kiss, she may pass through the magical mirror into the world already gone by. With Le Roy's literary example before him, Khnopff found in the image of the woman — and mirror — a means of representing humanity's rejection of the present in order to discover its true self in the ideal of the past.[18]

Knopff certainly responded in his own aesthetic to that expressed in Schopenhauer's pessimism.[19] The large pastel *Memories* (1889), represents another source of inspiration. Seven young women — all identical — are seen, tennis rackets in hand. Despite the fact that they are shown in different clothing and different poses, they all represent the same model, Marguerite, Khnopff's sister, multiplied by the power of dreaming to seven — the magic number — like a call echoing down the corridors of infinity. Is it not the same theme of the errant soul searching for another self to which Alain Mercier,[20] who knew the Symbolists' work so well, refers and which is seen as well in the *Serres Chaudes* of Maeterlinck? The exquisite technique employed by Khnopff, so typically Symbolist, was marvelously described by J. Dujardin in 1892: "His work became more and more immaterial. Looking at it, one could say it was like a jewel, which after being chiseled with great care was mounted in a delicate setting."[21]

But such refinement was not always free from mannerism, which appeared in Delville's work as well as Khnopff's.[22] Delville was the principal Belgian disciple of Sâr Mérodack Péladan. The elongation and arabesque of bodies in *Love of Souls* is reminiscent of the sixteenth-century mannerist style, while vapor trails in the background are moved more by the breezes of Art

Fernand Khnopff
Memories 1889
Pastel on paper mounted on canvas
127.0 x 200.0 cm. (50 x 78³/₄ in.)
Collection: Musées Royaux des Beaux-Arts de Belgique, Brussels

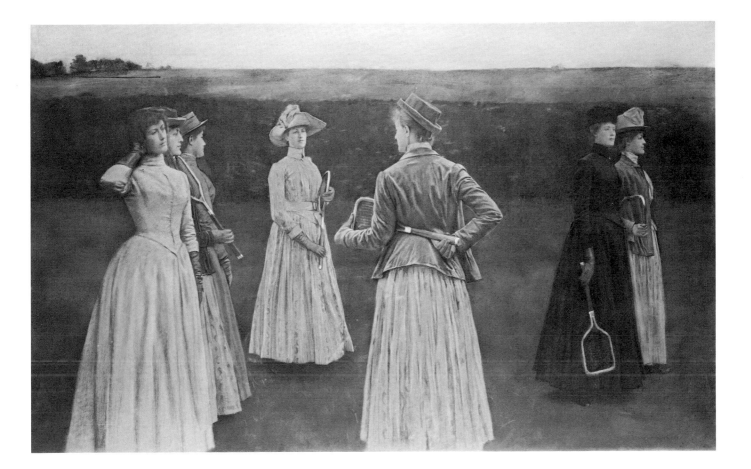

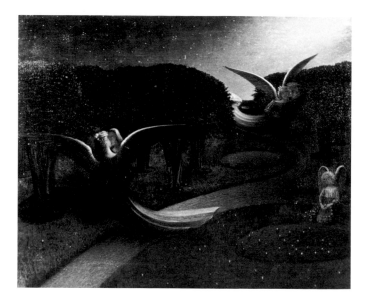

Nouveau. *Madame Stuart Merrill* (cat. no. 10), haloed by her red hair, eyes rolled upward, her pale, mask-like face posed like a beacon upon a book inscribed with the "perfect triangle of human knowledge," is a flawless example of international Symbolist portraiture. It is a most exacting illustration of this artist's own text, for Delville was a writer as well as an artist: "The human head is constructed according to the rhythm of the planetary laws; it is an element of attraction and radiation, and extra-terrestrial astral influence effects it absolutely. There is no difference between the network of planetary attractions and the radiation of the nervous tissues."[23] In another work, *The Idol of Perversity* — a splendid drawing with strong similarities to those by Félicien Rops for the *Sataniques* — another point of view is evoked by the phrase of Villiers de l'Isle Adam which Delville has placed above one of his own poems in *The Shiver of the Sphinx:* "Let us listen neither to the emotions, for they are of the earth, nor to the flesh, for it is of the night."[24] Delville habitually disguised the eroticism of his work under moral condemnation. This type of language always accompanies the idealist discourse under the form of commandments proffered by an initiate communicating with the world beyond.

Mellery, Khnopff, Delville, Fabry, and Montald all represent the idealist current which "occupied in art the same place as nobility in society; its coat of arms is tradition. Idealism made a divine attribute of its goal, the perfection of reality beyond history and nature."[25] Léon Frédéric, unlike the idealists, was able to work in the areas of both Symbolism and Naturalism. The slice of life, with its social import, best illustrated by the series *Women in Rags*, is joined in the *Chalk Merchants* to the nomadic theme so familiar to *fin-de-siècle* artists; a motif which, apart from its social impact, is

a kind of ode to the vagabond freed from material responsibility and, in the final analysis, the motif becomes an allegory of the eternal, wandering soul. And later, an immense breath of cosmic naturism swelled his most exaggerated showpiece, *La Nature* (cat. no. 32), which is somewhat reminiscent of those heads composed by the prince of mannerists, the Milanaise Arcimboldo.

Individualism, a typically Belgian trait that is clearly demonstrated in the group of artists we recall today under the name of Symbolism, is found in the wake of that great declaration of principle published in 1871 by *L'Art Libre*, the cultural review attached to the Société Libre des Beaux-Arts: "Our dominant idea is to fight for freedom. We represent the new art with its absolute liberty for all stylistic tendencies, with its characteristics of modernity." If there is a place for Delville and Frédéric, there is also a place for Degouve de Nuncques, whose poetic style often comes close to being naive in its hieratic quality and its minutiae, and through his "innate sense of the sacredness of things."[26] *L'Art Moderne* of May 5, 1893 speaks of "a sort of deliberate Primitivism." It was ingenuous. But, in the Symbolist period, faced with so much sophistication and an excess of preciosity, cultivated by a Khnopff in the visual arts, incarnate in the celebrated heroes of J. K. Huysmans in *À rebours,* one also finds praise for such artlessness. Verlaine is admired for his ingenuousness. Maurice Dullaert, speaking of the *Fêtes galantes,* qualifies the poetry of Verlaine in these terms: "Ingenue and savant, [he is] childlike and complicated, full of charming awkwardness." Max Elskamp in Belgium, and Francis Jammes in France are the brothers of Degouve.[27] Intimist that he is, one can approach his art somewhat on the same terms as that of Mellery or Spilliaert.

Intimacy is also a nearly constant trait in Belgian painting; it is used in a dreamlike way — dreams of intimacy, sweet dreams, rarely nightmares — and at the same time lends itself to relentless fidelity to detail. This applies to Frédéric as well as to Van de Woestijne, Mellery, Rops, Degouve de Nuncques, and Ensor. "The melancholy of the dream is joined to a precision of analysis," was a description given to the work of Rodenbach. It is also true for the visual arts. Khnopff

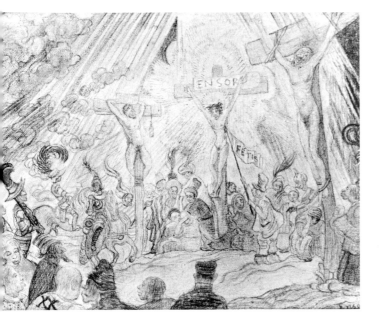

drew the paving stones, one by one, in a deserted square upon which the sea was encroaching; Ensor lingered over the tassels of a curtain to the point of exciting tactile sensation. But the accumulation of excessive detail has just the opposite effect of Realism. The image becomes a mirror behind which a second mirror, more important than the first — the visible, the illusory one — is hidden. But it is through the first that one reaches the reality of the second. Like Magritte, later, but in a less deliberate and less intellectual way, strangeness had already lodged itself in the heart of everyday matters; the supernatural haunted the natural and, truly, 'all that is visible [was] joined to all that is invisible.' Ensor, consciously or not, went so far as to show the other side of the mirror when, after some years, he reworked earlier Realist pictures, enhancing them with fantastic creatures which appeared to be the converse of the first prosaic motifs. Ensor dominates all Belgian Symbolism with his prodigious stature, yet he follows no style. On the contrary, masks and skeletons, the fruits of his hallucinations, of his terror and his rages during his great nerve-wracked solitude, were used in such a personal manner by him that the public found them unacceptable, even though they were part of Symbolism's repertory. To absorb the full measure of his anguish it has been necessary to put temporal distance between the works and the spectator. Ensor's obsession with death, embodied in the skeletons, the human comedy personified by costumes and masks, the projection of his tormented ego in the myth of a persecuted but triumphant Christ, is indeed fundamental to Symbolism, which also had its roots deep in nineteenth century Romanticism; but analogous thoughts haunted Gauguin, Van Gogh, and Munch. And elsewhere, these have been the great themes which, independently of Symbolism, have crossed all of art.

As for Spilliaert, he sometimes showed the greatest attention to detail in his still lifes — "nature mortes," but badly named so, since each object seems to breathe — and sometimes used a technique that was totally indifferent to minute description. In the second style, his images become extremely abstract, showing a preference for synthesis of form and an economy of means, which allow us to see another side of the world

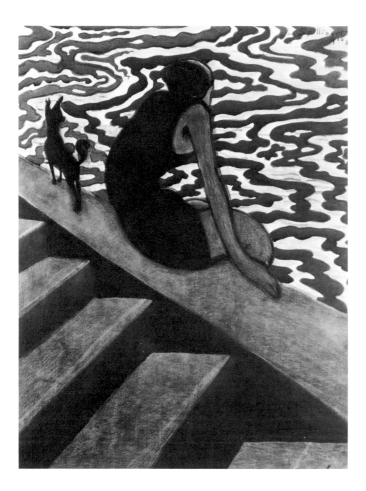

Léon Spilliaert
La Baigneuse 1910
Bathing Woman
Watercolor and colored pencil wash
63.5 x 48.0 cm. (25 x 18⅞ in.)
Collection: Musées Royaux des Beaux-Arts de Belgique, Brussels

— the all-powerful kingdom of the night — and another side of humanity — the figure seen from behind, face turned away toward infinite space. Spilliaert's Symbolist period lasted from about 1910 to 1913 — overlapping the beginnings of Expressionism and, like Ensor's work, forming a hinge to join the two movements. But, in the long run, his independence and freedom, served by a very personal technique which adapted itself to his every mood, isolated him. Even though his power underlines certain similarities in his work to various periods of art, one must always impose a restriction in describing him and his art: Spilliaert was allied to nothing here; he came from another world. This was Symbolism in its final hour.

1. Jean Moréas, "Manifeste du Symbolisme," Paris, *Le Figaro,* September 18, 1886.
2. Paul Lacomblez, ed., *Les Disciples à Sais et les Fragments de Novalis traduits de l'allemand et précédés d'une introduction par Maurice Maeterlinck* (Brussels, 1914), p. 218. This citation was given to me by the painter Jacques Lacomblez, a knowledgeable admirer of the German romanticists.
3. Stéphane Mallarmé, "Réponse à une enquête lancée par *L'Écho de Paris,*" published in issues of the same paper between March 3 and July 5, 1891.

4. Émile Verhaeren, "Silhouettes d'artistes, Fernand Khnopff," *L'Art Moderne,* September 12, 1886, p. 290.
5. Péladan to Rops, ("Paris, Mardi midi"), #8727, Archives de l'Art contemporain, Musées Royaux des Beaux-Arts de Belgique, Brussels. This is part of a series of which the first letter is dated March 22, 1883.
6. Joséphin Péladan, *Introduction to the catalogue of the first Salon of the Rose + Croix* (Paris, 1892).
7. [Émile Verhaeren], "Maurice Maeterlinck," *L'Art Moderne,* no. 29, (July 21, 1889).
8. Émile Fabry, quoted in Gustave van Zype, *Nos Peintres:* Supplement to *La Gazette,* November 29, 1903, Archives de l'Art contemporain, Musées Royaux des Beaux-Arts de Belgique, Brussels.
9. Charles van Lerberghe, "À propos des *Serres Chaudes* de M. Maeterlinck. Frontispice et culs-de-lampe par George Minne. Edition sur Hollande, Paris, Vanier, MDCCCLXXXIX," *La Wallonie,* no. 7 (July 21, 1889), pp. 227–228.
10. Albert Aurier, "Le symbolisme en peinture: Gauguin," *Mercure de France,* March 1891, pp. 155–165.
11. René Guénon, *Aperçu sur l'initiation* (Paris, 1946), p. 132.
12. Georges Pillement, "Peinture, gravure et sculpture," *Encyclopédie du Symbolisme* (Paris, Somogy, 1979), p. 47.
13. The friendship between Khnopff and Burne-Jones is well documented; the two artists had begun to exchange their works. However, while Khnopff may have been influenced by the second generation of Pre-Raphaelites, his work may also have been a stimulus to Burne-Jones. *Memories* might easily have inspired the procession of women seen in the *Marriage of Psyche* of 1895 (Musées Royaux des Beaux-Arts de Belgique, Brussels).
14. Émile Verhaeren, "Les XX," *La Jeune Belgique,* 1883–1884, p. 243.
15. Odilon Redon, *À soi-même (Journal 1867–1915)* (Paris, Floury, 1922).
16. Francine-Claire Legrand, "Fernand Khnopff Perfect Symbolist," *Apollo,* no. 62 (April 1967), pp. 283–287.
17. "Sans Rops que seraient Khnopff et bien d'autres . . . ," *L'Étoile Belge,* 1893, (Archives des XX, Don Albert Vanderlinden, Musées Royaux des Beaux-Arts de Belgique, Brussels); and Félix Fénéon, "La partie la moins contestable de ce volume est probablement le symbolique frontispice au vernis mou du belge Fernand Khnopff," Paris, *La Revue Indépendante* 9 (1888), p. 498.
18. Lesley Dixon Morrissey, "Fernand Khnopff: The Iconography of Isolation and the Aesthetic Woman (Ph.D. diss., University of Pittsburgh, 1974).
19. Louis Dumont-Wilden, *Fernand Khnopff* (Brussels: Van Oest, 1907), p. 32.
20. Alain Mercier, *Les sources esotériques et occultes de la poésie symboliste 1870–1914* (Paris, Nizet, 1969), p. 96.
21. J. Dujardin, *La Fédération Artistique,* February 14, 1892, Archives des XX, Don Albert Vanderlinden, Musées Royaux des Beaux-Arts de Belgique, Brussels.
22. On this subject see the letter from Georges Lemmen to Octave Maus for June 8, 1895, speaking of "un terrible travail de knopffiserie" (play of words with "confiserie"), #8815, Archives des XX, Don Albert Vanderlinden, Musées Royaux des Beaux-Arts de Belgique, Brussels.
23. These ideas were developed by Jean Delville, *Dialogue entre nous: Argumentation kabbalistique, occultiste, idéaliste* (Bruges, n.d. [1895]).
24. Jean Delville, *Le frisson du sphinx* (Brussels: Lamertin, 1897).
25. L. and E. De Taeye, *La Fédération Artistique,* December 14, 1890, Archives des XX, Don Albert Vanderlinden, Musées Royaux des Beaux-Arts de Belgique, Brussels.
26. Brussels, Musées Royaux des Beaux-Arts de Belgique and Otterlo, Rijksmuseum Kröller-Müller, *Le groupe des XX et son temps,* note on Degouve de Nuncques by S. H. W., 1962, pp. 49–50.
27. Herman Braet, *L'accueil fait au symbolisme en Belgique 1885–1900* (Brussels: Palais des Académies, 1967) cites *Le Magasin Littéraire et Scientifique* 1 (1896), p. 77.

Antwerp, Als Ik Kan, and the Problem of Provincialism

Jean F. Buyck

Curator
Koninklijk Museum voor Schone Kunsten
Antwerp

Perhaps the worst offense for an artist is to be labeled a "provincialist."[1] It implies backwardness, narrowness, lack of sophistication and, worst of all, a naive belief in the excellence of being in that state. Keen observers of French nineteenth-century life, like Stendhal or Balzac, analyzed the provincial mind as being characterized by mediocrity and conceit. In France more than anywhere else in Europe, the unquestioned predominance of Paris as the center of political and cultural activity made it inevitable for life in the provinces to be considered a second-rate existence — though the arrogance of the metropolitan man was matched by the pride of his provincial counterpart, who opposed his more robust simplicity to the presumably artificial refinements of life in the big city. Nevertheless, the necessity of obtaining recognition from the worldly-wise arbiters of taste in Paris drew a constant flow of talented hopefuls there from the provinces. And the artist who failed to receive consecration in the capital was bound to remain "une gloire de clocher" — just a local celebrity.

The situation was the same in Belgium, though more complicated because of the nation's linguistic and ethnic duality. During the nineteenth century, Brussels became increasingly French-speaking, while the Flemish had difficulties in accepting the supremacy of the capital. Moreover, most cities had a strong feeling of their own value and tried to preserve their independence *vis à vis* the central government. Antwerp, especially, resented the centralizing tendencies of the young Belgian state. The city by the Scheldt fostered the idea of being "la Métropole des Arts," leaving Brussels to be "la capitale politique." In art, the rivalry of the different cities was a fact not to be ignored, and Baudelaire was perfectly right when he wrote in the notes for his pamphlet, *La Pauvre Belgique*, that in Belgium there were not only different language communities of Flemings and Walloons, but also competition between the different cities, citing Antwerp as a special example of contentiousness.[2]

The Antwerp art circle Als Ik Kan (The Best I Can [Do]), founded in 1883 by a small group of ambitious young artists,[3] was able to maintain its stance as artistic saviour of the city for only a few years. The group's chief problem lay in being too self-serving, but also in

a lack of feeling or daring needed to become true modernists in the spirit of the times and, further, they had no unifying artistic program. But they are not entirely to be blamed for this attitude. As an artist's city, Antwerp was hardly inviting; the public showed no inclination toward innovation in art, and what was being produced had little of interest to offer anyone. This stagnant phase, at the end of the nineteenth century, resulted from the habit of clinging to tradition past the time when it could any longer be considered nourishing. Romanticism lingered on in the academies, in theory and in practice, long after its glory had faded — particularly in the guise of history painting with its attachment to pictorial form and content of the past. Antwerp also wished to preserve the honor of "local" tradition and skill, and well past 1900, the mid-nineteenth-century Antwerp artist Henry Leys[4] was still being used as a model by local history painters. Last, but not least, the academicians, the critics, and the public all believed in the sanctity of an ennobled vision of nature, which was an immense obstacle to any artist who wished to freshen his conceptions of the world around him.

Brussels, on the other hand, was in close contact with Paris — because of its francophone tendencies — and consequently, artists there found the style of contemporary movements interesting for their own work. This situation, creating strong ties between the two French-speaking cultural centers, made Brussels far more attractive to many artists than other Belgian cities, and Antwerp's boasting assertion that it was the "Metropolis of Arts" became an empty phrase, signifying no more than a provincial irritation for its rival city.[5] The centralizing policy of the government increased Brussels' primacy in the arts and soon the triennial Salons held in the capital surpassed anything Antwerp or Ghent could produce. Brussels' own art museum was first promoted to the position of a state institution and, in 1845, had become the first Royal museum in the country, with the implication that its collections were superior to any others and deserved "national" status.

Perhaps the most important development for Brussels' rise to the commanding position in art was the creation of the Société Libre des Beaux-Arts in 1868, which advocated freedom for the individual artist in his interpretation of nature and supported the new "realism" against the diatribes of pontifical academics. The outspoken rebellion of this early group made the inception of the most famous of all artistic circles in Belgium — Les XX — both possible and popular. Les XX, ironically, held its first meeting three days after Als Ik Kan was founded.

The Als Ik Kan artists joined together in October of 1883 essentially in order to better their own position on the art market. They wanted the privilege of exhibiting, unimpeded by the regulations of the official Salons. In order to exhibit with the existing artists' circles, such as Het Koninklijk Kunstverbond or Cercle Artistique, Littéraire et Scientifique, one must have already been accepted at least twice in the Salons which were held alternately in Ghent, Brussels, and Antwerp. These circles offered very attractive opportunities for selling works, a mercantile aspect of their activities which was pointed out in the columns of De Vlaamsche School, Antwerp's leading art journal since 1855: "Artists formed alliances in order to get what the patronage of State, City, or Commune could not or would not give them. They wanted an artists' collective — a painters' syndicate. Als Ik Kan goes beyond that and is a sort of traveling salesman for the joint account. In this unified exploitation of marketable art lies a guarantee of independence and an awareness of self-esteem which is not to be underestimated."[6]

One surely cannot suspect Als Ik Kan of being revolutionary in intent; their name, after all, was taken directly from the motto of Jan Van Eyck, the "father" of Flemish Primitivism. That, in itself, would seem to rule out any thoughts of rebellion or rejection of tradition. It is not surprising, therefore, that the art world was little troubled by the appearance of this new young group. Instead, they were welcomed congenially to easygoing Antwerp, which still proudly luxuriated in the security of its artistic heritage from highly respected earlier generations. The activities of Als Ik Kan were reported from the beginning by the aforementioned, very conservative De Vlaamsche School, and treated in admiring or admonishing terms, according to whether the works currently being shown could be favorably compared to the old masters. Most of the pieces exhibited were still life or genre compositions,

Piet van Engelen
Sechtende Kemphanen 1902
Fighting Cocks
Oil on canvas
171.0 x 252.0 cm. (67³⁄₈ x 99¹⁄₄ in.)
Collection: Koninklijk Museum voor Schone Kunsten, Antwerp

landscapes, and portraits — all conceived in the traditional manner. One painting, by Charles Boland, represented "dogs tearing up a copy of Zola's novel, *Nana*," while another, by Jaak Rosier, showed "an Italian looking at his daughter's face and finding such a close resemblance to his dead wife there, that he exclaims, 'Just like her mother!' — which is the title of the painting."[7] Among the participants in these rather prosaic exhibitions, it is certainly surprising to come across the name of Henry van de Velde.

For five years the criticism of Als Ik Kan in *De Vlaamsche School* remained generally favorable. But in 1888, Max Rooses, the eminent historian and critic who was devoted to the theories of Hippolyte Taine, reviewed their fifteenth exhibition in a negative light, saying:

> What many of these young artists lack is true freshness and youth. Heavy painting and everyday subjects are dominant. There is no recklessness, no daring. We do not preach a surfeit of boldness or any other extravagance, but would rather see the young acting a bit younger; a man has a whole life in which to grow old, so it is not necessary to start this early. We like it better when he twitters like the birds in the woods or gambols like the foal in the fields; the time will come soon enough when he is imprisoned in a cage or harnessed to a cart, in order to earn his daily bread.[8]

It is true that this adverse commentary appeared after the only true modernist in the group, Henry van de Velde, had already resigned. Charles Mertens' style was not yet transformed, and the most promising younger artists, Evert Larock and Richard Baseleer, were not yet members. But it soon became clear that this new art circle had no intention of upsetting the established reputation of the Academy, for most of its founders were very recent graduates of that institution and still admired their teachers. In the beginning, the prominent academician Charles Verlat (1824–1890) followed the activities of his students who became founders of Als Ik Kan with pleasure, and perhaps with pride as well.

After his return from a voyage to Palestine, where he had spent time in order to build up a repertory of biblical imagery, Verlat entered the local art scene as a

primus inter pares. He was a man of the world — having spent many years in Paris and Weimar — and an influential pedagogue who was also involved in the reorganization of the Antwerp Academy when he became its director in 1885. His views on desirable changes in higher art education were published in 1879[9] and his *Causerie artistique*, published in 1883, went so far as to draw uncomplimentary contrasts between the lethargy of Antwerp's artists and the progressive, youthful dynamism of the Brussels circle, L'Essor. He also ventured some predictions about the future of art, granting safe-conduct, as it were, to young artists, but also urging them to assert themselves as a group. He saw the art of the future growing closer to Naturalism, and attached great importance to the development of photography. Finally, he advocated the preservation of a native tradition in painting and warned against the growing influence of French art — an argument always raised by Flemish nationalism and directed against the Brussels "school."

Henry van de Velde eulogized Verlat after his death, but also expressed a certain amount of bitterness because he thought Verlat had forsaken independence and progressive ideas in order to obtain the directorship of the Antwerp Academy.[10] Verlat's influence over Als Ik Kan and its members lasted into the twentieth century. Piet van Engelen[11] painted his *Fighting Cocks*

of 1902 in the master's style, and the technical excellence of his work is overshadowed by its shamelessly anachronistic conception. The same is true of the *Still Life* of Edouard Chappel (1859–1946), which is undated and therefore lends itself even more strongly to a ridiculous relationship with seventeenth-century formulas. Both pay homage to tradition, but in doing so reduce themselves to the most objectionable aspects of academism. It would be absolutely unjust to lower the entire output of Als Ik Kan to this level, but the tendency to historicism was truly prevalent. The pseudo-Rococo setting of the fancy-dress parties of Jan-Willem Rosier (1858–1931), or the heavy-handed effusiveness of Léon Brunin's (1861–1941) genre work — which proves just how badly he misunderstood Henri de Braekeleer — are both unfortunate examples of the reactionary tendency in the group.

There was, however, a recognizable divergence between the traditionalists and the progressives, which produced a moderate "center" as well. Henry Luyten,[12] Dutch by birth, but one of Als Ik Kan's most active members, was one artist who took the middle road. In 1886, he painted *A Session of the Art Circle, "Als Ik Kan," in 1885,* a psychologically diversified group portrait of his colleagues. One wonders whether the composition is intentionally reminiscent of the composition commonly used for *The Last Supper* which, in this case, would place Van de Velde in the Judas seat, isolated from his companions. It would be appropriate, indeed, since Van de Velde was the renegade of the group and left it at the end of 1886 — the same year in which Luyten made this picture.

Modernism played a greater part in Antwerp's artistic life after the formation of L'Art Indépendant in 1887; the new group was much more strongly affiliated with the ideas already in practice in Brussels at Les XX. Four years later, according to the well-informed critic and historian of Flemish art, Jules Dujardin,[13] the rupture with academic traditionalism became an accomplished fact with the formation of the circle, Les XIII. Henry van de Velde, on the other hand, scorned any notion that Les XIII were responsible for creating a contemporary atmosphere in the city.[14]

On November 14, 1891, Als Ik Kan opened its twenty-fifth exhibition. It was a moment for an already well-

Facing page, top:
Edouard Chappel
Stilleven n.d.
Still Life
Oil on canvas
202.0 x 235.0 cm. (79½ x 92½ in.)
*Collection: Koninklijk Museum voor
Schone Kunsten, Antwerp*

Facing page, bottom:
Léon Brunin
In Gepeinzen 1891
Lost in Meditation
Oil on panel
93.0 x 70.0 cm. (36⅝ x 27½ in.)
*Collection: Koninklijk Museum voor
Schone Kunsten, Antwerp*

Right:
Jan-Willem Rosier
Het Menuet 1891
The Minuet
Oil on panel
119.0 x 179.0 cm. (46⅞ x 70½ in.)
*Collection: Koninklijk Museum voor
Schone Kunsten, Antwerp*

Right, bottom:
Henry Luyten
**Een Zitting in de Kunstkring
"Are ick kan" omstruks 1885** 1886
A Session of the Art Circle,
"Als Ik Kan," in 1885
Oil on canvas
190.0 x 246.0 cm. (74¾ x 96⅞ in.)
*Collection: Koninklijk Museum voor
Schone Kunsten, Antwerp*

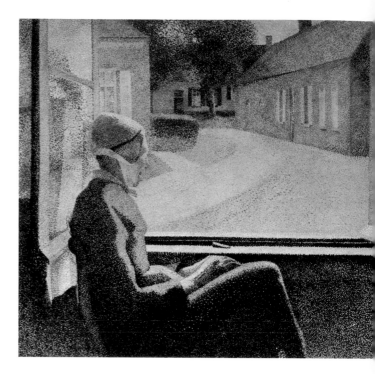

respected institution to celebrate, looking back proudly on a number of manifestations which, although in no way epoch-making, had proved useful and interesting for artists. The bilingual catalogue resembled nothing so much as a miniature of the official Salon catalogue. Edmond de Taeye, the art critic, wrote with irony about the exhibition of 306 works by the 38 members: "It is not enough to varnish carefully and to buy expensive frames in order to flatter the eye of the bourgeois, nor even to have such honorably Flemish first names as Piet, Jan, Frans, etc.!"[15] Was his judgment too sharp? The catalogue, after all, included Henry van de Velde: "No. 261. *Faits de Village. VI. La Femme à la Fenêtre,*" which had also been exhibited in 1890 with Les XX in Brussels, and at the sixth Salon des Indépendants in Paris. If the consistent pointillism of *Woman at the Window* was not modern enough for De Taeye, what would have been? The comments of Emmanuel De Bom were not so blunt, even though he found many of the works mediocre. By praising Luyten, Mertens, and Larock, De Bom proved to have keen critical insight; it is indeed true that the works of the last two artists named are well within the limits of moderate modern ideology and the most attractive which Als Ik Kan had to offer.[16] This exhibition certainly marked an end to the era which had thought it possible to create a renaissance of art in Antwerp. Als Ik Kan had to content itself with having found a niche in the shadow of The Royal Society for the Encouragement of Fine Arts and — although it was no match for Les XX — with having played a small part in the transformation of Antwerp's artistic milieu toward the end of the century, when it became the first circle to attempt a break with the restraints of officialdom.

The more progressive members, however, failed to gain a favorable response from the public, and received very little credit for their efforts from the Brussels critics who championed avant-garde art. The case of Charles Mertens was typical in this respect.[17] He was applauded at the beginning of his career by a local public who admired his skilled and very traditional genre pieces, but later, when his style had changed thoroughly, the same public rejected him. Pol De Mont, a critic who claimed to have saved Mertens from complete ruin, berated the "grocers and pedants"[18]

Below:
Henri de Braekeleer
Stilleven *circa* 1885
Still Life Accessories
Oil on canvas
35.0 x 52.5 cm. (13³/₄ x 20⅝)
Collection: Koninklijk Museum voor Schone Kunsten, Antwerp

Below, bottom:
Charles Mertens
Schildersatelier 1884
The Painter's Studio
Oil on panel
49.0 x 59.0 cm. (19¹/₄ x 23¹/₄ in.)
Collection: Koninklijk Museum voor Schone Kunsten, Antwerp

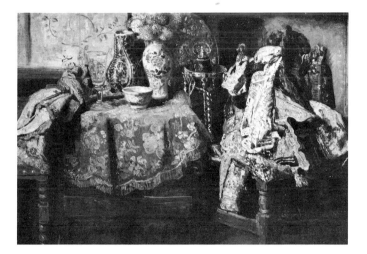

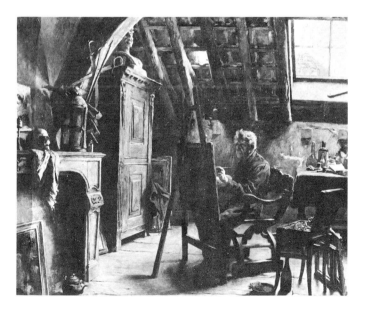

who stuffed their mansions with worthless paintings and were so obtuse that they could not appreciate the artist's development in his later years. When he exhibited his work, buyers seem never to have attended, and the critics of Antwerp's reactionary press actually enjoyed his defeat. Charged with heresy by the local public and ignored by the progressive critics, Mertens even failed to fit the later historians' idea of a modern Flemish artist in Belgium, since he was neither a Symbolist nor an Expressionist.

Henry van de Velde was the only member of the group to successfully escape the grasp of provincialism. His enthusiasm for Seurat, his adoption of the divisionist technique, and his membership in Les XX — "the only honor [he] coveted,"[19] — took him far away in both theory and practice from the local scene. He was discreetly silent about his former association with Als Ik Kan during his entire long career as an internationally famous architect and designer; the fact is not even mentioned in his memoirs.[20]

Besides the special case of Van de Velde, it is now possible to indicate other examples of members whose work ran counter to the routine of academism and the time-honored models of local repute. Looking back with a clearer eye, from a greater distance, on the complex reality of late nineteenth-century art reveals to us the extent to which Als Ik Kan mirrored new trends — slight though it may have been. *Pleinairism,* with its consequent local coloration and moderately Impressionist style was already accepted, as we know from the "school" of Tervuren and the artists painting at Kalmthout. Richard Baseleer (1867–1951), the quiet intimist, forever in love with the mists rising on the lower Scheldt, who joined Als Ik Kan in 1890, can be considered a late offshoot of the Impressionist trend. Evert Larock (1865–1901), whom De Bom considered the most inspired of the whole group — he, too, joined in 1890 — also belongs to this persuasion. And the influence of Henri de Braekeleer on Als Ik Kan was important for some of its most interesting members — even though he was not one of them himself. Following his mental breakdown between 1880 and 1883, De Braekeleer executed a final series of masterpieces, which became models for younger painters. The still life in Charles Mertens' *Painter's Studio* would have

Evert Larock
De Unnozele 1892
The Idiot
Oil on canvas
148.0 x 121.0 cm. (58¼ x 47⅝ in.)
Collection: Koninklijk Museum voor Schone Kunsten, Antwerp

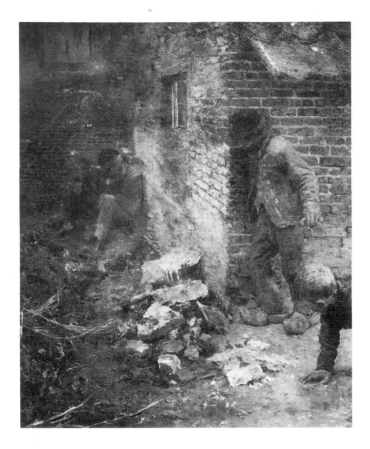

been inconceivable without De Braekeleer's example. Larock's treatment of the same subject seems a tribute to the older man, as also suggested by the very particular treatment of one of De Braekeleer's favorite themes in Van de Velde's *Woman at the Window.*

The international trend toward Naturalism is also reflected in the work of many Als Ik Kan members. Bastien-Lepage (1848–1884), whom Van de Velde met in Paris in 1884, had many followers in this style, and the same rural directness seen in his painting *The Haymakers*[21] is echoed in Larock's *The Idiot* and Mertens' *Game of Crowns.* Outside the circle of Als Ik Kan these qualities of rough charm are found in the work of Émile Claus, Léon Frédéric, and Frans van Leemputten (1850–1914). German Naturalism was another source for this kind of painting, especially that of Max Liebermann and Fritz van Uhde — who worked in Zandvoort during the summer of 1882 — and there is certainly a relationship between Dutch painting of the Hague School and pictures by a number of Antwerp artists. *Children of the Sea* by Luyten, the Dutch-born Als Ik Kan member, is strongly reminiscent of Josef Israels' paintings.

In essence, Als Ik Kan failed to make Antwerp aware of contemporary art. Conservatism among its members and the practical nature of its needs combined to prevent any resurgence of energy or fame in the art world of Antwerp. Only Henry van de Velde left the local

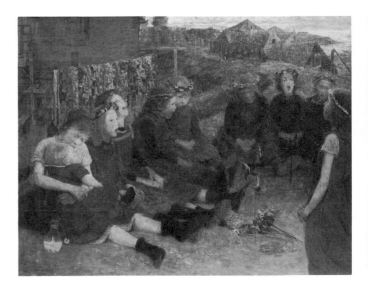

Right:
Frans van Leemputten
Brooduitdeling op het dorp 1892
Distribution of Bread in the Village
Oil on canvas
64.0 x 78.0 cm. (25¼ x 30¾ in.)
Collection: Koninklijk Museum voor Schone Kunsten, Antwerp

Right, bottom:
Henry Luyten
Kinderen der Zee 1898
Children of the Sea
Oil on canvas
162.0 x 197.0 cm. (63¾ x 77½ in.)
Collection: Koninklijk Museum voor Schone Kunsten, Antwerp

Facing page, bottom:
Charles Mertens
Zingende Kinderen in Slaanderen 1894
Game of Crowns
Oil on canvas
154.0 x 198.0 cm. (60⅝ x 78 in.)
Collection: Koninklijk Museum voor Schone Kunsten, Antwerp

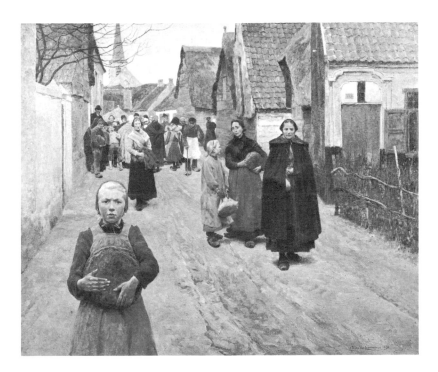

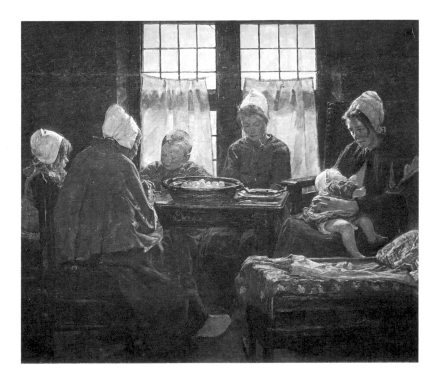

scene and gained honor, and in order to do so he had to pass through Brussels as a member of the progressive group, Les XX. The turn of the century found Antwerp still largely committed to its past and generally outside the current ideology of 1900, although there are some remarkable examples of Art Nouveau architecture in the city.

Antwerp played no part either in the revival of artistic innovation outside Brussels, which was indicated after the dissolution of Les XX in 1893 — even though La Libre Esthétique carried on the spirit of modernism in the capital. In one sense, the provincial spirit triumphed; it offered a kind of inspiration that no city could give. While the first generation of Symbolists remained esoteric in the extreme, the artists who followed them discovered a mystic quality, that was enhanced by rural simplicity. Jakob Smits is an artist who demonstrates this development from complex sophistication to a less elaborate iconography; after starting his career in a cosmopolitan setting, he turned to a remote corner of the Campine area and began to paint the plain interiors of country houses and the modest people who inhabited them. He totally abandoned esoteric intellectualism for natural Symbolism suitable to his deep religious convictions.

Even more important for art in the switch from city to countryside was the rise of the so-called School of Laethem-St.-Martin near Ghent, where several artists who would play a dominant role in the further development of Flemish modern art settled around 1900: Valerius de Saedeleer in 1898, George Minne in 1899, Karel van de Woestijne in 1900, Gustave van de Woestijne in 1901, and Albert Servaes in 1904. Their goal was to return to "the sources" — a move of great significance for all subsequent Flemish art, which has continually tried to reaffirm its identity in the twentieth century by rejecting all forms of cosmopolitanism.

In Antwerp, the true beginnings of a more pronounced interest in modern art are evident in the foundation of Kunst van Heden (Art of Today) in 1905. Though this association began its activities with exhibitions honoring Henri Leys and Henri de Braekeleer, it embodied a spirit of a final tribute to the masters of a previous era and the promised start of a new artistic ideology for a new century.

1. The present essay is based mainly on two former publications: "De kunstkring Als Ik Kan en zijn betekenis voor het culturele leven te Antwerpen in de tachtiger jaren van de XIXde eeuw," Introduction to the exhibition catalogue, Antwerp, Koninklijk Museum voor Schone Kunsten, 1974; and "De schilder en beeldhouwkunst in de 19de eeuw," Twintig Eeuwen Vlaanderen, vol. 11, (Hasselt, 1978), pp. 354–373.
2. Oeuvres complètes (Paris, 1954), p. 1298: "Il n'y a pas de peuple belge, proprement dit. Il y a des races flamandes et wallonnes, et il y a des villes ennemies. Voyez Anvers."
3. The founders (on October 25, 1883) were: F. Adriaenssens, Ch. Boland, L. Brunin, E. Chappel, P. De Wit, F. Hanno, J. Rosier, H. Rul, and H. Van de Velde.
4. Leys (1815–1869) was an important painter of historical subjects, treated as genre, and was Henri de Braekeleer's uncle and teacher. Opposed to the academicism of Niçaise de Keyser (1813–1887; Director of the Antwerp Academy 1855–1879), he gathered around him some of the major younger artists such as his nephew, Henri de Braekeleer, and Jan Stobbaerts.
5. In 1892, an exhibition of Als Ik Kan was organized in Brussels and treated in the review L'Art Moderne as "un enfoncement de portes ouvertes."
6. De Vlaamsche School, 1892, p. 86.
7. De Vlaamsche School, 1884, p. 94.
8. De Vlaamsche School, 1888, p. 60.
9. Plan général des études à l'Académie Royal d'Anvers et des Réformes à introduire dans les Cours de Dessin et de Peinture (Antwerp, 1879).
10. L'Art Moderne, 1890, pp. 348–349.
11. Engelen (1863–1924) joined Als Ik Kan in 1886.
12. Luyten (1849–1945) joined Als Ik Kan in 1884.
13. "Les artistes contemporains," L'Art Flamand 6 (1900), pp. 156 and following. As a matter of fact, the founders of Les XIII were only twelve in number: E. Claus, Th. Verstraete, E. Farasijn, E. De Jans, H. De Smeth, L. Van Engelen, H. Luyten, F. Hens, Ch. Mertens, L. Van Aken, P. Verhaert, and R. Looymans.
14. L'Art Moderne, 1892, p. 70.
15. Compare Dujardin, "Les artistes contemporains," p. 153.
16. De Vlaamsche School, 1892, pp. 1–13.
17. Mertens (1865–1919) joined Als Ik Kan in November 1883.
18. Vlaamsche Meisters der negetiende eeuw (Antwerp, Ghent, 1902); and Schilders van hier en nu (Antwerp, 1929).
19. Van de Velde to Maus, cited in Brussels, Palais des Beaux-Arts, Henry van de Velde 1863–1957, by R.-L. Delevoy, p. 27.
20. Geschichte meines Lebens (Munich, 1962). Delevoy (Henry van de Velde 1863–1957, p. 21, note 6) says Van de Velde's membership is fictitious, an inaccuracy repeated by K.-H. Hüter (Henry van de Velde: Sein Werk bis zum Ende seiner Tätigkeit in Deutschland [Berlin, 1967]) and A. M. Hammacher (De Wereld van Henry van de Velde [Antwerp, 1967]).
21. The painting, exhibited at the Paris Salon of 1878, is now in the Musée du Louvre.

Catalogue

Paintings
Drawings
Sculpture

Note
Dimensions are in centimeters (inches in parentheses);
height precedes width and, where applicable, a third figure
indicates depth. The collection is given in italics.

Catalogue contributors:

[PB]	Pierre Baudson
[JB]	Jane Block
[JK]	Jean F. Buyck
[DC]	D. Cardyn
[MC]	Marie-Jeanne Chartrain-Hebbelinck
[RD]	René Daelmans
[FE]	Françoise C. Leonard-Etienne
[PF]	Patricia Farmer
[SF]	Sarah Faunce
[SH]	Suzanne Houbart-Wilkin
[RH]	Robert Hozee
[FL]	Francine-Claire Legrand
[PM]	Phil Mertens
[GO]	Gisèle Ollinger-Zinque
[PR]	Philippe Roberts-Jones
[LS]	Lydia Schoonbaert
[CT]	Carol Tabler

Henry van de Velde
Paysage Puéril 1891
Childhood Landscape
Cat. no. 104

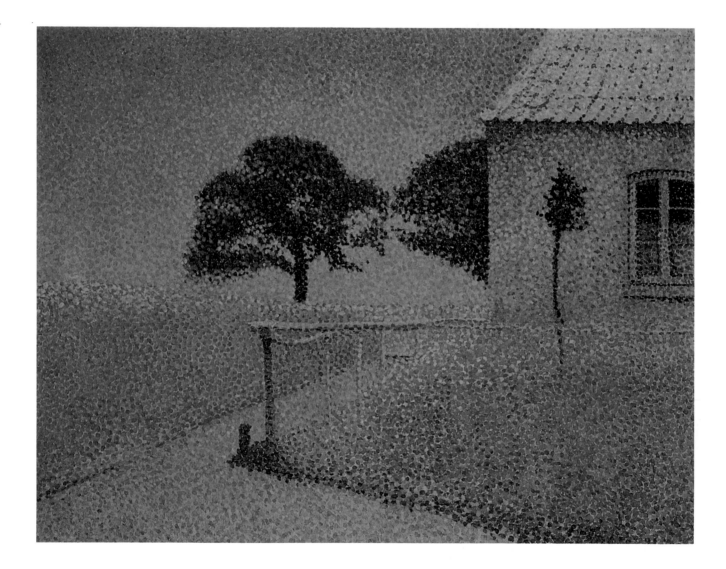

The son of the painter Ferdinand de Braekeleer, and nephew of the history painter Henri Leys, De Braekeleer grew up in a family of eminent Antwerp artists. Though he attended classes at the Antwerp Academy from the time he was fourteen, his most important training came from working with his uncle. Leys required the boy to make studies of old houses and churches, both the exterior and interior, and these he later used for his own paintings of historic Flanders. In 1858, De Braekeleer took part in his first Salon, at the age of eighteen and while still a student. Travels to the Netherlands and Germany brought him into contact with a number of old masters whose work he emulated, particularly those of the Dutch seventeenth century, like Pieter de Hoogh and Vermeer. It was not long before he moved away from anecdote and sentimental subject matter to develop his own personal genre style, in which simple objects became metaphors for the expression of internal emotions — the "objective correlatives" of T. S. Eliot. In 1869, he made a contract with the Brussels banker, Coûteaux, who played the role of collector-dealer for many Antwerp artists. De Braekeleer won a gold medal at the Brussels Salon of 1872 and a medal of honor at the World Exhibition in Vienna the following year. But in the years between 1880 and 1883 he fell prey to his naturally melancholic disposition and suffered a real mental breakdown, which forced him to stop painting altogether for a time. When he resumed his work, he developed an interest in light and color that presents itself as a kind of broadly conceived Impressionism in the brushwork, and a prelude to Expressionism. In the year before he died, the Brussels avant-garde group, Les XX, recognized De Braekeleer's special talents and invited him to show at their 1887 Salon. He was singled out from the Antwerp painters as the only "modernist" — the critics who wrote for *L'Art Moderne* in Brussels presenting him to their public as an exception in the sclerotic art world of the city by the Scheldt. The surface of his pictures is often as interesting in its own right as the illusion of the objects which are formed by the closely woven tapestry of paint. [JK]

HENRI DE BRAEKELEER
1840–1888

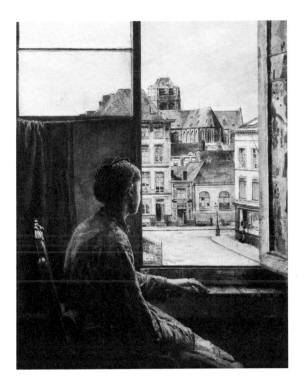

1 **De Teniersplaats te Antwerpen** 1878
Teniers Square in Antwerp
Oil on canvas
81.0 x 64.0 (31⁷/₈ x 25¹/₄)
Koninklijk Museum voor Schone Kunsten, Antwerp

De Braekeleer uses a favorite motif here, which comes directly from the Romanticism of the early nineteenth century: a figure, lost in thought, who looks through an open window. Two years earlier he painted a work which is now the most famous example of this theme, *The Man at the Window*. Contrary to the standing man in that painting, whose view extends over the rooftops of a city, the woman seen here is seated and looks out on an old, sunny square. Her presence is firmly placed in the foreground of the composition so that the viewer is forced to share the view by looking over her shoulder — a situation emphasized by a strong contrast between the shaded interior area where she sits and the brilliant light of the scene outside. By isolating and magnifying an ordinary moment, De Braekeleer shows us a basic theme in iconology that centers on the longing of a lonely person for deliverance from symbolic imprisonment. The desire is for escape to infinity, but here, as is so often the case, even the world beyond the prison is boxed in on every side. Henry van de Velde later expressed his great admiration for De Braekeleer by painting this same subject in the most painstaking Pointillist application (illustrated on page 76). Tralbaut ("De Braekeleeriana," *Antwerpen,* 1964, pp. 115 and following) challenges the date of this painting for the same reasons that he doubts 1878 is correct for *The Picture Restorer* (cat. no. 2). *Teniers Square in Antwerp* was exhibited in Antwerp with Kunst van Heden at the commemorative exhibition *H. Leys — H. De Braekeleer* (1905, cat. no. 203; dated 1878 and mentioned as belonging to the widow of Coûteaux), and at the retrospective exhibition of De Braekeleer in Antwerp at the Koninklijk Museum voor Schone Kunsten in 1956 (G. Van Zype, *Henri de Braekeleer* [Brussels, Paris, 1923], cat. no. 94, p. 103).

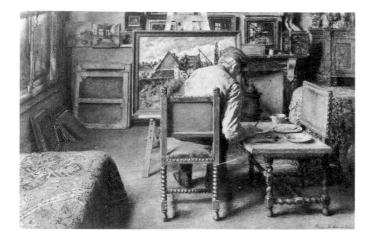

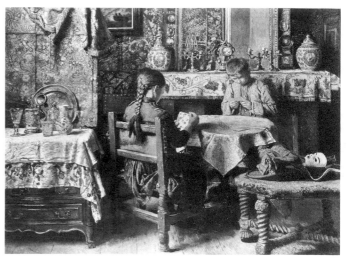

2 **De Schilderijenhertoetser** 1878
The Picture Restorer
Oil on canvas
40.0 x 62.0 (15³/₄ x 24³/₈)
Koninklijk Museum voor Schone Kunsten, Antwerp

3 **The Card Players** 1887
Oil on canvas
52.0 x 70.5 (20¹/₂ x 27³/₄)
Musées Royaux des Beaux-Arts de Belgique, Brussels

In this work, the viewer is presented with the back view of a man seated before an easel which holds a painting by De Braekeleer called *The Market Garden,* of which he painted two versions — one now at the Musée des Beaux-Arts in Tournai, the other in Antwerp. The question is immediately raised as to why the artist has shown one of his own works undergoing restoration by another man. It seems evident, both from the clothing this man wears and in comparison with the figure seen in a painting from the previous year entitled *De Braekeleer's Studio,* that the artist has not represented himself here. Perhaps his brooding nature envisioned a time after his death when his work would need attention from hands other than his own. In contrast to similar compositions, like *The Geographer,* in which the illustration of material exuberance is carried by a brilliant pictorial technique, *The Restorer* reveals very controlled brushwork, sober coloration, and a clear, compact structure. Tralbaut ("De Braekeleeriana," *Antwerpen,* 1964, pp. 64 and following) disputes the usual dating for this work on the grounds that 1878 is too late to fit with either the earlier death of Coûteaux, in whose collection it is later mentioned, or with the termination of De Braekeleer's contract with the banker in 1876. The old dating is retained here since the possibility of Coûteaux's widow carrying on with his business in the art world has not been ruled out. The painting was exhibited with the Cercle Artistique in Antwerp in 1891, and with Kunst van Heden in 1905 (Antwerp, cat. no. 204).

The writer Maurice Gilliams called this painting a serene good-bye to the world of the senses. "The supreme work of a man whose mind is already sick to death, sensitive to death, and ready to die. It is a mind which lacks the imagination and inner demoniac vision necessary to transcend a basic bourgeois adherence to the visual charm of reality." (*Inleiding tot de idee Henri de Braekeleer* [Antwerp, 1945]). In this masterful "psychogenetic" statement, the author fails to understand De Braekeleer's fundamental significance for the modern conception of the organization of the picture plane in pure pictorial terms. In this respect, and within the limits of his provincial ambience, De Braekeleer deserves a place on the international scale of things. His modernism begins well before the loose Expressionistic brushwork of his paintings in the eighties; it is manifested in the dense surface pattern which he creates to exist simultaneously with the implied depth of space. This appears to be an exploration of the same problem that would soon capture all of Cézanne's efforts. Émile Verhaeren, writing about this painting when it was exhibited at the only Salon of Les XX in which De Braekeleer participated, described it as "provincial but superb . . ." (*L'Art Indépendant,* March 1887, p. 370). The work was also exhibited at the *Exposition générale des Beaux-Arts* (Brussels, 1887, no. 94), with Kunst van Heden (Antwerp, 1905, cat. no. 221), and in the retrospective of 1956 in Antwerp (Koninklijk Museum voor Schone Kunsten, cat. no. 77). *The Card Players* is reputed to be De Braekeleer's last painting.

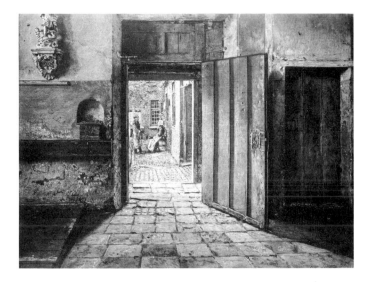

4 **De conversatie** *circa* 1884
The Conversation
Oil on canvas
49.0 x 64.0 (19¹/₄ x 25¹/₄)
*Koninklijk Museum voor Schone
Kunsten, Antwerp*

De Braekeleer offers a view through an open door into a deeply recessed courtyard in this picture, much in the manner of Dutch painters of the seventeenth century. Two women are seen talking at the far end of the court, which is reached by traveling visually over the perspective of diminishing paving stones, beginning at the lower edge of the picture plane. The painting was made after the artist's nervous breakdown, and the change in his technique is easily apparent in the quick, small brushstrokes which produce a very painterly effect and catch the light, holding it captive in multiple small paint drops. Tralbaut again suggests a different dating, placing it in 1881, which would coincide with the first year of the artist's breakdown, when he had stopped painting. This was exhibited with Kunst van Heden in Antwerp in 1905 (cat. no. 212).

EMILE
CLAUS
1849–1924

Émile Claus was born in 1849 in Sint-Eloois-Vijve, a village on the Lys in the West of Flanders, and spent his youth — he was the youngest of a family of sixteen children — entirely in the country. His early interest in drawing led him to attend drawing lessons at a local academy, but it was not until 1870 that he enrolled as a student in the Academy in Antwerp, then a stronghold of Flemish academism. Claus was trained under the romantic landscape painter, Jacob Jacobs, and the well-known history painter, Niçaise de Keyser. His studies lasted four years, giving him sufficient mastery to exhibit at the Salons of Brussels, Antwerp, and Ghent, where he showed anecdotal scenes, often inclining toward social realism. In 1882, his first exhibit in the Paris Salon, *Cockfighting in Flanders* (now in a private collection), was a great success, and from then on, Claus was found in Paris very regularly, sometimes staying there the whole winter. Claus did not immediately submit to the influence of French Impressionism. Upon his first contacts in France followed a series of highly finished Realist paintings, with a non-academic range of subjects, depicting the life in the country. The scenes were set in the open air and enabled the artist to express his increasing interest in atmosphere and light, as well as his narrative approach to nature and country life. At this time, he mainly worked in a village called Astene, on the banks of the Lys, where he eventually settled in 1886. In the late eighties, further contacts in Paris (among them Le Sidaner), and increasing encouragement from the critic Camille Lemonnier, prepared his final acceptance of Impressionism in the nineties, when he became its major follower in Flanders. He kept working as an Impressionist until he died in Astene in 1924, having enjoyed wide recognition as the leader of the Impressionist — also called the "Luminist" — movement in Flanders. Claus' Impressionism varies from a straightforward application of Impressionist and Post-Impressionist methods to a more intuitive assimilation of the French principles, when he translates his experiences in his native countryside in charming and intimate scenes. Here, trees, people, and animals are very much present as subject matter — as protagonists in an illustrative narration about Flanders. These are authentic works in which Impressionist technique and the new color range merely enhance a fundamentally poetic-Realist approach. [RH]

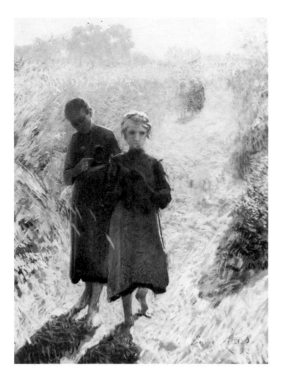

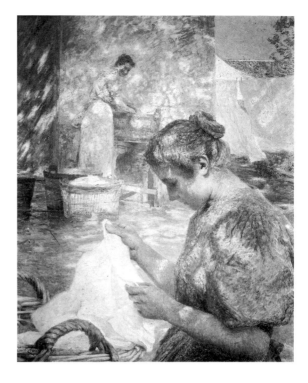

5 **Meisjes in het Veld** 1892
Maidens in the Field
Pastel on paper
71.0 x 53.0 (28 x 20⁷/₈)
Museum voor Schone Kunsten, Ghent

6 **Zonnige Dag** 1899
Sunny Day
Oil on canvas
92.5 x 73.0 (36³/₈ x 28³/₄)
Museum voor Schone Kunsten, Ghent

Claus occasionally used pastels to make fairly large drawings which were intended as final works in themselves. Although he painted a large version of this in oils (130.0 x 98.0 cm., now in a private collection in Brussels; and no. 49 in the Claus exhibition in Ghent in 1974), the pastel version of *Maidens in the Field* should be considered not as a sketch, but as an autonomous work. Millet set the example in pastel technique for all later nineteenth-century artists. Claus has here been able to catch a beautiful effect of light and atmosphere, with children walking two by two through the cornfields, in the full glare of the sun. Two of them are obstructing the light and casting a blue shadow in the left foreground, while the shapes of four others, further back, are completely dissolved in a play of bright white light and color. The general appearance of this work is one of elegance and lightness, which Claus rarely attained when working in oils. The subject, so frequent with Claus, is a familiar country scene in which a disjointed row of school-children walks home across the fields. They hold their clogs in their hands in order to proceed more comfortably. According to his biographers, Claus was extremely fond of scenes which showed village children living harmoniously in nature — with which he, himself, was in daily contact. (Ghent, Museum voor Schone Kunsten, *Retrospectieve Tentoonstelling Émile Claus 1849–1924*, by Paul Eeckhout, 1974, p. 49.)

This painting is an example of Claus' mature style, when he had assimilated the Impressionist idiom and established his personal version of it. It was painted in 1899, the year that saw the completion of his ambitious canvas, *Cows Crossing the River*, a large work which took him eight years to finish (200.0 x 305.0 cm., on loan from the Musées Royaux des Beaux-Arts de Belgique, Brussels to the Museum voor Schone Kunsten, Ghent). Like most works from shortly before and around 1900, *Sunny Day* has a characteristic bright and variegated coloring, and an overall clearness and definition, whereas later works tend toward a more subdued or blended coloring and a much more unifying, sketchy technique. Although the artist is here interested in one particular effect of radiant light, he cannot help portraying every figure and object in great detail. He keeps to the closed forms, and it is only within the outlines that he handles the paint freely, giving various sorts of textural and luminous effects. What the work may lose in unity and simplicity, it gains in richness of visual information, due to its equal emphasis on all elements. *Sunny Day* was recently shown in London at the *Post-Impressionism* exhibition where it was rightly related to the work of Camille Pissarro with regard to "the scale of the dominant woman in the foreground, the peasant subject matter and the technique of short crisscross brush strokes of bright juxtaposed colors." (References: Ghent, Museum voor Schone Kunsten, *Retrospectieve Tentoonstelling Émile Claus 1849–1924*, by Paul Eeckhout, 1974, p. 53, no. 74, plate facing p. 56; Ghent, Museum voor Schone Kunsten, *Gent Duizend Jaar Kunst en Cultuur — Muurschilderkunst, Schilderkunst, Tekenkunst, Graveerkunst, Beeldhouwkunst*, 1975, p. 318, no. 148, plate 71; London, Royal Academy of Arts, *Post-Impressionism*, 1979–1980, p. 261, cat. no. 391.)

WILLIAM DEGOUVE DE NUNCQUES
1867–1935

Born at Monthermé in the French Ardennes, William Degouve de Nuncques was descended from a large and very old family of the nobility that was traditionally associated with the arts. He was devoted to his father, an extremely cultivated man who introduced his son not only to art, but to literature, music, philosophy, and the sciences as well. Degouve was only three when his family decided to move to Belgium, first to Spa and eventually to Brussels. Encouraged by his father to do so, William always let himself be guided by his intuition and emotions, from early childhood onward. He attended the Brussels Academy for a few months, but soon dispensed with professional teachers and continued to learn about art by teaching himself. Indeed, he was primarily a self-taught painter. "I started to draw and paint, subsisting entirely on the attractions of country life, without master, advice or influence, giving priority to my instincts, to the pleasure of deliberately living alone." In 1883, he met Jan Toorop, the Dutch painter, who helped him in learning more about his chosen profession. An even deeper friendship was the one he formed with Henry de Groux. Strengthened by the advice of these friends, Degouve was soon ready to realize a legitimate career as an artist. He showed his first canvas at the Paris Salon of 1890 under the sponsorship of Rodin, and found a buyer for it immediately. On October 30, 1894 he married Juliette Masin, a talented painter and the sister-in-law of Émile Verhaeren, who introduced Degouve to the Symbolist poets of La Jeune Belgique. In Brussels, he became acquainted with Eugène Demolder and Maurice Maeterlinck; while in Paris, he met Puvis de Chavannes and Maurice Denis. In the course of seeking sources of inspiration, he traveled often — especially in Italy, Austria, and Switzerland — and from 1900 to 1902, he lived in the Balearic Isles. During the First World War, he stayed in Holland; then, on returning to Brussels in 1919, his wife died, and in his bereavement, he stopped working altogether for a time. On moving to Stavelot, however, he gradually regained his ability to enjoy life — thanks to Suzanne Poulet, who became his second companion and who he married in 1930. In time, his painting became exclusively devoted to the Ardennes countryside. It was before 1900, during his Symbolist period, that Degouve's work was marked by the strange atmosphere that prefigured Surrealism. [GO]

7 **La Maison Rose** (La Maison du Mystère)
1892
The Pink House (The House of Mystery)
Oil on canvas
63.0 x 42.0 (24³/₄ x 16¹/₂)
Rijksmuseum Kröller-Müller, Otterlo
Reproduced in color on page 6

A strange accord exists between the work of William Degouve de Nuncques and the writing of Edgar Allan Poe. Poe gives us the funereal *House of Usher* rent by the macabre crack which, when the last member of the family dies, will enlarge enough to bury all, and then allow the remains to slip beneath the lake. Degouve communicates a similar idea in painting a "blind house" having windows without panes — analogous to eyes without sight that have no wish to see the terrible waters destined to engulf them. It is a strange work, dominated by the bizarre, the unreal, the fantastic. It was initially shown with Les XX in 1893, the same year that Degouve was first invited to exhibit with the group. It appeared then under the title *La Maison Rose*, descriptive of the dominating coloration. The following year it reappeared at the first exhibition of *La Libre Esthétique* — Les XX having been dissolved — and this time its title was more suggestive of Symbolism: it was called *La Maison Aveugle (The Blind House)*. Verhaeren later said that Degouve "gave landscape more than a gothic vision; he endowed it with a gothicism that also has a sense of mystery and a perfection of the eccentricities existing within reality" (*Le Journal de Bruxelles*, March 19, 1893). He later concluded that "he is more of a poet than a painter, which is why he is sometimes accessible only to those familiar with [a certain type of] literature" (*L'Art Moderne*, March 24, 1895, p. 90). Visually, this painting shows a similarity to *The Empire of Light* of René Magritte (illustrated on page 14), which is also bizarrely lighted in an uneasy silence where no movement troubles the scene. The comparison between Symbolism and Surrealism has often been made, but was most brilliantly demonstrated by the exhibition *Painters of the Mind's Eye: Belgian Symbolists and Surrealists* (New York, The New York Cultural Center and Houston, The Museum of Fine Arts, 1974). Degouve is a "single-minded and literary" painter whose work evolves continually from the real to the unreal, so that one can never tell where actuality ceases and the dream begins.

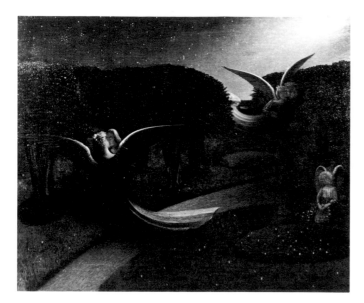

8 **Anges dans la nuit** 1894
Angels in the Night
Oil on canvas
48.0 x 60.0 (18⁷/₈ x 23⁵/₈)
Rijksmuseum Kröller-Müller, Otterlo

9 **Effet de Nuit** (Paysage Bleu) 1896
Nighttime Effect (Blue Landscape)
Pastel on paper
47.0 x 68.0 (18¹/₂ x 26³/₄)
Musée d'Ixelles, Brussels

"If there was ever a painter of dreams, it is William Degouve de Nuncques. If there was ever a human being in which the man and the artist became inextricably intertwined, it is again Degouve, who thinks, breathes and lives only for his art." This is the way in which Maria Biermé describes this artist (*Les Artistes de la Pensée et du Sentiment* [Brussels, 1911], p. 87), giving us the keys which open his universe of dream, sincerity and meditation. *Angels in the Night*, painted in 1894, was first exhibited at La Libre Esthétique in 1895. Degouve had considerable success at this exhibition since before the show was over he had already sold two works: *Leprous Forest* and *The Black Boat*. Émile Verhaeren was the first to speak of *Angels in the Night*: "They hover and glide in an extraordinary atmosphere of nocturnal mystery, in an ecstatic dream of childhood, in a sweet and astonishing Paradise" (*L'Art Moderne*, March 24, 1895, p. 90). Degouve was for him "a discoverer of the souls of things." It is indeed true that his art is transported to the beyond — to the troubled, unreal world of dreams. And though he reveals nothing of the unknown to us here — angels, a park, flowering nature — one senses that he is in a faraway land of sweetness and reverie, where, as again Verhaeren said, he was "a thoughtful and attentive pilgrim." Here a heavy silence, troubling and commanding, impregnates the atmosphere. All movement has been banished; life is suspended and the figures which made the real world manifest are now nothing more than figments of a dream. For Degouve, inspiration comes from the heart; the troubling atmosphere of the invisible world is not represented, as it might be, in cold allegory, but is rather transformed under his brush into tender poetry. The greatest part of his oeuvre is devoted to nature, to which he is drawn both as an artist and a poet, and from which he extracts that hidden harmony that lives at its heart, combining it with mysticism to endow his work with personal charm and originality.

This work, dated 1896, was given to the Ixelles museum by Octave Maus, Secretary of Les XX and Director of its succeeding group, La Libre Esthétique. Degouve was a latecomer to Les XX, exhibiting his work only in the final Salon of 1893, but he showed with La Libre Esthétique several times: in 1895, 1896, 1897, 1899, 1903, 1905, and 1908. Speaking of his art, Degouve said, "In order to paint a picture, it is sufficient to take some colors, draw some lines and fill the rest with emotion." In *Nighttime Effect*, he shows us how right he was and how much more important emotion is than artistic creativity. While his subject is nature, his primary interest is in atmosphere, manifested in the tranquility of dusk or night, the hour when the soul gives up its confidences. He loved the night and painted many scenes sheltered in its mysterious shadows. He also loved solitude and only rarely do any figures disturb the dreamlike settings of his work, whether in spring or winter, in bright light or in shade. The pictorial problems of technique and materials interested him very little. "He is not a painter of surfaces, satisfied with mere color. He looks very closely. For this artist of dreams, color does not have to be charming, it is palpable" (Verhaeren in *L'Art Moderne*, March 24, 1895, p. 90). Sometimes, and particularly here, his pictures seem monochromatic, but there are true symphonies of color in them and, like a musician, he is able to obtain extraordinary chords, based on a handful of colors. His hues, always subordinated to sensation, are never an end in themselves but a means of revealing his soul and expressing his emotions — blue, for example, a gentle color, for Degouve is always melancholy. He once wrote to his mother, "Autumn is the bearer of the ultimate melancholy, sometimes terrible, but very propitious for the realization of powerful work. I hope that my work carries this sense."

JEAN DELVILLE
1867–1953

Born at Louvain, of a Flemish father and a Walloon mother, Jean Delville revealed his talent as a painter very early in life, attending classes at the Brussels Academy under Portaels, where he soon distinguished himself. He made his debut as a painter with L'Essor in Brussels in 1885, and from that year on, his literary preoccupations were equal to his artistic interests and he became passionately devoted to the works of Villiers de l'Isle Adam, Barbey d'Aurevilly, and Joséphin Péladan — who he visited often when staying in Paris. In Brussels, he maintained contacts with all the Symbolist poets by writing for La Jeune Belgique, and in 1888, he first published his own verses in the review La Wallonie. Later, his work clearly showed his deep interest in esoterica, especially in the paintings Dialogue Between Us (1895), The Great Occult Hierarchy, The Messianic Ideal, and The Shiver of the Sphinx (1897). Beginning in 1892, Delville became one of the most active members of the group Pour l'Art, for whose first catalogue he designed the cover — a sphinx. In 1896, he conceived the Salon d'Art Idéaliste, whose goal was "to provoke an aesthetic renaissance in Belgium." The meeting of Delville and Péladan, Grand Master of the Rose + Croix, occurred in Brussels and Delville, immediately enthusiastic about Péladan's theories, went to live in Paris. He participated in all the Salons of the Rose + Croix between 1892 and 1895, and thereafter, the occult, the esoteric, and idealism were the basis of his work. When he returned to Brussels, he busied himself with producing Péladan's plays (La Prométhéide and Oedipe et le Sphinx) since it had been impossible to stage them in Paris where the actors had declared them "unplayable." The missionary ardor displayed by Delville eventually led him into teaching. In 1900, he was made a professor at the celebrated Glasgow School of Art, where he was also the director for a time. Around 1907, he returned to Brussels and, until 1937, was on the faculty of the Academy there. His art is completely involved with his research, both literary and pictorial, and the scenes he shows are always surrounded by streams of astral light, a phenomenon in which he held a firm belief. [GO]

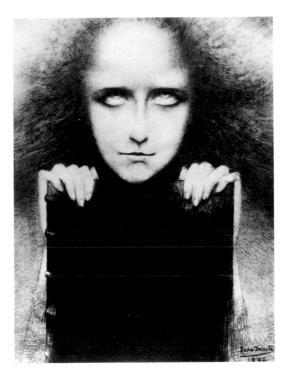

10 **Mysteriosa** (Portrait de Madame Stuart Merrill) 1892
Oil on canvas
38.1 x 27.9 (15 x 11)
Edwin Janss, Jr., Thousand Oaks, California

This work, of which the original title was *Mysteriosa*, was exhibited, under that title, for the first time in March 1893 at the second Salon of the Rose + Croix in Paris, and the following January at the Brussels Salon Pour L'Art. Not long after the painting was made, it was identified as the portrait of an American writer's wife, Mrs. Stuart Merrill (1863–1915). Because Merrill's grandfather was Consul with the American Embassy in Paris, he spent a great deal of his life in that city, befriending the Symbolist poets and publishing many of his own works, notably *Les Gammes* (1897) and *Les Fastes* (1891). According to Philippe Jullian (*Dreamers of Decadence* [London, 1971], p. 77), this painting was directly inspired by a novel of Villiers de l'Isle Adam, *L'Eve future*, which appeared in 1886. The heroine of the novel is a delicate and spiritual person, with a sensual body and a melancholy soul. With this painting, Delville entered wholeheartedly into the world of the Symbolist disciple, putting into practice all the theories of Sâr Péladan and the Rose + Croix. Here, we penetrate with him into the universe of magic, of the Kabbal, of occultism and the esoteric. The iconography is, however, reduced to essentials: a woman's face and a book — which face, what book, is not important. The eyes that stare at us are those of a medium; they do not see, because they are looking elsewhere, into an invisible world that eludes us. The tousled hair forms a halo whose luminous rays encircle her head. The hands, long and diaphanous, belong more to a spectre than to a simple woman. The book, bound in black leather, is clearly marked with an equilateral triangle. It is the sacred book showing the emblem of wisdom — the equilateral triangle being the symbol of three, as for the Trinity. The woman's chin leans on the binding, leading us to understand that humans can only escape the world of doubt and shadow by leaning on wisdom. Luisa Maria Frongia (*Il Simbolismo di Jean Delville* [Bologna, 1978], p. 59) discusses this bipolarity of head and book as a common motif in Delville's work, citing its appearance again in *Parsifal, The Death of Orpheus,* and *End of the Reign.*

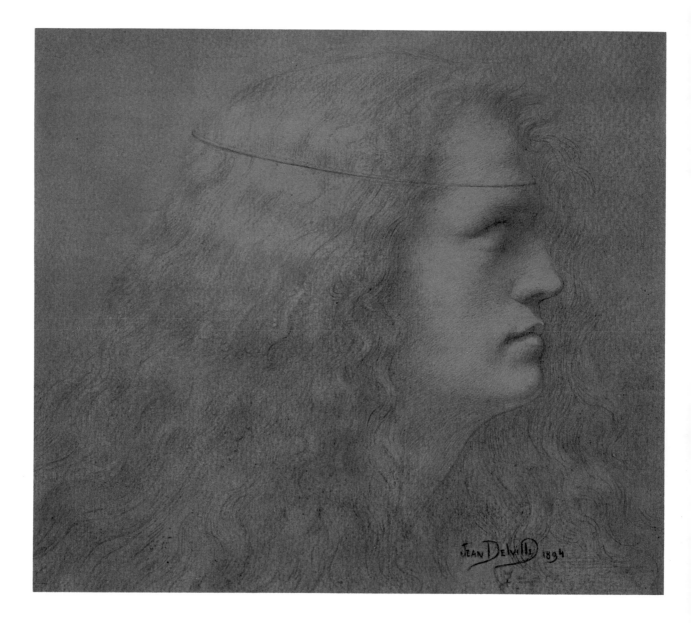

James Ensor was born in Ostend to a British father and a Flemish mother. His only sister, Mariette — also called Mitche — was born a year later. At seventeen, Ensor began a three-year term at the Brussels Academy, where he became friends with classmates Fernand Khnopff and Théo Hannon. They in turn introduced him to Ernest Rousseau and his wife, Mariette Rousseau-Hannon, whose home was a meeting place for scientists, writers, and artists. Ensor returned to Ostend in 1880 — where he was to remain for the rest of his life — and began his career by drawing the local fishermen and their wives and painting portraits in the Realist-Impressionist manner of the time, as well as interior scenes set in the rather gloomy salons of bourgeois homes. He maintained his contact with the cultural milieu of Brussels and exhibited his work there, becoming one of the founding members of the avant-garde group Les XX (1883–1893). Problems later arose in the group because of Ensor's difficult personality and the satiric nature of some of his art, but his work flourished. Sometime after 1885 he made his first studies of light relating to Rembrandt and Turner, and also began to make etchings. He gave symbolic meaning to light, and developed a characteristic that was to remain with his work of identifying himself with the image of Christ — though it is always an ironic error of judgment that is represented rather than a holy vision. Ensor's well-known mask paintings, in which devils and death figures are surrounded by an unreal world of expressive color, perhaps best demonstrate the darker side of his personality. Gradually the linear quality of his many drawings and graphic works began to influence his painting style, and by 1893, Ensor had arrived at a hallucinatory synthesis of reality and dream, poetry and sarcasm. His creativity waned after 1900 but his reputation grew and in 1929 he was made a baron. Ensor's completely new, symbolic universe prepared the way for Expressionism and Surrealism. He died at eighty-nine, shrouded in his own legend. [LS]

11 **Tête de femme en profil** 1894
Head of a Woman in Profile
Bleuine on paper
20.0 x 21.5 (7⁷/₈ x 8¹/₂)
*M. and Mme. Wittamer-De Camps,
Brussels*
Reproduced in color on facing page

Jean Delville founded the Salon d'Art Idéaliste in 1896 and the first exhibition, called the *Iᵉʳᵉ Geste (First Gesture)*, opened in Brussels on January 11. The catalogue carries two quotations chosen by the founder, both descriptive of his personal approach to art, and particularly the work shown here. The first is from Péladan: "Beauty in a work [of art] is created from reality made sublime." The other is Wagner: "Art begins where life ends." This drawing, which was inspired by Marie Lesseine, "a beautiful Ardennaise" whom Delville married (J. Delville, *Autobiographie*, #23792, Archives de l'Art contemporain, Musées Royaux des Beaux-Arts de Belgique, Brussels, p. 2), shows the influence of Wagner since it carries the title *Parsifal* on the reverse — it is no longer mere reality but the sublimated reality desired by Péladan. No longer a beautiful woman, this is a mystic, a saint, and Delville encircles her forehead and locks of hair with a slender aureole. Earthly life has ended and another life is beginning, that of the world beyond, whose mysticism and slightly melancholy ambience is rendered perceptible by Delville's treatment. The drawing, which is dated 1894, belonged to Philippe Wolfers and was exhibited in 1910 at the retrospective *Les Peintres de la Figure et de l'Idée* (Brussels, Palais des Beaux-Arts, no. 73). It is a monochromatic blue scheme, and the technical procedure which Delville uses was discovered in France in 1860 and called "bleuine" (Louisa Maria Frongia, *Il Simbolismo di Jean Delville* [Bologna, 1978], p. 59). Delville searches for beauty frenetically, and it is not a simple physical beauty, but an ideal, divine beauty which leads to the spiritualization of his art. For him, aesthetic perfection is based on a "Trinitarian" formula, which is the same principle as that of Idealist art: Spiritual Beauty, Formal Beauty, and Technical Beauty. The immediate mission of art was to purify man; the Idealist work was that which would **bring** into harmony, in itself, the "three great Words of Life: the Natural, the Human and the Divine." (J. Delville, *La Mission de l'Art* [Brussels, 1900], pp. 14–15, 152).

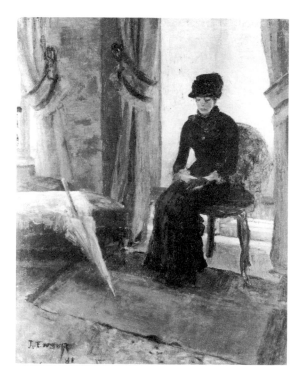

12　**La Dame Sombre** 1881
Somber Lady
Oil on canvas
100.0 x 80.0 (39³/₈ x 31¹/₂)
*Musées Royaux des Beaux-Arts de
Belgique, Brussels*

13　**Les Enfants à la Toilette** 1886
Girls Dressing
Oil on canvas
135.0 x 110.0 (53¹/₈ x 43¹/₄)
Private Collection, Antwerp

In this painting from the series of "bourgeois salons" made between 1880 and 1890, Ensor catches the material reality of objects indigenous to a nineteenth-century interior. He also enjoys the effects of light vibrating on the window sill, the sofa, and the brightly colored umbrella, and contrasting strongly with large areas of deep shadow. Although the window, which reveals the world outside, takes up a large part of the painting, the interior remains closed. A slight tension is achieved in the composition through the use of diagonal lines. A woman, eyes downcast, with her hands lying quietly in her lap, is seated before the window, forming a silhouette against the light. The opposition of light and shadow, the self-contained form thrown into relief by the bright space of the window, help to transform the visual reality of the scene into one of atmospheric reality. Ensor is able to suggest a drama without actually describing it, creating an ambience which recapitulates the woman's state of mind. *Somber Lady* is one of several paintings for which Mitche (1861–1945), Ensor's sister, posed. It was exhibited for the first time with L'Essor in Brussels in 1882 and was formerly owned by Edgar Picard (Jemeppe) and Carlo van den Bosch (Antwerp).

By 1886, Ensor was no longer concerned with representing texture or modeling with light and shade. He preferred the unreal effect of light, like that used by Rembrandt and Turner, with which he could suggest a visionary quality. *Girls Dressing*, F.-C. Legrand has said, "is the most beautiful of the bourgeois interiors, and closest to being a Symbolist work in the sense that the evocation of mystery is at the heart of Symbolism, and here that mystery is the most simple, a confrontation of bodies stripped of protective disguise, rejoined to the Symbolism of creation" (*Ensor cet inconnu* [Brussels, 1971], p. 55). Despite the large windows, no exact source of light is indicated; it is diffused everywhere. Things have lost their material quality in an ethereal atmosphere that is suggestive of a pure and serene new life. Soft, vertical lines are repeated in the shape of the tall mirror and the slim body of the girl, placed parallel to the axis of the painting. A timeless, restful effect is achieved, yet because of the flowing, transparent curtains and the simplicity of the children's gestures, the scene remains innocent. The figures' gentle nudity is surrounded by the light like a cocoon. Ensor's other paintings are seldom as bright; he himself considered this work a study of light. Light is indeed the key word for those years when his art was transposed from reality to total imagination. *Girls Dressing* was first exhibited at Les XX in 1888, and was originally in the Lambotte Collection (Antwerp).

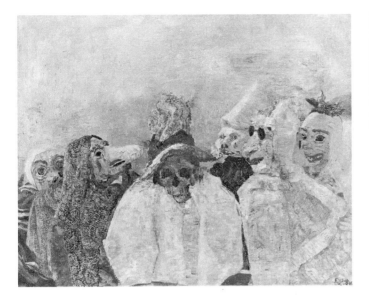

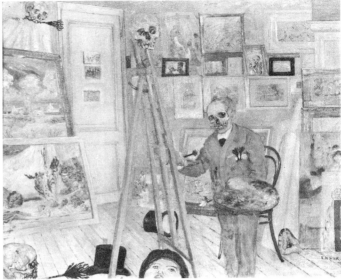

14 **Masks Confronting Death** 1888
Oil on canvas
81.3 x 100.3 (32 x 39½)
The Museum of Modern Art, New York,
Mrs. Simon Guggenheim Fund, 1951

15 **Het Schilderend Geraamte** *circa* 1896
Skeleton Painter in His Atelier
Oil on panel
37.0 x 45.0 (14½ x 17¾)
Koninklijk Museum voor Schone
Kunsten, Antwerp

Death, beloved *leitmotiv* of the Symbolists, was nearly always present in Ensor's works after 1888. The skull appeared initially as an object, then more frequently as a clothed skeleton. Occasionally, death became a skeleton with a scythe, as in medieval Christian iconography. Typically Ensorian is the manner in which Death is represented here: a figure in carnival dress is seen among colorfully disguised maskers. He is evidently an uninvited guest. Unconcealed mockery, at the left, is strongly contrasted with puzzled anguish on the other side; the huddled central figure is an object of conflicting feelings, revealing nothing but a void in itself. Ensor at this time was twenty-eight years old. He played ironically with the subject of death in order to conquer it through absurdity. He repeated the composition, a central figure surrounded by a group of mocking maskers or monsters, a number of times — examples are *Old Woman Surrounded with Masks* (1889), *Demons Tormenting Me* (1888), *The Despair of Pierrot* (1897), and *Masks and Death* (1897) — occasionally adding feverishly glowing eyes to the skull in order to identify himself as one of the "living" dead. Death is then equated with waning creativity, the element of self-doubt which Søren Kierkegaard called the "sickness unto death." In 1888, however, Ensor was at the height of his creative powers and brought vividly to life the glittering colors of his many-faceted fantasies, including his universe of masks. *Masks Confronting Death* was shown in the 1890 exhibition of Les XX. An article in *L'Art Moderne* (February 23, 1890, p. 59) mentions that this work and Ensor's *Garden in Sunlight* were sold during the exhibition itself. The painting has been in the collections of Rousseau (Brussels), Born (Antwerp), and Van Geluwe (Brussels).

Ensor painted this panel after a photograph which was reproduced in the issue of *La Plume* (Paris, 1899) dedicated to him. The painting is not dated but cannot have been done before 1896, the year *Dangerous Cooks* — another of Ensor's paintings, which appears in this one — was made. In the *La Plume* photograph, Ensor is seated, while in this painting he stands erect, but the proportions of his torso to the space around it remain unchanged; his legs are so short that he appears a dwarf. In the work of an artist whose technical ability is unquestioned, such a deformation clearly indicates that Ensor was treating himself as an object of irony; he also replaces his own head with a skull, its eyes glazed and feverish. They are the sole sign that he is still alive, since he is not painting. The brushes, bristles frayed and tousled, are useless. The psychiatrist H. T. Piron (*Ensor, een psychanalytische studie* [Antwerp, 1968], pp. 78–79) finds this very important: "The brush and other objects so closely related to his work identify his level of self-esteem, indeed, his whole self." 1896 is generally considered the end of Ensor's finest creativity. In *Dangerous Cooks,* seen behind the easel, the head of the artist is served to a group of art critics seated around a dinner table. Behind Ensor, one can identify a part of his painting, *Ecce Homo,* also called *Christ and the Art Critics* (1891). Ensor's lack of recognition is isolated in this small detail, where he appears as the tormented Christ, a rope fastened tightly around his neck by the critics Fétis and Sulzberger. Like Dürer, in *Melancholia,* Ensor personalized self-doubt. *Skeleton Painter in His Atelier* was part of the Picard Collection (Jemeppe) and the Krebs Collection (Brussels).

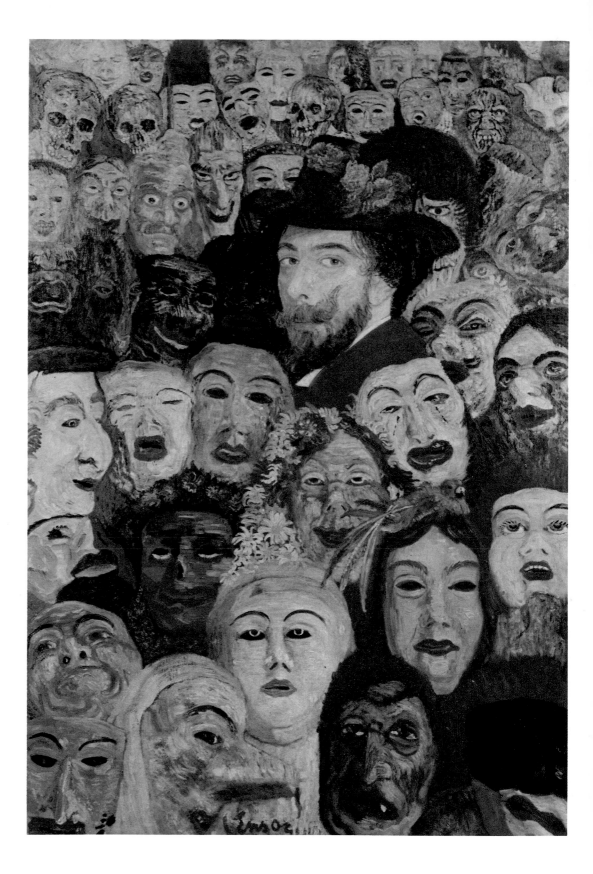

HENRI EVENEPOEL 1872–1899

Evenepoel's mother died when he was two years old. He grew up in Brussels in a cultivated bourgeois atmosphere with a father who, as an amateur musicologist, engendered in his son a love of cultural pleasures. Showing great promise in drawing, Evenepoel began his studies in the studio of Blanc-Garin and with the decorator Crespin. In 1892, he left for Paris, where he made his home with his cousin Louise de Mey. He was admitted to the École des Beaux-Arts in 1893, in the *atelier* of Gustave Moreau, who helped Evenepoel to strengthen his artistic personality. Among the students there who became his friends were Rouault, Baignière, Bussy, Milcendeau, and Matisse. In 1894 he was accepted at the Salon des Artistes Français and participated for the first time in the exhibition of the three studios of the École. He was invited to join the circle La Palette in 1895, and was also asked to show at the Salon of La Société Nationale, where he subsequently sent his work every year. Beginning in 1896, he exhibited not only portraits but scenes of contemporary Parisian life, in which one sometimes catches a glimpse of Manet, Degas, or Toulouse-Lautrec. The artists Baertsoen, Frédéric, J. Émile-Blanche, and Cormon found his work interesting, as did Fierens-Gevaert, then editor of the *Journal des Débats*. In October of 1897, Evenepoel set off for Algeria. The work he did there is set apart from the rest of his oeuvre and reveals him as a precursor of Fauvism. His first one-man show, held at the Cercle Artistique et Littéraire of Brussels during his absence in North Africa, was a success. When he returned to Paris, he began to paint interiors, still life, and, especially, portraits and scenes of modern life with a new, deeper knowledge of composition and color. His year of triumph was 1899: the press was very favorable after his show with the Salon de La Nationale, the Ghent Museum acquired his *Spaniard in Paris,* and he exhibited again with the Cercle Artistique et Littéraire. In the same year, he was invited to show with La Libre Esthétique and to submit work for the Belgian section of the *Exposition Universelle* in Paris, but typhoid fever brought his life to an end on December 27, 1899. [MC]

16 **Portret van J. Ensor omringd door Maskers** 1899
Portrait of the Artist Surrounded by Masks
Oil on canvas
120.0 x 80.0 (47^1/$_4$ x 31^1/$_2$)
Private Collection, Antwerp
Reproduced in color on facing page

Ensor here fuses ideas embodied in two earlier paintings: the *Self-Portrait in a Flowered Hat* of 1883 (Ostend, Museum voor Schone Kunsten), and *The Old Woman with Masks* of 1889 (Ghent, Museum voor Schone Kunsten). In this later self-portrait, the flowered and plumed hat, as well as the more upright, less tentative pose of the head provide a direct — albeit ironic — reference to Rubens, while in comparison to the *Old Woman*, the artist figure is much smaller in scale and appears in the midst of a thrusting crowd of masks, akin to that of the suffocating crowd in *The Entry of Christ into Brussels*. The implication of the image is clear: only the artist — both the individual, Ensor, and the artist as inheritor of the great Flemish tradition — shines out with a true human face in a world of disguise and hypocrisy. But for Ensor, masks were more than symbols of an idea; they were concrete vivid impressions from his childhood and youth in Ostend. There were masks in the family shop, and the annual Carnival in Ostend was famous for its masks. Ensor participated in these Carnivals and was fascinated to see members of his family and friends transformed by grotesque appearances. The Carnival permitted him as well to assume a disguise and roam the streets playing whatever absurd role he wished. (See Paul Haesaerts, *James Ensor* [New York, 1959], pp. 163–165.) [SF]

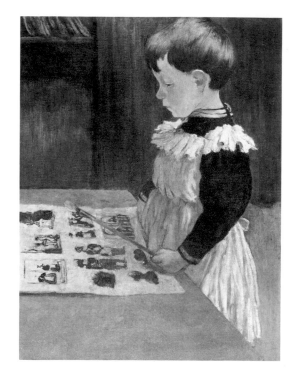

17 **Louise en deuil** 1894
Louise in Mourning
Oil on canvas, remounted on wood
79.0 x 46.5 (31¹/₈ x 18¹/₄)
*Koninklijk Museum voor Schone
Kunsten, Antwerp*

18 **Les Images — Portrait de Louis-Charles
Crespin** 1895
Oil on canvas
82.0 x 62.5 (32¹/₄ x 24⁵/₈)
*Musées Royaux des Beaux-Arts de
Belgique, Brussels*

As Philippe Roberts-Jones has written, "Portraiture was the first place where Evenepoel distinguished himself. Beginning in 1894, he brings together a carefully expressive truth and a sense of human nobility" (*Du Réalisme au Surréalisme* [Brussels, 1969], p. 69). On March 15, 1894, the artist told his father that he had finished this portrait "en emballage," indicating that, driven by an unceasing emotional state, he had worked on the picture without stopping until it was completed. The great — and only — love of his life, Louise de Mey, née van Mattenburgh, was his first cousin and often served as his inspiration in painting. At the time he painted this portrait she was in mourning for her father and for the maternal grandmother she and Evenepoel shared. The vertical format of the picture accentuates the elongation of her thin silhouette, all in black, which stands away from a subdued background, with the light concentrating on her profoundly sad, pale little face. Gustave Moreau thought very highly of this work, finding in it "a good tonal quality . . . well-drawn," but also remarked that it showed how much his pupil had been "impressed by Manet and Whistler." In fact, Manet is one of the modern masters whom Evenepoel admired the most and for whom he expressed his enthusiasm in letters to his father and to Charles Didisheim — particularly on one occasion in May 1894, when he had seen a group of Manet's works at Durand-Ruel. As for Whistler, who was in Paris in 1894, his influence must have been evident to Moreau in the black and gray orchestration of Evenepoel's picture, which was reminiscent of *Portrait of the Artist's Mother*. Following the advice of his teacher, Evenepoel sent the portrait to the Salon des Artistes Français, where it was accepted. On April 28, 1894, he gives a concise account of his impression of the *vernissage*: "varnished, hung rather high, seems very little." This picture may have been more appreciated in two later exhibitions: first in Antwerp, Koninklijk Museum voor Schone Kunsten, *La Rétrospective Evenepoel*, 1953, (cat. no. 9), and then in Brussels, Musées Royaux des Beaux-Arts de Belgique, *Hommage à Henri Evenepoel*, 1972.

Shown in Brussels at the Pour l'Art exhibition of 1896, this canvas explains a passage written about Evenepoel in *L'Art Moderne* saying that he "interests us with his portraits of children in their own special attitudes." In truth, he did have a remarkable ability for understanding the psychology of children. He painted this portrait of the eldest son of his former professor and friend, Adolphe Crespin (see cat. no. 117), while he was vacationing in Brussels during the summer of 1895. He had made Crespin's own portrait in 1894, and it is possible to see parallels between the two works, which not only have the same format, but in which both figures are seen standing in profile before a table, painting, with the same grave expression, lighted by a smile from within. With tender humor, the artist indicates that this three-year-old child — Louis-Charles was born in August of 1892 — considers his play as seriously as an adult does his work, and can find the same amount of pleasure in it. Between Evenepoel's execution of the first and second portraits, certain technical progress has been made, with this one showing a richer use of impasto and broader brushstrokes. The dominant colors are white and a vivid green, producing a springlike freshness that is in harmony with the age of the little boy. This picture is full of charm and has been seen in many exhibitions of Evenepoel's work: notably in 1898 at the Cercle Artistique et Littéraire of Brussels, again in 1913 and 1932 at the Georges Giroux Gallery in Brussels (Introduction to the 1932 catalogue by P. Lambotte), and in 1942–1943 at the Musées Royaux des Beaux-Arts de Belgique in Brussels; in 1948 at the Cercle Artistique et Littéraire in Charleroi (Introduction: P. Fierens); in 1953 at the Koninklijk Museum voor Schone Kunsten, Antwerp (Introduction: W. Vanbeselaere); and in 1972 at the Musées Royaux des Beaux-Arts de Belgique (Introduction: M.-J. Chartrain-Hebbelinck).

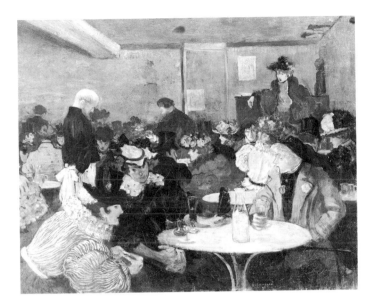

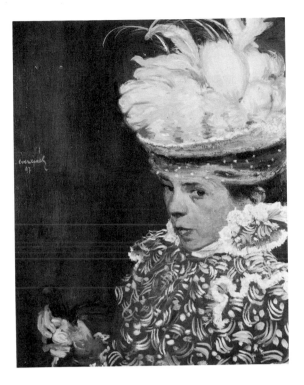

19 **Le Caveau du Soleil d'Or** 1896
The Cellar at "The Golden Sun"
Oil on canvas
73.5 x 92.0 (29 x 36¹/4)
*Musées Royaux des Beaux-Arts de
Belgique, Brussels*

20 **Le Chapeau blanc** 1897
The White Hat
Oil on canvas
57.0 x 46.0 (22¹/2 x 18¹/4)
Louis Franck, Antwerp

The genesis of this composition is related by the artist in correspondence addressed to his father. The idea first occurred to him on the evening of February 14, 1895 when Evenepoel and his friend Hucklenbrock went to the brasserie of The Golden Sun on the corner of the Quai St. Michel. In a letter decorated with a number of expressive sketches, he first describes the height of the room, then "the most curious spectacle is down below, in the cellar . . . the walls are painted in bright yellow and covered with caricatures and huge drawings . . . beside a dilapidated piano, the singers take their turns singing what they wish, to say no more . . . during which the little women students, thin and narrow-hipped, come and go. . . ." It is certainly the scene as described that the painter has presented in the *Cellar at "The Golden Sun."* The picture was among the twelve works which he brought to Moreau for the annual exhibition of the studios attached to the École des Beaux-Arts. The professor was immensely interested in the character of the figures, and in the ability of his pupil to render the smoky atmosphere in ochre, lightened with touches of acid pink, red, and white; and he could not help but appreciate the composition, so cleverly and rhythmically animated by the round tabletops. It is the choice of subject more than the style of the painter which makes this work seem so close to contemporary graphic artists, like Toulouse-Lautrec and Steinlein. Moreau made no mistake in assuring Evenepoel that this work expressed his own artistic personality. Shown at the Salon du Champ de Mars in 1897, together with seven other paintings, *The Cellar at "The Golden Sun"* was bought from the exhibition by the American painter William Dannat for six hundred francs. The artist used the money to buy a pocket Kodak, with which he accumulated many instantaneous scenes as source material for his work.

In 1897, Louise van Mattenburgh (de Mey), served as the model for two portraits; one, dated at the bottom and entitled *La Dame au chapeau vert,* and this one, signed and dated in the middle, called *Le Chapeau blanc.* Around 1900, many painters and engravers used fantastically decorated women's hats in their work. Like Renoir, Bonnard, Vuillard and others, Evenepoel was seduced by this eminently pictorial motif and has adroitly recreated the fluffy, white mass of feathers which embellish this young woman's hat. A stylized design of small bright feathers is also scattered over the material of her dress. By using the decorative motif of the dress to model the bust, and in decentralizing the figure, Evenepoel is proceeding according to the aesthetic of the Nabis. But it is also possible that he was thinking of Degas, whose contrived compositions of the unexpected he so admired. This work, however, which is painted with exceptional care, remains above all else a portrait, and the virtuosity of its execution adds to the grace and poetry of the model. Evenepoel wrote to his father, concerning this picture, on October 18, 1894, "At this school of Moreau's, I have learned that one must paint, loving what one makes, and that, only that which is loved by the heart can be praised, that each touch of the brush must be directed by the senses." This painting was shown with *Les Images* in all the same exhibitions, with the exception of that of 1972 (see cat. no. 18), as well as in a number of exhibitions with the works of other painters — most recently, at the *Post-Impressionism* exhibition in London (Royal Academy of Arts, 1979–1980, cat. no. 399).

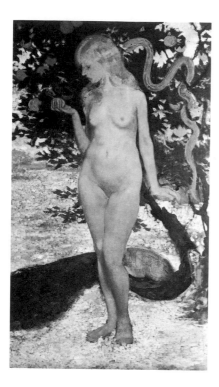

21 Eve 1896
Oil on canvas
155.0 x 90.0 (61 x 35¹/₂)
*Musées Royaux des Beaux-Arts de
Belgique, Brussels*

Outside of studio work, Evenepoel seems to have had no predilection for the nude. He began work on this picture in order to please his father, who sought, in a positive way, to direct his young artist son toward subjects that would prove popular with his audiences. On May 9, 1896, Evenepoel wrote to him that he had started "the study for the woman on whom we decided," and added, "I intend to show it as a study at the studio exhibition in July and as *Eve* at the next Salon du Champ de Mars." On the tenth of June, he hired a model, Madame Miriam, who had already posed for Puvis de Chavannes, J. P. Laurens, and Rodin. "She has beautiful legs, and a torso with not very strongly-developed breasts, without being pretty, her head has some character. I will show her standing, holding an apple which she is looking at and which she is going to bite," a pose which remained unchanged. The artist appears to have proceeded with work on this painting without much enthusiasm. It was still unfinished in the fall, and on November 13 he noted that he had begun to paint it again but that at the same time there were "several things to which I give my attention depending upon how I feel at the time." He did not send it to the Salon du Champ de Mars in 1897, but it was shown at the exhibition of the Cercle Artistique in Brussels in 1898. In the stylization of the tree and its foliage, and the treatment of the ground, the painter has adopted a decorative effect similar to that of the Nabis, creating a simplified backdrop, from which the delicately modeled nude figure seems detached. Evenepoel did not spontaneously choose to paint this picture and so it has remained a charming, parenthetical expression within his oeuvre. In speaking of *Eve*, Francine-Claire Legrand believes that — like nearly all artists in the final years of the nineteenth century — Evenepoel could not "escape the contagion of Symbolism" (*Le Symbolisme en Belgique* [Brussels, 1971], p. 211).

EMILE FABRY
1865–1966

Born in Verviers, Fabry was the son of an industrialist who objected to his son's desire for a career in the art world. Nevertheless, Fabry attended the Brussels Academy and studied with Portaels — who, having been a pupil of the great Belgian Neo-Classicist, Navez, gave Fabry a feeling for monumentality. His subsequent admiration for Michelangelo, Puvis de Chavannes, and Hodler was based on the heroic qualities of their art. Fabry worked in a Symbolist style until 1900, coming under the influence of Sâr Mérodack Péladan and theosophy. He showed at the Rosicrucian Salons of 1893 and 1894 in Paris and become a founder, with Jean Delville, of the Brussels Symbolist-*Idéaliste* circle, Pour L'Art, in 1893. He was clearly influenced by contemporary Symbolist theatre and produced works which Francine-Claire Legrand has suggested transpose the suffering of Maeterlinck's stage scenes to canvas. Fabry called this time prior to 1900, "my nightmare epoch." One of his chief interests was in monumental decoration, and he collaborated with Victor Horta on the Hotel Aubecq and later with Paul Hankar in work for the villa of Philippe Wolfers, who was a close friend of Fabry's. He also made murals for several public buildings in the Brussels area — among them, the Théâtre Royale de La Monnaie and the town halls of St. Gilles, Woluwe and Laeken, as well as the Tervuren Museum for Central Africa. In 1900 he was appointed professor at the Brussels Academy and taught there until 1939. His interest in Blake and Fuseli, whose works combined the aspects of symbol and grandeur which were Fabry's greatest passions in art, was superseded by his discovery of the Pre-Raphaelites when he and his family spent the war years in England. It was on his return to Brussels in 1919 that he executed cartoons for six monumental mosaics at the Musée d'Art et d'Histoire of the Cinquentenaire. In 1923 he succeeded Constant Montald to the post of Director for the course in mural and decorative painting at the Academy of Art, and was also elected to the Royal Academy. He continued to paint after his retirement, and lived to be over one hundred, working until the last day of his life at his home in Woluwe-St. Pierre, curious to the end about everything around him. [RD]

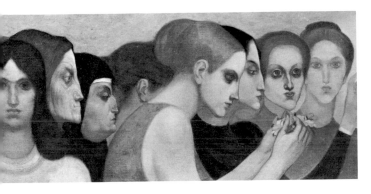

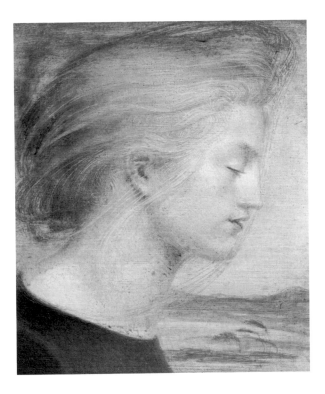

22 **L'Offrande** *circa* 1884–1886
The Offering
Oil on canvas
45.0 x 100.0 (17³/₄ x 39³/₈)
*Musées Royaux des Beaux-Arts de
Belgique, Brussels*

23 **La Vierge** 1912
The Virgin
Tempera on panel
47.5 x 41.5 (18³/₄ x 16¹/₄)
*M. and Mme. Wittamer-De Camps,
Brussels*

This work, strongly characteristic for the period during which Fabry was under the influence of Symbolism and theosophy, is very close in feeling to his painting *The Thread of Life* (1892). A frieze of female heads presents sharply delineated profiles played off against the hollow-eyed, hallucinatory gaze of frontal faces. The rhythmic play of contours, the spaceless, airless ambience of the setting, and a disturbing power that emanates from these ritually arranged heads are all part of Fabry's very personal style. His beings always seem to have their eyes fixed on another world where the appearance of reality is like that described in the myth of Plato's cave. This work was recently shown in the exhibition, *Portaels et ses Élèves* (Brussels, Musées Royaux des Beaux-Arts de Belgique, 1979, cat. no. 33).

The Virgin comes from a period well after Fabry had left Symbolism. His decorative works on a grand scale were in full swing during this time, and though he had discarded elaborate allegory, he remained obsessed with the passage of time, which is often referred to in the ages of the figures he paints.

Willy Finch was one of the founding members of Les XX, and one of its most consistent defenders against official pomposities, in favor of a free and cosmopolitan attitude. He was born in Brussels of English parents, spent his childhood at Ostend, and studied at the Brussels Academy from 1878 to 1880. There he knew Ensor, who was also of English origin. He also knew and admired Whistler, and it was through him that Whistler was invited to the first exhibition of Les XX in 1884. Whistler also invited Finch to show in the 1887 and 1888 seasons at the exhibitions of the Society of British Artists in London. Finch seems to have seen a side of Whistler not evident to everyone; he wrote that "he is a very genuine fellow, who works very seriously at everything to do with art: and what is more, he is very disinterested — still a rare thing" (Bruce Laughton, "British and American Contributions to Les XX, 1884–1893," *Apollo 76* [1967], pp. 372–379). When, in 1886, the question arose of Whistler's becoming a member of Les XX — which he would have been happy to do — Finch urged it strongly, but the suggestion was defeated. The most significant influence on his mature painting, however, was Seurat, who first showed at Les XX in 1887. Finch was the first of the Vingtistes to adopt the divisionist technique; the works that appeared in the Les XX exhibition of February 1888 already show him experimenting with it. His most important Neo-Impressionist paintings were made between 1888 and 1892. By the early 1890s he, Lemmen and Van de Velde were increasingly active in the making of decorative arts, spurred by the ideals of the English Arts and Crafts movement which were very much alive in Les XX at this period. Finch began to make ceramics, first at a commercial factory and after 1895 at a privately supported kiln at Forges. Some of his work was seen by the Swedish Count Louis Sparre, who persuaded him to come to Finland to run the Iris pottery works at Borga. From his time on, though Finch traveled to England and the Continent, he was based in Finland, where in 1902 he became teacher of ceramics at the School of Decorative Arts in Helsinki. He continued to paint, but his main role lay in the stimulation of modern art in Finland and in his activities in decorative arts and design. The significance of Finch's Neo-Impressionist painting was first recognized in this country by Professor Robert Herbert, whose essay on Finch in his *Neo-Impressionism* catalogue (New York, The Guggenheim Museum, 1968) remains the basic source in English. [SF]

ALFRED WILLIAM FINCH
1854–1930

24 **L'Hippodrome d'Ostende** 1888
The Racecourse at Ostend
Oil on canvas
49.5 x 59.0 (19⅛ x 23¼)
The Art Museum of the Ateneum, Helsinki

The date of 1888 marks this as one of the earliest of Finch's works using the divisionist method which so impressed him in the paintings of Seurat and Pissarro in 1887. According to Hintze and Gulin (Brussels, Palais des Beaux-Arts, A. W. Finch Retrospective, 1967, n.p.), the painter was not satisfied with the picture and reworked it in 1892. Be that as it may, the painting does have a kind of spatial awkwardness in the leap from fore- to middle ground, which indicates that the artist was still in the process of assimilating the new way of constructing a picture. Nonetheless, that very leap, marked by the staccato of the near and far fence rails, has a kind of jazzy excitement about it. Finch clearly seized upon the element of a strong foreground diagonal, seen in such works of Seurat as the *Beach at Bas Butin, Honfleur* (Tournai, Musée des Beaux-Arts) and *Evening, Honfleur* (New York, Museum of Modern Art) — shown at the Les XX exhibition of 1887 — and used it in this quite original, if slightly off balance, way. Ostend was the city where Finch grew up; at this time it was not only a Channel port, but a seaside resort. The painting was acquired by the museum at the Finch sale in 1937; it was exhibited at the Galerie Hörhammer in Helsinki in 1955 (*A. W. Finch 100 Years*, no. 13) and at the Finch retrospective at the Palais des Beaux-Arts in Brussels in 1967 (cat. no. 91).

25 **Les Meules** 1889
Haystacks
Oil on canvas
32.0 x 50.0 (12½ x 19¾)
Musée d'Ixelles, Brussels

26 **L'Estacade à Heyst, Temps Gris**
1889–1890
Breakwater at Heyst, Gray Weather
Oil on canvas
36. 0 x 54.0 (14⅛ x 21¼)
Mrs. Hugo Perls, New York

Not in exhibition

This little painting was exhibited at Les XX in February of 1890 and at the Paris Indépendants exhibition of 1890. Octave Maus, Secretary of Les XX, owned the picture, and it was bequeathed to the museum at Ixelles, a residential district of Brussels, as part of his collection. By the summer of 1889, Finch had fully assimilated the Neo-Impressionist style and had arrived at his own statement within it. The cool palette and the dots of color of closely-related value are characteristic of his work, while the play of the subtly different diagonals of the conical haystacks against those of the planar roofs shows how intelligently he had grasped Seurat's sense of rhythmic design. A small study of the same motif by Georges Lemmen (New York, Perls Collection) indicates that the two friends must have painted together on this occasion. The picture has been exhibited at Brussels and Otterlo (*Le Groupe des XX et son temps,* 1962, no. 38), at the Finch retrospective at the Palais des Beaux-Arts in Brussels in 1967 (no. 96), and at the Guggenheim Museum in New York (*Neo-Impressionism,* 1968, no. 120). Most recently it has been shown in the exhibition of *Post-Impressionism* at the Royal Academy of Arts in London (November 1979–March 1980, no. 401).

Like *Haystacks,* this painting was exhibited at Les XX in 1890 and at the Indépendants in Paris in March–April of that same year (no. 357, under the title "un bris-lame à Heyst, temps gris, Novembre"). In its austere elegance it is one of the most advanced of the early Neo-Impressionist paintings, building upon such a work as Seurat's *Evening, Honfleur* (1886) but, as Herbert points out, achieving a more radical simplicity of structure (New York, Guggenheim Museum, *Neo-Impressionism,* 1968, cat. no. 121). In addition to its formal sophistication, the painting is notable for its subtle, silvery light.

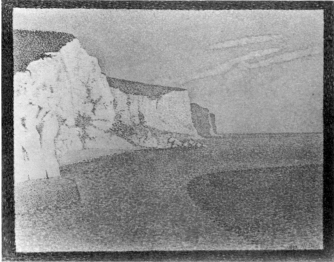

27 Les Falaises au South Foreland 1891
English Coast at Dover
Oil on canvas
66.5 x 80.5 (26¹/₈ x 35⁵/₈)
*The Art Museum of the Ateneum,
Helsinki*

Robert Herbert convincingly identifies this painting with *Les Falaises de South Foreland,* one of three Dover coast paintings exhibited at Les XX in February of 1892 (New York, The Guggenheim Museum, *Neo-Impressionism,* 1968, no. 124). As well as painting on the Channel coast of Belgium, at Nieuport, Heyst and Ostend, Finch worked also on the English coast; the 1888 Les XX catalogue lists works by him done in Ipswich, Felixstowe and other places on the Suffolk shore. Dover in Kent was even closer, and he worked there in the summer of 1891. The cool gray light common to both sides of the Channel and most frequently seen in Finch's paintings is here varied by the light of a clear blue day; but Finch maintains his cool, close-valued palette. The chalk cliffs rising from the flat sea provide a strong vertical-horizontal motif, appealing to his heightened sense of two-dimensional structure: to this he adds the elegant ellipses of shoreline and the stylized demarcation line between deep and shallow water. Following the lead of Seurat, who was very sensitive to the destructive effect on his paintings of conventional gilded frames, Finch has surrounded the picture with a border in divisionist tones which harmonize with the composition. This painting has been exhibited in Helsinki, at the Finch retrospective at The Ateneum in 1929 (no. 4), and at the Palais des Beaux-Arts in Brussels in 1967 (no. 98), as well as in New York in 1968 (see above).

**LEON
FREDERIC
1856–1940**

Baron Léon Frédéric, whose father was a master jeweler, was born in Brussels. When he was seven, crowded conditions at home forced his parents to send him to a Jesuit boarding school near Ghent and, at fifteen, he was apprenticed to the painter-decorator Charles Albert, while also attending evening classes at the Brussels Royal Academy. Although he failed, in his early twenties, to win the competition for the Prix de Rome, his family sent him to Italy at that time in the company of two other young artists. On his return, he became a professional decorator and, in 1880, joined the artists' group L'Essor. He won the first of many gold medals when he showed the central panel of his great triptych *Chalk Merchants* at the Brussels Salon of 1882. This work demonstrates Frédéric's interest in peasant life, one that grew with his discovery of the Ardennes village of Nafraiture, where he subsequently spent nearly every summer, sharing his neighbors' rural lives and making them the subject of his paintings. His devotion to humble Realism was occasionally replaced by allegory, and his most famous Symbolist work is probably the immense triptych dedicated to Beethoven, called *The Stream,* a tapestry of doll-like children and swans at frolicsome play and quiet repose beside the swift waters of life. At least one biographer has claimed that Frédéric was disposed to "think out" compositions such as these, and to begin directly on the finished work rather than spending much effort on preparatory sketches. His sense of perfection in his own work was often praised. Octave Maus, Director of Les XX and later of La Libre Esthétique, called him "one of the great decorators of our epoch," who "paints with admirable sincerity," letting "nothing leave his hands without being perfectly executed." Fernand Khnopff, the leading contemporary Symbolist, also praised Frédéric's work in the English art periodical, *The Studio.* [PF]

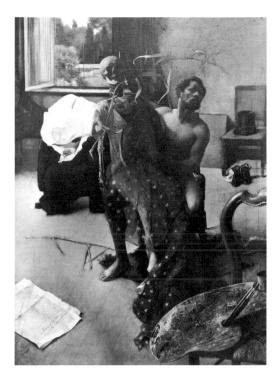

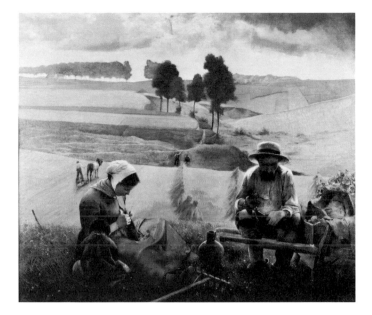

28 **L'Interieur d'Atelier** 1882
Studio Interior
Oil on canvas, remounted on panel
158.0 x 117.0 (62¹/₄ x 46)
Musée d'Ixelles, Brussels

29 **Le Repas du Laboureur** 1885
The Laborer's Repast
Oil on canvas
105.0 x 119.0 (41³/₈ x 46⁷/₈)
*Musée "Hôtel Charlier,"
Saint-Josse-ten-Noode, Brussels*

This work is an enigma in Frédéric's oeuvre. The present Baron Frédéric remembers that his father said it was intended for the first Zwans exhibition, an irreverent Salon that parodied individuals and styles — "zwans" means "joke" in Brussels *patois*. But evidence of its presence there is not convincingly documented. The subject is certainly bizarre, rather like an exquisite nightmare: a naked man, seated in a bare studio, holds a skeleton draped in spangled gauze on his lap. Discarded evening clothes are scattered in the background, a palette is pushed prominently to the foreground — providing almost the only area of brilliant color, while the rest is fugitive and subdued — and a paper lies on the floor, inscribed "Le beau et le laid sont des conventions." (Beauty and ugliness are conventions.) Even the technique is notably different from the brighter, more brittle brushwork of his allegories. It is this intention of elegance, the date, and the inscription which cast some doubt upon the painting's appearance in any of the burlesque Salons. Francine-Clare Legrand (*Symbolism in Belgium* [Brussels, 1972], p. 102) has perceptively noted the possible influence of Antoine Wiertz's *La Belle Rosine*, a work which certainly appears ridiculous today in its overblown tragi-romanticism and may have done so in Frédéric's time, forty years later. However, Frédéric's first Zwans exhibition was in 1885, three years after the date of this work (Jacques Lennep, "Les expositions burlesques à Bruxelles de 1870 à 1914: l'Art Zwanze — une manifestation pre-dadaiste?", *Bulletin des Musées Royaux des Beaux-Arts de Belgique,* February 1970, pp. 127–148). He is designated, in the inverted style preferred by the spoofers, as "Noel Cirederf" in two of the catalogues (see Lennep, above, for catalogue bibliography), but the entries following are too oblique to make an identification with this painting certain. It is true that the 1914 Zwans retrospective lists "le beau c'est le laid" under the Frédéric pseudonym, suggesting a work which may have been, not this painting, but a satire on his own youthful idealism.

Painted three years after the *Chalk Merchants, The Laborer's Repast* has a similar feeling for the noble poor and is composed with the same high point of view — both literally and figuratively. It also anticipates the series of finished drawings of 1888, *Flax and Wheat,* which Frédéric made to celebrate the part played by food and clothing in peasant life, and which — ironically — became the property of a wealthy Russian princess. Here, beyond the *répoussoir* figures of the farmer's family, the neatly pruned fields of Nafraiture are seen spreading to distant trees. The dedication to a social ideal — evident, as it is here, in much of Frédéric's work — springs from the sense of "hope and ardor" ascribed to him by Octave Maus (*Art et Décoration* 1 [1899], p. 188). He was also completely "ignorant of any aesthetic regionalism," as Lucien Jottrand said (*Monographies Belges: Léon Frédéric* [Brussels, 1950]), being equally fond of painting the inhabitants of Heyst-sur-mer in Flanders as he was of using his Ardennaise neighbors for models. It was the simplicity of their lives that he admired. The general critical success of these homely sentiments was sometimes offset by harsh words: his methods were called "heavy, hard and crude . . ." (*L'Art Moderne,* October 1, 1886, p. 10), or "cold, calm, methodical, tenacious, persevering, with no enthusiasm . . ." (*L'Art Moderne,* May 29, 1887, p. 171). Nevertheless, in a 1925 newspaper poll, he was voted Belgium's most popular living artist.

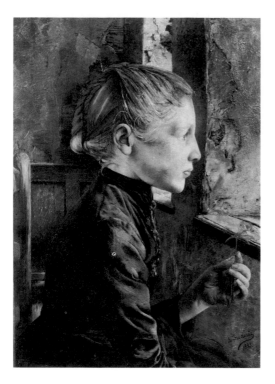

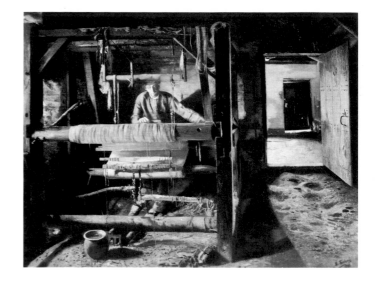

30 **Portrait d'Elodie Lamotte** 1893
Oil on canvas
51.0 x 38.0 (20¹/₈ x 15)
Private Collection, Brussels

31 **Le Tisserand** 1896
The Weaver
Oil on canvas
68.0 x 87.0 (26³/₄ x 34¹/₄)
*Musées Royaux des Beaux-Arts de
Belgique, Brussels*

This picture seems to confirm Frédéric's ability to act as "a living mirror of the diverse, successive tendencies of his epoch . . ." (Lucien Jottrand, *Monographies Belges: Léon Frédéric* [Brussels, 1950], p. 9). The realistic simplicity and implied Symbolism seen in this child's portrait represent the two dominant forces in Frédéric's career. Elodie Lamotte was undoubtedly a child from Nafraiture. She might have been a suitable choice to model for the young Virgin Mary in the series of murals the artist wished to paint for a church in his adopted village, if he had not dropped the project when he was warned off "Realism" and asked to dress his holy family in "traditional" clothing. Elodie Lamotte has a spiritual quality: her gaze passes the window opening in the peeling plaster wall, and she lightly holds a wispy but bright nasturtium blossom, surely a symbol — perhaps of hope? Her attitude is transfixed, as if in meditation, and her features are so finely drawn that she seems aristocratic and mature beyond her years. Her dignity is reminiscent of that seen in the peasant subjects painted by the contemporary German artist, Wilhelm Leibl. There is a cool-warm contrast between the gray walls and rose-tinted skin of the girl that is remarkable in an artist not often praised for his color. The painting was exhibited in Brussels in 1905 *(Exposition des Peintures et Sculptures de l'Enfant)*, and once belonged to the Belgian Art Nouveau jewelry designer, Philippe Wolfers.

In this comparatively small work for Frédéric, the subject is one common to his epoch, recalling Van Gogh's well-known drawings and oil sketches of men at looms. This painting, however, is extremely luminous, with delicate but rich coloring applied more tonally than in the majority of Frédéric's works, and with none of the heavy gloom projected in similar scenes by other artists of industrial Realism in the nineteenth century. When *The Weaver* was shown at the *Exposition Ancien Champ de Mars* in Paris in 1897, it was described as "the most important [Belgian] contribution" to the exhibition and Frédéric was hailed as a "modern Albert Dürer" *(Indépendance Belge,* May 22, 1897). Since then, it has appeared in a number of other exhibitions both abroad (Algiers, *Art Belge,* 1938; Oslo and Prague, *Art Belge,* 1948–1949) and at home (Charleroi, *Trente Ans Art Belge, 1890–1920,* 1960; Antwerp, *Le Travail dans l'Art,* 1952; Saint-Josse-ten-Noode, *Léon Frédéric,* 1973, cat. no. 22).

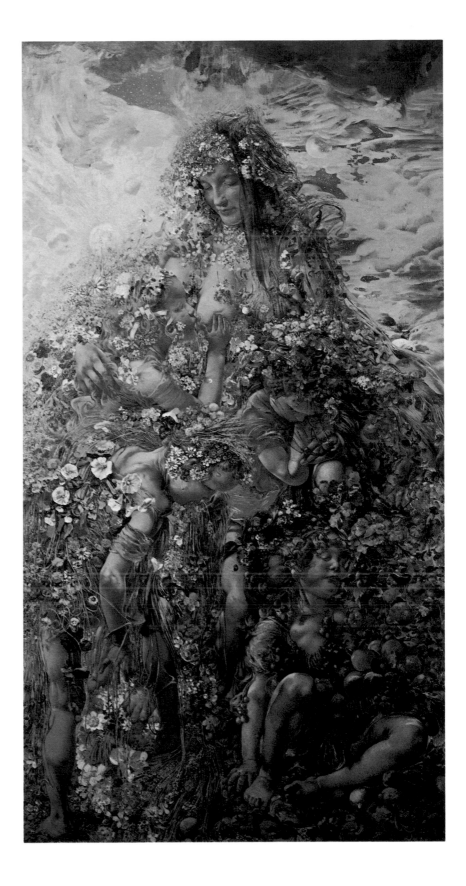

Léon Frédéric
La Nature 1897
Cat. no. 32

32 **La Nature** 1897
Oil on canvas
166.0 x 91.0 (65³/₈ x 35³/₄)
Van Raes-Tyberghien, Ypres
Reproduced in color on page 105

Winner of a gold medal at the 1904 World's Fair in St. Louis, this is the central panel among five, of which the others each represent one of the seasons personified by the same children seen here (counterclockwise): Spring, receiving nourishment; Summer, bedecked with her own generosity; Autumn, torpid beneath the rich harvest; and Winter, already morose in fading finery. The enameled precision of burdensome, fruity detail, describing immoderate abundance, is oddly unnatural for a representation of nature. It is both fascinating and repugnant, creating a sensation which has been compared to that engendered by Dali (F.-C. Legrand, *Symbolism in Belgium* [Brussels, 1972] p. 103). It was, however, deeply regretted by an anonymous critic of the time when the picture failed to enter a Belgian museum: "Our neighbors [the French state, which had just purchased Frédéric's *Three Ages of the Worker*] are more clairvoyant than the Belgian state, which has let the occasion escape to buy a work no less important or admirable . . . *La Nature*, recently exhibited at La Libre Esthétique . . ." (*L'Art Moderne*, May 15, 1898). Frédéric's Italian trip was thought to have made him fond of Botticelli and the other Florentine "Primitives," but in the 1956 retrospective held in his home commune of Schaerbeek, many sketches after Titian, Veronese, and Rubens were shown. In this work and others, including *The Stream*, Frédéric's affinity for opulence in flesh is clear and must have inspired the French reviewer who wrote, ". . . one regrets the absence . . . of Léon Frédéric, who is their [the Belgians'] Rubens." (Quoted in "Le Salon d'Art Belge à Paris," *La Meuse*, December 2, 1927.) This painting, which, with its other panels, belonged formerly to the Goldschmidt-Clermont Collection, has been recently exhibited in Brussels (Musées Royaux des Beaux-Arts de Belgique, *Portaels et ses Élèves*, 1979, cat. no. 38).

FERNAND KHNOPFF 1858–1921

Khnopff, who liked to speak of his sixteenth-century Austrian and Portuguese origins, came from a family of upper middle-class magistrates. From 1859 to 1864 he lived in Bruges, a city which made a strong and lasting impression on him. His sister Marguerite, who would become his favorite model, was born in 1864, and the next year the Khnopff family moved to Brussels, vacationing during the summer holidays on property they owned in Fosset. In 1875, Khnopff attended law school for a time, but he was more interested in literature (Baudelaire, Flaubert, Lecomte de Lisle, among others) and left the university in order to attend art classes in the studio of Xavier Mellery and at the Academy. Between 1877 and 1880, he made a number of trips to Paris, where he established his admiration for Ingres, Alfred Stevens, Delacroix, Moreau, Millais, and Burne-Jones. He also studied with Jules Lefebvre and at the Académie Julian. His first exhibition with L'Essor was at the 1881 Salon in Brussels; the critics were not enthusiastic about his work, except for Émile Verhaeren, who always supported him. Khnopff was a founding member of Les XX in 1883 and of its successor, La Libre Esthétique, exhibiting regularly with both groups, as well as at the Salons of the Rose + Croix — to which he was introduced by Joséphin Péladan in 1885. His first contacts with England occurred in 1889, and from then on, he also frequently showed his work there with the artists who became his friends — Watts, Hunt, Rossetti, Burne-Jones, and Ford Madox Brown. In 1895 he accepted the post of Belgian correspondent on the English art review, *The Studio*, directing the column called "Studio-Talks-Brussels" until 1914. In 1898 Khnopff made a trip to Vienna, where he was entered in three exhibitions, most notably with twenty-one pieces for the inaugural show of the Secession, at which he was triumphantly received. After 1900, Khnopff dedicated all his energies to building his house, a veritable temple to the self, which he designed completely, using only blue, gold, and white for the decorations. From 1903 to 1913, he created costumes and scenery for the Théâtre Royal de La Monnaie. Khnopff was internationally acknowledged as the leading artist among the Belgian Symbolists. He painted and drew — particularly in pastels, watercolor, and mixed media — but was also interested in making sculpture (in plaster, bronze, and marble) and photography, which he often touched and signed in the same way as a completely original work of art. [GO]

33 En écoutant du Schumann 1883
Listening to Schumann
Oil on canvas
101.5 x 116.5 (40 x 45⁷/₈)
Musées Royaux des Beaux-Arts de Belgique, Brussels

34 Portrait de Madame de Bauer 1893
Oil on panel
40.0 x 50.0 (15³/₄ x 19³/₄)
Marcel Mabille, Rhode-St.-Genèse, Brussels
Reproduced in color on page 108

Dated 1883, this painting was first seen in that year, in two exhibitions (Brussels, Cercle Artistique et Littéraire, *XIème Exposition d'Oeuvres d'Art*, no. 110 and Ghent, Casino, *Triennale*, no. 547). A work of Khnopff's youth, it shows an interior scene, a "salon bourgeois" like those of Ensor's early style. Khnopff's mother is seated in an armchair, one hand over her face, withdrawn from her surroundings as she listens to the music. In 1886, this canvas was exhibited with Les XX, and Ensor took umbrage over the resemblance between this picture and his own *Russian Music* of 1881. He accused Khnopff of copying him and informed Octave Maus of his feelings; but Maus supported Khnopff in the dispute. Seven months later, the issue still rankled with Ensor; in two letters to Maus he equates Khnopff with Fagerolles, the successful artist in Zola's novel *L'Oeuvre* who plagiarized the work of the unhappy hero, Claude Lantier — with whom Ensor identifies himself (F.-C. Legrand, ed., "Les Lettres de James Ensor à Octave Maus," *Bulletin des Musées Royaux des Beaux-Arts de Belgique,* 1966, no. 1-2, pp. 24–25). Following this incident, Ensor and Khnopff were never friends again, each one following a totally different style and goal in art.

A detached observer may, however, note that the only thing the two paintings have in common is the theme of listening to music. Ensor's picture shows a woman at the piano and a seated man turning toward her, listening; it is painted in Ensor's early style, with a warm palette and broad, impastoed strokes. Khnopff, on the other hand — even at this early period — defines most of his forms with subtle precision, and his tones are cool and silvery. Most important, he stresses the solitude of his single, centralized figure by showing her with her face hidden in her hand; even the source of the music is hidden from view. Music ceases to be a shared experience between performer and listener and becomes instead a paradigm of that introversion which was so central to Khnopff's own life and work. *Listening to Schumann* is published with full bibliography in Delevoy, Ollinger-Zinque and De Croës, *Fernand Khnopff* (Brussels, 1979), no. 52, p. 219.

Khnopff, who was the most sought-after portraitist for Belgium's nobility and upper middle class, worked twice for the de Bauer family. In 1890 he made a portrait of *Mademoiselle Jeanne de Bauer*, the future wife of Joseph May, and in 1893 (although the work is not dated), the picture of her mother seen here (*Fernand Khnopff* [Brussels, 1979], nos. 140 and 233). Madame de Bauer, wife of the Chevalier de Bauer, was a member of the same family as the banker Lambert de Rothschild. Before making this portrait, Khnopff executed a large, highly finished study in charcoal and pencil with white highlights (see *Fernand Khnopff* [Brussels, 1979], no. 232). By happy coincidence, the study and the final painting have both entered the same collection. It was Khnopff's habit to make a number of studies before he did a portrait. In a letter of February 1899 to his friend Paul Schultze-Naumburg (reproduced in *Fernand Khnopff* [Brussels, 1979], pp. 26–27), he explains his reasons for doing so: "When I execute a work, I make few sketches, but many studies. I imagine the life that people have led up to the moment when they become part of the work of art. It is these prior details which give the [final] work its complexity." This very beautiful portrait, endowed with all the aristocracy such a great lady deserves, was first seen in 1896 at the Brussels Salon (no. 79), and was not heard of again publicly until the exhibition *Peintres de l'Imaginaire* (Paris, Galerie Nationale du Grand Palais, 1972, no. 50), seventy-five years later. At that time it was called *Portrait of a Seated Woman*; its true identity was re-established only with the publication in 1979 of the catalogue raisonné of the artist's work (see above).

Fernand Khnopff
Portrait de Madame de Bauer 1893
Cat. no. 34

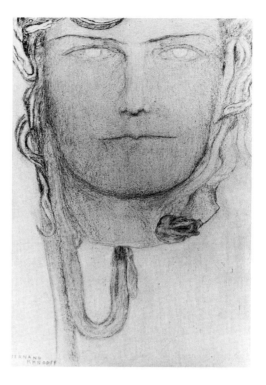

35 **La Méduse endormie** 1896
Sleeping Medusa
Pastel on paper
28.0 x 12.4 (11 x 4⁷/₈)
Private collection, Lausanne

Not in exhibition

36 **Étude pour le sang de Méduse** 1898
Study for the Blood of Medusa
Pastel on paper mounted on board
21.5 x 15.0 (8¹/₂ x 5⁷/₈)
Barry Friedman Ltd., New York

There are two versions of the *Sleeping Medusa;* one, dated 1896, is a large pastel (72.0 x 29.0 cm.), which belongs to the Surrealist painter Félix Labisse of Paris *(Fernand Khnopff* [Brussels, 1979], no. 276). The other (no. 282 in the catalogue raisonné) shown here, is not dated but is evidently a study for the first, given its smaller dimensions. The subject is identical. Khnopff seems to have been very much drawn to the Gorgons, the pre-Olympian monsters whose piercing gaze turned to stone anyone who looked directly at them. There were three sisters: Sthéno, Euryale, and Medusa — only the last being mortal. Khnopff shows Medusa perched on her rock, eyes closed, facing the sea. Francine-Claire Legrand interprets this picture as a disclosure of the artist's misogyny and pessimism: "It is a work harsh in form and color, intense and mysterious — an eagle with the profile of a woman, eyes closed, alone on her rock in the night . . . this is Khnopff's Symbolism in its most essential and direct form *(Le Symbolisme en Belgique* [Brussels, 1971], pp. 69 and 72). Khnopff is very much interested in the different aspects of Medusa's legend, ranging from works where she is shown alive — the sleeping bird on the rock — to the head decapitated by Perseus. He created several pictorial images of the slain Gorgon and one sculpture, *Head of Medusa (Fernand Khnopff* [Brussels, 1979], no. 364), which includes a broken section of Perseus' shield and a luxurious growth of snakes from the monster's head. Khnopff exhibited *Sleeping Medusa* frequently: in 1897 in London and Liverpool (New Gallery, *Summer Exhibition,* no. 7 and Walker Art Gallery, *Autumn Exhibition,* no. 479); in the Secession show of the same year in Vienna (no. 218), the Munich Secession of 1898 (no. 247), and the following year at the Venice *Biennale* no. 59). This drawing was recently seen in London in 1970–1971 at The Picadilly Gallery exhibition of *Drawings and Watercolors* (no. 46), and in 1971 in *Belgian Drawings* (The Picadilly Gallery, no. 26).

This work is inspired by the same myth as the *Sleeping Medusa.* Here, Khnopff chooses the finale of the legend: Medusa has been decapitated by Perseus and we are shown a "head cut with the same care as metalwork for armor. She is posed on a shining void. She floats. In a brightness which Blanchot would say is the 'nonlight of light' " (R. L. Delevoy in *Fernand Khnopff* [Brussels, 1979], p. 150). Earlier literature mentions several versions of the *Blood of Medusa,* and two others besides the one shown here can be identified: one is a drawing in colored pencil belonging to a private collection; the second is a lithograph, one example of which is now in the Cabinet des Estampes in the Bibliothèque Royale in Brussels *(Fernand Khnopff* [Brussels, 1979], nos. 318 and 319). The pastel here is a preparatory study for a more elaborate work which has not yet been rediscovered, and itself was found only since the publication of the catalogue raisonné. Louis Dumont-Wilden *(Fernand Khnopff* [Brussels, 1907], p. 72) mentions that a drawing of *The Blood of the Medusa* was in the Mayer-Stametz Collection in Vienna, but that is the last trace of information to have come to light. One version of the subject was exhibited for the first time in 1898 at the Vienna Secession, suggesting a time period for the execution of the undated versions. Khnopff must have attached particular importance to this theme of the decapitated Medusa since he always kept a version of it in his own collection of favorite works. The effect he has achieved is extraordinary and must certainly have fascinated his guests. Maria Biermé, who visited Khnopff's studio, speaks of a "head with terrible and tragic locks, thin lips, piercing eyes, filled less with cruelty than with sorrow because she must turn all those who gaze on her to stone" *(Les Artistes de la Pensée et du Sentiment* [Brussels, 1911], p. 37).

37 **L'Encens** 1898
Incense
Pencil with white highlights on paper
58.5 x 34.5 (23 x 13⁵/₈)
M. and Mme. Wittamer-De Camps,
Brussels

Fernand Khnopff made five versions of *Incense,* which are catalogued with full bibliography in the catalogue raisonné of his work (nos. 308, 314 [the exhibited drawing], 325, 580, 594). The largest (86.0 x 50.0 cm.) is an oil on canvas which stayed in the artist's possession until his death. The others are drawings: in pastel, charcoal, or pencil with white highlights. A later version should also be mentioned (oil on wood, 32.0 x 17.0 cm.), which can probably be dated around 1917 and belongs to the Clemens-Sels Museum of Neuss in Germany. The subject in all these pictures is nearly identical, except for some small details such as variations in the object the woman holds in her left hand or the treatment of the lower portion of the composition. Khnopff photographed his sister, Marguerite, swathed in rich fabrics shot with gold, and used the prints as the basis for this group of pictures entitled *Incense.* The work exhibited here is not dated but was certainly made around 1898. At one time it belonged to the collection of the Minister Paul Hymans, in Brussels. It was exhibited for the first time in 1900 (Brussels, Académie des Beaux-Arts, *Exposition centennal 1800–1900,* no. 139). According to Maria Biermé (*Les Artistes de la Pensée et du Sentiment* [Brussels, 1911], p. 35), the work was originally conceived by the artist as a triptych. *Incense* would have been one wing; the central panel was to have been called *Gold,* and the other wing, *Myrrh.* Only *Incense* was completed, and Biermé notes that Khnopff ". . . gave the figure symbolizing incense, as well as the ambience surrounding her, the diverse colors which we associate with the burning of incense, whether still in its resinous state or transformed into smoke which rises from the censers, taking by turns shades of yellow, gray or black."

38 Le Secret 1902
Pastel and charcoal on paper
Diameter: 30.0 (11³/₄)
Lea Vanderhaegen, Ghent

39 Des souvenirs de la Flandre. Un canal
1904
Memories of Flanders. A Canal
Pencil, charcoal, and pastel on paper
25.0 x 41.5 (9⁷/₈ x 16³/₈)
Barry Friedman Ltd., New York

Like *Incense* (cat. no. 37), this drawing was inspired by a photograph of Marguerite Khnopff, posing for her brother while robed in heavy, blue-mauve draperies. She is shown seated before a mask which she lightly touches on the lips with her gloved hand. Her gesture, made as if to close these lips — to impose silence on them — is symbolic of the secret they keep. This mask — modeled from Marguerite herself — was made in ivory, bronze, and enamel by Khnopff in 1897. He made other copies, for *L'Art Moderne* (June 12, 1898, p. 192) reported that at the inaugural exhibition of the Vienna Secession, Khnopff had a great success with them, selling several even before the official opening. He always kept one in his studio. *Le Secret* is the first version of the final work on this theme, which is 19.5 cm. larger in diameter (see Delevoy, Ollinger-Zinque, and de Croës, *Fernand Khnopff* [Brussels, 1979], no. 378a, with full bibliography; our drawing is no. 380). The final version was joined with a drawing of l'Hôpital St. Jean in Bruges within a single frame which Khnopff made himself. This ensemble of two different drawings — one round, the other rectangular — is now at the Groeningen Museum in Bruges and is often called *Secret-Reflet*. Just as the ancient building is reflected in the still water of the canal, so the mask gazes back at its model. In *Le Secret*, Khnopff treats three themes dear to the Symbolists: silence, the double image, and the inward focus of the self. One of the two versions — it is not known which — first appeared in 1902 (London, The New Gallery, *Summer Exhibition*, no. 35).

Sixty-seven years have passed since this work was last heard of or seen in public, when it was exhibited in 1913 at Scheveningen, Holland (Kunsthandel Arti, *Fernand Khnopff*, no. 1). The scene is laid in Bruges, where Khnopff passed his childhood from 1859 to 1864. More precisely, it is a view of the canal that runs beside the well-known Green Quay, near the Chapel of the Holy Blood, with a glimpse of the rear walls of the Hotel de Ville and the Palais de Justice. The work is not dated, but was first shown in 1904 (Brussels, *Les Aquarellistes*, no. 58), thereby suggesting an approximate dating. Khnopff never forgot his years in Bruges: "I passed my childhood in Bruges (which was then a true *ville morte*, unknown to visitors), and I have kept many memories of it, distant but precise." (Letter to Paul Schultze-Naumburg, February 1899, reproduced in *Fernand Khnopff* [Brussels, 1979], p. 27.) Around 1904, Khnopff made a number of "Memories of Flanders," all of which centered on Bruges (see *Fernand Khnopff*, nos. 392-3, 398, 403–5, 413; our drawing is no. 399, with full bibliography). Many of these views of Bruges were directly inspired by the *similigravure* illustrations of Georges Rodenbach's novel *Bruges-La-Morte*, which had appeared in Paris in 1892. This drawing shows the same scene as the illustration on page 81 of the novel, but Khnopff has accentuated the mystery and eccentricity by cutting off the upper part of the buildings — just as he sometimes cut off his figures in mid-forehead — deleting the sky and the rooftops in order to give more importance to the water and the reflections of the buildings that border it. The work was executed from memory and imagination, based on the illustration. None of Khnopff's Bruges drawings could have been done from life because he was adamant in his resolve never to return to the town, so as to avoid seeing any changes that had taken place since his childhood.

Georges Le Brun
La Garde-Malade *circa* 1903
The Nurse
Cat. no. 44

EUGENE LAERMANS 1864–1940

Eugène Laermans was born in Brussels, where his father was a bank cashier and his mother owned a butcher shop. Laermans' own career as an artist was decided early on when meningitis left him completely deaf and nearly mute at the age of eleven. His mother claimed he began drawing when he was only eighteen months old. In any case, the isolation of his handicap certainly reinforced his remaining senses, although it also led to odd behavior among his fellow students at the Brussels Academy — a situation that resulted in occasional fistfights. And Laermans was angered by the comments of his teacher Portaels, who wrote on his classroom drawings, "Why are you not more advanced?" or "This is too tormented!" He erased them, scribbling in their place, "I am searching for new sensations!" Yet he was not a violent man. When his commune honored him in 1910, renaming both a street and the local art academy for him, he was described as "a humanist wanting a better life for his fellow man . . . a better redistribution of goods. . . ." After some youthful experimentation with romantic landscapes, portraits, and satanic fantasy in the style of Rops, Laermans began to work with the subjects he knew best: the industrial workers and peasants of Brabant. Though Impressionism and Symbolism were the popular modes, he chose a harshly expressive Realism to describe the encroachment of factory upon field — the mechanization of existence — that he observed throughout his life in Molenbeek, on the edge of Brussels. In 1924, he suffered the greatest tragedy of all for an artist when cataracts left him blind. An operation was successful enough that he could paint again, but never with the same power. He said then, "I am no longer Laermans. I can create no more." When he was created a baron in 1927 in reward for the artistic honors he had brought his country, he chose the motto, "Heureux qui sait voir" (Happy is he who knows how to see). Laermans showed with all the major circles of his time: Voorwaarts, Pour l'Art, La Libre Esthétique, as well as at the Galerie Georges Giroux. He had a major retrospective in 1899 at the Maison d'Art in Brussels. [PF]

40 **Soir de Grève** 1893
Evening of the Strike
Oil on canvas
106.0 x 115.0 (41³/₄ x 45¹/₄)
Musées Royaux des Beaux-Arts de Belgique, Brussels

Painted a half-dozen years after the Belgian Socialist Party inaugurated the first of its major strikes, and after both the poet Émile Verhaeren and critic Camille Lemonnier had written books on the subject of industrial social reform, this picture, which was first entitled *The Red Flag*, has been singled out as Laerman's chef d'oeuvre by many critics (see commentary on *The Path* [cat. no. 42] for selected bibliography). It has been widely exhibited (Antwerp, *Le Travail dans l'Art*, 1952; Belgrade, Zagreb, Llubjana, *Le Folklore et Le Travail dans l'Art Belge*, 1953; Moscow, *Exposition d'Art Belge*, 1957; Geneva, *Art et Travail*, 1957; Charleroi, *Le Travail dans l'Art*, 1958; Brussels, *Le Drame Social dans l'Art*, 1960; Warsaw, *L'Art Belge de la Fin du XIXᵉ et XXᵉ Siècles*, 1957; Brussels, *Portaels et ses Élèves*, 1979, cat. no. 51) for this reason, and is probably the work which most makes Laermans seem political. In this context, he was selected by Marius-Ary Leblond (*Peintres de Races* [Brussels, 1910]) as an artist who, "in Belgium, a country in strong social fermentation," reinforced the idea that "art must be social." Yet, like Constantin Meunier, he was truly less dogmatic ideologue than reporter. *Evening of the Strike* is remarkable for its mood of dangerous depression; the crowd, nearly monolithic — as in Daumier's painting of 1860, *The Uprising* — moves with a slow, plodding pace toward some unseen destination. Only the protesting child, the threatening sky and the rusty-bloody red of the flag and women's shawls invoke the possibility of violence, but the single-minded, silent determination of the tattered phalanx is terrifying. Laermans made an etching of the same subject.

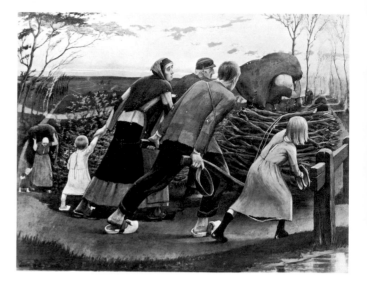

41 **Portrait de Marie** 1894
Oil on canvas
78.0 x 57.0 (30³/₄ x 22¹/₂)
Private collection, Brussels

42 **Le Sentier** 1899
The Path
Oil on canvas
135.0 x 175.0 (53¹/₈ x 68⁷/₈)
*Musées Royaux des Beaux-Arts de
Belgique, Brussels*

The title of this portrait was given in both 1925 (Brussels, Galerie Georges Giroux, *L'Oeuvre d' Eugène Laermans*) and 1930 (Brussels, *Exposition Centennale de l'Art Belge, 1830–1930*) as *Portrait of a Young Girl*. Its identification as "Marie" must have occurred after Laermans' death, when it came to public notice that he was survived solely by a family servant of that name who had come into his parents' household when he was still a young man. It is interesting to discover that like his contemporary, Léon Frédéric — also a Realist painter of working-class people — Laermans was an admirer of the rich, fleshy bodies found in seventeenth-century Flemish painting, and was particularly fond of Jordaens. *Marie* reflects something of that taste, in strong contrast to the angular, bony forms of the more Expressionist style that appears in his other works in this exhibition. An earlier picture, of 1890, called *Reflections* — also, perhaps, of Marie van Hemelryck — shares with this portrait a natural, affectionate truth to the model. *Marie* has been described in a review (of the 1925 retrospective) as having been painted with a "delicacy one would not suspect of this 'savage bear'" and as having the "transparency of porcelain . . . a simple unity, precise and pure [which is] found in all his work" (Jacques Ottevaere, *Le Flambeau* 1 [1925], p. 472). Laermans' ability to draw and model the human figure came slowly, but he worked at it continuously for ten years after leaving the Academy, attending life classes every week at the "free" academy in a studio above the café "La Patte du Dindon" on the Gran' Place.

Laermans has always been noted as a colorist, skilled in using his palette knife for the placement of flat bright areas among the grimmer tones so suitable to his frequently tragic subject matter (Yvonne Villette, "Laermans au Musée de Bruxelles," *Union Civic Belge,* n.d., p. 18). In *The Path* he evokes the cold air of a winter evening by playing off blue shreds of sky against a mass of darkening clouds and the remnants of glowing orange foliage clinging to black branches. But the most notable touches are small, jarring juxtapositions of vivid color patches, such as the white sabot and red sock of the little child against its mother's purple stocking and black shoe. This and other works from the period 1890–1900 are often compared with Breughel because they share certain structural elements — a winding road which ties the composition together across a wide expanse of land — as well as an interest in the common man, but the analogy has been philosophically debated in the many works devoted to Laermans. (Among the most important are: G. van Zype, *Eugène Laermans* [Brussels, 1908]; Paul Colin, *Eugène Laermans* [Brussels, 1929]; F. Maret, *Eugène Laermans, Monographies de l'Art* 46, [1959]; Armand Eggermont, *La Vie et l'Oeuvre d' Eugène Laermans, peintre pathétique des paysans, 1864–1940,* Collection nationale, 4th ser., no. 38, [1943].) Like Breughel, Laermans employed an expressive use of the human body, which earned him the description of "painter-caricaturist." It is their work and the ill-fitting clothes they wear that deform his peasants and working people, making them "often grotesque, sometimes curious, but never so faithfully rendered . . ." (*L'Art Moderne*, January 10, 1892, p. 11). Laermans worked from notebooks full of rapid, candid sketches and never asked his subjects to model because ". . . they would come shaved and combed . . . in new clothes." (Quoted in Maria Biermé, *Les Artistes de la Pensée et du Sentiment* [Brussels, 1911].)

**GEORGES
LE BRUN**
1873–1914

Le Brun was born in Verviers, in the Ardennes, a hilly rural area which still retains something of the harsh remoteness of its earlier days. "La Fagne," or the barren moors with their occasional farm buildings huddled within a screen of wind-twisted trees, was the artist's spiritual home and the essential subject of his work. He studied drawing and watercolor at the local *lycée.* An attempt at a conventional university career in medicine convinced Le Brun to stay with art; a short time in 1895 spent at the Academy in Brussels convinced him that the academic course of teaching was not for him. His experience and his subject lay in the Ardennes. Nonetheless, he spent time during these years in Brussels, befriended other artists, and came to know Octave Maus, who perceived his originality and invited him to show at the Salon of La Libre Esthétique in 1900 and again in 1903. At the same time, Maus also asked Le Brun to write criticism for *L'Art Moderne.* For paradoxically, while Le Brun's instincts in his own art led him to the life of simple rural folk and to a quasi-naive style of painting, he was at the same time a connoisseur of art of great sophistication, familiar not only with the advanced work of his own time but with European painting in general. This knowledge was acquired in the best possible way; by traveling and by careful observation of objects and monuments wherever he went. He wrote clearly and perceptively about works of art, and one can only speculate that had he lived beyond the age of forty one he might have further developed this side of his talent.

Le Brun's oeuvre — primarily images of silent farm interiors and equally silent rural landscapes — must be characterized as Symbolist; not, as Mme. Francine-Claire Legrand remarks in her introduction to the first retrospective of his work (Brussels, Musée d'Ixelles, 1975–1976, n.p.), because of any literary connections but because of the artist's approach, which, like that of the Symbolist poets, is essentially intuitive and involved with a kind of magical approach to the image. These interiors are simplicity itself, yet, again in Mme. Legrand's words, they are "icons," conveying a strong sense of the mystery of the everyday. From the time he settled permanently in the village of Theux in 1904, until the outbreak of World War I, Le Brun lived a satisfying and productive life, often using his seventeenth-century house as a subject for his art. He was one of the first of his countrymen to enlist after the outbreak of war and his death in October 1914 was one of the earliest of all those that were to come. [SF]

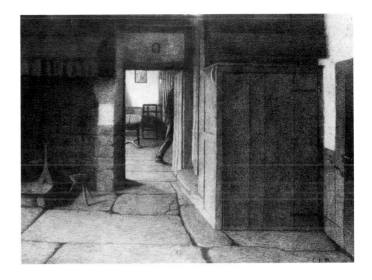

43 **Intérieur: l'homme qui passe** 1900
Interior: A Man Passing Through
Charcoal on paper
47.0 x 61.0 (18^1/$_2$ x 24)
*Musées Communaux, Verviers, Gift of
Mme. Émile Peltzer*

This drawing was done at Xhoffraix, the small village where Le Brun lived and worked in the years before his marriage. The structure of the space is clearly based on the traditional receding sequence of rooms found in classical Dutch painting, and used also by De Braekeleer. Yet the atmosphere of silence and mystery is highly personal, its closest affinity being with the drawings of interiors by Mellery who, like Le Brun, creates a sense of mystery through purely tonal means. The critic of the 1911 exhibition of Walloon art in Brussels also made this connection; he noticed both in Le Brun's work and in Mellery's "the same enveloping light, the same love of the artist-hermit for the charm of the corners that one sees every day" (*L'Art Moderne,* December 17, 1911, p. 405). Without any suggestion of anecdote, the enigmatic mood is intensified by the presence of the half-seen figure of the man passing through the farther room. The drawing was included in the Le Brun retrospective at the Musée d'Ixelles in Brussels in 1975 (cat. no. 11).

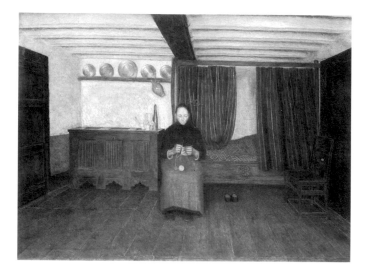

44 La Garde-Malade *circa* 1903
The Nurse
Oil on canvas
47.0 x 64.0 (18½ x 25¼)
*Musées Communaux, Verviers, Gift of
Mme. Émile Peltzer*
Reproduced in color on page 112

45 La Salle à Manger 1906
The Dining Room
Pastel on paper
51.0 x 80.0 (20 x 31½)
Musée d'Ixelles, Brussels

This is one of the relatively few works in Le Brun's oeuvre done in oil; like many of his compatriots of this period he preferred to work in watercolor, pastel, charcoal, or a mixture of the three. Again, we are in a farmhouse interior; in this case, a bedroom with one figure fully shown, another — the sick person — shrouded behind the bed curtains, present by implication, as it were. The planes of the room are locked together by the immobile, frontal, absolutely centered figure of the nurse, who knits through the empty moments until her patient wakes. Francine-Claire Legrand aptly characterizes that special kind of silence which is intensified by the regular clicking of knitting needles, as by the ticking of a clock: "To knit is to take the pulse of silence, to hear its very existence" (Musée d'Ixelles, *Georges Le Brun,* 1975–1976, n.p.). The precise placement and detailing of the sparse furnishings of the room — and the figure of the nurse has the carved solidity of a piece of furniture — freezes the image into that particular kind of immobility by which so-called "naive" art transcends ordinary realism. The picture was included in the retrospective at the Musée d'Ixelles (cat. no. 17, illustrated in color).

The dining room is that of the 1630 house in Theux which Le Brun and his wife lived in from 1904 and where their two children were born. According to Mlle. Jeanne Le Brun, their daughter, who wrote the biography in the catalogue of the Ixelles exhibition, both parents had an eye for objects and enjoyed gradually furnishing the beloved house. The drawing shows us the charm of a room in the French provincial style; but the atmosphere of the image goes well beyond that of a simple description. As the nurse in *La Garde Malade* (cat. no. 44) is presented with the rigid centrality of an icon, so the naively symmetrical disposition of these furnishings creates a hushed mood bordering on reverence. The dining table, framed by the mantelpiece, above which glows the light of a lamp reflected in the mirror — a light which is the only warm tone in the picture — takes on the aspect of an altar table. The feeling of mystery and expectation is heightened by the absence of any living being; an absence taken for granted in traditional still life, but unsettling in an interior. This theme of the empty room, so intrinsic to Mellery's art, is continued in the early twentieth century by the young Spilliaert, as well as by Le Brun. *The Dining Room* was exhibited in the 1975 retrospective at the Musée d'Ixelles (cat. no. 41, illustrated in color).

The son of a Brussels architect, Lemmen briefly attended the School of Drawing at Saint-Josse-ten-Noode. By the time he was seventeen was already exhibiting at the Ghent Salon. The works Lemmen showed at L'Essor from 1884 to 1886 reveal a close affinity to the works of Fernand Khnopff and a debt to the Northern Renaissance artists, Dürer and Holbein. In 1888, Lemmen was elected a member of Les XX and showed annually from 1889 to 1893. He also exhibited frequently with its successor, La Libre Esthétique, between 1894 and 1912.

GEORGES LEMMEN
1865–1916

Like several other members of Les XX, Lemmen came under the influence of Seurat, who showed with the group in 1887, 1889, 1891, and 1892. Most of Lemmen's Neo-Impressionist work was executed during the years 1890–1895. As a member of the Franco-Belgian Neo-Impressionist coterie, Lemmen exhibited with the Indépendants in Paris in 1889–1891 and later during his intimist phase in the years 1901–1902, 1904–1906, and 1908. In addition, Lemmen not only showed with Van de Velde's Antwerp Association Pour L'Art (1892), but assisted its Secretary Max Elskamp in organizing the exhibition.

During the Neo-Impressionist years Lemmen developed his lifelong interest in the decorative arts. Influenced by his anglophile friend Willy Finch, Lemmen expressed his admiration for Walter Crane in his article published in L'Art Moderne of 1891. Lemmen hailed Crane — who illustrated books and designed wallpaper and tapestries — as an "ouvrier de l'art," and followed Crane's example by devoting himself to the decorative arts. His keen desire to be innovative led him to explore a great variety of media; he even won a French competition for designing a desk in 1899.

For the period 1895–1916, the bulk of Lemmen's work consists of still lifes, nudes, and intimist family scenes. Though often subject to feelings of inadequacy and disheartened over the poor sale of his works, Lemmen was nevertheless given several one-man shows: at the Galerie Druet in Paris in 1906 and 1908, and at the Galerie Georges Giroux in Brussels in 1913 — which was, in fact, a resounding financial success. Giroux also held a major sale of his works in 1927 and an exhibition in 1929. More recent exhibitions include: Paris, Galerie André Maurice, 1959; Brussels, Bibliothèque Royale, centennial exhibition, 1965; Paris, Galerie de l'Institut, 1966; and Robert Herbert's Neo-Impressionism exhibition at the Guggenheim Museum in New York in 1968. A most gifted, versatile artist, Lemmen still awaits a major retrospective of his oeuvre. [JB]

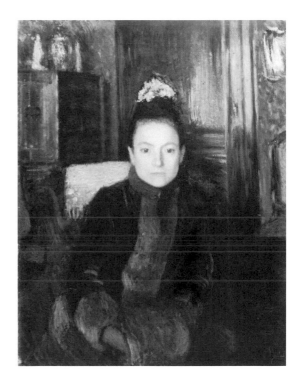

46 **La Visiteuse** 1889
The Visitor
Oil on canvas
68.0 x 53.0 (26³/₄ x 20⁷/₈)
S. N., Brussels

Lemmen depicts his sister Julie attired in fur trimmed coat and muff in an interior setting. Behind her, to the left, are still life elements which adorn the room. The effect of Lemmen's somber palette is modified by passages of light that highlight the sitter's face, the flowers in her hair, and the fabric on the back of the chair. During the group's early years, several members of Les XX (such as Ensor, Khnopff, Toorop, and Van Strydonck) executed similar works. In the choice of subject matter — a domestic interior — the indistinctness of form, and the psychological overtones, Lemmen recalls most closely Ensor's paintings of bourgeois interiors such as *Afternoon at Ostend* (1881). Lemmen's work is very much in the mainstream of Belgian Impressionism, which was based far more upon the tradition of Flemish Realism than on its French counterpart.

According to Marcel Nyns, who has written the sole monograph on Lemmen (*Georges Lemmen* [Antwerp, 1954]), this work was exhibited at Les XX in 1890 under the title *La Dame en Visite*. This work was also shown in Paris at the Galerie André Maurice in 1959, at the *Groupe des XX et son temps* exhibition in Brussels and Otterlo in 1962, and in London (Arts Council of Great Britain, *Autour de 1900: L'Art Belge,* 1965).

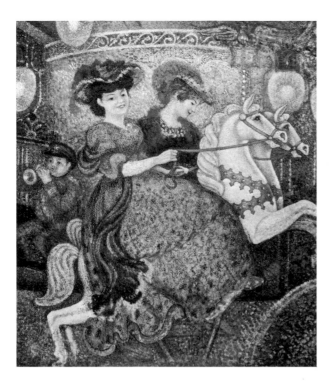

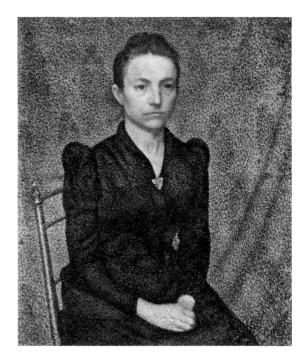

47 **Le Carrousel** 1890–1891
Oil on canvas
123.0 x 105.0 (48¹/₂ x 41³/₈)
Mme. H. Thévenin-Lemmen, Toulon

48 **Portrait of the Artist's Sister** 1891
Oil on canvas
62.2 x 52.0 (24¹/₂ x 20¹/₄)
The Art Institute, Chicago

The Carousel was first exhibited at Les XX in 1892 under the title *Fête foraine (motif de décor)*. It was exhibited several months later under the same title at the Antwerp Association Pour l'Art. Albert Dasnoy (*Peinture Vivante* [Brussels, 1965–1966], vol. 3, no. 23) placed the work around 1895 and Marcel Nyns (*Georges Lemmen* [Antwerp, 1954], p. 10) dated it around 1900. But a letter from Lemmen to Octave Maus dated August 31, 1890 reveals that the artist had already conceived the idea of painting a kermess with a merry-go-round; he asked Maus' aid in securing a model with a dazzling costume for his composition. The artist's daughter, Elisabeth Thévenin-Lemmen possesses a delicate study for *The Carousel* dated November 16, 1890, and Pierre Lemmen, the artist's son, possesses a small oil sketch very similar to the final version.

As Dasnoy suggests, *The Carousel* is an anomaly in Lemmen's oeuvre; usually he prefers to depict his subjects engaged in simple, almost ritualistic indoor activities such as reading and crocheting. However, as with his intimist scenes, *The Carousel* is a work inspired by everyday life. Lemmen was clearly influenced by Seurat, and this work recalls *Le Chahut* (exhibited at Les XX in 1891) in the abstraction and stylization of the horses, the arabesques of the costumes, and the mannequin-like depiction of the models. Lemmen may have thought of *The Carousel* as an homage to Seurat, whose death occurred while he was working on the painting. He owned three of Seurat's drawings — one of which was a study for *Le Chahut* — and lent them to the 1892 memorial exhibition. *The Carousel* has rarely been exhibited. It was included in the 1927 sale of Lemmen's work at the Galerie Giroux in Brussels, and was exhibited in 1959 at the retrospective exhibition of Lemmen's work at the Galerie André Maurice in Paris.

In comparison to the earlier portrait of his sister, this Neo-Impressionist work is greatly simplified and stylized. The artist has stripped away all the still life and background elements present in the 1889 work. Julie's face is no longer soft and prettified; instead, there is a decorative emphasis on the silhouette of her form and costume. Lemmen here is returning to the influence of Northern Renaissance artists such as Dürer and Holbein that marked his early works of 1883–1886. This paring down of detail and abstraction of form seem typical of many Belgian Neo-Impressionist works such as Van de Velde's *Bath House at Blankenberghe*, Rysselberghe's *Sea and Sky* and Finch's *Breakwater at Heyst* (cat. no. 26). Drawing inspiration from everyday life, Lemmen depicted members of his family throughout his lifetime. Portraits of Julie, particularly, abound in his work. She was thirteen years older than her artist brother and died in 1940.

Like so many other Neo-Impressionists, Lemmen became disenchanted with the style. In a letter of March 26, 1903 (Archives de l'Art contemporain, Musées Royaux des Beaux-Arts de Belgique), to Finch, Lemmen criticized the method as too restrictive and lauded Seurat as the only one able "to dominate and soften" it. This work was first exhibited in May 1892 at the Association Pour l'Art (Antwerp) under the title *Mlle. L* and two months later in The Hague (Kunstkring, *Tentoonstilling van Schilderijen en teekeningen van eeningen uit de 'XX' de 'Association Pour l'Art*). More recently it appeared at the Guggenheim Museum's Neo-Impressionism show of 1968 (cat. no. 126).

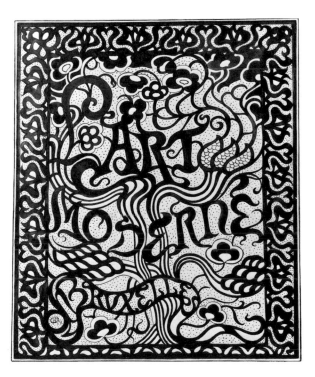

49 **La Tamise** 1892
Thames Scene. The Elevator
Oil on canvas
61.0 x 86.7 (24 x 34¹/₈)
*Museum of Art, Rhode Island School of
Design, Providence*

50 **L'Art Moderne** *circa* 1892
Ink on paper
26.5 x 22.0 (10¹/₂ x 8⁵/₈)
Musée d'Ixelles, Brussels

Lemmen's precarious financial condition thwarted his dreams for extensive travel, but he did manage two trips to England in 1892 and 1894. During his first trip, he executed two major, known Neo-Impressionist works of the Thames. In addition to this painting, a work entitled *Factories on the Bank of the Thames* hangs in the Rijksmuseum Kröller-Müller in Otterlo. For each of these works Lemmen prepared a small oil sketch on a wood panel (similar to his method in painting *The Carousel*, cat. no. 47). The study for the Otterlo work is part of the Altschul Collection and the study for the Rhode Island work belongs to Madame Thévenin-Lemmen.

There is a mysterious stillness to this work created by the insignificance and inactivity of the workers, and the absence of movement on the river. The calm is broken by the billowing smoke at the left, implying an unseen source of energy at odds with the serenity of the Thames. Robert Herbert (New York, The Guggenheim Museum, *Neo-Impressionism*, 1968, pp. 55 and 175) has pointed out the appeal and frequency of the commercial scene to Neo-Impressionist artists such as Albert Dubois-Pillet, Camille Pissarro, and Maximilian Luce. Herbert suggests that, aside from the visual appeal of rendering mist, sea, and sky, these artists may have chosen sites such as these for their "modern" appeal. Lemmen may have been attracted to this site for similar reasons; his choice of subject matter may reflect his concern for the social condition of the working man. In general, however, Lemmen favored figure and still life painting over seascapes — though he also executed several views of the Meuse near Liège, and many small oil panels of Heyst-sur-mer. This painting was exhibited in 1968 at the Neo-Impressionism show at the Guggenheim Museum (cat. no. 130).

Lemmen's drawing for *L'Art Moderne* was exhibited at the last show of Les XX in 1893. It was his second title page for the periodical and appeared from 1894 to 1903. *L'Art Moderne*, a weekly periodical, was founded in March 1881 by Edmond Picard, Octave Maus, Eugène Robert, and Victor Arnould. In 1888, Arnould and Robert left and Émile Verhaeren became the third member of the editorial staff. With Maus as the Secretary of Les XX and the Director of La Libre Esthétique, *L'Art Moderne* was firmly committed to defending and propagating the artistic ideas of these two societies. The name *L'Art Moderne* is synonymous with the most avant-garde movements in art, literature, and music in Belgium. It sought to create controversy and fought to overthrow governmental control over the arts. As a Vingtiste, Lemmen came into contact with the most avant-garde currents of the day, and, an excellent art critic, he often contributed informative and witty articles to *L'Art Moderne* (see for example "La Question des Refusés," *L'Art Moderne*, May 23, 1897, pp. 164–165).

Lemmen designed his first title page for *L'Art Moderne* in 1891, along with his first catalogue cover for Les XX. The second *L'Art Moderne* title page seen here is more typical of the Art Nouveau style in its use of the decorative, vegetal motif. The symbolic importance of line was investigated by numerous Vingtistes and can be seen in works by Jan Toorop, Henry van de Velde and Théo van Rysselberghe. Like Van de Velde and Finch, Lemmen was very interested in the English Arts and Crafts movement; it was he who suggested that Walter Crane be invited to show at Les XX in 1891, and he lent his collection of children's books illustrated by Crane. His own work in graphic design and illustration included contributions to such periodicals as *Le Masque* and *The Savoy,* and several illustrated books, among them, Georges Eekhoud's *La Nouvelle Carthage* (1883), Gustave Kahn's *Limbes de Lumière* (1897), and the typeface for Henry van de Velde's 1908 edition of Nietzsche's *Also sprach Zarathustra*.

**FRANCOIS
MARECHAL
1861–1945**

François Maréchal was the son of a master weapons maker from Housse, and at the age of twelve he went to work in his father's shop. He also undertook lessons with the decorator-painter Delbecke at this time, and, three years later, enrolled in an evening course at the Academy of Feronstrée. Throughout his career, Maréchal was principally engaged in etching, although he also produced paintings and worked in the other graphic media. Beginning in 1885, he became a *plein-airiste,* with a special feeling for the effects of light; his talents were such that he could easily suggest the seasons of the year and the hours of the day. His inspiration came from his environment; he observed Liège and its neighboring villages, the industrial areas, the countryside of the Lower Meuse, and all the people who lived in these places. Like other Realists of his time, he was witness to the social struggles that saddened the last quarter of the nineteenth century, and his pictures expressed the problems of working men and women. In 1902, he went to Italy for three years, and there improved on his ability to paint landscape. He also became a friend of the Italian Naturalist Vaccari and, as a consequence, made drawings of microscopic plants and insects, thus raising scientific drawing to the level of fine art. Maréchal introduced the first engraving course at the Royal Academy in Liège, where he was also the Director, and his graphic work was voluminous, eventually consisting of 728 plates. As a participant in exhibitions held in Brussels (Société des Aquafortistes Belges, 1893 and 1901; Cercle Artistique et Littéraire, 1898 and 1907) and Ghent (Cercle Artistique, 1899), he came into contact with other Belgian artists like Fernand Khnopff and writers such as Georges Eekhoud who mentioned his work in their writing. Maréchal also showed his work in Paris (Salon des Cent, 1896), Marseille (Palais des Beaux-Arts, 1908), Faenza (1908), and Brighton (Public Art Galleries, 1926). [FE]

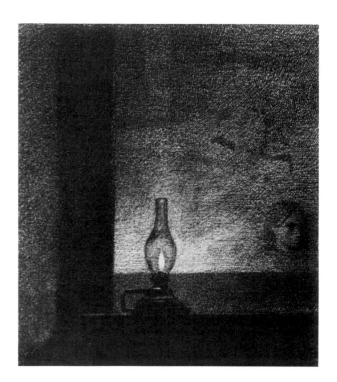

51 **La Lampe** 1888
Ink, charcoal, pastel on paper
16.6 x 14.5 (6½ x 5¾)
Musée des Beaux-Arts, Cabinet des Estampes, Liège

In this tiny drawing, Maréchal is working directly with one of the central preoccupations of Belgian art of the *fin-de-siècle* — the phenomenon of light in darkness. Like Mellery, he uses the white of the paper to show the penetration of light into deep, velvety blacks. The sense of mystery is heightened by the ambiguous presence of a woman's head in the shadows at the right. This drawing, together with the other two in the exhibition, was included in the retrospective exhibition *François Maréchal* at the Belgian House in Cologne, 1979 (cat. no. 77), with full bibliography on the artist.

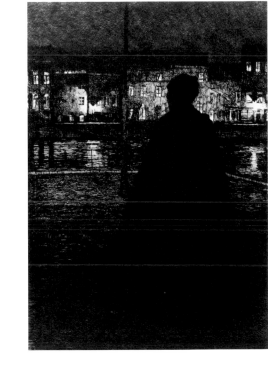

52 **"On Lecheu D'Baie"** 1895
"The Parasite"
Charcoal, Conté crayon, and pencil on
paper
31.3 x 25.8 (12¼ x 10⅛)
*Musée des Beaux-Arts, Cabinet des
Estampes, Liège*

53 **Les Quais le soir** 1906
Evening on the Quays
Etching
44.6 x 30.5 (17½ x 12)
*Musée des Beaux-Arts, Cabinet des
Estampes, Liège*

This drawing was made at a time when the city of Liège was undergoing an industrial crisis which put great hardship on unemployed workers. As often happens, the more secure members of society referred to those in need of help as "parasites": hence the ironic title. Maréchal shows us a workman with nothing to do, sitting on the bank of the River Meuse, staring at nothing with a bitter face. In a manner typical of the artist, the mood is created not by rhetoric or drama but by means of simple description in terms of light and shade. (*François Maréchal*, 1979, no. 79.)

The poetry of the night and the riverside of his native Liège fascinated François Maréchal. In the composition of this large etching — one of his most beautiful — he uses the contrasts between a number of elements to give it form: shadow and light, motion and stillness, liquid and solid. There is a sense of the strength of attraction that water has for a disturbed mind. The motif of the solitary figure seen from behind, which Caspar David Friedrich contributed to the vocabulary of Romanticism, is given effective expression here within the terms of Maréchal's Realist style and the etching technique. The black shape of the isolated woman, merged with the deep shadow around her, looms against the flickering white of the buildings across the river, creating a brooding image which goes beyond anecdote or local description. Maréchal treated the theme of solitude and waiting many times in his work; in "The Parasite" (cat. no. 52) the theme has a specific social context, while in this work the affinities with Symbolism are more apparent. Pierre Somville has written of the role of this theme in Symbolist art in "Les Artistes Symbolistes en Wallonie" (*La Wallonie, le pays et les hommes* [Brussels: La Renaissance du Livre, 1978], p. 547). (*François Maréchal*, 1979, cat. no. 40.)

XAVIER MELLERY
1845–1921

Xavier Mellery was born in 1845 at Laeken, a suburb of Brussels near the Royal Palace Park, where his father was a gardener. A talented draftsman, he was started early on an apprenticeship with the painter-decorator Charles Albert, and in 1860 began classes at the Brussels Academy where he continued to study until 1867. In 1870, Mellery won the Prix de Rome. As he traveled across Germany and through the cities of Italy his enthusiasm for the artists of the Renaissance mounted and, in the hope of emulating them, he made many drawings after their works. In these pictures, he had already begun to show his interest in drawing style, paying close attention to comparative values in tonality and degrees of lighting. Around 1878–1879, Charles de Coster asked him to illustrate a book about Zeeland and, as a result, Mellery went to stay on the island of Marken not far off the coast of Amsterdam — an experience which affected him deeply and produced numerous paintings and drawings. In 1882, he made the preparatory designs for the small bronze personifications of different trades — now surrounding the little park of the Petite Sablon in Brussels — and a few years later created the symbolic figures adorning one of the façades on the Palais des Beaux-Arts, today's Musée d'Art Ancien. He also made the illustrations for Camille Lemonnier's "La Belgique," which was published in *Le Tour du Monde* in 1888. He was an exhibitor with Les XX in 1885, 1888, 1890, and 1892, and with La Libre Esthétique in 1894, 1895, 1899, and 1908. Mellery lived in the world of imagination, an atmosphere in which he lingered in order to understand the life of inanimate objects. At exhibitions, he showed a wide-ranging complexity of work: meditative paintings; small, hushed drawings of a velvety obscurity, sometimes so austere as to verge on abstraction; or allegorical compositions on golden backgrounds — an extroverted reversal of the same ideas sensed in his intimist works. Works in the more introverted style were grouped by the artist himself under the name "L'Âme des Choses" (The Soul of Things), while his allegories were designated as part of a "modern synthesis." It was Mellery who, as Khnopff's teacher, introduced him to the spiritual world of symbol and mystery, the contemplation of objects, silence, time and space. His career was crowned officially by membership in the Royal Academy of Belgium, and in 1921 he died, where he was born, in Laeken. [SH]

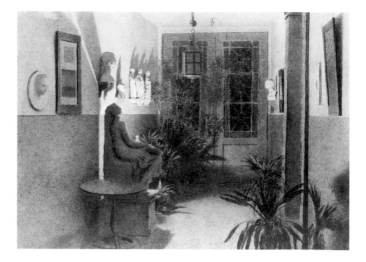

54 **L'Entrée de l'Atelier** *circa* 1889
Entrance to the Studio
Black chalk and ink with wash on paper
54.0 x 75.0 (21¼ x 29½)
Hilda Vanderhaegen, Ghent

This drawing is part of the group Mellery called *La Vie des Choses (The Life of Things)*, three of which were exhibited in Brussels at the Salon des Aquarellistes in 1889 and in Namur the same year at the *Exposition Internationale et Triennale des Beaux-Arts*. The drawing was described in a review of the first exhibition as: "This vestibule, feebly lit by a lamp which gives hallucinatory glimpses of silhouettes on the walls . . ." (*L'Art Moderne*, 1889, p. 139). On December 19, 1889, Mellery wrote to Maus that he would like to show these drawings again at Les XX in 1890, because they were not well seen at the Aquarellistes (Fonds XX, #5281, Archives de l'Art contemporain, Musées Royaux des Beaux-Arts de Belgique). Seven drawings, including this one, were shown at Les XX, under the title *La Vie des Choses*. Our drawing was included again in the group, now titled *L'Âme des Choses (The Soul of Things)*, which was shown at La Libre Esthétique of 1895. The hallway shown is outside of Mellery's studio in his house at Laeken. The sculpture of the seated figure at the left is *La Poverella* by Paul Devigne, which appears in several other of the artist's drawings. Characteristically, Mellery makes a familiar place mysterious by the subtle play of darks and lights. As one critic said of this group of drawings, "X. Mellery triumphs. His three drawings are astonishing; they seem to represent nothing but deserted interiors, and yet they are haunted by something alive" (*L'Art Moderne*, 1889, p. 203).

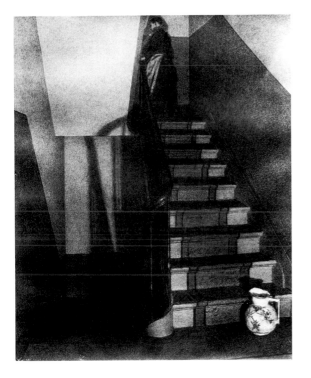

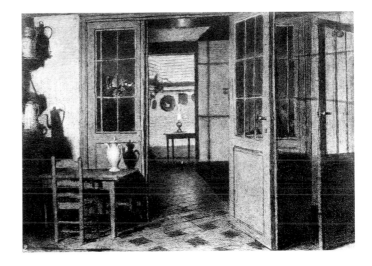

55 **L'Escalier** *circa* 1889
The Staircase
Black chalk and sanguine on paper
57.0 x 45.0 (22¹/₂ x 17³/₄)
*Koninklijk Museum voor Schone
Kunsten, Antwerp*

56 **Intérieur de cuisine** 1890
Kitchen Interior
Black chalk, white chalk, ink and wash
on paper mounted on cardboard
56.0 x 78.0 (22 x 30³/₄)
*Koninklijk Museum voor Schone
Kunsten, Antwerp*

This drawing, like the preceding one, was one of those exhibited first at the Aquarellistes in Brussels in 1889, in Namur, and again in February of 1890 at Les XX, under the title *La Vie des Choses*. In the first exhibition it was called *Escalier au pot blanc (Stairway with white pot)*, and it is further identified by a description in *L'Art Moderne* (1889, p. 139): ". . . this steep stairway which has just been climbed — one might almost say furtively — by a woman, a servant, or housekeeper; who knows what humble, poor or mild person." The stairway was a favorite motif in Mellery's work. Its ancient symbolism of aspiration and spiritual ascent is incorporated into Mellery's feeling for the mystery of domestic surroundings. He plays with the form — its linear design, its planes and volumes — sometimes becoming nearly abstract, as in this Antwerp drawing, one of his most beautiful representations of a stairway. The left side of the drawing, if isolated, might be taken for a Cubist or Suprematist work. The planar rhythms create a calm, structured environment, lit by fugitive reflections: at the foot of the stairs, a pitcher glimmers like the moon. The drawing was exhibited again in 1895 at La Libre Esthétique together with others under the title *Emotions d'Art, l'Âme des Choses (Emotions of Art, the Soul of Things)*. The source of this title, *L'Âme des Choses*, is a poem by Hector Chainaye first published in 1887; but by the time Mellery used the phrase it had become a Symbolist poetic idea (see pages 49–50). In spirit, Mellery is closer to the poetry of Georges Rodenbach, who often used the image of the silent, night-lit room. In this century *The Stairway* has been exhibited in Paris (*L'Art belge ancien et moderne*, 1923, no. 67) and in Brussels (*Rétrospective Mellery*, 1937, no. 97).

Kitchens were among Mellery's favorite subjects from early in his career. The early examples have an anecdotal character, but he soon went beyond this to endow this room with a sense of being a sanctuary; he approached the motif with seriousness and respect. The drawing of the empty kitchen exhibited here is without doubt the most beautiful, the most intellectual in its equilibrium, and the most Symbolist of all his works on this theme. We confront doors which open on other doors, spaces which lengthen into other, more secret spaces; it is a labyrinth of planes and lines, projected shadows, and overlapping reflections. A strange light emanates from a source outside the picture, illuminating the white pots which throw echoing shadows on the wall and door. There is a subtle rhythm here, a calculated harmony, based on a childhood memory but now transmuted into an image of inner experience and silent mystery. In recent years the drawing has been exhibited in *Le Mouvement Symbolist* (Brussels, Musées Royaux des Beaux-Arts de Belgique, 1957, no. 798) and in *Les Sources du XXᵉ Siècle* (Paris, Musée Nationale d'Art Moderne, 1960–1961, no. 442).

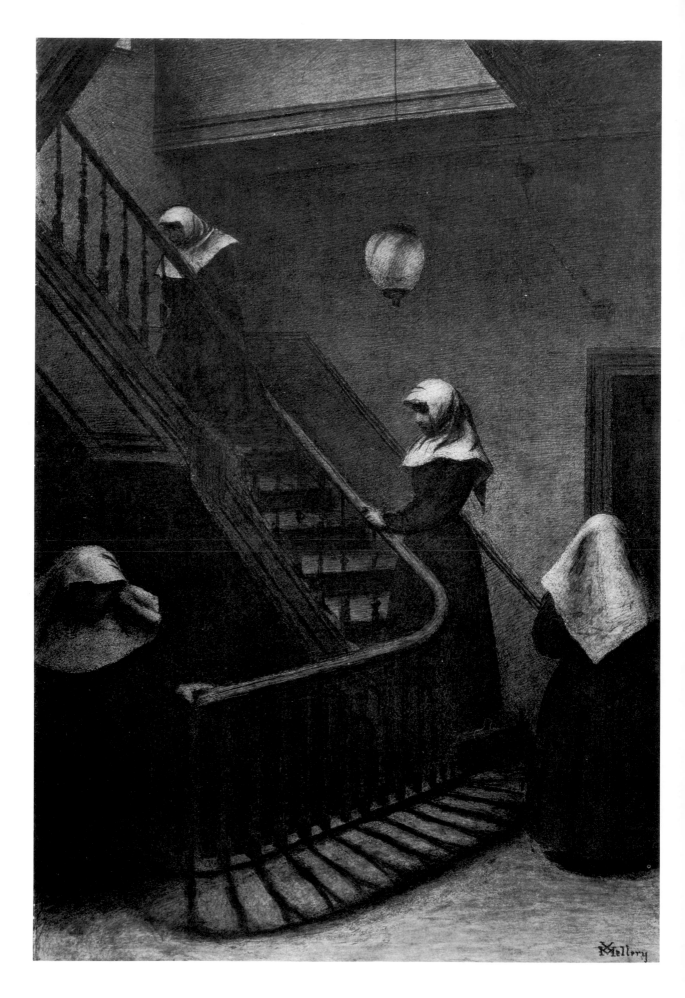

57 **Après la prière du soir** *circa* 1900
After Evening Prayers
Black chalk and sanguine, with ink and
wash on paper
100.0 x 70.0 (39 x 27½)
Musée d'Ixelles, Brussels
Illustrated on facing page

58 **Terpsichore** *circa* 1894
Conté crayon and watercolor on paper
mounted on gilded board
58.0 x 78.0 (22⅞ x 30¾)
*Musées Royaux des Beaux-Arts de
Belgique, Brussels*

After Evening Prayers, also called *After the Service* or *Return from the Service,* uses as a model a different staircase than the one seen in the Antwerp drawing (cat. no. 55). The steep, straight staircase represented in that work was in Mellery's family home, which was destroyed around 1897, while the one shown here still exists in the house he built on the same site in 1898 (*Bulletin des Musées Royaux des Beaux-Arts de Belgique,* February 2, 1964, p. 28, note 3 and pp. 38–39, figs. 11 and 12). In this drawing, however, he moves from domestic surroundings to another favorite theme, that of the cloistered life of nuns. His works on this theme are only a step away from his "secular" interiors; the traditional religious symbol only inflects, or makes more explicit, the sense of silent meditation that pervades this whole series of drawings. As so often in these works, the source of light is ambiguous; here the evenly spaced white coifs themselves seem to glow in the dim stairwell, and a ritual effect is achieved through the measured repetition of the dark habits and simplified forms. Their calm rhythm is echoed in the quicker beat of the railing and its shadows, increasing the sense of silent movement taking place against this spatial punctuation. *After Evening Prayers* was exhibited at the Brussels Salon des Aquarellistes in 1912 (cat. no. 107), the same year in which it was bought from the artist for the Ixelles museum. It has most recently been shown in *Painters of the Mind's Eye: Belgian Symbolists and Surrealists* (New York Cultural Center and Houston Museum of Fine Arts, 1974–1975, no. 39) and in *Post-Impressionism: Cross-currents in European Painting* (London, Royal Academy of Arts, 1979–1980, no. 405).

Mellery sought to express two things in his art. He aspired toward the creation of a monumental decorative art, destined for history, and, more frequently, made work on a modest scale with an internalized aspect to its content. "The first," said Octave Maus, writing in *L'Art Moderne* (1891, p. 13), "because of its decorative eloquence, its message, its harmony with architecture, includes the whole range of Art." *Terpsichore* illustrates this conviction perfectly. The muse of the dance stands nude, between two companions clad in floating tunics; as a group they express strength, grace, rhythm and eternal balance, a sensual vision of reverie. The gold background creates an effect of timelessness, converting the dancers into iconic figures. At the same time, the figures are fully modeled by soft, tonal means which creates an illusion both of weight and surrounding atmosphere. This dichotomy between figure and ground was characteristic of Mellery's allegorical work, which had many contemporary admirers. The artist dreamed of making mural decorations for the public buildings of Brussels, but the commissions were never secured. *Terpsichore* was first shown at the Aquarellistes Salon of 1894 in Brussels (cat. no. 109), and most recently in Brussels (*De l'Allégorie au Symbole,* 1968, no. 31), Paris, New York, and Houston (*Peintres de l'Imaginaire: Symbolistes et Surréalistes Belges,* 1972, no. 58; *Painters of the Mind's Eye: Belgian Symbolists and Surrealists,* 1974–1975, no. 33).

59 La Delicatesse est Fille de la Force
circa 1894
Delicacy is the Daughter of Strength
Conté crayon and watercolor on paper
mounted on gilded board
79.0 x 57.0 (31¹/₈ x 22¹/₂)
*Musées Royaux des Beaux-Arts de
Belgique, Brussels*

There is little doubt that this work was conceived with a large
decorative project — probably a fresco — in mind. It should also
be compared to a number of designs that Mellery made for di-
plomas and posters, with messages of social or moral significance.
(*L'Art Moderne,* 1891, p. 382.) Here, Mellery uses the ancient allegori-
cal device of personification to express a somewhat subtle moral
idea: that delicacy, far from being — as is commonly supposed — the
opposite of strength, is rather an outgrowth of it. The work was first
exhibited at La Libre Esthétique in 1894 (no. 288), and entered
the Brussels museum collection in 1909. It was shown in the
Mellery retrospective at the Brussels museum (1937, no. 92) and
most recently in London (Arts Council of Great Britain, *Autour de
1900: l'Art Belge,* 1965, no. 34) and Ostend (Musée des Beaux-Arts,
Europa 1900, 1967, no. 66).

**CHARLES
MERTENS
1865–1919**

Charles Mertens grew up in Antwerp,
beginning his studies at the Academy
there under Charles Verlat. In 1883, he
became a member of the Antwerp circle
of painters, Als Ik Kan. His early works
were realistic and very precisely-painted
genre scenes, often of interiors with one
or more figures, in the tradition of Henri
de Braekeleer. Mertens became a
professor at the Academy in Antwerp in
1886 and then developed a freer and
broader technique of painting, in which
the role of natural light and its influence
on color became more and more
important. When he started painting in
the open air, his works became larger;
1890 marks the beginning of this evolu-
tion. He eventually resigned from the
traditionally conservative Als Ik Kan and,
in 1891, was one of the founders of the
group of artists called Les XIII. Mertens
often painted in Zeeland, where he
found inspiration for very bright and
sensitive works. He helped in establish-
ing Kunst van Heden (Art of Today) in
1905, a group begun in Antwerp by
connoisseurs and artists who wanted to
make modern Belgian art better known.
Mertens was asked to decorate the
ceiling of the Royal Flemish Opera in
Antwerp (opened in 1907) and the
painting he made for it on canvas was
installed in 1910. The subject chosen
was *ritmus,* the rhythm of universal
harmony that fixes the pace of humanity.
The theme was inspired by the
"Confessions" of Hegenscheidt,
published in the art periodical *Van Nu
en Straks.* At the outbreak of the First
World War, Mertens went to England,
where his work grew more atmospheric
and the tones of his palette softened.
[DC]

60 **De Broodstooi** n.d.
The Bridal Finery
Oil on canvas
84.0 x 108.0 (33¹/₈ x 42¹/₂)
*Koninklijk Museum voor Schone
Kunsten, Antwerp*

61 **Zeeuws Paar** n.d.
Couple in Zeeland
Pastel on paper
37.0 x 58.0 (14⁵/₈ x 20⁷/₈)
*Koninklijk Museum voor Schone
Kunsten, Antwerp*
Reproduced in color on page 130

In this scene out of the life of Zeeland farmers, Mertens observes closely, but without indulging in anecdote or in any of the sentimentality that such a subject could inspire. On the contrary, the dim room with its shafts of light, the stiff, almost strained silence of the bride, and the bowed figure of the attendant create a mood quite different from what one might expect. As in Ensor's "salons bourgeois," the light penetrates an interior that seems palpably heavy, its weight pressing down upon the figures within it. When it was exhibited in 1922, a critic noted its "severity and sober power" (*Veilingscatalogue Atelier Charles Mertens* [Antwerp, 1922]). Since that date it has been exhibited only once (Antwerp, Als Ik Kan, 1975, p. 44). [SF]

In this work, Mertens employs a Naturalist technique and subject to create a work that comes close to the mood of Symbolism. The two heads are brought up to the surface of the picture plane, with little to define the space between them and the middle-ground details. Thus they impose themselves in an unsettling way, like some of the heads of Khnopff and Delville. Their gazes are separately directed and unfocused, so that they seem to dream, immersed in their private thoughts. At the same time, their distinctive features and weather-beaten skins are described in scrupulous detail; this sharp-focus realism, realized in the soft medium of pastel, contributes to the oddly disturbing quality of the image. *Couple in Zeeland*, like *The Bridal Finery*, has not been shown before outside of Belgium. It was exhibited in Antwerp, in *Keurtentoonstelling van Belgische Meesters 1830–1914*, 1920, no. 139; and with Als Ik Kan, 1975, p. 44. [SF]

Meunier was born in Brussels, and at the age of sixteen, entered the Academy there to take courses with the sculptor Charles A. Fraikin. But because sculpture as a medium was still imprisoned by rigid rules of academism, Meunier found it too restricted for his artistic aspirations. Instead, he began in 1854 to work with Navez at his *atelier*. There he formed friendships with Charles de Groux, Louis Dubois, Félicien Rops and others who, in 1868, would become founding members of the Société Libre des Beaux-Arts in Brussels. With them, Meunier attended an "atelier libre," thereby joining the Realist avant-garde. In the years 1857–1875, he painted mostly religious pictures, followed by history scenes, which he then abandoned around 1878 when he discovered factory life as a subject. Beginning in 1880, he exhibited work dedicated to the industrial world and a year later made a trip through the Black Country and its coal mines with the writer Camille Lemonnier. Just as Meunier was discovering the focus for his true interests, the government sent him to Seville — from October of 1882 to April of 1883 — to copy a *Descent from the Cross* of Flemish origin. Shortly after his return to Brussels (probably in 1884), Meunier took up sculpture again. From that period on, he used painting, sculpture, and drawing as perfect complements to one another in describing the worker at his work. After the showing of his sculpture, *The Hammerer*, at the Paris Salon of 1886, he became well known, and in 1887 was offered a teaching position at the Louvain Academy, which assured him of relative material security. It was here that he made some of the pieces that became most significant for the germination of his *Monument to Work* project. Meunier returned to Brussels in 1894 — his reputation having grown considerably — and two years later Samuel Bing, who had just opened his Paris gallery, L'Art Nouveau, organized a retrospective of his work. In 1897, his sculpture was exceptionally well received in Dresden, as it was the following year in Berlin. He began to exhibit regularly all over Europe and the press declared him to be Rodin's equal. Meunier continued to work non-stop, until the day he died, in the studio-house he had built on the outskirts of Brussels — which today is his museum. [PB]

CONSTANTIN MEUNIER
1831–1905

62 **Mineurs à la descente** n.d.
Miners Descending
Grease pencil, sanguine, white and
orange chalk on papier chamois
76.5 x 56.0 (30¼ x 22)
Musées Royaux des Beaux-Arts de Belgique, Brussels

The works Meunier showed at the Salon of La Libre Esthétique in 1895 included — besides twenty important sculptures — a group of pastels and reworked drawings. One critic noted how strongly the works on paper confirmed the robust character of all his oeuvre: "Here, in his choice of objects: dikes, scaffolding, enormous chimneys, gigantic hangars, he reveals his taste for things with character, for the picturesque. It is the strength of wood, of iron, and of steel which he celebrates . . ." ("La Libre Esthétique," *L'Art Moderne*, March 3, 1895). These elements — walls, machinery, and metal framework — are dominant, overriding the vigor of man himself. They have become the principal actors on Verlaine's "brutal sites," where industrial work takes place. This territory of the Agrappe and Avaleresse coal mines and pits is, in reality, more evocative of inhumanity than the "Voreux" that Zola invented for his novel *Germinal*.

63 Coin de fabrique d'acier n.d.
Corner of a Steel Factory
Charcoal, pastel, and white chalk on
paper
88.4 x 74.0 (34³/₄ x 29¹/₈)
Musée Constantin Meunier, Brussels

64 Pont sur la Tamise (Londres III) *circa*
1898
Bridge on the Thames (London III)
Grease pencil on paper
47.0 x 73.0 (18¹/₂ x 28³/₄)
Musée Constantin Meunier, Brussels

In 1878, while staying with Daniel de Groux, the son of his old friend Charles de Groux, Meunier discovered the laminating presses of Régissa. He would later visit other revealing sites — glass plants, factories of all sorts, coal mines. "Chance," he wrote to Georg Treu, Director of the Dresden Museum, "led me to the Black Country, the industrial land. I was struck by this tragic and wild beauty. I sensed a revelation of my life's creative work" (Georg Treu, *Constantin Meunier* [Dresden, 1898], p. 23). "Meunier," says another author, "wants to know the secrets of the coal mine, of the factories in Liège, of Val-Saint-Lambert, of Cockerill at Seraing, of the glass manufacturers of the Sambre and the industrial shops of Charleroi. The first works made by Meunier in the Black Country, from Liège to Cockerill, were all studies consecrated to constructions and buildings called, in the style of the landscapist, 'fabriques' [factories]" (*Catalogue complet des oeuvres dessinées, peintes et sculptées de Constantin Meunier* [Louvain, 1909], p. 32). Here we see the "fabriques" whose fire and smoke dominate the human factor, reducing it in scale, reversing the order of values. We are certainly in the "country of russet braziers and tragic factories" as described by Émile Verhaeren.

This drawing belongs to a series of four works treating the same theme, but is without doubt the most astonishing of them due to its power and unusual composition. It is neither the bridge itself nor the Thames which seems to interest the artist here, but rather the detail of the pilings that support the architecture. They are shown in very eccentric perspective, appearing enormous, monstrous, nearly animalistic. Meunier made many drawings of the Thames and its banks; some of the most beautiful of them are very nearly Neo-Impressionist in treatment. None are dated. It is known, however, that Meunier made a trip to London in 1898 (Octave Maus, "Alphonse Legros," *L'Art Moderne*, July 8, 1900, pp. 214–215). In any case, here, as in a number of his works, the accomplished, mature style of this artist reveals the degree to which he was fascinated by the static and monumental power of those things that are apparently inanimate.

Charles Mertens
Zeeuws Paar n.d.
Couple in Zeeland
Cat. no. 61

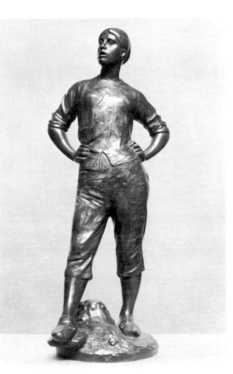

65 **Étude pour une fécondité**
circa 1904–1905
Study for Fecundity
Charcoal on paper
64.8 x 49.9 (25¹/₂ x 19⁵/₈)
Musée Constantin Meunier, Brussels

66 **Hiercheuse appelant** 1888
A "Rammer" Calling Out
Bronze, *patine verte*
68.0 x 27.0 x 30.0 (26³/₄ x 10⁵/₈ x 11³/₄)
Musée Constantin Meunier, Brussels

This is one of four preparatory drawings for the sculpture group called *Fecundity* which Meunier intended as a monument to Émile Zola. He accepted the commission for this work, in collaboration with the French sculptor Alexandre Charpentier, in February of 1903. In Meunier's mind, the representation of *Fecundity*, together with other groups symbolizing *Work* and *Truth,* perfectly synthesized the career of this writer whom he so greatly admired. *Fecundity* was developed simultaneously with the *Monument to Work,* which embodied the theme that remained close to his heart during the remainder of his life. Meunier was working on *Fecundity* the day before he died — April 3, 1905. The drawing, certainly one of Meunier's last, is very close to the large plaster model for the sculpture, which shows a mother nursing her newborn baby, while with her left arm she protects another child who kneels at her side. Both works demonstrate the same power and, at the same time, simplicity of conception, so characteristic of this artist.

Meunier made studies of women, especially in sculpture, chiefly to express the sadness of life, to describe motherhood, in which tenderness and strength combine, or to speak of the desolation of old age. However, his sensitivity to the beauty of young bodies and feminine grace — pure though fleeting — is expressed in some rare representations of the "hiercheuses," who worked in the mines. Naturally severe in his style, Meunier was, nevertheless, struck by the fragile charm and sometimes by the courage of these young girls, employed for some of the most exhausting tasks: to push or load the wagonettes at the depths of the mines. With the evolution of social legislation, these conditions terminated. When Meunier made this sculpture, there may have been several hundred such girls in the coal pits of Hainaut but, by the time he died, there were no more than a few dozen.

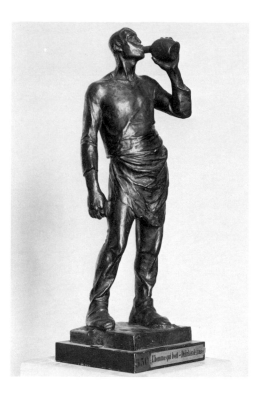

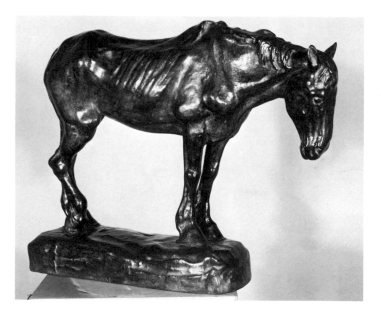

67 **L'homme qui boit** 1890
Man Drinking
Bronze
49.5 x 16.2 x 14.7 (19¹/₂ x 6³/₈ x 5³/₄)
Musée Constantin Meunier, Brussels

68 **Vieux cheval de mine** 1890
Old (Coal) Mine Horse
Bronze
36.5 x 49.0 x 14.6 (14³/₈ x 19¹/₄ x 5³/₄)
Musée Constantin Meunier, Brussels

This worker quenching his thirst, a small piece executed around 1890 in the studio at Louvain, was shown for the first time at the exhibition held by Samuel Bing in Paris during February and March of 1896 — probably at the suggestion of Meunier's friend, Henry van de Velde. It is strange that Meunier had not exhibited this little masterpiece earlier, since he was extremely fond of the intensity its movement conveyed, banal though the gesture was in itself. The artist shows us a familiar action, modeling the figure with only the most essential lines of description — those which immediately reinforce its character — just like his marvelous drawings made with broad strokes of charcoal. Through this simplification, which sacrifices detail, our attention is drawn exclusively to the physical attitude of the man as he drinks; we discard the anecdote in favor of the archetype. A work such as this makes us believe that Meunier was incapable of producing a sculpture, no matter how small, that was not a major piece.

Together with *Coal Gas, Man Drinking* (cat. no. 67), and *Woman of the People,* this is certainly one of Meunier's most important sculptures, despite its relatively small size. In 1893, it was seen at the triennial Salon in Brussels as well as at the Paris Salon, and the following year Meunier sent it to the first exhibition held by La Libre Esthétique, in Brussels. One critic wrote: "In this old hack, with his emaciated legs, withered body, and bulging sides, the artist has brought together all the tortures and vicissitudes of life. He [the horse] has stopped for a last rest before dying. We know that his head, lowered in meditation, will never be raised to the sky again, that his feet will never take another step, that his body will only move again when it falls to the ground" (Hubert Krains, "Le Salon de La Libre Esthétique II," (Brussels, *Les Beaux-Arts,* April 8, 1894). The same author also said that Meunier had achieved an eloquence in this piece that was equal to Tolstoy's *Death of the Horse.* But still another literary analogy might be made between Bataille, from Zola's *Germinal,* who "remained with lowered head, trembling on his old feet, making futile attempts to remember the sun." The idea for this work must have occurred to Meunier at the same time as that for *Coal Gas* when, in March of 1887, a terrible gas explosion took place in the Boule du Rieu du Coeur pits at Quaregnon and one hundred and thirteen miners were killed. He saw an old horse there, brought back to work in the mines, who expressed sadness in every line. There is a drawing, very close to the sculpture, that was undoubtedly done from life at that time and is now in the Musée Constantin Meunier. There is also a horse of the same sort in the little oil painting, *Coal Mine in the Snow,* now in the Musées Royaux des Beaux-Arts de Belgique.

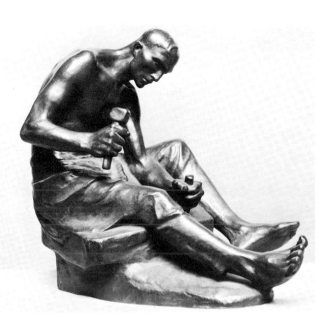

69 **Le Tailleur de pierres** 1898
The Stonecutter
Bronze
34.0 x 26.0 x 41.5 (13³/₈ x 10¹/₄ x 16³/₈)
Musée Constantin Meunier, Brussels

GEORGE
MINNE
1866–1941

The sculptor and designer George Minne belongs to the generation that produced Symbolist literature. He was born in Ghent and his early studies were in architecture at the Academy there (1882–1884), but in 1885 he turned to sculpture. He was a great admirer of Rodin, meeting him in 1890, and also became a friend of the poet Maurice Maeterlinck, who introduced him to other Symbolist writers: Grégoire Le Roy, Émile Verhaeren, and Charles van Lerberghe. Minne illustrated Maeterlinck's *Serres Chaudes* (1880) and Verhaeren's *Villages Illusoires* (1894) as well as other Symbolist works. These contacts influenced his own work powerfully. He was also strongly effected by Gothic sculpture. In 1891 and 1892, he exhibited with Les XX, to which he had already been invited the previous year. In Brussels for three years beginning in 1895, Minne introduced the motif of the kneeling youth to his work, and later developed it in his best-known sculpture, the *Fountain with Kneeling Youths,* which stands near the cathedral of St. Bavo in Ghent (see *Kneeling Youth,* cat. no. 74). He established himself at Laethem-St.-Martin in 1899 and became the leading figure of the first group of artists in this colony, later known as the Symbolists. There he made a number of religious drawings composed in spiral movements and, in 1908, another series based on the theme of "Mother and Child." Between 1900 and 1914, Minne went through a period of doubt and distress about his work and produced only naturalistic figures and portraits. He stayed in Wales with his family and some of the other Symbolists during the war years, and his work there also expressed insecurity. A series based on the *Pietà* was especially moving; he continued to use the motif after the war. In 1921, he returned to sculpture and some of his earlier themes, but using rounder, softer forms. His oeuvre characteristically contains only a few motifs to which he returned repeatedly in both sculpture and drawing. [DC]

Meunier's work after 1880 — and particularly his sculpture from 1885 on — is chiefly concerned with the world of the miner and the metalworking industries, though his interest in all types of labor continued to grow at the same time. Even before discovering the Black Country, he had chosen the worker and his work as thematic material. He himself said, "My studies of reapers began when I was twenty-seven, and those of brickmakers about the time when I was just married" (*Catalogue complet des oeuvres dessinées, peintes et sculptées de Constantin Meunier* [Louvain, 1909], p. 24). This places the origins of his special interest between 1858 and the date of his marriage in 1862. After 1880, he also seems to have discovered a motif in the work of the stevedores on the Antwerp docks, a subject that he treated in one of his first sculptures, made in 1884 and shown at Les XX in 1885. Subsequently, and particularly in the closing years of his life, Meunier created many types of workers: fishermen from the Belgian coast, blacksmiths, iron founders, glassmakers, quarriers, woodcutters, various peasants, and, finally, stonecutters — a world of statuettes, often described in lines of great purity and quintessential gesture.

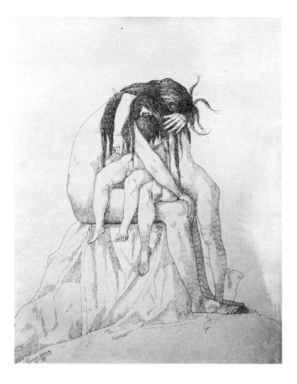

70 **Mère pleurant ses deux enfants** 1888
Mother Weeping over Her Two Children
Ink on paper with wash
36.0 x 26.7 (14¹/₈ x 10¹/₂)
Raskin-Le Roy, Brussels

71 **Mère Éplorée** 1890
Mourning Mother
Pencil on paper
39.0 x 29.0 (15³/₈ x 11³/₈)
Le Cerff-Le Roy, Brussels

One of Minne's earliest and most constant themes was that of the mother in anguish, either sheltering or mourning her child. Pierre Baudoin has suggested that such an obsessive theme was less likely to have arisen from a specific childhood experience (i.e., the sight of refugees from battle in the Franco-Prussian war) than from the unconscious memories of a fearful, overprotective mother, mixed with his own youthful efforts to find his way as an artist in the face of parental disapproval (Brussels, Musées Royaux des Beaux-Arts de Belgique, *Meunier-Minne,* 1969, n.p.). This drawing was one of three exhibited at Les XX in 1891, belonging to the poet Grégoire Le Roy — for whose book, *Mon Coeur Pleure d'Autrefois,* Minne had made illustrations on this theme in 1889. It drew critical praise: ". . . the tenderest work on exhibition was the wonderful drawing on green-tinted paper by George Minne. With the simplicity of a Gothic woodcut, the group sharply defines the melancholy quality of life . . . all this misery expresses the wretched suffering of our spirit and our flesh" (G. Vermeylen, *De Vlaamsche School* 4, 1891, p. 186).

This drawing, too, was one of those that Grégoire Le Roy loaned to the 1891 Les XX exhibition. It drew the attention of Verhaeren, who wrote of it, "It is essential sorrow, sadness beyond all reasoning, anguish before any sin — in a word, the elemental human soul . . ." (*La Nation,* January 5, 1891). Francine-Claire Legrand has remarked that this image is the art of Buchenwald *avant la lettre.* (Paris, Rotterdam et al., *Le Symbolisme en Europe,* 1975–1976, cat. no. 129 with full bibliography and exhibition history.) Certainly the cruel realism of the infant corpse is an extraordinary invention for a dreamy youth from a comfortable home in Ghent.

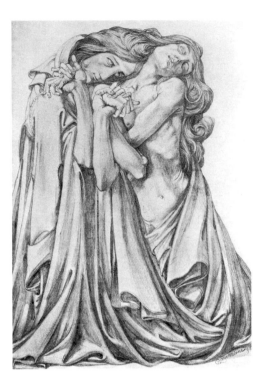

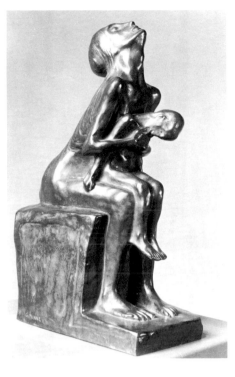

72 **Les Réprouvés** 1898
The Condemned
Lithograph
26.8 x 18.2 (10¹/₂ x 7¹/₈)
Bibliothèque Royale, Brussels

73 **Mère pleurant son enfant mort** 1886
Mother Mourning Her Dead Child
Bronze
45.5 x 15.0 x 27.0 (17¹/₂ x 5⁷/₈ x 10⁵/₈)
*Musées Royaux des Beaux-Arts de
Belgique, Brussels*

In this composition Minne makes explicit the medievalism that is so strong a force in his art. Not only the theological subject, but the twisted angularity of the forms — in particular, the hands — recall late Gothic sculpture. The motif of flowing hair, so favored by the Symbolists, is especially striking here. This work has been exhibited in Paris (Musée Nationale de l'Art Moderne, *Les Sources du XX^e siècle*, 1960–1961, no. 452), Knokke (*Het Symbolisme in Belgie*, 1974, no. 50), and Paris, Rotterdam et al. (*Le Symbolisme en Europe*, 1975–1976, no. 130).

This sculpture is the earliest in Minne's oeuvre on the theme of the mourning mother. It was made when he was only twenty, in the year when he met Maeterlinck and became part of the circle of Symbolist poets. Verhaeren, writing of the Les XX exhibition of 1891 at which both Minne and Meunier exhibited, drew the contrast between the two figural sculptors — Minne, totally absorbed with inner states of feeling; Meunier, the observer of the working-man in his outward conditions of life (*La Nation*, December 5, 1891). This work was exhibited in London (Arts Council of Great Britain, *Autour de 1900: l'Art Belge*, 1965, cat. no. 36) and in Brussels (Musées Royaux des Beaux-Arts de Belgique, *Meunier-Minne*, 1969, no. 81).

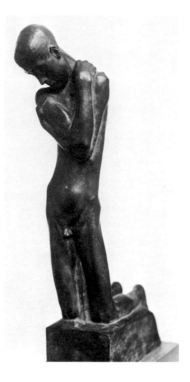

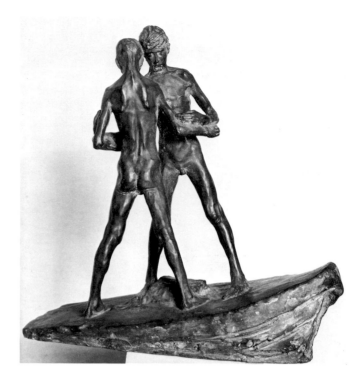

74 **De Geknielde** 1898
Kneeling Youth
Bronze
Height: 78.0 (30³/₄)
Museum voor Schone Kunsten, Ghent

75 **Solidarité** 1898
Bronze
66.5 x 67.0 x 26.5 (26¹/₄ x 26³/₈ x 10¹/₂)
*Musées Royaux des Beaux-Arts de
Belgique, Brussels*

Minne settled in Brussels in 1895, and around this time a new theme appeared in his sculpture, that of the kneeling adolescent boy. This series took several forms, the best-known of which is exemplified by the *Kneeling Youth* shown here, his arms folded over his chest in a self-protecting gesture. Five of these figures, in larger scale and placed in a circle, form the *Fountain of Kneeling Youths* — called "The Narcissus Fountain" by the poet Karel van de Woestijne — which is near the Cathedral of St. Bavo in the city of Ghent. The project for the fountain was shown at La Libre Esthétique of 1899. Though criticized at the time, the fountain became the major work of Symbolist sculpture. More than one observer has noted the direct influence of this ascetic, introverted figure on the work of the young Wilhelm Lehmbruck.

As Baudson points out (Brussels, *Meunier-Minne*, 1969, n.p.), the several images of the youth in Minne's sculpture — the wounded boy, the reliquary-bearer, the kneeling boy — all have in common a self-enclosure and a hesitation to emerge into space, which is expressed by the need for some kind of support. In this work, the forms open out to some extent, but at the same time the two figures together are self-enclosed, supporting one another. The sculpture was a project for the monument in Ghent to J. Volders, founder of the Association for Workingmen's Insurance. A plaster version was shown at La Libre Esthétique in 1898.

CONSTANT MONTALD
1862–1944

Montald was born to a Ghent family of modest means on December 4, 1862. His artistic talents surfaced early and his father allowed him to follow this inclination. From 1875 to 1886, he attended the art academy in his own city and, in his final year there, won the annual competition's grand prize of three thousand francs, which he used for a trip to Paris. During his stay there he attended neither studio nor school, but spent all his time visiting museums with his friend, the painter Privat Livemont. It was in Paris that he painted his first large picture: *The Human Struggle* (1885–1886), a work which contained all the major characteristics of his mature professional style. When he returned to Belgium in 1886, he entered the Prix de Rome competition, the subject of which that year was *Diagoras Borne in Triumph*. An episode taken from the Youth Olympics in Ancient Greece, it offered an artistic opportunity to explore a variety of poses, for both nude and draped bodies. When Montald won, he received — like the hero of his picture — a triumphal welcome in Ghent. He spent three years in Italy, from which he visited all the great art centers in Europe, as well as in Greece, Egypt, and Turkey. Montald's artistic ideals were strongly oriented toward monumental mural decoration, and his most cherished desire was to revive the great fresco tradition of the past in his own work. From 1896 to 1932, Montald held the position of "First Professor" in decorative painting at the Brussels Academy, where he proved himself an excellent teacher. He was an active member of the circle Pour l'Art from 1893, and exhibited regularly at the Salon d'Art Idéaliste, the Brussels group founded by Jean Delville in 1896. Because of his interest in sculpture, he often visited the studio of Charles van der Stappen where, in 1896, he met Émile Verhaeren. They immediately became fast friends, and both the poet and his wife, Martha, were frequent visitors to the house which Montald built in 1909 in the Brussels suburb (commune) of Woluwe-Saint-Lambert. Montald's murals, dominated by a taste for allegory and symbol, are important, but one should never forget his easel paintings — landscapes and portraits, particularly some very beautiful and perceptive pictures of his friend Verhaeren. [GO]

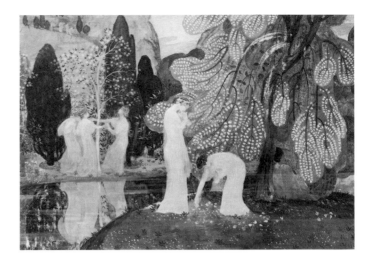

76 **Nymphes dansant** *circa* 1900
Dancing Nymphs
Oil on canvas
95.5 x 135.5 (37¼ x 53⅛)
Musées Royaux des Beaux-Arts de Belgique, Brussels
Not in exhibition

These slender nymphs, clad in the implausibility of a dream, tread on grass sprinkled with flowers, beneath the shelter of a strangely formed tree. They dance around the sacred tree as if to the strains of a serene harmony. The immaterial aspect of the scene is created here through layers of transparency, a technique Montald later replaced by a predilection for opacity, in order to obtain a matte finish like that of the fresco painting he admired in Italy. Montald never tried to hide the deep influence which these Italian painters had on his art. "Italy made an enormous impression on me," he said. "The countryside seemed to me as if it were constantly under the enchantment of Giotto and his school . . . the fresco was my ideal and nearly all my studies were directed toward it. The fourteenth- and fifteenth-century artists were my [true] masters . . ." (Brussels, Galerie Sneyers, *Exposition Montald*, 1917). Montald responded to the almost "fairy-tale" quality of early Renaissance frescos in his dreamlike works, in which the range of blues have a musical quality and the trees are often gold.

Constant Montald
Le Paradis Terrestre 1904
The Earthly Paradise
Cat. no. 77

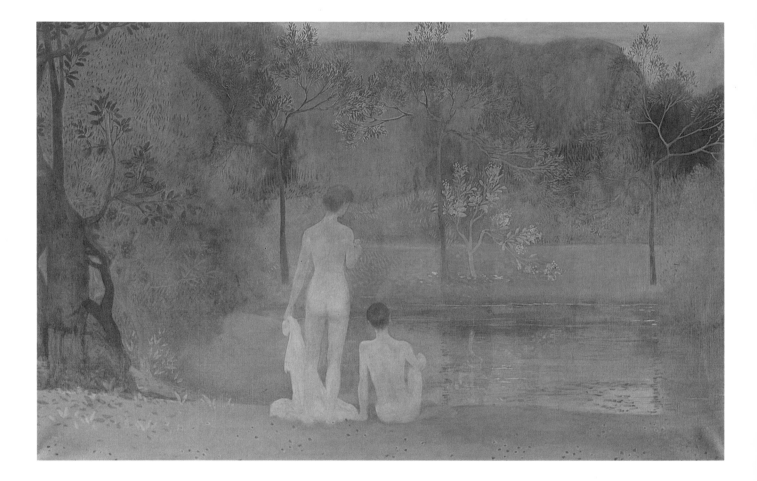

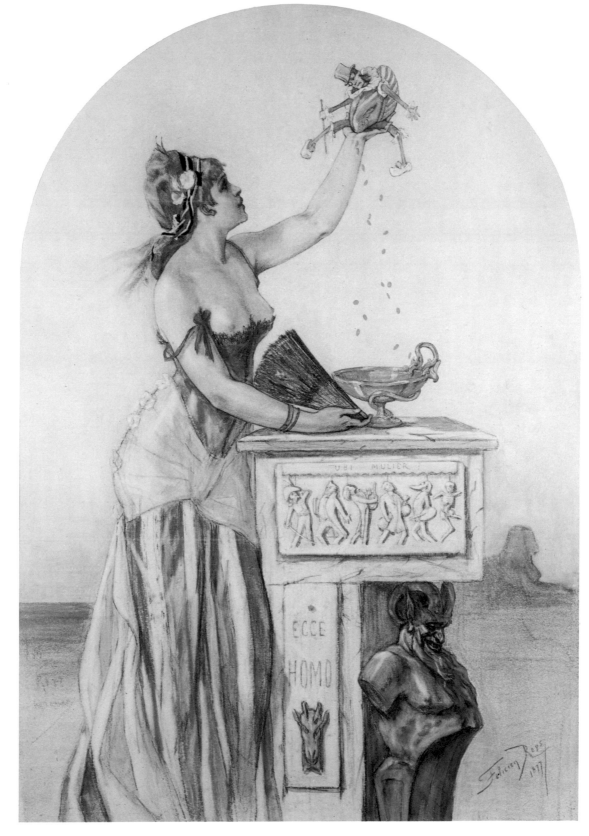

77 **Le Paradis Terrestre** 1904
The Earthly Paradise
Oil on canvas
110.0 x 175.0 (43$^1/_4$ x 68$^7/_8$)
Private collection, Brussels
Reproduced in color on page 138

Montald sought always to unite figures with their setting and to redefine the values of both. As Francine-Claire Legrand noted, "Montald's style is designed to firmly integrate the people he paints with their botanical surroundings" (*Le Symbolisme en Belgique* [Brussels,1971], p. 94). In fact, nature prevails, as it does in this work, where man plays the minor role of a decorative detail. Montald especially loved beautiful trees, recreating their forms synthetically, and with great delicacy. His trees and plants seem to sing, making music of the subtlest sort, like an incantation revealing the enchantment of the seasons — of nature itself. Montald was a member of Delville's Idéalistes and, like them, preferred the intangible to the palpable, which he expressed through stylization and synthesis rather than descriptive detail. This painting is exemplary in that respect, demonstrating a faithful concurrence with Delville's theories: "In art, physical forms lose their suggestive powers and spiritualism if the artist forgets the idea. . . . It is the idea which creates the form" ("L'Idée dans l'Art," #21931/45, Archives de l'Art contemporain, Musées Royaux des Beaux-Arts de Belgique, Brussels).

**FELICIEN
ROPS**
1833–1898

Félicien Rops was born in Namur. As a child, his fiercely independent personality was nurtured in an environment removed from cosmopolitan society and confined by a strict Jesuit education. While studying at the Academy in Brussels and later at law school, he attended the *atelier* Saint Luc, and in 1853 began his graphic career with rather unsuccessful lithographs and woodcuts, which he contributed to a weekly student magazine called *Le Crocodile*. By 1856, Rops had founded his own satirical weekly, *Uylenspiegel*, which was patterned after Philipon's *Charivari* and to which he contributed many lithographs reminiscent of Daumier and Gavarni. But eventually lithography no longer sufficiently challenged him, and in 1862 he left for Paris to study etching with Bracquemond and Jacquemart. Rops was continually experimenting with the potentialities of this medium — particularly with the perfecting of the soft ground — and he gradually relinquished the strain of Realism found in his earlier painting and graphics. His later series of five soft-ground etchings, *Les Sataniques,* whose content was not restricted by any accompanying text, transmits a powerful Symbolist message through sinister and sadistically erotic images. The intellectual stimulus of the Parisian literary world served as a catalyst to Rops' art. He made his reputation as an illustrator, eventually producing prints for some eighty-two publications by authors such as Charles de Coster, Alfred Delvau, Alfred de Musset, Théophile Gautier, Paul Verlaine, and Villiers de l'Isle Adam. And it was Rops who was chosen over Bracquemond by the publisher Poulet-Malassis, to execute the frontispiece for Baudelaire's *Les Épaves* — the collection of poems censured from the original edition of *Les Fleurs du Mal* and published in Amsterdam in 1866. Baudelaire and Rops had become acquainted two years earlier and their affinity is particularly close in their preoccupations with skeletal imagery and erotic fantasy. In 1870, Rops founded the Belgian Société Internationale des Aquafortistes, which was active for five years, and he was also a member of Les XX from 1886 to 1893. His pupils included Armand Rassenfosse — with whom he developed the ground wittily labeled "Ropsenfosse" — François Courboin, and Louis Legrand. His last years were spent traveling or quietly in residence at his private estate "La Demi-Lune" in Essones near Paris. [CT]

78 **La Dame au Pantin** 1877
Woman with a Puppet
Watercolor on paper
53.0 x 41.0 (20^7/$_8$ x 16^1/$_8$)
Babut de Marès, Namur
Reproduced in color on page 139

79 **Le Rideau cramoisi** before 1883
The Crimson Curtain
Pen, ink, and gouache on paper
26.0 x 18.0 (10^1/$_4$ x 7^1/$_8$)
Carlo de Poortere, Kortrijk
Illustration to *Les Diaboliques*

This watercolor's high quality of execution demonstrates Rops' technical proficiency in the painterly medium, yet he always said he preferred etching to any other artistic process. The theme of man as the puppet-victim of woman was one of Rops' favorites, and he often repeated it using different models, costumes, and compositional arrangements. Péladan enthusiastically stated that Rops' treatment of this particular theme would suffice to immortalize the artist (*La Jeune Belgique* 4 [1885], p. 172). This version in watercolor provides an example of how Rops applied his innate literary ability to his chosen pictorial vehicle. The details of the scene are read as a narrative and build to a dramatic climax. Rops represents his woman of questionable virtue lusting after money and taking pleasure in eviscerating a Polichinelle puppet in order to collect the pieces of gold inside it. Sinister accessories, such as a herm with the grimacing features of Satan, the serpent coiled around the cup into which the gold pieces fall, and the distant profile of an elusive sphinx, set the stage for the enactment of this malicious crime. The full horror of the scene is absorbed at the sight of such tiny details as the top hat and cane of the puppet, attributes of the gentleman of fashion or man of means — who is usually invulnerable, so solidly entrenched in his comfortable niche in society. Yet woman has become his deadliest enemy because her threat goes foolishly unrecognized or cannot be withstood by such a childlike Polichinelle. On a bas-relief underneath are represented men from various professions as puppets on strings, trophies of the huntress, who have already met similar fates. The inclusion of a skeleton among these victims implies that man cannot escape woman's evil powers even in death. While Rops obviously borrows the words "Ecce Homo" from religious rhetoric, he transforms their sacred meaning with biting sarcasm when he applies them to his image of ignominious sacrifice, placing the head of a goat — Christian symbol of the damned — directly under them on the pedestal.

Rops' nine illustrations to *Les Diaboliques,* a series of six short stories by Jules Barbey d'Aurevilly, were originally published by Alphonse Lemerre in the 1883 edition. These six drawings closely correspond to their analogous etched versions and may even be more or less final studies for them, as indicated by the inscription "1er dessin" on one of them. They may have been included in a group of drawings from *Les Diaboliques* exhibited with Les XX in 1889, although precise identification is not possible. The first three drawings listed above were exhibited in Paris, Rotterdam et al., in the exhibition *Le Symbolisme en Europe* (1975–1976, no. 197). All were exhibited in New York and Houston (*Painters of the Mind's Eye,* 1974, nos. 43–48).

In his preface to the first edition, Barbey describes himself as a "Christian moralist" and makes an effort to justify his telling of immoral tales by attesting to their complete veracity, by acknowledging that the characters therein behave wickedly and wrongly, and by commending the directness of his method, which utilizes the literary device of informal conversation. His chief protagonists are women in adversity, willful women, unfathomable women, instruments of fate, victims and victimizers in their roles as pawns of the devil. There is rarely any suggestion of moral victory or reference to religious ideology. The amoral philosophies of illustrator and author are ideally suited to one another. Rops' view of women, who serve as the center of focus throughout his pictorial oeuvre, closely parallels Barbey's, and his evocative illustrations capture the essence of Barbey's bizarre tales in what can be called a truly Symbolist style.

Le rideau cramoisi is the story of a clandestine love affair between a young soldier and his landlord's daughter, Albertine, whose inscrutable behavior — both furtive and passionate — results in the seduction of the tenant. They meet in the soldier's bedroom, where a symbolically significant crimson curtain hangs at the

80 **Le plus bel amour de Don Juan**
before 1883
The Greatest Love of Don Juan
Pen, ink, and gouache on paper
24.5 x 17.0 (9⅝ x 6⅝)
Carlo de Poortere, Kortrijk
Illustration to *Les Diaboliques*

82 **Le bonheur dans le crime** before 1883
Happiness in Crime
Pen, ink, and gouache on paper
25.5 x 17.5 (10 x 6⅞)
Carlo de Poortere, Kortrijk
Illustration to *Les Diaboliques*

81 **À un dîner d'athées** before 1883
At an Atheists' Dinner
Pen, ink, and gouache on paper
28.0 x 18.5 (11 x 7¼)
Carlo de Poortere, Kortrijk
Illustration to *Les Diaboliques*

83 **Le dessous de cartes d'une partie de whist** before 1883
The Last Card at the Whist Party
Pen, ink, and gouache on paper
23.0 x 16.0 (9⅛ x 6⅝)
Carlo de Poortere, Kortrijk
Illustration to *Les Diaboliques*

window. One night, during a fervent embrace, Albertine mysteriously dies, leaving the deeply shocked young soldier in an impossible dilemma. He contemplates throwing the body out the window to simulate suicide, but its discovery under his very window would inevitably incriminate him. Thwarted in his search for a solution, he departs before dawn, never to learn the outcome of the affair. Rops' haunting illustration transcribes the most psychologically complex moment of the story. The scene graphically summarizes the moment when the young soldier considers throwing the body out the window. As if still supported by the bed, the naked body floats rigidly through the empty darkness beyond the curtained window. Hands beneath, reaching out from behind the curtain, are held as if they pushed it. Behind the curtain at the left, the eerie shadow of a well-clad female, from which the naked spectre seems to emanate, not only portrays the transition from life to death but also juxtaposes, in a succinct visual metaphor, Albertine's dual personalities — the "femme fatale" by night and the impassive prude by day. The former ultimately dominates both in the story and through Rops' sheer graphic emphasis. Her vixenish smile betrays a diabolical intent. By her death, she has placed the young man in a frustrating situation from which he cannot extricate himself honorably. Thus the hands at lower left can be interpreted not only as threatening the body but as attempting to fend off an undesirable fate. The motif of detached hands seems to have been noted by Fernand Khnopff, who, in his frontispiece for one of Péladan's novels, Les femmes honnêtes (1888), utilized the device of a grasping pair of hands to inject a mood of fear.

Le plus bel amour de Don Juan is a tale told largely by a Don Juan character during the course of a supper gathering of twelve former mistresses. Upon request, he describes his "most beautiful" lover, who initially appears to be a wealthy and attractive married woman. Her socially awkward daughter becomes suspicious of her illicit liaison and grows increasingly hostile toward the playboy intruder. One day the daughter, who has always been a model of chastity and piety, discloses to her mother that she believes herself to be pregnant by none other than the Don Juan himself. The conception is supposed to have taken place when the ignorant girl sat on a chair just vacated by him. Rops misses none of Barbey's subtle irony, as the reader is brought to the realization that the "most beautiful" lover can be identified as the awkward girl. His masterfully simplified image conjures up the essence of mystery, terror, and psychological trauma experienced by the adolescent girl. Naked but for two religious medals around her neck, she sits on the chair from which, she imagines, residual flames of passion still have sufficient potency to implant their seed. Fear and anxiety, naïveté, enlightenment, and guilt are all written in her expression. Her body stiffens as she brings her legs together, her hands endeavoring to hide the shameful transgression. Behind her looms like a phantom the easily recognizable, moustachioed features of Barbey d'Aurevilly himself, shrouded in a shadowy cloak which billows out as if, like a magician, he is revealing his literary creation for the first time. However, this figure can also be identified as the playboy whom the girl imagines as the epitome of masculine virility into whose trap she has carelessly fallen. By means of this dual identity, Rops seems to be making a witty reference to the ability of the author — in the guise of his male protagonist — to conspire against foolish innocence. Rops' figure of the adolescent girl seems to be a direct iconographical precedent for Edvard Munch's Puberty (1894–1895), although Munch insisted he had not derived this motif from Rops (compare Washington, D. C., National Gallery of Art, Edvard Munch: Symbols and Images, 1978, p. 50).

À un dîner d'athées is a tale told at a dinner attended by atheists who demand to know why one of their colleagues has been seen entering a church. A complicated explanation ensues, involving three characters: a Major, his nymphomaniac mistress Rosalba, and a Captain, the narrator of the story, who has had a brief affair with Rosalba. One night while the Captain happens to be visiting Rosalba, long after their affair is over, the Major arrives unexpectedly. The Captain hides in a closet and overhears a terrible argument between the two lovers. In a spiteful rage Rosalba names the Captain as the father of her dead child, a confession that triggers physical violence, in the course of which the embalmed heart of the child is taken from its crystal urn and utilized as a weapon. In a quite literal, yet compelling, transcription of the narrative, Rops depicts the immediate aftermath of the story's harrowing climax. The unscrupulous character of Rosalba must have amply fulfilled Rops' criteria for the "femme fatale." A ghastly justice is wrought when the victimizer of men's souls is herself physically tortured. Fragments of clothing cling to her voluptuous body, which is stretched on a table where the Major has thrown her in order to brutally apply hot sealing wax to the offending private part of her anatomy with the pommel of his sabre. The tremulous light of a lone candle casts sinister shadows over the drama. Visible at lower right are the limp legs of the Major, who has been slain at the last moment by the valiant Captain come from hiding. The Captain finally decides that the child's heart deserves a proper Christian burial, thus compromising his atheistic principles. In a less than convincing attempt at final analysis, Barbey intercedes with an explanation for his protagonist's uncharacteristically pious act, acknowledging, almost apologetically, the church's necessary function as a shelter for human souls, both living and dead — a curiously bland and ineffective moral for such a gripping tale of reckless passion.

Le bonheur dans le crime concerns two unrepentant lovers who have resorted to deceit and cold-blooded murder to achieve a state of total happiness together. Once again, woman plays the role of worst offender. A Marquis, whose reputation is impeccable in his small provincial town, falls in love with Hauteclaire, an outwardly pragmatic fencing instructor, who has inherited her unusual profession from her father. Inexplicably, Hauteclaire gives up her prosperous business and drops out of sight. Actually, she has surreptitiously changed her name and become lady's maid to her lover's wife. Living in the same house, the two lovers can see each other every day and conspire gradually to poison the Marquise, who senses their evil plot but prefers death to bringing dishonor upon her noble rank by denouncing her murderers. Rops chooses to literally monumentalize the monstrosity of this crime in statuesque grandeur. The lovers are shown embracing passionately on top of a tall pedestal while the supplicating figure of their victim agonizingly claws the inert stone in a vain attempt to reach them, her skull-like face a symbol of her eventual tragic fate. Mounted on the pedestal and presiding over the lovers as their guardian is a Gorgon's head wearing a serene expression that condones the adulterous act. The snakes of her headdress further sanction this union by tying the couple together. An enormous reptile coils itself around the entire ensemble, winding across the upraised arms of the victim beneath and expiring like a sacrificial offering at the foot of this pagan idol, ghastly fangs protruding from its open mouth. Here, Rops utilizes the same motifs of serpents and bodiless heads that would later be incorporated into the Symbolist iconography.

In the story Le dessous de cartes d'une partie de whist, the denouement is revealed by insinuation rather than explanation. The action takes place in a boring provincial town where the aristocracy's only amusement is continuous card parties. The plot develops within the familiar framework of the love triangle and involves a vicious, unnatural jealousy and covert misdeeds undisturbed by pangs of conscience. A mother and daughter both fall in love with a new member of the whist players, a Scotsman, who reciprocates neither love, but who, one suspects, would take advantage of any opportunity for sexual pleasure. The daughter dies, one assumes, from poison administered by her jealous mother, who in turn dies a month after the abrupt departure of the Scotsman. At this point, the cadaver of a child is discovered in the mother's house, buried in the potting soil of some mignonettes that are to be transplanted outdoors. One concludes that this unnatural mother resorted to filial homicide on two occasions in order to protect her obsessive interests. Always intrigued by perversity, Rops appropriately represents the murderess treading on the corpse of an innocent newborn infant, behind which can be detected traces of the symbolic mignonettes — a motif Rops omits from the final etched version. Outwardly a figure of propriety in

84 **La femme et la folie dominant le
monde** before 1883
Woman and Folly Ruling the World
Pen, ink, and gouache on paper
25.5 x 17.5 (10 x 6⁷/₈)
Carlo de Poortere, Kortrijk
Illustration to *Les Diaboliques*

85 **Le Vice Suprême** 1883
Pen on paper
23.5 x 16.0 (9¹/₄ x 6¹/₄)
Carlo de Poortere, Kortrijk

her long gloves, beribboned hair, and chic gown, the mother's exposed shoulders and plunging bodice betray her lascivious nature. She is stifling any temptation to confess her sin by covering her mouth with both hands. A gag with a padlock on it is wound around the lower extremity of her head, and the door in the background is thoroughly bolted. Thus Rops admirably transcribes the constricted psychological ambience of secret guilt.

La femme et la folie dominant le monde is a drawing for the second postface, and the last of Rops' nine illustrations. This image does not correspond specifically to any of Barbey's stories, but it nonetheless adequately reflects the predilection for cynicism shared by both artist and author. The seductive display gesture of the female identifies her as a woman of easy virtue. Wearing fool's cap and bells, folly keeps her firmly in hand with a piece of clothing wrapped around her legs. He peeks mischievously out from behind her, a monocle on one eye, impersonating one of the gentlemen who patronize her. His grimacing facial features appear to be Satan's own. Both figures have cloven hooves like those of a goat — symbol of the damned in representations of the Last Judgment. They stand triumphantly on a segment of the earth's orb, an expanse of starry universe as a backdrop. Rops' message that folly and prostitution are universally prevalent, inextricably linked, and mutually irredeemable, is clearly stated. Yet for all the intensity of his critical insights, Rops is never a misogynist. His absorption with the theme of woman actually stems from a congenial fascination with her. For example, Rops once wrote a letter to Calmels, in which he refers to his first confrontation with the Parisian woman: "M. Prudhomme, meeting on some corner of the boulevard the Hottentot Venus in national costume, would be less stupefied than I in front of this incredible mixture of cardboard, taffeta, nerves and rice powder. And how I love them!" (Translated from E. Demolder, *Félicien Rops: étude patronymique* [Paris, 1894], p. 10.)

This drawing is either a final realization before printing or a later facsimile of Rops' etched frontispiece to Péladan's novel of the same title, published in 1884. In subsequent editions, this book would also be published as the first in a series of twenty-one volumes entitled *La décadence latine,* a term devised by Péladan to describe modern civilization. Rops also contributed frontispieces to the next three volumes in this series. The drawing has recently been included in three major exhibitions (Ixelles, 1969, no. 156; New York-Houston, 1974, no. 49; Paris, Rotterdam et al., 1975–1976, no. 199). Péladan was the self-proclaimed high priest of the Order of the Rose + Croix. Characteristically, he said of Rops, "Between Puvis de Chavannes, the harmonious one, and Gustave Moreau, the subtle one, Félicien Rops, the intense one, closes the Kabbalistic triangle of great Art" (*Le Jeune Belgique* 4 [1885], p. 177). At this early date he had already sensed Rops' affinity with the precursors of Symbolism. However, Rops was generally judged more infamous than famous by other contemporary critics, except for J.-K. Huysmans, who considered him the unique master of the frontispiece (*Certains* [Paris, 1889], p. 116). Rops' frontispiece for *Le vice suprême* is an ironical variation on the Baudelairian theme of dancing death, but does not seem to reflect the high ideal of Péladan's story about the development of a perfect, androgynous love. His male and female skeletons on a nocturnal outing continue to love each other in death, but an unimpassioned, chivalrous kind of love it has become; hence the irony of the title "Supreme Vice." The female fans herself demurely as she strides out of her coffin, while the male figure, decorated with medals, politely holds under one arm his decapitated head, presumably severed during some futile act of military heroism. Rops' black humor and literal representation belie the philosophical connotations of his image: the tragic paradox of living death or death in life — the fatalism expressed in the opposition of trivial social graces and implacable ultimate decay. The pedestal relief representing an emaciated she-wolf and the limp remains of Romulus and Remus clearly refers to Péladan's "décadence latine."

THEO VAN RYSSELBERGHE 1861–1926

Born in Ghent, Théo van Rysselberghe first studied at the Academy there and, in 1879, with Portaels in Brussels; his earliest works, dating from 1881, are Realist in manner. In 1882, Van Rysselberghe visited Spain with Meunier, Charlet, and De Regoyos, traveling as far as Morocco, to which he returned in 1883. In the same year, he began his long friendship with Émile Verhaeren, and participated in the formation of the avant-garde circle, Les XX. As one of its most active members, he assisted the Secretary, Octave Maus, with the organization of the yearly exhibitions and in choosing the invited artists. After the dissolution of Les XX in 1893, he played the same role with its successor, La Libre Esthétique (1894–1914). Following his stay in Morocco, Van Rysselberghe's landscapes became more luminous and his portraits took on a delicate intimacy, revealing the influence of Whistler and Degas. In 1888, he became a convert to Neo-Impressionism, a style to which he would rigorously apply himself for the next twenty years. As a portraitist, Van Rysselberghe is the best, if not the only artist who uses the divisionist technique without losing the human quality of his models. A third trip to Morocco on an official mission with Edmond Picard took place in 1887, and from then on he traveled frequently. In 1889 he married Maria Monnom, whose mother directed the press at which both *L'Art Moderne* and *La Jeune Belgique* were printed. Beginning in 1890, he exhibited with the Indépendants in Paris and became as much a part of the avant-garde world of arts and letters there as he was in Belgium — Seurat, Signac, Cross, Denis, Toulouse-Lautrec, Gide, De Régnier, Fénéon, and many others were his friends. In 1898 he moved to Paris — and, in 1910, built a second home in Saint-Clair in the south of France — but he always remained in close contact with Belgium, showing his most recent works there regularly. Among the most important paintings at this time were the decorative panels for the Hôtel Solvay in Brussels that he made in 1902 and 1913. Around 1903, he gave up divisionism to return to a more traditional style, but without losing the psychological penetration of his portraits or the quality of perfection in his technique. Van Rysselberghe's entire artistic life was very active: he joined in the revival of applied arts with Van de Velde, made sculpture, graphic works, and illustrations for books, and continued, throughout his career, to paint. [MC]

86 **Portrait d'Octave Maus** 1885
Oil on canvas
98.0 x 75.5 (38½ x 29¾)
Musées Royaux des Beaux-Arts de Belgique, Brussels

At the 1886 Salon of Les XX, Van Rysselberghe exhibited one landscape and nine portraits, one of which was *Le Portrait d'Octave Maus*. That year, the French artists Redon, Monet, and Renoir had been invited for the first time; nearly unknown in Belgium, they were the center of attention, and the press paid very little attention to artists whose work had already been seen. Verdavaine, however, writing in *La Fédération Artistique* of February 20, regretted the change in style from "the brilliant *Fantasia arabe*, so full of air and light," shown the previous year, and remarked that Van Rysselberghe, like so many of his contemporaries, was submitting to the influence of Whistler. This artist, who had already been invited to show in 1884 and who participated in the 1886 Salon as well, was greatly admired by the Vingtistes, and certainly by Van Rysselberghe (though his first love was Degas). In the portrait shown here, the subtle color harmony — black, rose, and gray — is undeniably in the spirit of the American painter's style. But this combination of colors has also been deliberately chosen for its suitability to the subject. Together with the objects (the piano, Japanese lamp, and gilded chair) and their reflection in the mirror, an alliance is formed that creates a suitably intimate atmosphere for the silhouette of Maus — the painter's friend, man of action, and "seductive aesthete" — and suggests his refined tastes. As the critic Paul Fierens wrote, ". . . the originality of Théo, painter of figures, bursts forth in the natural perfection of the attitude, the interpretation of facial expression, and even of self, in an admirably sustained accord between the essential and the accessory, each detail helping to intensify or subtly blend the significance of all" (*Théo van Rysselberghe* [Brussels, 1937], p. 151). The same year, Van Rysselberghe painted another portrait of the Les XX secretary, standing in a garden; but the one on exhibition here is the more deeply experienced. This portrait remained with Octave Maus, then with his widow Madeleine Octave Maus, who willed the work to the Musées Royaux des Beaux-Arts.

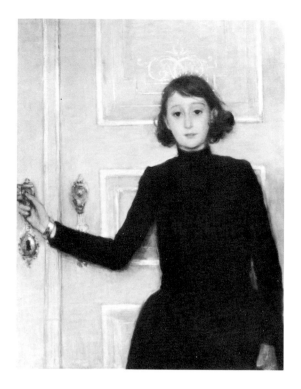

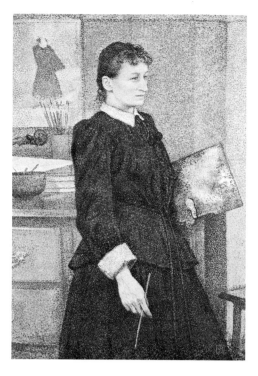

87 **Portrait de Marguerite van Mons** 1886
Oil on canvas
90.0 x 70.0 (35½ x 27½)
Museum voor Schone Kunsten, Ghent

88 **Anna Boch** *circa* 1889
Oil on canvas
95.2 x 64.8 (37½ x 25½)
*Museum of Fine Arts, Springfield,
Massachusetts*

The two portraits of the Van Mons sisters, Camille and Marguerite, were first exhibited with the *Portrait of Octave Maus* and six other portraits at Les XX in 1886, the year when Monet and Renoir had been invited for the first time and Whistler for the second. The pictures reappeared in the Salon of 1887 where, despite the formidable presence of Seurat's *La Grande Jatte,* they were described as "two young girls dressed in black . . . in a Japanese manner, who attracted attention from even the most indifferent" (*La Reforme,* February 6, 1887). In the two canvases, the somber silhouettes are outlined in arabesques against the same background: a closed door painted in white, with pink reflections, discreetly heightened by the gilded metalwork. Camille is seated; Marguerite is standing, holding the door handle. The influence of Whistler is perceptible; and "is it not Degas' best portraits which these charming images recall, where the atmosphere evokes a sweetness surrounding the subjects . . . Harmony and intimacy [are described] at the same time with the most exact physical and psychological notations" (P. Fierens, *Théo van Rysselberghe* [Brussels, 1937], p. 15). Marguerite's expression seems slightly questioning, and her gesture troubled but resolute — both suggesting, perhaps, that the adolescent is about to open the door of life and find her freedom. This portrait, along with that of Camille, was shown in 1927 in Brussels at the Galerie Georges Giroux, *Exposition rétrospective Théo van Rysselberghe* (cat. nos. 6 and 8); and in Ghent, Museum voor Schone Kunsten, *Exposition rétrospective Théo van Rysselberghe,* 1962 (cat. nos. 40 and 41).

Anna Boch was born in 1848 to a family of master porcelain-makers; she became a painter, and in 1882 she met Théo van Rysselberghe through her cousin, Octave Maus. She became interested in the new movement in art, and studied further with the young Van Rysselberghe. Invited to join Les XX in 1885, she showed with the group each year from 1886 on. Like Van Rysselberghe and other members of Les XX, she responded positively to Neo-Impressionism. She was also an active collector of advanced art; her collection included works by Seurat, Gauguin, Van Gogh, Ensor, and Van Rysselberghe — this portrait as well as others. Van Rysselberghe himself reacted at first with shock to Seurat: the story is told that when he went with Verhaeren to see *La Grande Jatte* in Paris, he broke his cane in anger. (Paul Fierens, *Théo van Rysselberghe* [Brussels, 1937], pp. 16–17.) But over the next two years he began to experiment with the new method, and by 1889 he had shown at Les XX his first major portrait in the new style, *Mlle. Alice Sèthe* (St. Germaine-en-Laye, Musée du Prieuré). He used the method strictly, only until the mid-nineties; for him, it was always more a style of brushwork than a means of composing through color. Fundamentally responsive to the human figure, Van Rysselberghe never ceased to give it its full three-dimensional weight through modeling, even when the modeling was achieved by untraditional means. In this characteristically sympathetic presentation of his friend, a thoughtful and dedicated woman seen in her studio with her tools of work, Van Rysselberghe conveys not only the character of the sitter, but also her role as an artist and collector of the kind of art that interested her and her fellow Vingtistes — exemplified by the Japanese print that hangs on the wall behind the sitter, its pose and angular shape echoed by that of the artist with her palette. The portrait was sold at the artist's estate sale in 1936, and remained in private hands until its purchase by Springfield in 1970 (see *Bulletin of the Springfield Museum of Fine Arts* 37, no. 4 [April–May, 1971]). [SF]

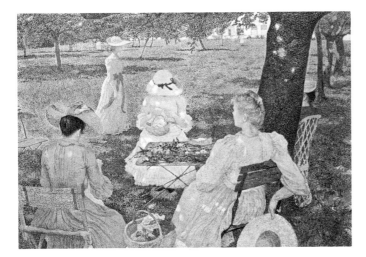

89 Famille dans le Verger 1890
Family in the Orchard
Oil on canvas
115.5 x 163.5 (45½ x 64½)
Rijksmuseum Kröller-Müller, Otterlo
Detail reproduced in color on front
cover

90 Voilier sur L'Escaut 1892
Sailboat on the Escaut (Scheldt)
Oil on canvas
66.7 x 90.2 (26¼ x 35½)
Arthur G. Altschul, New York

This picture, seen in the 1891 Salon of Les XX and called *En juillet avant midi (In July Before Noon)*, was perhaps also exhibited at the 1890 Salon under the title *At Thuin*. In any case, it was described in *L'Indépendance* (February 9, 1891) and in *Le Journal de Bruxelles* (March 3, 1891): ". . . some young girls and some young women are seen together on a sunny lawn . . . in an orchard." This orchard was near an old building belonging to the Abbey of Aulne at Thuin, which Van Rysselberghe's mother-in-law, Madame Monnom — Director of the press for the reviews *La Jeune Belgique* and *L'Art Moderne* — had rented. The artist's wife, seen from the back, is seated in the foreground of the picture, with Maria Sèthe, the future Madame Van de Velde, on her right; two other young women, whose faces are hidden, are also seated around a garden table beneath flowery branches, while a fifth figure crosses the lawn. Such an assemblage of feminine figures outdoors is certainly an Impressionist theme, but the artist, having converted to Neo-Impressionism, has organized his immediate sensations under the rigorous and deliberate divisionist technique, in a color scheme that transmits the brilliance of the light perfectly: green on the ground, yellow for the grass, variations of pink and lilac for the clothing. However, unlike Seurat and Signac — from whom he has borrowed his artistic vocabulary — Van Rysselberghe creates figures that retain the suppleness of life rather than appearing to be stylized mannequins; "he never wanted to exclude either charm or sensitivity from art. He only wanted to make an art of clear forms and exact harmony" (Brussels, Galerie Georges Giroux, *Exposition rétrospective Théo van Rysselberghe*, 1927, preface). This painting was most recently exhibited in London (Royal Academy of Arts, *Post-Impressionism*, 1979–1980, cat. no. 410).

During his wedding trip to Brittany in 1889, and his stay at Thuin in 1890, Van Rysselberghe executed some splendid landscape paintings in a rigorous divisionist technique. The works made in this technique between 1892 and 1895, however, are of the most exceptional quality, as has been pointed out by Robert Herbert in the catalogue of the exhibition *Neo-Impressionism* (New York, Guggenheim Museum, 1968, no. 136), where this work was shown. The river's waters reach as far as the edge of the frame at the bottom of the picture, while a narrow, wooded bank separates them from the sky at the top. The triangle of a sail, four piles of wood, and their rhythmic reflections, are also seen. Painted in a dominant yellow with contrasts of blues and mauves, this picture is bathed in a pale sunlight, tempered by the still humid air. Like the other Neo-Impressionists, Van Rysselberghe is interested in coloring his frames; Seurat and Signac disliked gilded frames and preferred them to be white or stippled in hues that complemented and extended the paintings they enclosed. Van Rysselberghe has chosen the second solution here. Shown at Les XX in February of 1893 under the title, *The Scheldt Rising Toward Antwerp — After the Fog*, the picture was also sent to Paris the following month, to the Indépendants exhibition, this time titled *The Scheldt Rising Toward Antwerp — Afternoon.*

147

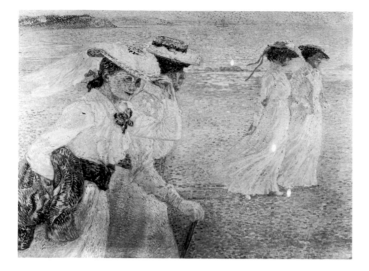

91 **La Promenade** 1901
Oil on canvas
97.0 x 130.0 (38¹/₄ x 51¹/₈)
*Musées Royaux des Beaux-Arts de
Belgique, Brussels*

92 **La Lecture** 1903
The Reading
Oil on canvas
181.0 x 240.0 (71¹/₄ x 94¹/₄)
Museum voor Schone Kunsten, Ghent

Although begun at Ambleteuse and dated 1901, this picture was not finished until 1903. Actually, the artist wrote to Maus at the end of 1902 that on account of his promised contribution to the Secession in Vienna and his obligation to finish the decorative panels for the Hôtel Solvay, he would not have time to "complete the little women walking on the beach" for the 1903 Salon of La Libre Esthétique — if it was going to be held, according to custom, in the springtime. In 1904, Maus organized a retrospective of Impressionism. Invited as the single Belgian among a group of French artists, Van Rysselberghe showed seven works, of which two were compositions with figures, and also portraits: one grouped in an interior — *The Reading* (1903; cat. no. 92) — and the other in a seaside setting — *La Promenade*. Without forsaking the Neo-Impressionist style, the artist nevertheless demonstrated a much less rigorous application of its theories by using a larger, and irregularly placed, brushstroke. This is true of both pictures, but in *The Reading*, Van Rysselberghe has heightened his colors, while in *La Promenade* the process is used to make the light vibrate and to intensify the effect of clarity. Four women are seen walking two by two on the beach: the closest figure is that of the poet Jean Dominique (Marie Closset). The decorative point of departure is emphasized by the cadence of the walkers and by the opposition of the vertical figures to the various horizontal levels of the scenery — beach, sea, cliffs, and a narrow band of sky. A floating veil, the curving silhouettes of the large hats, and the wide skirts all add joyful animation to the scene. At the end of this exhibition of La Libre Esthétique, the Musées Royaux des Beaux-Arts was allowed to choose between Van Rysselberghe's two entries; *La Promenade* won the vote.

The Reading offers further evidence of Van Rysselberghe's friendship with Émile Verhaeren, whose portrait he had already painted several times since 1883. It is also one of this artist's best-known works. As a group portrait, it shows the same spirit as Fantin-Latour's *Studio in the Batignolles Quarter,* and the *Homage to Cézanne* of Maurice Denis. In a letter to Viélé-Griffin dated March 27, 1903 (Ghent, Museum voor Schone Kunsten, *Exposition rétrospective Théo van Rysselberghe,* 1962, p. 44), the artist explains, "The group will have no literary significance, simply being friends of Verhaeren's and mine who will help me by giving me a few hours of sitting time in the studio, in order to realize a picture for which I have had the idea a long time." He specifies that the subject is a reading by Verhaeren; the people he includes are, from the left of Verhaeren: Félix Le Dantec, Francis Viélé-Griffin, Félix Fénéon (standing), André Gide, Henri Ghéon (standing), Maurice Maeterlinck, and Henri-Edmond Cross (from the back). The painter first made some separate studies of each sitter; when he showed them finally, all together, he demonstrated a clear diversity among their personalities but united them through the profound attention they pay to the reader. The setting is Verhaeren's home at St. Cloud. Minne's *Kneeling Youth* (cat. no. 74), a small bronze by Meunier, a reproduction of Whistler's *Portrait of Carlyle,* an abundance of books, and a vase of flowers suggest the culturally rich environment in which the author lived. In the composition, curves — in the round table, and the grouping of the seated figures — are skillfully opposed to verticals — in the standing figures, the hangings, the bookcases; Van Rysselberghe is still using the divisionist technique of Neo-Impressionism here, but is taking many liberties with it. The contrast of the underlying tones, red and vivid green, deep blue and orange, are a prelude to Fauvism. Shown in 1904 at the Salon of La Libre Esthétique dedicated to Impressionism, this work drew favorable attention; it reappeared at the Ghent Salon of 1906 and was acquired at that time by the museum there.

VALERIUS DE SAEDELEER
1867–1941

Born in Aalst, Valerius de Saedeleer was the son of a manufacturer who first had him learn weaving. He studied drawing and painting in the Academies of Aalst and Ghent and in the *atelier* of the landscape painter Frans Courtens, with whom he later traveled in Holland. He fathered five daughters who also became weavers and who eventually created an artisans' fabric studio in De Saedeleer's family home. A restless person with strong political interests, De Saedeleer was active in the socialist-anarchist circle of Ghent during the nineties. He visited the quiet Flemish village of Laethem-St.-Martin in 1893 for the first time and took up residence there in 1898 and again between 1904 and 1907. His friendship with the so-called "first Laethem-St.-Martin group" artists — George Minne, Binus van den Abeele, and Gustave van de Woestijne — ultimately led him back to Catholicism, and he gave up his Realist-Impressionist style, which he came to consider shallow, to begin his symbolic landscape paintings. The immense space and timeless tranquility of these works express his deep religious sense — human figures and animals are absent, simply because of their temporal nature. His best work was done in a hilly region of Flanders called Tiegem. During the First World War, and until 1920, De Saedeleer stayed in Wales, where his painting changed again to a decorative, idyllic pattern. On his return to Belgium, he once more sought the hills of South Flanders, this time in Etichove, and continued creating the spacious panoramas for which he was famous. He died in Leupegem in 1941. The most important bibliographical materials on De Saedeleer are: Valery D'Hondt, *Valerius de Saedeleer, zijn leven en kunst* (Aalst, 1908); André de Ridder, *Laethem-Saint-Martin, colonie d'artistes* (Brussels, 1945); and Jan Walravens, *Valerius de Saedeleer* (Antwerp, 1949). [LS]

93 **Boomgaard in de Winter** 1907
Orchard in Winter
Oil on canvas
63.0 x 148.0 (24³/₄ x 58¹/₄)
Koninklijk Museum voor Schone Kunsten, Antwerp

André de Ridder called the work of this artist "an open book for those who wish to know the Flemish countryside" *(Valerius de Saedeleer en Zuid-Vlaanderen* [Antwerp: Oude God, 1938], p. 5). *Orchard in Winter* shows a slice of the landscape around Laethem-St. Martin and, in fact, the very orchard which the artist saw from his studio. In 1904, De Saedeleer gave up Luminism to share the contemplative art of the Laethem-St.-Martin Symbolists. His landscapes have their roots in reality but are never anecdotal; their sense of spatial infinity expresses an inner spiritual reality related to eternal life. These panoramas are also a tribute to Breughel, whom he admired. De Saedeleer darkens the vast reaches of his skies as they stretch away from earth, and places plants, trees, and houses against the broad plains, like miniatures of the original models. He achieves a unity of expression and construction through the use of subtle tones based on one fundamental color: green, white, or gray. *Orchard in Winter*, like many of De Saedeleer's paintings, is quite large, ". . . as if it were stretching out for a rest" (Paul Haesarts, *Laethem-St.-Martin's* [Brussels, 1965], p. 139). Its winter setting was chosen to show off the dark silhouettes of leafless trees against the snow; he seldom painted summer scenes, preferring the time of year when nature worked invisibly. This work was shown in Munich at the Secession exhibition of 1908.

Born in Rotterdam, Smits was first introduced to art by his father, and later attended academies in both Rotterdam and Amsterdam. A fellow student of Breitner, he became a disciple of the Hague school of Realism and the intimist style of Maris, Mauve, and Istaëls. He left Holland in 1873 to attend the Academy in Brussels and take classes in Stallaert's studio — though without much positive effect — and later, a desire to further his studies of the old masters drew him to schools in Munich, Vienna, and Rome. On his return to Holland in 1881, he took up a

JAKOB SMITS
1855–1928

career as "peintre-decorateur," married his cousin, and began to lead a very comfortable life on the proceeds from the many important commissions he received — including the vestibule of the old Boymans museum in Rotterdam. In 1885, he and his wife separated and Smits went to live in Blaricum, becoming Director of the School for Applied Arts in Haarlem and often painting in Drente, in the Dutch part of Limbourg. With his friend Neuhuys he discovered the Flemish Campine region, and finally settled down in Achterbos in 1888. He married Malvina de Deyn in 1899 and became a naturalized Belgian one year later. During the 1890s, Smits dedicated himself exclusively to the use of watercolors, pastels, and charcoal. Exhibiting both in Belgium and abroad, he was particularly successful in Munich and Dresden during 1897. After 1900 his interest focused on painting and problems of light; he used in the beginning the same chiaroscuro technique he found so compelling in Rembrandt, and created a sensation of interior illumination by applying a number of superimposed paint layers. In 1905, Smits joined the Antwerp group Kunst van Heden; between 1914 and 1918, he gave up his art in order to help the war effort, but after 1918, he redoubled his creative output. Smits was never part of a school or group, but remained relatively isolated, pursuing that aspect of Symbolism which had to do with the mystery of light, and the inner life of man as expressed through images of simple, elemental folk. [PM]

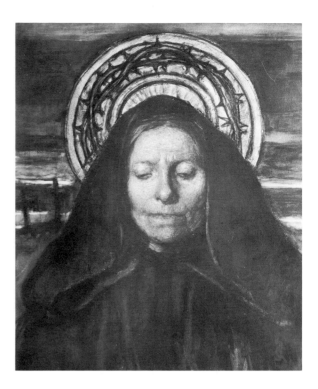

94 **Mater Dolorosa** (Golgotha) 1894
Watercolor on paper
50.0 x 42.5 (19³/₄ x 16³/₄)
Musées Royaux des Beaux-Arts de Belgique, Brussels

Van den Bosch (*La vie et l'oeuvre de Jakob Smits: Catalogue de l'oeuvre* [Antwerp, 1930]) dates this work 1894 and says that it belonged to the Lembrée Collection at that time. In December, 1927, it was given to the Musées Royaux by Laurent Meeus for the new Fierens Gallery. The same subject is treated in a drawing of 1899, and there is a sketch of a head from the same year, which is similar but less dry — and more tragic in the lighting of the face. This work belongs to the pre-1900 period when Smits was committed to the mediums of pastel, charcoal, and watercolor. He also used gold for the background of his drawings and created aureoles around his figures, both techniques reminiscent of Byzantine and Sienese painting, and the Germanic style of Grunewald and Dürer. His methods also reflect the then current interest in Symbolism, recalling the gilded grounds upon which Xavier Mellery also drew, and the materialization of mystic glory and consecration to human suffering that was germane to so much art in this period. The silence of the figure seen here carries in it all the nostalgia of *fin-de-siècle* thought.

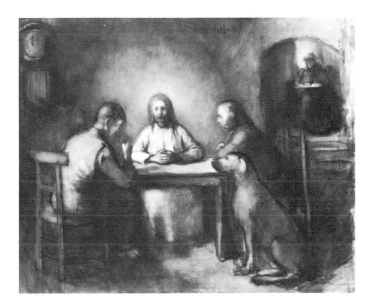

95　**De Pelgrims van Emmaus** 1898
The Pilgrims at Emmaus
Watercolor on paper
50.0 x 60.0 (19³/₄ x 23⁵/₈)
*Koninklijk Museum voor Schone
Kunsten, Antwerp*

This interpretation of the moment when Christ reveals his immortality to the two pilgrims with whom he breaks bread is the first of four finished works — as well as a number of drawings — on the same subject by Smits. The other three are oil paintings and become gradually more complicated with regard to setting and the number of figures represented — although they are all essentially farmhouse scenes, based on the local Campine interiors that the artist knew so well. In this watercolor, Smits is closer both in spirit and technique to the Louvre Rembrandt, using light as a source of mysticism appropriate to the miracle taking place. His biographer, Ernest van den Bosch, said that the watercolor's "piety, faith and human sympathy relate it to the Primitives" (*Jakob Smits* [Antwerp, 1930], p. 30), by which he certainly means Flemish painters of the fifteenth century.

**LEON
SPILLIAERT
1881–1946**

Spilliaert was born and raised in Ostend where, at a very young age, he taught himself to draw. His father owned a shop specializing in the sale of perfume, and the boxes and bottles there were among his first models. Spilliaert's ability was such that the faculty of the Academy in Bruges could teach him nothing, and in February 1903 he went to work for a year for the Symbolist publisher Edmond Deman in Brussels. The poets Verhaeren and Maeterlinck and the painters Van Rysselberghe and Lemmen were frequent guests in Deman's home and became friends with Spilliaert. In 1904, Verhaeren introduced him to the Symbolist-oriented artistic and literary milieu of Paris. When he returned to Ostend, Spilliaert rented a studio on the wharves — later to belong to Permeke — and in 1909 began to take part in many important exhibitions. Four years later, Frans Hellens dedicated a piece to him in the avant-garde review *L'Art Moderne*. Spilliaert married in 1916 and went to live in Brussels where his only daughter, Madeleine, was born. There he produced a suite of watercolors and lithographs based on the work of Maeterlinck. In 1920, he was contracted to exhibit at Sélection, which was under the direction of P. G. van Hecke and André de Ridder, who published a review of the same name. Spilliaert managed to maintain his Parisian contacts, however, and from 1922 on, he exhibited many times with Le Centaure and in the exhibitions of Kunst van Heden (Art of Today) in Antwerp, and provided a number of decorative pieces for the Surrealist review *Variétés*. This same year, he moved back to Ostend, returning to Brussels sometime after 1935. He was given some one-man shows at the Ars Galerie in Ghent and at the Palais des Beaux-Arts and the Galerie Georges Giroux in Brussels. As a member of the Compagnons de l'Art, he also showed with the Belgian Expressionists. Despite his strong attachment to several artistic groups, Spilliaert was able to maintain his independence and originality.　[FL]

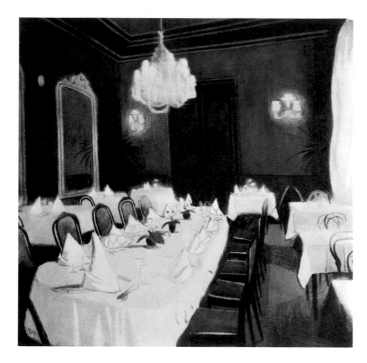

96 **Table d'Hôte** 1904
Watercolor and pastel on paper
47.5 x 47.5 (18³/₄ x 18³/₄)
*Musées Royaux des Beaux-Arts de
Belgique, Brussels*

97 **La Chambre à coucher** *circa* 1908
The Bedroom
Watercolor on paper
63.5 x 48.0 (25 x 18⁷/₈)
*Musées Royaux des Beaux-Arts de
Belgique, Brussels*

The intimacy of this representation links Spilliaert to Mellery, but here the color accentuates the strangeness of this room with its white tables awaiting phantom guests. An uneasy air of mystery weighs on this deserted interior, lending the scene a Symbolist dimension. In the words of Albert Dasnoy: ". . . the meeting with mystery must be a living expression for [the artist]; that is to say it is submitted to the intermittent quality of life and the morality of its functions. Also, the manifestation of mystery is generally indirect in art, or implicit, like its presence in real life. Spilliaert is one of the rare artists who has oriented his art toward a direct encounter with mystery. Without any doubt, he was predisposed to this attitude by his interest in Symbolism. But he took this direction so early and so clearly that one must assume it came to him naturally. Also, it is apparent that he never felt the need for recourse to the systematic approach of Symbolism, nor did he fall into the use of its intellectual artifices" (Archives de l'Art contemporain, Musées Royaux des Beaux-Arts de Belgique, Brussels). Spilliaert rejected oil painting in favor of wash and ink techniques, watercolors, pastels, gouache, and colored pencils. The use of reserved areas, very lightly reworked in the linens here, is characteristic. This work belonged to Alfred Dorff, a Brussels lawyer and a great friend of the artist. It was left by him to the Musées Royaux in 1957, at a time when Spilliaert, who was already eleven years dead, had not yet taken the place in Belgian art that is now his.

This watercolor, dominated by the violet shades of the armoire, strikes the same intimate note that related Spilliaert to Mellery in *The Soul of Things*. Violet is a color much loved by the Symbolists and it is often found in the works of Khnopff. The Belgian writer, Frans Hellens, who was one of Spilliaert's earliest admirers, comments in an article of 1913 in *L'Art Moderne* (p. 353), "Some reflections, vivid at a glance, the inflection of a line, a sonorous tone, some strange symmetry, all suffice to suggest obscure and silent existences, to which one does not usually pay attention. Around all that reigns an atmosphere, an unknown ambience. Reconsider this apparently dry and simplistic art and you will see the sarcastic gaze of the painter hiding in the shadow." The picture is dated through comparison with another of the same subject in the Musée d'Ixelles that bears the date 1908. The treatment of the reserved areas, the white curtain, the structure of the window, lightly reworked, recall the *Table d'Hôte*.

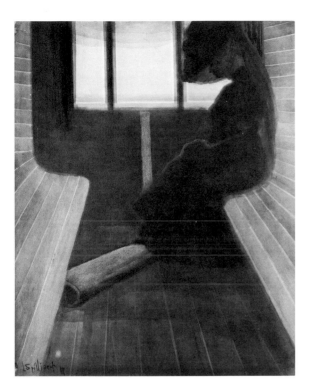

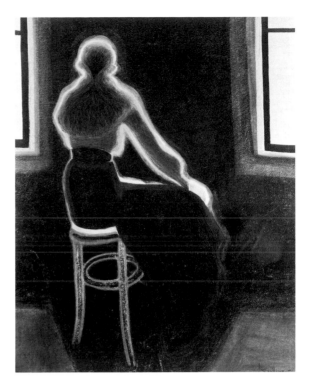

98　**La Dame dans le Train** 1908
Lady on the Train
Ink and colored pencil on paper
52.0 x 42.0 (20¹/₂ x 16¹/₂)
Private collection, Brussels

99　**Jeune Femme Assise sur un Tabouret**
1909
Young Woman Seated on a Stool
Pastel and colored pencil on paper
68.0 x 55.0 (26³/₄ x 21⁵/₈)
Private collection, Brussels

This painting, one of the best-known and most appreciated of the artist's works, has been shown in nearly all his retrospectives since 1933 (Ghent, 1953–1954; Ixelles, Hasselt, Ostend, and Tournai, 1961; Stuttgart, 1963; Antwerp, 1965; Brussels, 1972; Helsinki, 1975; Oslo, 1977) under the more anecdotal title of *The Widow*. It is a typically Symbolist work — in a sense, very reminiscent of Mallarmé; while nothing is said, everything is suggested. No one knows who the woman is, where she is going, or where she comes from. She is veiled, suggesting the title usually used — *The Widow* — but she could be in mourning for a father, a brother, or a child. She is alone and her baggage, lying abandoned on the floor, also suggests solitude — that she is someone who, climbing onto the train alone, without help, has no strength to lift her suitcase to the rack. Spilliaert has created something profoundly original in the contrast of the back-lighted figure, treated as a somber, curvilinear mass — though not in an Art Nouveau sense — to all the objects that are geometrically rectilinear: the floor, and the wooden lattice of the banquettes slanting diagonally toward the bright rectangle of the window. The technique and coloring are very characteristic of Spilliaert's Symbolist period. Ink and wash have been used, varying from the most opaque to the most transparent application, and producing an admirable range of grays that allow equal play to the white paper and give a vivid eloquence to a narrow, vertical red band at the center of the composition.

The figure with its back turned, whose face is a mystery — so typical for Symbolism — seems to be derived from the German Romantic painter, Caspar David Friedrich. She appears in the works of Munch, Van de Velde, and Gauguin, then reappears to haunt the Belgian Surrealists Magritte and Delvaux, the latter using her as a *repoussoir* figure, like those of the sixteenth- and seventeenth-century mannerists, whereas Magritte had other subterfuges for hiding faces. Munch is often cited when Spilliaert is discussed. We must not make the mistake of thinking Spilliaert was unfamiliar with the Norwegian artist's work — which was exhibited in Paris at the Salon des Indépendants at the end of the nineteenth century — and, in fact, these compositions became well known, thanks to their use in his graphic works; the curvilinear forms of Munch were adopted and adapted by Spilliaert. Furthermore, in the present instance, the rose-colored aura around this figure is also found in the celebrated *Frieze of Life*. But what is indigenous to Spilliaert alone is the opposition of the curves and the geometry of certain elements like the window. The spirit evoked here is that of Maeterlinck. References to Maeterlinck are frequent in connection to Spilliaert's early years and it seems probable that the two men met in 1900 or 1901 at the home of Edmond Demans, who published *La princesse Maleine* in 1901. A wash drawing of 1910 bears the same title as the book, and resembles this work, which was exhibited in 1972 under the name *Woman Seen from the Back* (Musées Royaux des Beaux-Arts de Belgique, *Hommage à Léon Spilliaert*, 1972, cat. no. 43).

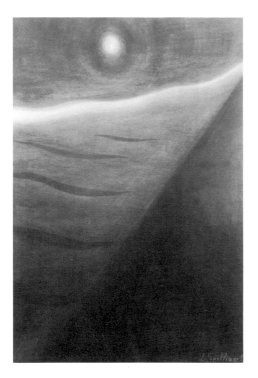

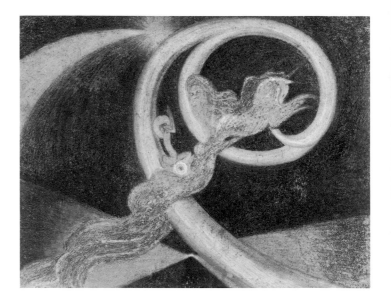

100 **La Bouée** *circa* 1910
The Buoy
Ink and pastel on paper
72.0 x 49.0 (28³/₈ x 19¹/₄)
Private collection, Brussels

101 **Elie et le char de feu** 1909
Elijah and the Fiery Chariot
Pastel on cardboard
68.0 x 89.0 (26³/₄ x 35)
Private collection, Brussels

This nocturnal scene with its plunging perspective is one of several in Spilliaert's work of this period. This one is composed along the diagonals of the dike and the white, lightly undulating line that represents the foaming crest of the waves. The two are joined in one of those acute angles that Spilliaert so often uses in his compositions. Beyond the white line, the sky and the sea become indistinguishable from one another, punctuated by the luminosity of the buoy, which is enveloped in a halo. On the beach, like a drawing in the sand, there appears that faint Art Nouveau arabesque that is often found in Spilliaert's Symbolist period. This diagonal composition, imprinted with Japanese stamps, but subjected to a pruning of details which the Japanese would never accept, is characteristic for this period; these landscapes are imbued with a nearly abstract aspect. "A kind of dream geometry which seduced Verhaeren . . ." wrote Spilliaert's intimate friend, the poet Henri Vandeputte (*La Jeune peinture belge*, special Nervie number, February–March, 1925). And Michel de Ghelderode, the Belgian poet and dramatist, said, ". . . one must flee into a moonlit landscape by Spilliaert, those scenes of harmonies which one can place on one's ear like a seashell . . ." (*Harmonies Ostendaises*, Tribord, August 1931).

The story of Elijah, separated from his son Elisha by a call from God — who carries him to the skies in a fiery chariot drawn by flaming horses in a whirlwind — is found in II Kings 2. Spilliaert was a great reader of the Bible and this most singular prophet must have had a special appeal for him because, at the end of his life, he chose again to represent Elijah being fed by the crows in the desert (I Kings 17). The extraordinary circular movement, described in brilliant colors, recalls the windstorm of the *Lighthouse at Ostend* of 1910 (presently exhibited in Washington, D. C., The Phillips Collection), which seems inspired by Futurism. But the latter work, which is very spectacular, shows some stylistic affinities to posters, while the work shown here is full of nobility and mystery. The visionary Spilliaert has imagined Elijah's ascension taking place at night above the sea and shore. Did War van Overstraete know that Spilliaert said of himself, "I am a Celt"? He makes the point insistently: "This Ostendais ties himself to those Celtic visionaries whose distant origin is touched on by a remark of Odilon Redon's: 'It is said that the Celts have accumulated for themselves over a long period the deposits of the human soul and like a legendary spirit . . . the ocean has left a breath of renunciation, of abstraction, in the aridity of the sand.'" (*Bulletin des Musées Royaux des Beaux-Arts de Belgique* 1953, no. 2, p. 80.) This large pastel, long forgotten, has probably never been exhibited before.

HENRY VAN DE VELDE
1863–1957

Henry van de Velde, who became internationally renowned for his part in the revival of architecture and industrial design, began his career as a painter. He studied at the Academy in Antwerp under Charles Verlat and was deeply impressed by Manet's *The Bar at the Folies-Bergères,* which was exhibited in Antwerp in 1882. When he visited Paris in 1884 he was drawn to the work of Millet, and on his return to Belgium a year later, he became one of the founders of the Antwerp circle, Als Ik Kan, and in 1887 also helped found the group L'Art Indépendant, whose goals were similar to those of Les XX in Brussels. Van de Velde was particularly active in the years 1886–1890 in the village of Wechelterzande, where he worked with "Luminist" landscape painters and made Impressionist works using the local farmers as his subjects. Seurat's *La Grande Jatte,* shown at Les XX in 1887, had a profound effect on Van de Velde and within two years he was showing works in the Pointillist technique. He joined Les XX in 1888, and in the following year's exhibition saw Gauguin's *Vision after the Sermon* as well as six Provençal paintings of Van Gogh. He was able to combine these influences in a highly individual manner, building form with curving lines of pure color, which at times verged on the abstract. By the early 1890s he had given up painting for applied art, becoming a leader in the Art Nouveau movement and a pioneer of the rational aesthetic. Between 1892 and 1894, he designed typography for the cultural periodical *Van Nu en Straks;* from 1900 to 1917 he worked in Germany, where he designed the interior of the Folkwang-Museum in Essen and founded the Kunstnijverheids-school in Weimar. After living in Switzerland for three years, he went to Holland in 1920 to draw up the first plans for the Kröller-Müller Museum and then returned to Belgium, teaching at the University of Ghent in 1925 and founding and directing the school in Ter Kameron between 1926 and 1935. He settled in Switzerland, finally, in 1947, to write his memoirs. During the short period he was a painter, Van de Velde taught himself a great deal about the function of movement — which he always rendered as rational, not impulsive. It was these discoveries through painting that led to his significant contributions to architecture and industrial design. [DC]

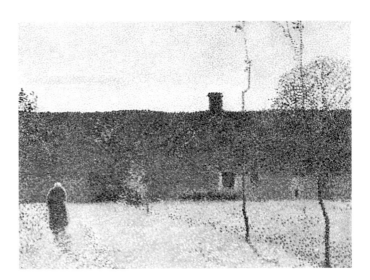

102 **Le Crépuscule** (Femme au Crépuscule)
1889
Twilight
Oil on canvas
45.0 x 60.0 (17³/₄ x 23¹/₂)
Rijksmuseum Kröller-Müller, Otterlo

Like Seurat himself, the young Van de Velde deeply admired the work of Millet, and the theme of peasant life was a continuing one in his work as a painter. In 1891, he was to give a lecture at Les XX on the subject of "The Peasant in Painting." But the most radical influence on his conception of painting was that of Seurat and his fellow Neo-Impressionists, whose work he first saw at the Les XX exhibition of 1887. Beginning in 1888, he began to paint in the divisionist technique, which from the outset liberated his gifts of pictorial construction. He showed his first works in this style at Les XX in 1889, at which time he met Seurat, who had come to Brussels for the exhibition. *Twilight* reveals Van de Velde's profound grasp of Neo-Impressionism; unlike many of Seurat's followers, he did not isolate the figure but integrated it within the total network of color-touches that made up the composition. This painting has been shown in the major Van de Velde exhibitions at Zurich (Kunstgewerbemuseum, 1958, no. 13), Hagen (Karl Ernst Osthaus Museum, 1959, no. 4), and Brussels (Palais des Beaux-Arts, 1963, no. 40). [SF]

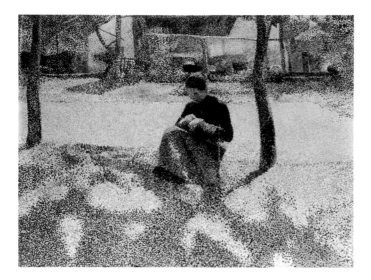 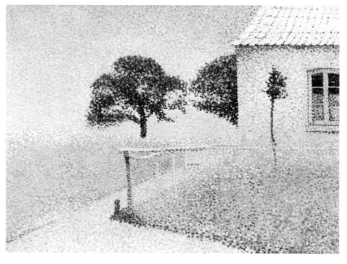

103 **La Ravaudeuse** 1889
Girl Darning
Oil on canvas
78.0 x 101.5 (30³/₄ x 40)
Musées Royaux des Beaux-Arts de Belgique, Brussels

104 **Paysage Puéril** 1891
Childhood Landscape
Oil on canvas
43.4 x 59.0 (17¹/₄ x 23¹/₄)
Arthur G. Altschul, New York
Reproduced in color on page 82

This painting was exhibited at Les XX in 1890 under the title *La fille qui remaille (Girl Mending)*. It is listed in the catalogue with two other paintings under the heading of "Les faits due village" — facts of village life. The series was done in the winter of 1889 at the village of Wechelderzande, where the artist lived from October 1886 to May 1890. (*Twilight,* cat. no. 102, was probably painted in this same series.) The theme of a woman sewing was a common one at this time, but is most frequently seen in an interior, bourgeois setting. Here, Van de Velde depicts a peasant woman outdoors. The Impressionist, *pleine-air* theme of stippled sunlight falling through leaves is here treated with great refinement in the divisionist style. [SF]

First exhibited in Antwerp at L'Association Pour l'Art in 1892, *Childhood Landscape* was shown again at Les XX in its final exhibition of 1893. A. Hammacher (*Le Monde de Henri van de Velde* [Antwerp, 1967], p. 331) expresses uncertainty about the date of 1891, written on the stretcher, on the grounds that this was the year during which the artist began to move away from the divisionist style. But the picture could well have been done early in the year — a time when Van de Velde was still very much an admirer of Seurat, as can be seen in the essay he wrote for *La Wallonie* at the time of the master's death in March 1891 (*La Wallonie* 6, 1891, pp. 167–171). Smaller and more intimate than his Blankenberghe paintings, this work resembles them in its use of diagonal shapes and its blond light. It was exhibited in the *Color and Field 1890–1970* exhibition organized by the Albright-Knox Museum in Buffalo (1970, no. 18). [SF]

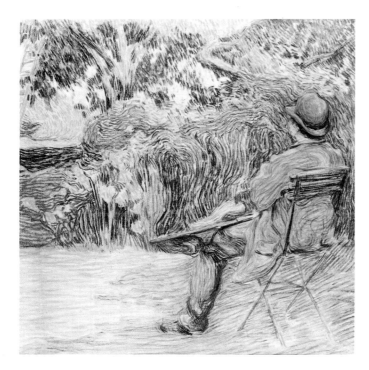

105 M. Briart au Jardin 1892–1893
M. Briart in the Garden
Pastel on paper
46.0 x 50.0 (18 x 19⁵/₈)
Galerie L'Ecuyer, Brussels

During the years 1891–1893, Van de Velde made a number of pastel drawings in which he developed a distinctive change in style. Retaining the divisionist principle of the juxtaposition of pure colors, he ceased to compose in small dots and began instead to build form with curving parallel lines of color. It is evident that he was greatly struck by the work of Van Gogh, which received its first public exhibition at Les XX in 1890; additional works were shown as a memorial exhibition in 1891. Van Gogh's drawing style, in particular, had a liberating effect on Van de Velde, enabling him to go beyond what he had begun to feel as the constriction of a strict divisionist technique. Although the rippling lines of a drawing like *M. Briart* create a sense of movement quite different from that of his earlier work, nonetheless a similar fusion of figure and ground is achieved by the way in which the linear elements in the figure are repeated in the surrounding vegetation. It was out of such pastel drawings as these that Van de Velde developed the curvilinear forms of his works in decorative art — some of the earliest productions in what came to be known as the Art Nouveau style. M. Briart was Van de Velde's brother-in-law; the young artist often visited his sister and her husband at their home in Kalmthaut in the early 1890s. [SF]

GUILLAUME VOGELS 1836–1896

Born June 9, 1836, Vogels was the son of a laborer, and after attending primary school, was a house painter for a time. In 1855, however, he became a master decorator, and finally the proprietor of his own painting and decorating firm. He was a self-taught artist. For a long time it was believed that he did not begin painting until late in his life, around 1878–1880. But we now know that he exhibited at the Ghent Triennale in 1874, with the Cercle Artistique in 1876, and was part of the group La Chrysalide from 1878 on. In 1881, his *Canal in Holland* was sent to the Salon in Paris, and in 1884, he was one of the founding members of Les XX. It was at this point that Émile Verhaeren, writing in the journal *La Jeune Belgique,* declared, "Vogels is a master. He has all the [necessary] gifts, developing and strengthening himself with his artistic authority." That same same year, Vogels participated in an exhibition of watercolorists — the *Hydrophiles* — and, according to *L'Art Moderne,* showed "the most beautiful work." However, he also received uncomplimentary reviews that expressed distaste for the sketchy quality of his pictures. Vogels was James Ensor's friend — even though the other man was twenty-four years his junior — and when they exhibited together at the Cercle Artistique in 1884, Vogels' influence on Ensor, and perhaps even on Jan Toorop and Willy Finch, was suggested. With the advent of Neo-Impressionism, Vogels, like Ensor, had problems with Les XX, and he sent nothing to the 1889 and 1891 exhibitions; but in the following year Verhaeren, as well as other reviewers, emphasized his importance among the exhibitors. Vogels died four years later, on January 9, 1896, eulogized by Octave Maus: "He was a precursor and an initiator." Though chiefly a landscapist, Vogels also painted flowers and made watercolors and drawings. His friendship with Périclès Pantazis was probably his source of influence for French Impressionism. His attachment to Belgian Realism, particularly through the work of Hippolyte Boulenger and Louis Artan, is even more apparent, and it was in this area that he developed his strongest qualities — ultimately to earn a place among the great masters at the end of the nineteenth century. [PR]

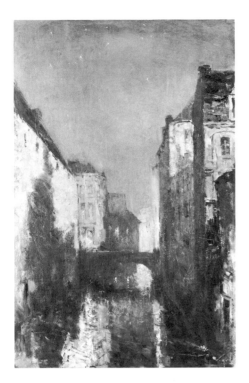

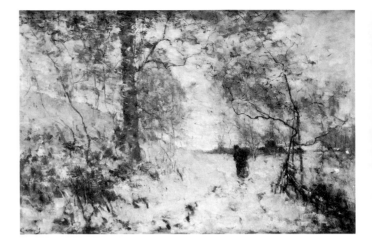

106 **La rue des Chanteurs** n.d.
Street of the Singers
Oil on canvas
83.0 x 54.0 (32³/₄ x 21¹/₄)
*Musées Royaux des Beaux-Arts de
Belgique, Brussels*

107 **La neige — soir** 1886
Snow — Evening
Oil on canvas
105.0 x 154.0 (41³/₈ x 60⁵/₈)
*Musées Royaux des Beaux-Arts de
Belgique, Brussels*

This nocturne, almost Whistlerian — as Fierens has already noted (*L'Art en Belgique* [Brussels, 1939], p. 484) — is not dated and was not shown at either Les XX or at La Libre Esthétique. Paul Colin has placed it between 1880 and 1884 (Brussels, *Rétrospective Vogels,* 1936, p. 47), which seems correct if one compares the painting to *L'Impasse des Quatre-Livres,* a work exhibited in 1884 at Les XX, in which the climate is also nocturnal and Whistlerian, and the technique very similar. Historians nevertheless considered *Street of the Singers* a major painting by Vogels and it has appeared in all his retrospectives (Brussels, 1921, no. 81; 1936, no. 16; and 1968, no. 60). It was also hung in Paris for the *Exposition de l'Art belge ancien et moderne* in 1923 (cat. no. 143), and on this occasion Gustave van Zype was quick to say of it, "All the characteristics of our [Belgian] art can be found there" (*L'Art belge du XIXᵉ siècle à l'exposition de Paris en 1923* [Brussels, 1924], p. 22). The subject shown is the Senne river in Brussels, since covered over, "a frightening corner of the capital, but sanctified by the night" (Fierens, *L'Art en Belgique,* p. 484). The strangeness and poetry of the atmosphere, which Vogels confers on many of the urban sites he paints, is obtained here by the dominantly blue and gray harmony, revealing, on close examination, a tonal richness, and accents ranging from pink to red, and green to yellow, which are freely brushed in with a lively effect of contrast. It was this sort of colored stroke and rapid calligraphy that developed into the substance and vibrations of such works as *Lightning, Snowstorm,* and *Twilight on the Pond* at the end of Vogels' life. Another version of this painting was in the exhibition of 1936 (cat. no. 17, reproduced in Colin, *La peinture belge depuis 1830* [Brussels, 1930], p. 308).

This remarkable evocation of falling snow at the close of day was shown with Les XX in 1886 (cat. no. 6), at the same time that *Russian Music* by Ensor and *Listening to Schumann* by Khnopff (cat. no. 33) were exhibited there. Among the artists invited that year were Monet, Renoir, Redon, and Whistler. Vogels, who caught the critics' attention, found himself described as a "subtle Impressionist." The same writer disapproved of the unfinished look of his works, which he called "interesting documents," recognizing the artist as possessing traits that were "poetic in [the midst of] his savagery" (A. J. Wauters, *La Gazette,* March 14, 1886). The picture was next seen at La Libre Esthétique in 1905 (no. 3), when the group Vie et Lumière was one of the exhibiting artistic circles (Claus, Degouve de Nuncques, Ensor, Lemmen, etc.) and the theme treated was "the external evolution of Impressionism." Octave Maus explained that it was "equitable to recall certain painters of the same persuasion, now dead, through some of their works in this style" — such as those of Vogels and Evenepoel. *Snow — Evening* was considered one of Vogels' masterpieces at that time, as attested to by the press and the letters addressed to its owner, Maus, who, that same year, suggested that it become an acquisition of the Belgian State for the museum. If the title and the general climate of this work — with its color range of rose to gray — evoke Impressionism, the technique — through its strong brushstrokes and impasto, as well as in its often vigorous and nervous graphic quality that imitates the pictorial surface — looks forward to Expressionism. Vogels had already suggested this new interest in 1885 when he exhibited *Foul Weather* with Les XX, as one of the key pictures in evolution of Belgian landscape painting. (Philippe Roberts-Jones, *From Realism to Surrealism: Painting in Belgium from Joseph Stevens to Paul Delvaux* [Brussels, 1972], p. 48.) An oil sketch, apparently preparatory to this picture, is also in the collection of the Brussels museum.

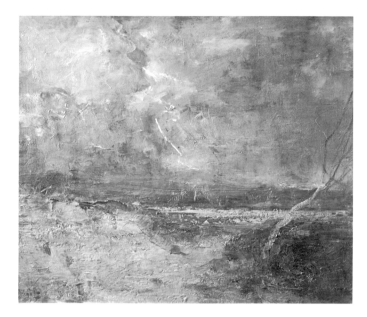

108 L'Éclair
Lightning
Oil on canvas
54.0 x 65.5 (21$^{1}/_{4}$ x 25$^{3}/_{4}$)
*Musées Royaux des Beaux-Arts de
Belgique, Brussels*

This painting is undoubtedly from the final period of the artist's life and was given to the Musées Royaux in 1906 (by the collector Fritz Toussaint), but was not shown until the *Le Groupe des XX et son temps* exhibition (Brussels, Otterlo, 1962, cat. no. 172), and later in the Vogels retrospective of 1968 in Brussels. This can probably be explained by the painting's audacious and innovative character, which replaces all anecdote with pictorial language. Lightning tears the sky — not in a precise and conventional manner, but in an intense and fleeting flash created in strong accents — bursts of paint — and brushstrokes so modern as to be surprising at the time. Only the substance and density of color establish the planes of the landscape and sky in the instant they are revealed by the lightning, lending permanence to this drama, a characteristic enforced by the graphic quality of the dead tree at the right of the scene. It is for these reasons that Vogels was understood only after the lessons of Expressionism had been learned. As Octave Maus said, in his funeral elegy, Vogels "took part in all the antagonistic exhibitions" and knew how to express "with a singularly expert hand [and] in a number of slashes with the brush, violent as sabre cuts, the summation of the impression sensed" (*L'Art Moderne,* January 12, 1896, p. 11).

GUSTAVE VAN DE WOESTIJNE
1881–1947

Gustave van de Woestijne, younger brother of the Flemish poet Karel van de Woestijne, was born and raised in Ghent at the end of the nineteenth century. He studied there at the Academy, but when he was only nineteen he fled the problems of life in an urban atmosphere and the pressures of academic education to live with his brother in the small village of Laethem-St.-Martin on the banks of the River Lys. It was there that he became the deeply introspective personality who was one of the most important of the Belgian Symbolists. The central idea of the little artists' colony was to search for a meaningful, spiritual art, its members believing it necessary to take a strong stand against the current and popular Luminism of Impressionists such as Claus and his followers. And in their worship of medieval art and culture — encouraged by the important Flemish Primitive exhibition at Bruges in 1902 — Van de Woestijne and his brother, Minne, De Saedeleer, and Van den Abeele might be said to resemble the earlier nineteenth-century brotherhoods of the Nazarenes and Pre-Raphaelites. Van de Woestijne married in 1908 and moved to Louvain, then lived in Brussels and Tiegem until the war, when he moved his family to Wales with Minne and De Saedeleer. He later became director of the Malines Academy and taught in both Antwerp and Brussels, where he died. His oeuvre consists mainly of portraits and figural compositions, though it also includes some landscape, still life and religious works. Many of his paintings possess a highly personalized, allegorical character and a strong feeling of alienation. Postwar works demonstrate the effects of Cubism and Expressionism on the artist in the loss of some of his earlier delicacy, restraint, and poetic tenderness. [RH]

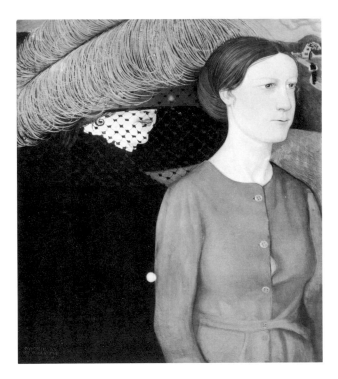

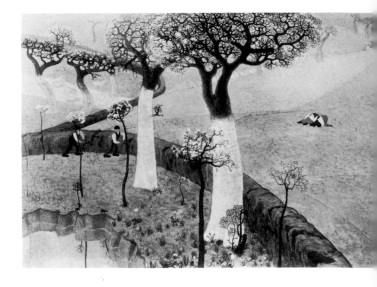

109 **De Twee Lentes** 1910
The Two Springs
Oil on canvas
73.0 x 63.0 (28³/₄ x 24³/₄)
*Koninklijk Museum voor Schone
Kunsten, Antwerp*
Reproduced in color as Frontispiece

110 **Lente op de Buiten** 1910
Spring in the Country
Oil on canvas
100.5 x 151.0 (39¹/₂ x 59¹/₂)
Private collection, Ghent

In its overt symbolism and sophistication, this double portrait, comparing the country woman and the city woman, is an early example of the enigma attached to all the female portraits this artist painted. Its subtitle, *The Town Mouse and the Fieldmouse,* does not really reveal its true purpose, which seems to be an analysis — both in form and content — of two different women, or of two different aspects of the same woman, through the contrast of two types of elegance. Though a fairly early work, *The Two Springs* shows Van de Woestijne's mature style, when he has achieved complete mastery of Symbolist devices and pictorial elements. He is able to create a mysterious and thought-provoking unity with the formal beauty of lines and silhouettes. He uses a particularly effective contrapuntal structure. The repetition of two heads, male or female, is a recurring feature in his work, best seen in the *Woman Drinking Liquor* of 1923 (Antwerp) where the artist himself is represented completing a double portrait of a female pair, placed in parallel. As a major work by Van de Woestijne, this painting has been seen in all his retrospectives (Brussels, 1929; Ghent, 1949; Malines, 1967; and Laethem-St.-Martin, 1970).

Spring in the Country is the first of a number of landscapes painted between 1910 and 1914, in which the artist expressed his love for the highly cultivated Flemish countryside around Laethem-St.-Martin. The pool, the pastures and fields, the farmhouse beyond, the sheep in the orchard with its whitewashed trees in blossom, the hedges and the miniaturized peasants, working two by two at their unchanging labors — all these elements combine in a true synthesis of rural West Flanders. Even the linear rhythm of rolling fields and twisted trees is hardly exaggerated, despite the general flatness of this typography in actuality. In comparison with the smaller pictures — generally portraits — that Van de Woestijne had been painting up until 1910, this is a rather ambitious work that contains clues to many influences in his oeuvre. Medievalisms are mixed with the distortions of Gauguin's synthetism, De Saedeleer's silhouettes, and Breughel's convincing seasonal effects. The left foreground is reminiscent of a "hortus conclusus," showing a tree and flower-ringed spring that is isolated from the rural fields by a hedgerow. A similar effect appears in *The Garden of St. Agnes* of 1911 (Brussels, Van Buren Museum) and *Eternal Reflections* from the same year, in the same collection. *Sunday Afternoon* of 1914 (Brussels, Musées Royaux des Beaux-Arts) is also related to *Spring in the Country.* The picture has been exhibited twice (Brussels, *Rétrospective Gustave van de Woestijne,* 1929, cat. no. 22 and Malines, *Gustave van de Woestijne,* 1967, cat. no. 25).

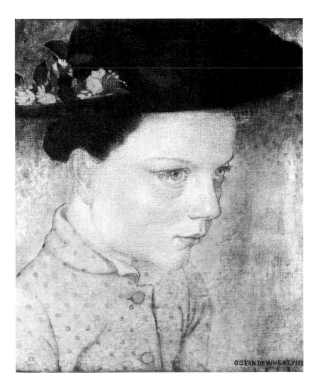

111　**Boerinnetje** 1913
Little Peasant Girl
Oil on canvas
37.0 x 32.0 (14$^{1}/_{2}$ x 12$^{5}/_{8}$)
Museum voor Schone Kunsten, Ghent

This portrait of a peasant girl has been shown in all the exhibitions devoted to Van de Woestijne's work, as one of the best examples of his prewar style. Though it is dated 1913, some years after the artist had left Laethem-St.-Martin, it relates strongly to his experiences there and to his portraits of peasants, in which accuracy of detail is combined with a refined attention to texture and an elegance in decorative outline. As Valentin Denis (*Openbaar Kunstbesitz in Vlaanderen* 1, 1963, no. 2) has remarked: "The artist here combines religious feeling and extreme realism, in its outlines, which he admired in the work of the Flemish primitives, and the soft colors of Italian fresco painting. The use of a gold background and of very thin paint, hardly covering the canvas, with its dematerializing and transparent effect, beautifully supplements the delicate linearism expressing a fragile beauty, purity and devotion which must have struck the artist in this girl's face. At the same time, details such as the knot in her hair, the head and the dress, bring the image down to a specific reality, dating it, and adding a touching provincial element to an otherwise timeless face."

Gustave Serrurier-Bovy
Furniture Group with Liberty Fabrics *circa 1895*
Private Collection, Brussels

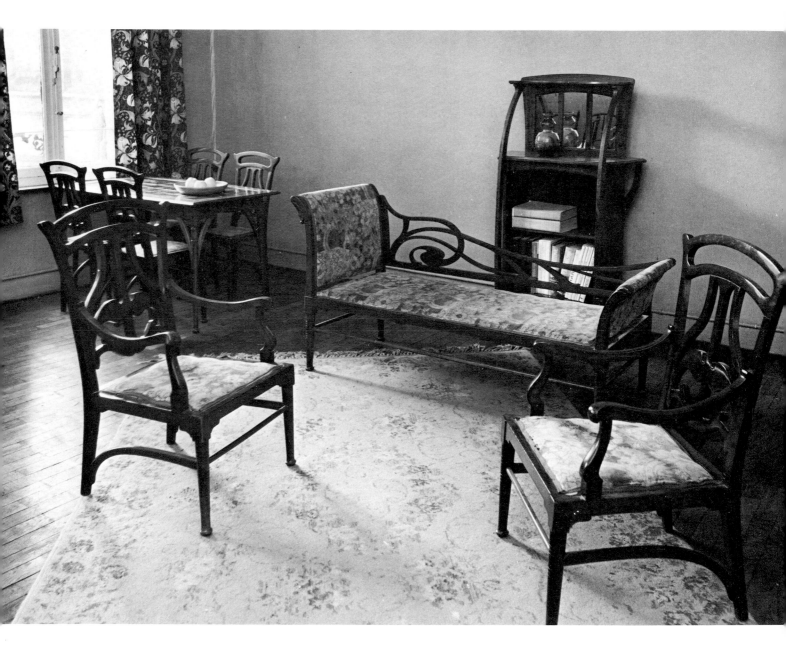

Belgium: The Blossoming of the Decorative Arts

Lieven Daenens

Director
Museum voor Sierkunst
Ghent

Jacques-Grégoire Watelet, O.P.

Art Historian
Brussels

The decorative arts are first mentioned in connection with Les XX in 1888. But their more conspicuous entry into the world of the continental Salon occurred during the group's eighth exhibition, in 1891.[1] It was a modest beginning, but a significant and prophetic one: the English illustrator Walter Crane was represented by nineteen illustrated books, owned by Georges Lemmen; Willy Finch, painter turned potter, showed decorated ceramic pieces that he had made at the Boch faïencerie in La Louvière where he was employed; and, perhaps most important of all, Paul Gauguin sent three ceramic vases along with his pair of polychromed reliefs, *Soyez Amoreuse* and *Soyez Mystèrieuse*.[2] For the first time, a group of painters, sculptors, musicians, and writers ignored the conventional separation of fine arts and artisanry to accept a group of decorative crafts on a level with their own work.

It was probably Henry van de Velde, elected to Les XX in 1888 — the year he became a disciple of Seurat's new technique — who encouraged the display of applied art in their exhibitions. In the early 1890s, Van de Velde reexamined his career in painting and came to the conclusion that he should abandon it in favor of the decorative arts. His future wife, Maria Sèthe, brought him into closer contact with the English Arts and Crafts movement, and he came under the influence of William Morris, who inspired him to devote his life to a similar crusade for higher standards of design in the home.[3] Two other Belgians also responded quickly to the English influence: Finch, whose ceramic work had been shown in the 1891 Salon and whose own origins were English; and Gustave Serrurier-Bovy, an architect from Liège who was responsible for bringing the first Liberty fabrics and wallpapers to Belgium — probably as early as 1884, when he formed his own firm for furniture design and decoration.[4] In 1893, Van de Velde exhibited his first handmade craft piece, *The Angels' Watch* (Zurich, Kunstgewerbemuseum), a "tapestry" — actually a cloth hanging made in appliqué technique and reworked with embroidery — which he designed and carried out with the help of his aunt.[5]

The popularity of the new interest spread rapidly and La Libre Esthétique, the group that succeeded Les XX,

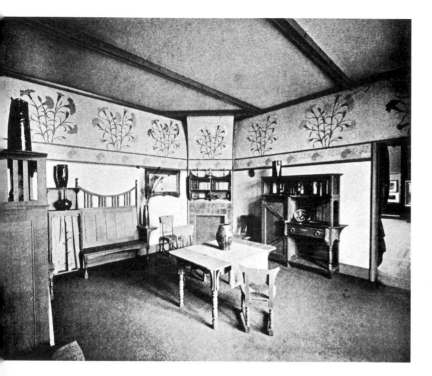

took a firm step toward commitment to the decorative arts at its inaugural exhibition of 1894, by showing an entire suite of furniture designed by Serrurier-Bovy,[6] as well as more work from England. Other Belgians would be seen in this capacity at future Salons: Van de Velde, of course; Victor Horta,[7] the great Art Nouveau architect; and dozens of ceramicists, glassmakers, leather workers, jewelers, and metal artisans. A true revolution in the arts had taken place in Belgium, echoing Morris and his disciples, but demanding, even more strongly, that painting and sculpture become an integral part of daily life.

In 1891, Brussels became the first city on the Continent where Liberty's line of ornamental objects, mostly Oriental in feeling, could be purchased — at a store called the Compagnie Japonaise. In his memoirs, Henry van de Velde[8] remembers being inspired by the new possibilities in design these objects suggested. Soon other Belgians were converted by the innovative excellence of English ornament; architects became *ébénistes*[9] — cabinet-makers — painters began to make pots[10] or invented patterns for wallpaper and textiles,[11] and sculptors turned to fine metalwork or created beautiful domestic necessities — candelabra, dishware, and silver settings.[12] Crafts were revived as a means of bringing a higher aesthetic to everyday life. Suddenly, art was everywhere. Everything from carpets to typography was affected, even to the extent that painting and sculpture were sometimes relegated to a less prominent position so that the equality of integration with objects would be complete. The artist's new role enhanced all aspects of life. This triumph of fashion, which had begun in England, was altered by its meeting with continental style; it became much stronger in Belgium. The desired results were not, of course, realized all at once, or without opposition. But the initiates of this *art nouveau* were extremely persuasive because of their strong personal conviction in the necessity for a new era of design.

But what, exactly, was the style that came to be known as Art Nouveau — that excited the enthusiasm and participation of so many sensitive and talented artists of the period? For the answer, one must return to an earlier period, when nature was rediscovered as a motif central to art. Ruskin and the Pre-Raphaelites

Victor Horta
Horta's House in Brussels 1898
Amerikastraat, St. Gilles
Window detail

Victor Horta
Horta's House in Brussels 1898
Amerikastraat, St. Gilles
Architectural detail

Henry van de Velde
Candelabra *circa* 1898–1899
Silver-plated bronze
Height: 58.5 cm. (23 in.)
Collection: Musées Royaux d'Art et d'Histoire, Brussels

Val-Saint-Lambert
Wineglass *circa* 1898 (cat. no. 150)
Crystal with wheel-cut decoration
Height: 18.4 cm. (7¹/₄ in.)
Collection: Museum voor Sierkunst, Ghent

Philippe Wolfers
Maleficia 1906
Wood (?), ivory, and amethyst
Height: 61.5 cm. (25¹/₂ in.)
Private Collection, Brussels

were the first nineteenth-century enthusiasts in the world of flora. Soon, analyses of plant forms and their potential for adaptation began to appear in pattern books published in England and France,[13] and the flower, as a creative source, experienced one of its many rebirths. The predilection for graceful plant forms occurred, at least partly, in reaction to the dry decor of Neo-Classicism — to the documentary eclecticism that was so prevalent in manufactured ornament. But the plant became even more than a novelty. Its freshness, its flexibility, its vitality and, perhaps most important, its admirably ingenious structure, became a paradigm of modern life. Almost everyone was strongly attracted to the plant as a model, and art experienced a springtime efflorescence.

Artists were particularly enchanted with Oriental flowers; the sinuous stalk upon which buds and blossoms swayed in Japanese woodcuts was a major source of ideas for design. At this stage in ornamental style, the curvilinear always took precedence; Van de Velde found it in the curling edge of a wave and Horta used it like a skeleton in the spatial dynamic of his construction — "I take the flower, I keep the stem," he said.

Designers created curves with materials that had never before bent with such alacrity: wood and iron, and all the precious metals were imbued with a pliancy comparable to that of a human acrobat. In painting, the same spatial counterpoint was developed on patterned papers and textiles, by former easel artists. Colors and fabrics responded to the materials of the furniture and objects with which they were associated; the new woods recently made available to Belgium through the exploitation of the Congo came in exotic blends of blond and brown. They were used with ivory — which also came from the new African colony — as well as with glittering enamels, uncut or faceted precious stones, and copper, pewter, silver, brass or gold. Glass appeared in all its iridescent potential, and in the form of glazes for ceramic work. This marvelous mixture of crystalline apparitions and natural phenomena formed a rich repertory for the creators of decorative objects. But the magical world lasted a relatively short time: only two decades. In the second generation, form and idea were repeated so readily

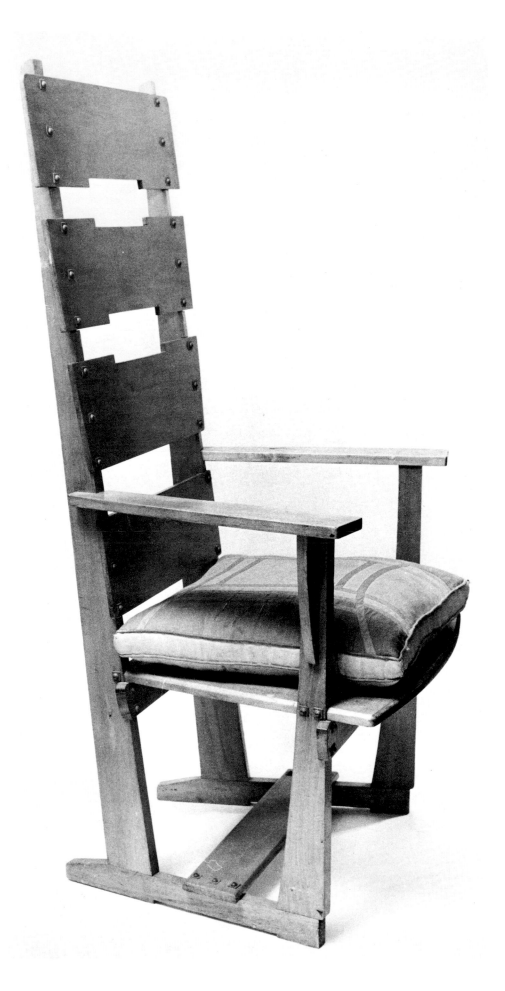

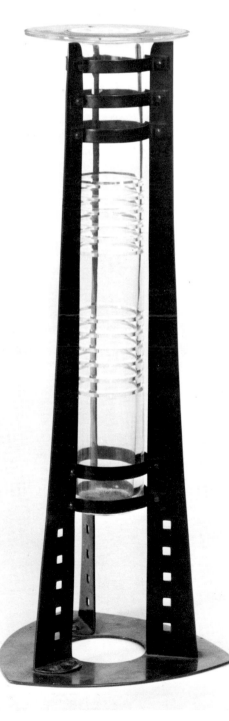

and rapidly that a point of saturation was reached, and the public, constantly fed on the notion of the "new," became jaded.

Artists throughout Europe — in France, Germany, Italy, and Spain — had surrendered to the intoxication of the curve. Ultimately, however, such an effusion of twisting, turning, spiraling, and trailing resulted that some relief was called for. The turn of the century brought with it a more disciplined contour, sedate in comparison to that of the decade that had blossomed before. Belgian artists and designers were drawn to the new style when they saw it at the Darmstadt Exhibition of 1901.[14] Clear color combinations, slender proportions, and easily understood structures echoed the work of Charles Rennie Mackintosh, who had enjoyed enormous success the previous year in Vienna. The Glasgow architect's genius, which was appreciated far more abroad than at home, had been recognized in Liège as early as 1895 when Serrurier-Bovy — with great prescience — had shown Mackintosh's furniture at L'Oeuvre Artistique.[15] Henry van de Velde left Belgium in 1900 to direct the School of Arts and Crafts in Weimar — later to become the first Bauhaus School, where the new sobriety that he supported would become a much more severe abstraction in the postwar years. The work of Horta and Serrurier-Bovy took on a more geometric appearance. It was also at this time that Joseph Hoffman, the Viennese architect, began work on the rectilinear Stoclet Palace in Brussels.

Merely by wishing to influence every detail of daily life, Art Nouveau was already a social revolution. To this end, it tried to erase all differences between artisan and artist, art and craft. But even so, it was understood and accepted only by a small group of progressive businessmen, who shared in Belgium's prosperous years at the end of the century. The artists and entrepreneurs of Art Nouveau wanted to extend their cultural innovations to a larger audience, spreading its influence as far as possible. What they desired was, in effect, a social art — art for everyone. When the young bourgeois socialists decided to build their Maison du Peuple, they engaged the innovative architect-engineer Victor Horta, whose concept of space, shaped by the stalks and tendrils of Art Nouveau, had revolutionized building interiors. Jules Destrée, art critic and director

Victor Horta
Brugmann Hospital, Brussels 1906–1926

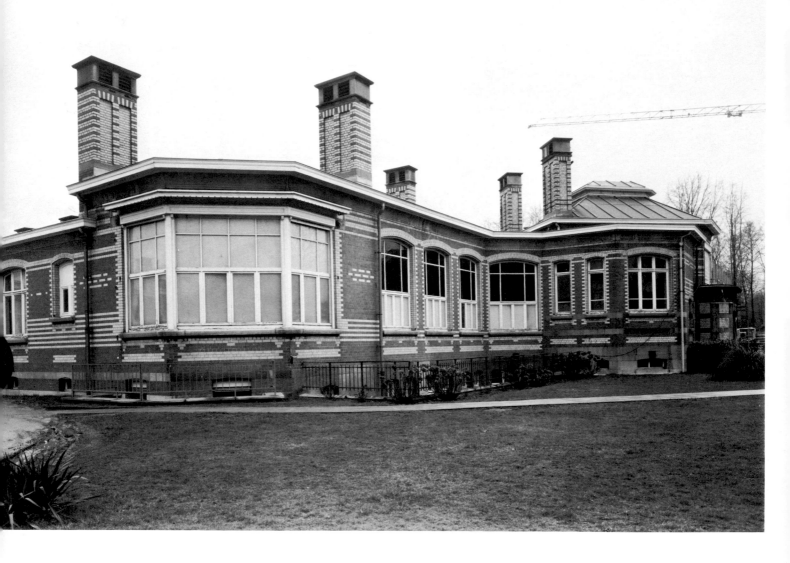

Josef Hoffman
Stoclet Palace, Brussels 1905–1911

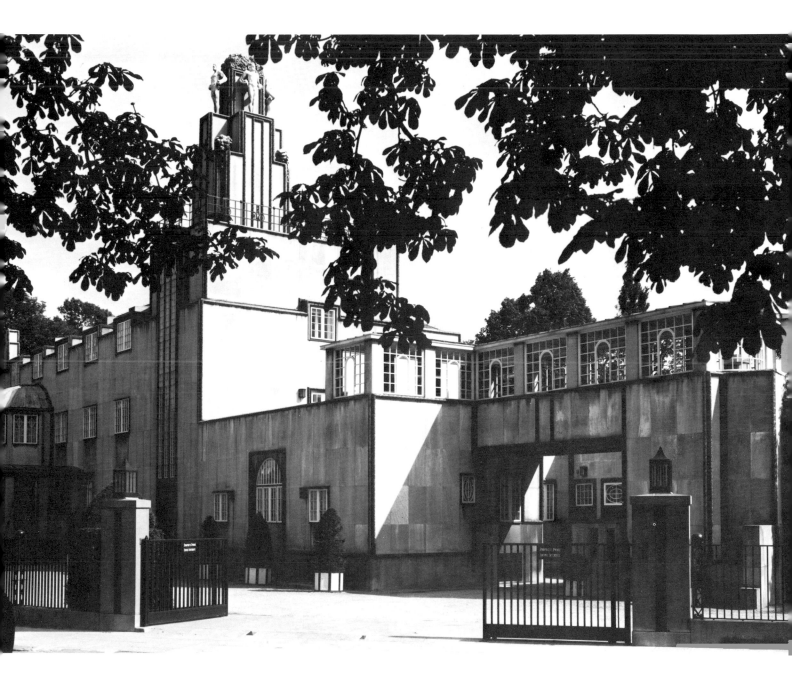

of the cultural program for the Belgian Workers Party, proposed to make the art of all ages available to everyone,[16] but particularly the creations of the Art Nouveau. The Party planned a number of methods for disseminating the new taste through educational programs and various other activities. Unfortunately, many of their laudable ideas remained in the planning stage, due probably to the middle-class paternalism that tainted them — even though the impetus was a progressive one. The working classes, toward whom these plans were directed, remained oppressed by the industrial system, and therein lay the paradox that stifled the reach of Art Nouveau. Those who wished to bring culture to the people often compromised themselves through their association with the economic system.

So the time for a truly democratic art was never realized through Art Nouveau. As William Morris had said, art must not only be *for* the people, but by the people as well.

1. Madeleine Octave Maus, *Trente années de lutte pour l'Art, 1884–1914* (Brussels, 1926), pp. 68, 114–115.
2. Maus, *Trente années*, p. 115.
3. Gillian Naylor, *The Arts and Crafts Movement: A Study of its Sources, Ideals and Influence on Design Theory* (Cambridge: MIT Press, n.d.).
4. J.-G. Watelet, *Gustave Serrurier-Bovy, architecte et décorateur 1858–1910* (Brussels: Académie Royale de Belgique, 1975).
5. Henry van de Velde, *Geschichte meines Lebens* (Munich: Piper & Co., Verlag, 1962).
6. Maus, *Trente années*, p. 178.
7. Maus, *Trente années*, pp. 211 and 220.
8. Van de Velde, *Geschichte*, p. 56.
9. Horta, Hankar, Hobe, Jaspar, Serrurier-Bovy, and Van de Velde, for example.
10. Finch.
11. Van de Velde.
12. Fernand Dubois, Charles van der Stappen.
13. Darmstadt, Mathildenhohe, Hessiches Landesmuseum, Kunsthalle, *Ein Dokument Deutscher Kunst — Darmstadt 1901–1976*, 1976–1977 (5 vols.). Serrurier-Bovy was so impressed that he wrote two articles about the exhibition in the Belgian review, *L'Art Moderne* (1902, pp. 35–37 and 202–203).
14. S. Tschudi Madsen, *Sources of Art Nouveau* (New York: Da Capo Press, 1976).
15. Brussels, Horta Museum, *Art Nouveau — Liberty*, 1979, p. 18.
16. Jules Destrée and Ernst Vandervelde, *Le Socialisme en Belgique* (Paris: Giard & Brière, 1898), pp. 229–249.

Afterword: The Social Context of Belgian Art

Gilberte Gepts-Buysaert

Director
Koninklijk Museum voor Schone Kunsten
Antwerp

This exhibition was intended not as a chronological review of the artistic development within its period of 1880–1914, but rather as an overall picture of the artistic climate existing in a small country, founded as an independent state within a European community to which it has strong bonds in the political, social, economic, and cultural fields — bonds that stem from long-standing, historical traditions of commonality.

The period has not been chosen by accident. It corresponds with the time known in Europe as *La Belle Époque*, the years of immense luxury and careless pleasure for the bourgeoisie. It was then that the Western world began to experience the excitement of technical progress and industrial discovery that pushed both time and space to ever greater expectations and provided a totally new outlook for the world as a whole. American and European inventors contributed strongly to this transformation of society, in which industrialism took precedence over agriculture, simultaneously bringing to an end the isolation of country living. The world shrank and the potential reach of every member of civilization lengthened. The class system lost strength, the philosophy of socialism became reality, and the cult of individualism on the basis of merit gained credence. Artists saw an opportunity for unrestrained freedom in expressing their personal feelings and creative ideas.

Among Belgian artists, changes in attitude were apparent early on. By 1880, when the young nation was celebrating its fiftieth anniversary, its artists, who had formerly focused their attention on the glorification of their homeland in history painting or romantic and patriotic allegory, were turning instead to the new exploratory modes: Realism, Impressionism and, above all, Symbolism. During this period, academic education in art lost much of its prestige, even in Antwerp where the country's oldest academy was founded in 1663. The so-called Antwerp School was no longer influential. Instead, Brussels — already the administrative, legislative, and economic capital of Belgium — also took on the role of cultural center. Artists from all over the kingdom were attracted to the city, where innovative work in all the arts was encouraged. Special groups devoted to promoting and exhibiting art, as well as presenting lectures and musical programs and

establishing small literary reviews, were founded and received with great enthusiasm in Brussels. Many came into existence, some flourished for years, and almost all were based on the notion of greater artistic freedom in all fields. At the end of the century, a strong bond formed between literature and the visual arts.

The periodical *La Wallonie,* founded by the poet Max Waller, chose the motto, "Soyons nous" (Let's be ourselves) and the theme, "L'art pour l'art"; but any self-indulgence in such an attitude was balanced by the equally strong motivation toward "l'art social," championed by the lawyer and connoisseur, Edmond Picard, among others. In 1883, the group Les XX — spoken of throughout this catalogue — began its exhibitions of work by artists who had no basis for stylistic brotherhood, but who held a common desire to create freely. The very distinctive points of view which were offered by their exhibitions is the basis for Les XX's incomparable position in the history of European art during the last two decades of the century. The group which inherited the mantle of Les XX in 1897, La Libre Esthétique, continued the spirit of their programs until the beginning of the First World War. Meanwhile, Antwerp regained something of its former importance for artists by creating the circle Kunst van Heden or Art of Today, which followed the freedom prescribed by the Brussels groups.

With the increased activity in exhibitions, the profession of art criticism came into existence in Belgium. Camille Lemonnier (1844–1913) was an early practitioner, who wrote reviews on the Salons and made studies of individual artists such as Alfred Stevens, Émile Claus, Henri de Braekeleer, and Félicien Rops.

This urge toward creative innovation was, of course, not merely Belgian, but was a phenomenon which found fertile ground all over Europe and was led by French artists: Corot, pioneer in pleinarism; Courbet, strong-willed advocate of Realism; Monet, who pushed Impressionism to a dominant position; Seurat, inventor and master of the divisionist technique. And it was the publication of Moreas' manifesto in a literary supplement of *Le Figaro,* on September 18, 1886, that made Symbolism a recognized movement. So, at the end of the nineteenth century, Paris had become the center of the avant-garde in Europe.

Relations between France and the Belgian bourgeoisie in the nineteenth century were extremely strong, not only with those from the francophone cities but with the rather large group of French-speaking people in the Flemish cities of Ghent, Antwerp, and Bruges. Many Belgians, however, were less attracted by the cultural philosophy of Paris than by its frivolous delights and, consequently, when an extraordinary artist — someone like Ensor — came to light in their own country, they were not equipped to recognize his genius. On the other hand, it is most surprising to find that, even in the face of such strong artistic influences from France, Belgian artists were able to maintain their own artistic personalities within the European movements they joined.

The exhibition offers a review of the work of about three different generations of artists, born after the year of independence, 1830. Within these different generations, it is possible to determine a growing and changing concern with the social situations prevalent in their lifetime. In some cases, social injustice is the keynote. In upper-class conditions, in cities like Antwerp or Brussels, luxury abounded while the lower classes of peasants and working people suffered enormously. The situation was even worse in Ghent and Bruges. In Wallonie, much of the countryside was industrialized, while the greater part of Flanders was still agricultural; but neither situation solved the problems of poverty and deprivation which prevailed among the workers. The period became a time of emigration, with many embarking from Antwerp to the United States. Sometimes their traveling expenses were even paid for by public assistance.

The organizers of this exhibition have often chosen works which stress the social reality of the times as Belgian artists saw it. The oldest artist whose works are exhibited here is Constantin Meunier, born in 1831. Meunier, Henri de Groux, and Eugène Laermans were the chief proponents of the social realist style in nineteenth-century Belgium. Meunier's major theme is the recurrent idea of the ennobled laborer. He shows coal miners and metal workers of the Borinage area, or men from the Antwerp docks, in the role of heroes returning triumphant from struggling with the substance of their backbreaking labor.

Constantin Meunier
Coin de fabrique d'acier n.d. (cat. no. 63)
Corner of a Steel Factory
Charcoal, pastel, and white chalk on paper
88.4 x 74.0 cm. (34³/₄ x 29¹/₈ in.)
Collection: Musée Constantin Meunier, Brussels

Eugène Laermans
Le Sentier 1899 (cat. no. 42)
The Path
Oil on canvas
135.0 x 175.0 cm. (53⅛ x 68⅞ in.)
Collection: Musées Royaux des Beaux-Arts de Belgique, Brussels

Émile Claus
Zonnige Dag 1899 (cat. no. 6)
Sunny Day
Oil on canvas
92.5 x 73.0 cm. (36⅜ x 28¾ in.)
*Collection: Museum voor Schone Kunsten,
Ghent*

Laermans' *leitmotiv* is the downtrodden peasant — men dressed in smocks, wooden *klompen*, and small caps; their women wearing heavy, shapeless skirts and clumsy jackets, scarf on head. They stumble along the roads of Flanders, weary, vanquished, and without visible hope; they are true victims of social inequity. Where Laermans shows landscape around them, it is as dejected and disconsolate as the people who move through it. Meunier's strength and pulsating life are flattened in Laermans' paintings, surrounded by strong contours and buried under dull, dark colors.

Émile Claus, who was younger than Laermans by fifteen years, preferred to work outdoors in a colorful and Impressionistic style. His subject matter was also the peasant, but his attitude is one that underlines the harmony of his subjects with their environment and their lives. In his works, women wash clothes happily in the warm sunshine and farmers bring their hay in from the fields with pleasant good will. Social realism embraces the middle classes as well as the poverty-stricken. Théo van Rysselberghe, Henry van de Velde, Charles Mertens, Georges Lemmen, and Henri Evenepoel all dealt with subjects drawn from the bourgeois life.

A growing reaction against the secularization of art brought Symbolism to its heights, in a search for the true meaning of life through mysticism. The images used by Symbolist artists, even though sometimes familiar, were often undecipherable — except to select initiates — and the aim of the movement was frequently unclear. Poetic notions of great delicacy mingled with eroticisms, and both had transcendental implications. Symbolism became one of the main currents of European art.

Léon Spilliaert
Jeune Femme Assise sur un Tabouret 1909 (cat. no. 99)
Young Woman Seated on a Stool
Pastel and colored pencil on paper
68.0 x 55.0 cm. (26³/₄ x 21⅝ in.)
Private Collection, Brussels

Henri Evenepoel
Le Caveau du Soleil d'Or 1896 (cat. no. 19)
The Cellar at "The Golden Sun"
Oil on canvas
73.5 x 92.0 cm. (29 x 36¹/₄ in.)
Collection: Musées Royaux des Beaux-Arts de Belgique, Brussels

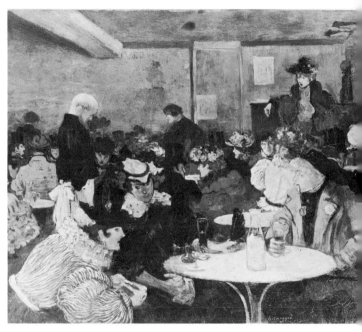

In the imaginary world of a leading Symbolist painter, Fernand Khnopff, the central theme was the cult of solitude, while his somewhat older contemporary and teacher, Xavier Mellery, strove to lay bare the soul of things through allegorical compositions or intensely silent and empty interior scenes. Others involved in the mystic realm took strongly divergent paths to its center: Félicien Rops dealt in erotic satire of great power, while George Minne probed the agonies of a mother confronted with the death of her child and drew a strong parallel with the *Pietà* theme of Christianity. Jean Delville, who was one of Péladan's disciples, found inspiration in his teacher's theosophical instruction. Degouve de Nuncques and Léon Spilliaert each gave, in his own way, expression to alienating experiences within the reality of their surroundings. The landscapes of Valerius de Saedeleer are emanations of a divine presence, while Gustave van de Woestijne of Ghent produced work of penetrating simplicity and religious fervor.

But, of the multitude of artists who appear before the First World War in Belgium, two are major: Henri de Braekeleer, born in Antwerp in 1840, and James Ensor,

Gustave van de Woestijne
Lente op de Buiten 1910 (cat. no. 110)
Spring in the Country
Oil on canvas
100.5 x 151.0 cm. (39$^{1}/_{2}$ x 59$^{1}/_{2}$ in.)
Private Collection, Ghent

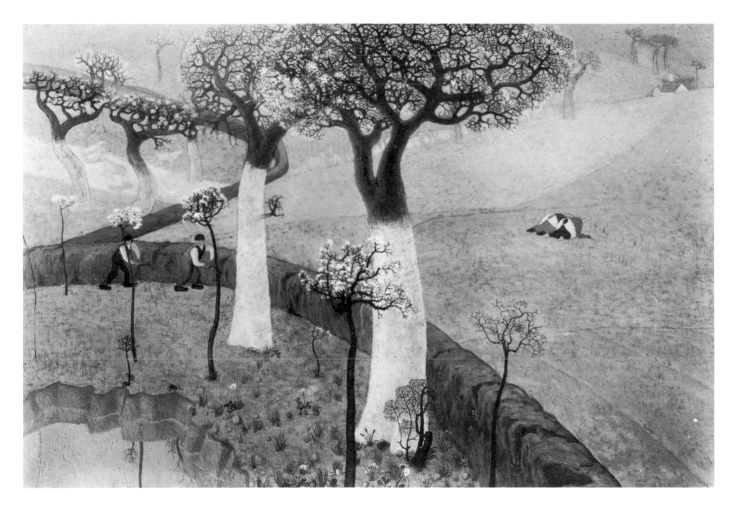

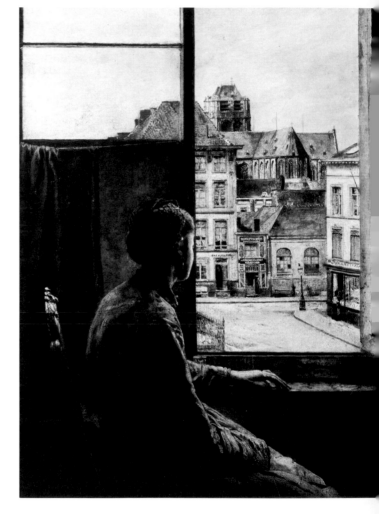

born in Ostend in 1860. Both reached a level of international importance in their best works. De Braekeleer was the last artist to carry on with the Flemish pictorial tradition that had existed from the time of the Van Eycks; his palette and his accomplishments in reproducing spatial illusion were both exceptional. All matter in De Braekeleer is animated by light and for this reason, as well as others, his work is often reminiscent of the Dutch seventeenth-century painters, such as De Hoogh and Vermeer. His interiors are faithful to many Antwerp rooms of the sixteenth and seventeenth centuries. While the attention to surface detail in De Braekeleer might give the impression that he is merely interested in material representation and middle-class values, his work is actually imbued with a mysterious significance. He speaks of man's longing for the eternal life and escape from his worldly prison.

James Ensor, whose mother was Flemish and father was English, lived beside the sea in Ostend. His themes are partially derived from these surroundings and the bourgeois milieu that existed there. But often he exceeds these quotidian realities and replaces everyday life with a visionary world. In 1875, Ostend was one of the world's most famous seaside resorts. Dandies and beauties played and swam on its beaches and frequented its Casino. During the season, everything appeared to be prosperous, but when the tourists had left and winter descended, the town was reduced to a few fishermen and their families, and the merchants who made their living there.

Ensor pictured the secluded middle classes in their darkened salons, the dunes and beach outside, the roofs of the town and the masks of Carnival. His manner of working was technically diversified, depending on his subject matter. The grotesques of his most important paintings are heavily, thickly painted, sometimes with a palette knife. These ghastly burlesques of human form are the sickly, inner reality of life revealed.

Until this exhibition, very few of the artists mentioned in this catalogue have achieved an international reputation. Perhaps it would be worthwhile, for art history, to explore even further into the complexity of Belgium's art world.

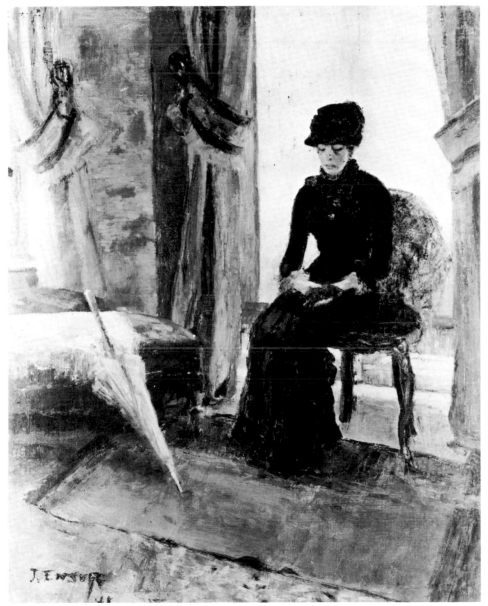

James Ensor
La Dame Sombre 1881 (cat. no. 12)
Somber Lady
Oil on canvas
100.0 x 80.0 cm. (39⅜ x 31½ in.)
Collection: Musées Royaux des Beaux-Arts
de Belgique, Brussels

Jules van Biesbroeck
Nouvelle Maison du Peuple 1899 (cat. no. 112)
The New ''House of the People''
Lithograph in six colors
124.5 x 90.0 cm. (49 x 35½ in.)
M. and Mme. Wittamer-De Camps, Brussels

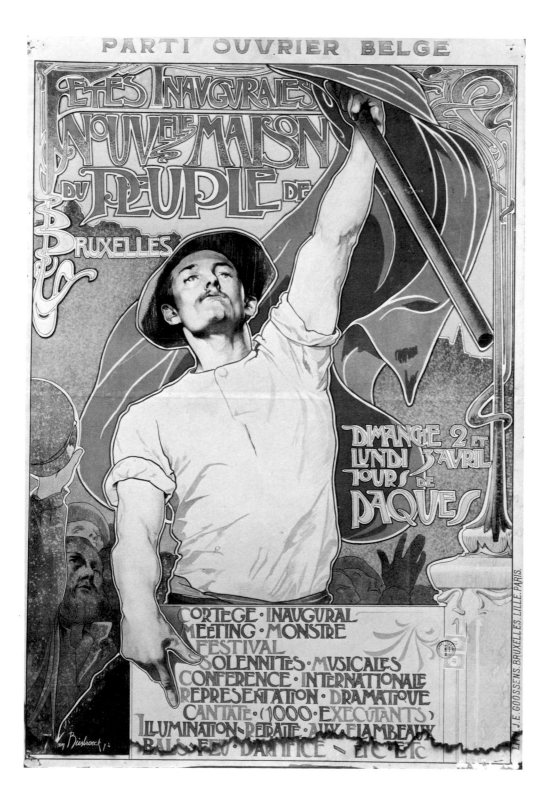

Catalogue

Graphic Arts
Decorative Arts
Architecture

Note
Dimensions are in centimeters (inches in parentheses); height precedes width and, where applicable, a third figure indicates depth. The collection is given in italics.

Catalogue contributors:
[JB] Jane Block
[MC] Maurice Culot
[LD] Lieven Daenens
[SF] Sarah Faunce
[YO] Yolande Oostens-Wittamer
[JW] Jacques-Grégoire Watelet

**Graphic
Arts**

**JULES
VAN
BIESBROECK**
1850–1920

Born in Ghent, Jules van Biesbroeck was a painter of portraits and genre scenes. He taught at the Ghent Academy in the 1890s, where among his pupils were Gust de Smet, Fritz van den Berghe, and his son, Jules-Pierre. Van Biesbroeck died in Bordighera, Italy in 1920. [YO]

112 **Nouvelle Maison du Peuple** 1899
The New "House of the People"
Lithograph in six colors
124.5 x 90.0 (49 x 35½)
M. and Mme. Wittamer-De Camps,
Brussels

The new Maison du Peuple was opened in 1899 by the Workers' Party of Belgium, to replace the modest cultural center founded in 1882. The importance attached to the new center by the Workers' Party is evident in the choice of Victor Horta as the building's designer. Horta was by now the master of the Art Nouveau style, which he had helped to create, and was known for his conception of fluid, dynamic space and abundant light. A characteristically Horta-esque steel column can be seen at the right of the poster. The image of the strong, proud young workman clearly expresses the idealism involved in the building of the House of the People; it was designed as a place for working people to meet, to have discussions and lectures. The most active writers and artists of the time lectured there and the events were well attended, despite critical prophesies that no one would come. This poster was shown in the exhibition of Belgian posters in the Wittamer-De Camps collection which circulated in the United States in 1970–1971 (Yolande Oostens-Wittamer, *La Belle Époque* [Washington, D. C.: International Exhibitions Foundation, 1970], no. 129).

GISBERT
COMBAZ
1869–1941

A scholar, lawyer, painter, poster designer, and illustrator, Combaz was born in Antwerp and was first made to study law by his father. Practicing for only a year, Combaz left the bar to devote himself to art, and took courses at the Royal Academy of Brussels. Fascinated by Asia, he became a reputable Orientalist, worked with such scholars as René Grousset, Paul Pelliot, and Henri Maspero, and published several significant books on Asian and Chinese art, which he collected as well as studied. Combaz the artist was an affable and devoted man of taste. From 1897 on he associated himself with La Libre Esthétique, exhibiting there in 1897, 1898, 1899, 1901, 1903, 1908, 1912, and 1914. He was often commissioned to design the poster for the exhibition.

Combaz never ceased to search for new modification of graphic expression to enrich his work. He created forms that were bound by a nervous, supple, and vibrant arabesque. Once the forms were set up, Combaz cast flat but often luminous color areas on them. Sometimes he worked the tones into relief or into spots and points, but the form, even though veiled, remained the guide; his compositions always remained centered on a principal subject despite a tangle of details. Combaz utilized the Neo-Impressionist technique on several occasions. His posters retain an astonishing freshness, harmoniously and diversely mixing the Orient, dreams, and reality. [YO]

113 **La Libre Esthétique** 1898
Lithograph in six colors
72.7 x 43.5 (28⁵/₈ x 17¹/₈)
M. and Mme. Wittamer-De Camps,
Brussels
Reproduced in color on page 194

114 **La Libre Esthétique** 1899
Lithograph in six colors
74.0 x 44.0 (29¹/₈ x 17¹/₄)
M. and Mme. Wittamer-De Camps,
Brussels

La Libre Esthétique was the organization that, beginning in 1893, took over the activities of Les XX after the latter's members voted to dissolve the group. Octave Maus continued to act as planner and manager, and with an even stronger hand, as there were no artists involved in organizing the exhibitions.

This poster and the following one of 1899 show Combaz at the peak of his most two-dimensional style; the composition is designed as a pattern of swirling lines and clear-cut, beautifully harmonizing shapes of color. The peacock, with all it provides and implies of opulent display and pride of beauty, was a favorite motif in Art Nouveau. (See Yolande Oostens-Wittamer, *La Belle Époque*, no. 23.)

In this work, the artist's love of silhouette leads him to invent a series of abstract "cutout" shapes as part of the design of the rising sun. The effect of the Japanese print, by this time pervasive in Europe, can be felt here. The year after Félicien Rops' death, 1899, was the occasion of a memorial exhibition of his work at the Salon of La Libre Esthétique. (See Oostens-Wittamer, *La Belle Époque*, no. 24.)

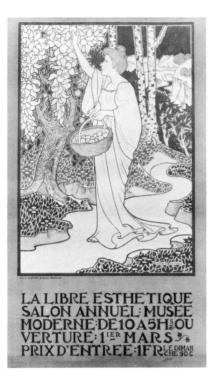

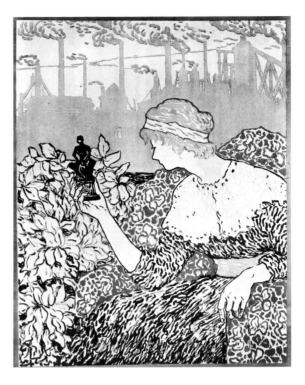

115 **La Libre Esthétique** 1901
Lithograph in three colors
74.0 x 43.0 (29^{1}/$_{8}$ x 17)
M. and Mme. Wittamer-De Camps,
Brussels

116 **Exposition au Pays Noir** *circa* 1911
Exhibition in the Black Country
Lithograph in four colors
99.6 x 60.1 (39^{1}/$_{4}$ x 23^{5}/$_{8}$)
M. and Mme. Wittamer-De Camps,
Brussels

Here Combaz continues to use a multitude of forms with crisp, clear outlines, but with a gentler mood created by the subject — a young woman gathering fruit — and the sense of pastoral space evoked by the path meandering into the distant landscape. The charm of the image is akin to that of the work of the French designer Eugène Grasset. (See Oostens-Wittamer, *La Belle Époque,* no. 26.) [SF]

"The Black Country" was that area of southwestern Belgium and northeastern France where the mines and steel mills were concentrated — the country of Le Borinage, where Van Gogh had once attempted to minister to the workers. In this image, Combaz makes vivid the contrast between the world of beauty — of nature, humanity, and art — and the world of the "dark satanic mills." His style here is more loose and painterly; separate strokes of color are used in a way that shows a debt to the Fauve painters. (See Oostens-Wittamer, *La Belle Époque,* no. 32.) [SF]

ADOLPHE CRESPIN
1859–1944

Crespin was a student of Janlet and Blanc-Garin in Brussels and of Bonnat in Paris. An early initiate into Japanese art (1876), Crespin's collection in that field developed his artistic taste and awareness. At the age of thirty, he participated in a competition sponsored by the Schaerbeek commune for establishing an art school. Crespin was chosen Professor of Drawing and Paul Hankar won the position for architecture. Very quickly, the two men became friends and enjoyed a fruitful collaboration. Crespin decorated the façade of his friend's house with symbolic graffiti. In 1896, they jointly won the prize of the Ixelles parish for Art on the Street for their façade of Timmerman's bakery on Wavre Road. A year later, they designed the decor for the ethnographic room at the famous Congo Exhibition at Tervuren. Crespin was also associated with the portraitist Edouard Duyck (1856–1897). Together they created numerous decorations, theatre costumes, and posters. It was in 1886 or 1887 (and perhaps with Duyck's help), that Crespin was the first Belgian artist — probably along with Rassenfosse — to become interested in poster art. In the beginning, the artists had to be content with monochrome posters, but their accomplishments, and foreign examples (Chéret's posters date from 1866), stimulated a renewal of printing techniques in Belgium.

As a professor in Schaerbeek (1894), with evening courses at the Royal Academy in Brussels (1895), and at the Bischoffsheim School (1897), Crespin developed a course in modern decorative composition. He also won a competition for the Professor's Chair of the History of Ornamental and Decorative Painting at the École Normale des Arts du Dessin at Saint-Josse-ten-Noode (Brussels). As a painter, he exhibited flower paintings, Japanese masks, and interior scenes. If Crespin was sometimes a captive of history, he was often a promoter of new ideas. [YO]

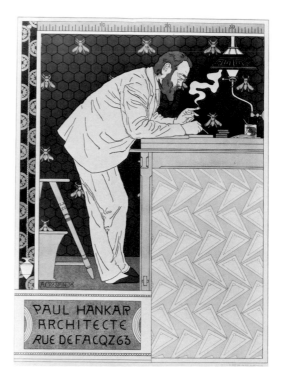

117 **Paul Hankar Architecte** 1894
Lithograph in six colors
54.0 x 40.3 (21$\frac{1}{4}$ x 15$\frac{3}{4}$)
M. and Mme. Wittamer-De Camps, Brussels

This poster, done for Crespin's friend, the Art Nouveau architect Paul Hankar (see page 214), draws a clever contrast between the informal, slippered architect at work at his drawing table and the controlled symbols of his design profession surrounding him: ruler, triangles, and pentagonally-patterned tiles. (See Oostens-Wittamer, *La Belle Époque*, no. 39.)

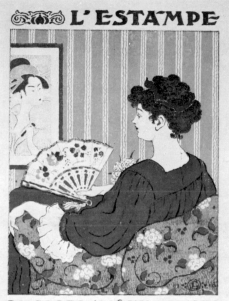

118 **L'Estampe** 1908
Lithograph
22.9 x 18.0 (9 x 7^1/$_8$)
M. and Mme. Wittamer-De Camps,
Brussels

GEORGES LEMMEN
1865–1916

Biographical details of Georges Lemmen appear on page 117. For other works by this artist see cat. nos. 46, 47, 48, 49, 50, and 143.

Lemmen designed this poster for the third annual exhibition of L'Estampe held from December 30, 1908 to January 24, 1909. In the summer of 1906, Georges Lemmen, Fernand Khnopff, Gisbert Combaz, and Henri de Groux, among others, founded L'Estampe to propagate and resuscitate the graphic arts. Its first Salon opened in January 1907 at the Musée Moderne in Brussels under the direction of its Secretary, Robert Sand. In 1911, Lemmen, as one of the artists featured at L'Estampe, showed this work along with over one hundred of his lithographs, etchings, and drawings. Lemmen's posters were usually commissioned for exhibitions such as La Libre Esthétique, the Berlin exhibition of Belgian art in 1908, Meier-Graefe's Maison Moderne, and Lemmen's first one-man show given in Paris at the Galerie Druet in 1906. Lemmen also designed posters for commercial enterprises. One such work for a soda water company was published in Yolande Oostens-Wittamer's *L'Affiche Belge 1892–1914* ([Brussels, 1975], p. 175) and another work, done for a bread company, is owned by Madame Thévenin-Lemmen.

In the L'Estampe poster, Lemmen's interest in decoration, kindled by Crane's example, is reflected in his treatment of the wallpaper and fabric. In fact, Lemmen created original designs for wallpaper, fabrics, rugs, locks, ceramic tiles, bookplates, and cushions. Moreover, Lemmen's poster openly acknowledges his admiration for Japanese art by creating a modern equivalent to the Ukiyo-e print. His use of broad flat areas of color, the undulating rhythms of the model's dress, ruffle, fan, and curve of her left hand, and the asymmetry of the composition, echo a treatment similar to its Oriental counterpart. Lemmen carries the analogy so far as to suggest that there is a mutual identification between the Western and Oriental models — each a reflection of the other.

Lemmen, like his French contemporaries Monet, Degas, Van Gogh, and Lautrec, owned Japanese prints; he lent seven prints by Hiroshige to the 1892 Association Pour l'Art exhibition in Antwerp. [JB]

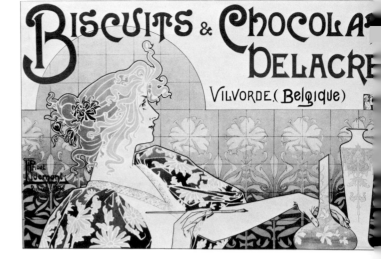

PRIVAT LIVEMONT
1861–1936

Following his studies at the École des Arts Décoratifs at Saint-Josse-ten-Noode — where a few years later he was to be Professor with Adolphe Crespin — Privat Livemont received a scholarship for study in Paris. There he was engaged by Lamaire to paint architectural decorations, and he later worked with Lavastre. In 1885, he collaborated on the stage designs for "Hamlet" at the Théâtre Français. In addition to his various design activities, he studied at night with Delaporte at the École Etienne-Marcel. In 1889, after six years in Paris, he returned to live, where he was born, at Schaerbeek. At this time, the architect Saintenoy entrusted him with the decoration of a number of town houses.

In 1890, Livemont designed his first poster for an exhibition at Schaerbeek. The success of his early posters confirmed him in this career, and by 1900 he had produced thirty. His increasing interest in lithography led him to become a printer as well. Styling himself after X. Havermans and E. De Linge, Livemont was a virtuoso poster lithographer, always drawing the image on the stone himself. Woman was the subject of his work, almost to the exclusion of everything else. He created a type to whom he remained faithful — with heavy eyelids, heart-shaped mouth, and long, decorative hair strewn with soft flowers. Octave Maus, writing on the artist in the Parisian *Arts and Décoration* (7 [1900], pp. 56–61), recognized that "it was easy to discover certain analogies between the posters of Privat Livemont and those of Mucha . . . perhaps the inquiry, far from being harmful to M. Privat Livemont, would be helpful to the artist from Brussels whose first posters go back to 1890, that is to say to a period when the name of Mucha was unknown." [YO]

119 **Biscuits et Chocolat Delacre** 1896
Lithograph in six colors
55.8 x 82.0 (22 x 32¼)
M. and Mme. Wittamer-De Camps, Brussels

Livemont was one of the designers who contributed to the apotheosis of the female figure as an advertising device, which characterized the posters of the 1890s. Here the image has no obvious relation to the product, but rather celebrates the blossoming of Art Nouveau design, with its decorated tiles, floral-patterned sleeves, and the refined young lady engaged in the delicate art of painting porcelain. In today's terms, there is a "subliminal" connection between the exquisite quality of her activity and surroundings, and that of the bonbons made by M. Delacre. [SF]

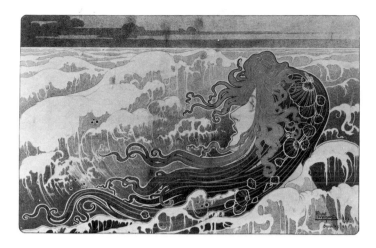

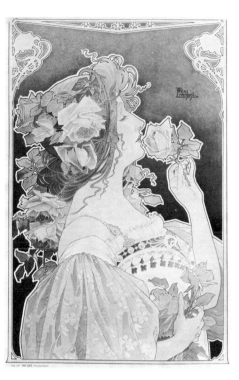

120 **La Vague** 1897
The Wave
Lithograph in four colors and gold
39.0 x 56.0 (15$^{1}/_{2}$ x 22)
*M. and Mme. Wittamer-De Camps,
Brussels*
Reproduced in color on page 195 and
back cover

121 **La Femme aux Roses** 1899
Woman with Roses
Lithograph in five colors
53. x 40.8 (23$^{7}/_{8}$ x 16$^{1}/_{8}$)
*M. and Mme. Wittamer-De Camps,
Brussels*

Livemont was always concerned in his posters with achieving a high technical quality of color printing. In the late 1890s, he began a series of lithographs that were to be independent works of art — not made for any specific purpose, but devoted to developing the technique of color lithography. *The Wave* was the first of these. (See Octave Maus, "Privat Livemont," *Art et Décoration 7* [1900], pp. 55–61.) Here, the elegant woman with flowing hair is changed into a Symbolist image of a disembodied head, the face transfixed Medusa-like despite her beauty, and the undulating hair made a part of the flowing ocean waves. The foam pattern of the waves is distinctly Japanese, while the image as a whole recalls a host of others, from Delville's *Death of Orpheus* back to the drowned Ophelias of the Pre-Raphaelites. Livemont has made the work his own by his complex patterning and his subtle handling of color. [SF]

Though done commercially — for J. C. Boldoot Eau de Cologne and Parfumerie of Amsterdam — this poster (here without text) shows the degree to which Livemont concentrated on fine color-printing technique in his regular posters as well as in his independent prints. The poster with text was shown in *La Belle Époque* (no. 86).

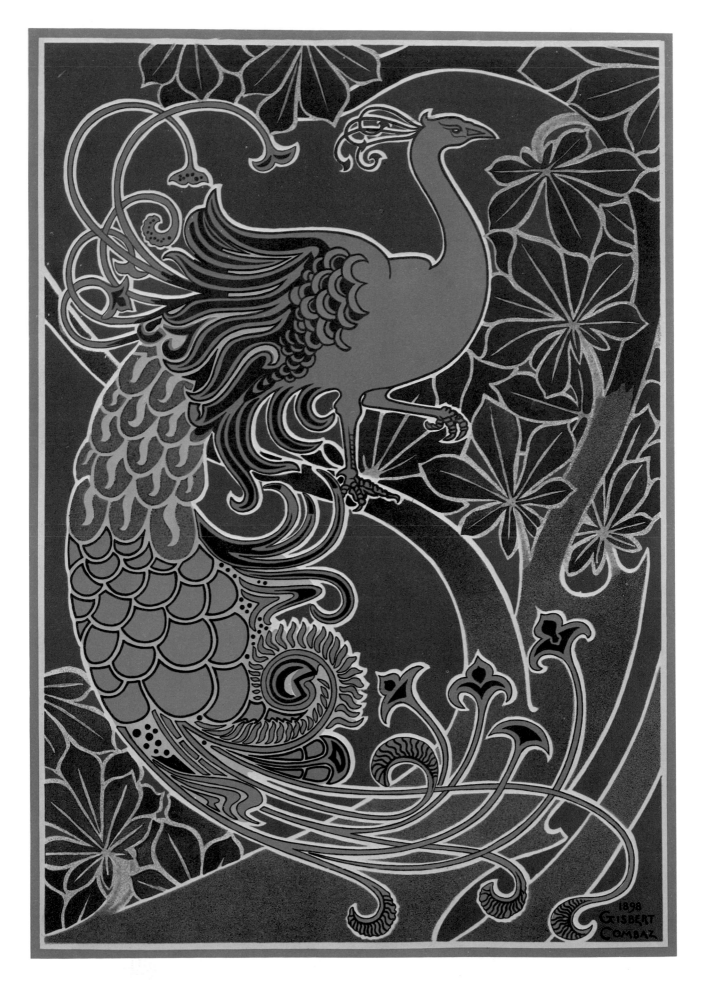

Facing page:
Gisbert Combaz
La Libre Esthétique 1898
Cat. no. 113

Below:
Privat Livemont
La Vague 1897
The Wave
Cat. no. 120

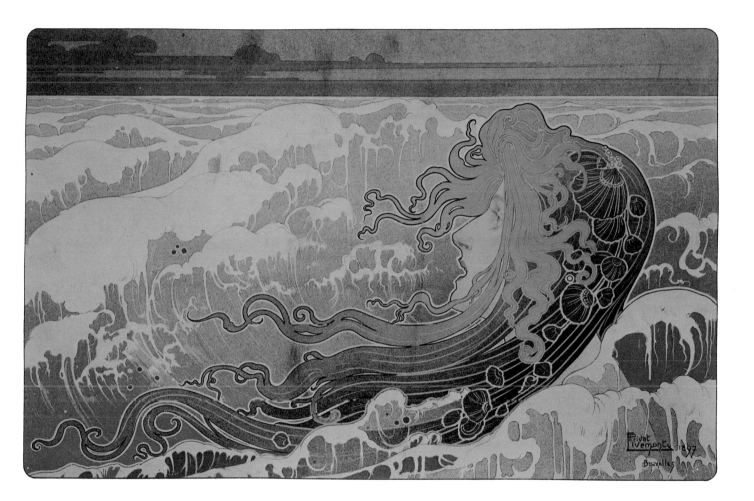

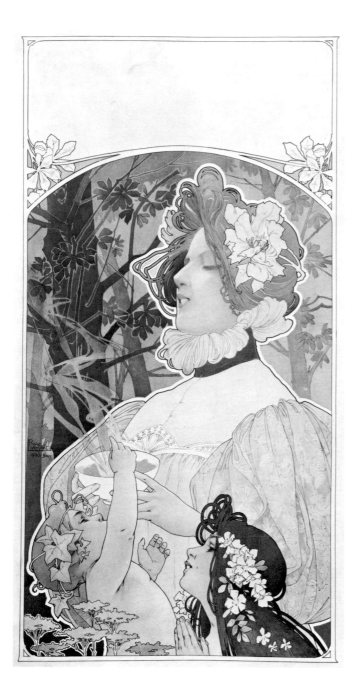

122 **Femme aux Enfants** 1900
Woman with Children
Lithograph in seven colors
75.7 x 39.5 (29³/₄ x 15¹/₂)
M. and Mme. Wittamer-De Camps,
Brussels
Illustrated left

This poster was made for Cacao A. Driessen, a chocolate firm in Rotterdam, and was published by Van Leer in Amsterdam. This example was printed without the text.

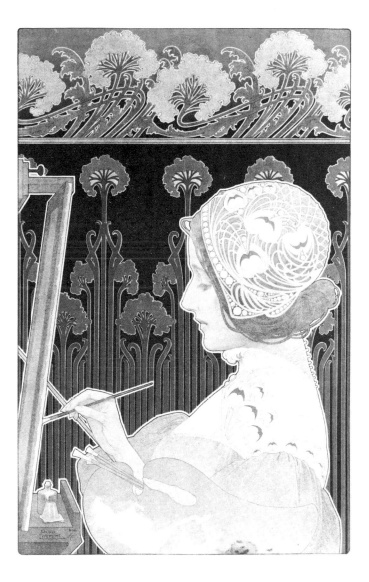

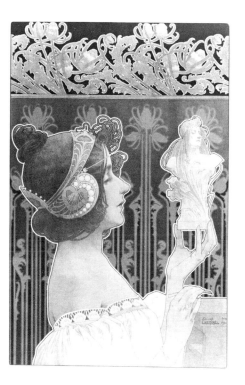

123 **La Peinture** 1901
Lithograph in seven colors
Motif: 60.0 x 42.0 (23⅝ x 16½)
*M. and Mme. Wittamer-De Camps,
Brussels*
Illustrated left

124 **La Sculpture** 1901
Lithograph in seven colors
Motif: 60.0 x 42.0 (23⅝ x 16½)
*M. and Mme. Wittamer-De Camps,
Brussels*
Illustrated above

Like *The Wave* (cat. no. 120), these designs were made as part of the series of independent color prints that Livemont made around the turn of the century. Though not intended as posters for any specific purpose, the themes are some of the designer's favorites; for example, a woman gazing at a sculptured female figure held in her hand appeared in a poster for the Cercle Artistique of Schaerbeek in 1897 (*La Belle Époque,* no. 81). The motif of *La Sculpture* may be compared to the Rassenfosse design for a Rops exhibition (cat. no. 125), which in itself grew out of Rops' own invention, the *Woman with a Puppet* (cat. no. 78). The idealized beauty of both figure and sculpture in this lithograph takes us a long way from Rops' mordant satire. [SF]

ARMAND ANDRE-LOUIS RASSENFOSSE 1862–1934

Born in Liège, Rassenfosse sold Oriental objects and various curiosity items in his parents' shop until he was thirty years old. Invincibly attracted to drawing, he taught himself the techniques of this art form. In 1892, Félicien Rops became his valuable counselor and good friend. Together, they worked with all the techniques of printmaking, particularly soft ground. They experimented endlessly, finding or rediscovering formulas — notably that of a new varnish that they baptized "Ropsenfosse." Rassenfosse exhibited at La Libre Esthétique in 1896, 1897, 1899, and 1914; at the Salon des Cent (in Paris) in February and November 1896; at L'Art Indépendant (in Paris) in 1896; and at the Société des Aquafortistes Belges in 1893 and 1895. Cultivated, amiable, and curious, Rassenfosse expressed himself best in printmaking. Woman was his *leitmotiv*. His nude figures are rendered in a precise, heavy outline and with elaborated, though unemphasized modeling. He imparted to them a minutely refined realism that was sometimes tinged with fantasy.

Rassenfosse illustrated Baudelaire's *Les Fleurs du Mal* for the Société des Cent Bibliophiles, *Les Campagnes hallucinées*, and many other texts. He also designed at least twenty-three bookplates. With Donnay, Berchmans, and Maurice Siville he founded the "Caprice Revenue." A printer at heart, Rassenfosse remained sensitive to halftones enhanced by an emphasized or spontaneous line. Sometimes his posters are of a simple realism; elsewhere, he works easily with complex compositions. Rassenfosse seems to have made his first posters around 1888, but since he did not sign them they cannot be positively identified. [YO]

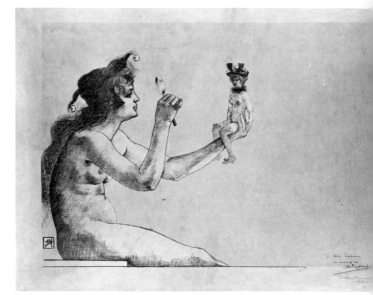

125 **Projet d'une Exposition Rops** 1896
Project for a Rops Exhibition
Lithograph in two colors
55.7 x 75.0 (22 x 29 1/2)
M. and Mme. Wittamer-De Camps, Brussels

Here, in the lower right-hand corner, Rassenfosse has written (as translated): "To Ad. Crespin, a remembrance from A. Rassenfosse (this drawing on paper was made for the poster of the Rops Exhibition which didn't take place)." The design was used instead for an exhibition of drawings and prints at the Salon des Cent, held in Paris in November and December of 1896. But the humor of the image is entirely related to its original connection with the artist's good friend and collaborator, Félicien Rops. Rassenfosse plays with Rops' *Woman with a Puppet* (cat. no. 78), reversing the roles, in a way, by putting the jester hat on the main figure's head, and having her hold — not a puppet, but a miniature Rops *fille de joie*, complete with gartered stockings, fancy head- and neck-wear, and nothing in between but a pertly inviting nakedness. (Unlike most artists of a later and grimmer age who took up the theme of prostitution, Rops softened his satire by conceding his subjects a physical appeal suitable to their trade.) The absurdity is heightened by the magnifying glass, which conjures up the idea of the expert scientist or connoisseur — who would in either case be a learned man full of years — examining a specimen. The fact that the miniature nude body is mirrored by that of her examiner adds yet another level of wit and suggestiveness. (See Yolande Oostens-Wittamer, *L'Affiche Belge 1892–1914* [Brussels: Bibliothèque Royale, 1975], no. 127.) [SF]

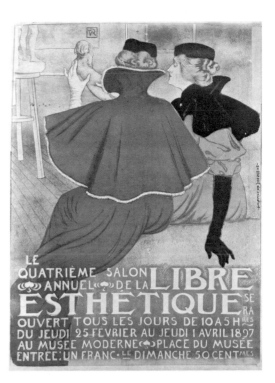

THEO VAN RYSSELBERGHE
1861–1926

Biographical details of Théo van Rysselberghe appear on page 145. For other works by this artist see cat. nos. 86, 87, 88, 89, 90, 91, and 92.

126 **La Libre Esthétique** 1897
Lithograph in five colors
100.0 x 74.5 (39³/₈ x 29³/₈)
M. and Mme. Wittamer-De Camps, Brussels

An unsigned note glued to the back of this poster says, "on the left, in red, Madame Van Rysselberghe, on the right, in an orange dress, Madame Octave Maus" (Oostens-Wittamer, *La Belle Époque*, p. 87, no. 133). Though unprovable, this identification is plausible, given both Van Rysselberghe's strong bent for portraiture and his close connection with Maus, whom he actively assisted with the work of organizing exhibitions for Les XX and La Libre Esthétique. By the mid-1890s, Van Rysselberghe had become increasingly involved with graphic design, and had illustrated a number of books by Émile Verhaeren and other Symbolist poets. He made only a few posters, the finest of which were done for La Libre Esthétique.

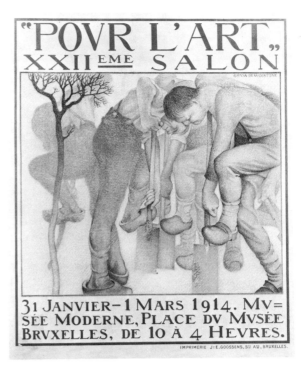

GUSTAVE VAN DE WOESTIJNE
1881–1947

Biographical details of Gustave van de Woestijne appear on page 159. For other works by this artist see cat. nos. 109, 110, and 111.

127 **Pour L'Art** 1914
Lithograph in four colors
69.5 x 59.5 (27³/₈ x 23³/₈)
M. and Mme. Wittamer-De Camps, Brussels

Pour l'Art was an exhibiting group founded in 1892 on the model of Sâr Péladan's Rose + Croix Salon, by Symbolist artists headed by Jean Delville and Émile Fabry. Though abandoned by Delville and others in favor of the Salon d'Art Idéaliste in 1896, the group appears to have continued. There is an illuminating contrast between the esoteric character of the founders' work and the more evangelical type of Symbolism expressed in the work of Van de Woestijne, twenty-two years later. Here, mystical feelings find their imagery not in sign or allegory but in the primitive life of the peasant, tilling the soil in his wooden shoes as his ancestors had done far back into the Middle Ages. The drawing style here shows a characteristic fusion of subtle tonality, sharp detail, and linear stylization. (Oostens-Wittamer, *La Belle Époque,* no. 130.) [SF]

**Decorative
Arts**

**OMER
COPPENS
1864–1926**

Born in Dunquerque (France), Coppens began his studies in painting at the Ghent Academy. Following his training there, Coppens became an independent artist, living and working mostly in Flanders and on the Belgian coast. Landscapes and cityscapes are his most important and familiar subjects, both in his painting and colored engravings — the latter being published by Dietrich in Brussels. Coppens was also a founder of the art circle Pour l'Art and a member of L'Essor. He took part in the exhibitions of La Libre Esthétique from 1895 on, and showed his work at the international exhibition of 1910 in Brussels. Though he is best known as a painter and engraver, Coppens also made ceramic works and bookbindings. His pottery consists mainly of plates, vases, and small figures, in which a particular interest in the finish of the pieces is made evident through his use of colored glazes that have been allowed to run over the surfaces. Émile Gallé, who was a close friend, dedicated one of his own vases to Coppens. The artist died in Brussels in 1926. [LD]

128 **Vase** *circa* 1895
Glazed ceramic
Height: 31.5 (12³/₈)
Galerie L'Ecuyer, Brussels

ARTHUR CRACO
1869–?

Born at Saint-Josse-ten-Noode, Brussels in 1869, Craco studied with Constantin Meunier while the sculptor was teaching in Louvain, as well as later in Brussels at the Academy. Following his years with Meunier, Craco went to France, where he began work in ceramics at the Orchies school. He was one of the designers who received some of the ivory provided for artists in 1894, at the time of the international exhibition in Antwerp. Later, during the famous Tervuren exhibition of 1897, he had a great success with three sculptured groups in ivory and bronze: *The Orchid, The Angel of the Annunciation,* and *Dream.* Craco also participated in the La Libre Esthétique exhibitions of 1894, 1895, and 1897 and, in 1896, became a founder-member of the Brussels group, L'Art Idéaliste. Like the work of Omer Coppens, Craco's ceramics are characterized by flowing colored glazes, and a tonal harmony. [LD]

The technical distinction and artistic importance of Omer Coppens' glazes are clearly shown on the simple form of this vase. Loops of green slip are combined with dripping gradations of glazes to create a seemingly artless and delicate floral ornamentation. This piece was exhibited in Houston and Chicago in *Art Nouveau Belgium-France,* 1976 (cat. no. 248).

129 **Vase** n.d.
Glazed ceramic
Height: 60.0 (23⁵/₈)
Galerie L'Ecuyer, Brussels

Craco shows the technical diversity of which he is capable in this decorative flower vase. The glazes, which have been very loosely controlled in order to form a subtle pattern, are a harmonious complement of brown, blue, yellow, and gray.

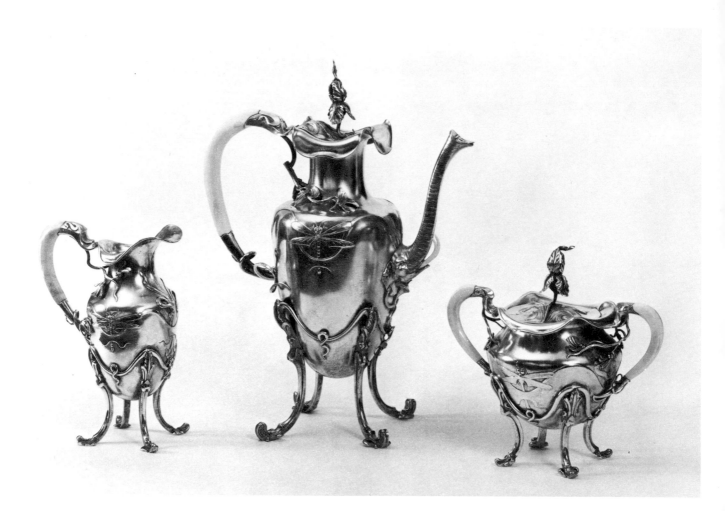

DEBOUS There is no known biographical material on Debous.

130 **Coffee Service** *circa* 1897
Silver gilt and ivory
Coffeepot: 37.0 x 28.0 (14$\frac{1}{2}$ x 11)
Sugar bowl: 21.0 x 23.0 (8$\frac{1}{4}$ x 9)
Creamer: 22.0 x 18.0 (8$\frac{5}{8}$ x 7$\frac{1}{8}$)
Tray: 80.0 x 53.0 (31$\frac{1}{2}$ x 20$\frac{7}{8}$)
Galerie L'Ecuyer, Brussels

This unique coffee service was exhibited at the 1897 world exhibition in Tervuren. Its Rococo sensibilities are combined with decorative elements from Art Nouveau — insects, flowers, and curvilinear motifs. There is a clear reference here, through the amusing use of an elephant's head and trunk for the spout of the coffeepot, to the spirit of the times — and particularly for Belgium, with its new associations on the African continent in the Congo. The service was shown again in Tervuren at the Royal Museum for Central Africa during the retrospective exhibition, "Tervuren 1897," in 1967 (cat. no. 15).

ISIDORE DE RUDDER
1855–1943

De Rudder, who came from a family of artists, began his painting studies with Stallaert, Portaels, and Simonis in Brussels. He married Hélène du Ménil, who executed a great many of her husband's designs in embroidered work, among which were *Civilization and Barbarism, Family and Polygamy, Religion and Fetishism,* and *Liberty and Slavery* — all made especially for the opening of the colonial exhibition of 1897 at Tervuren. De Rudder is particularly well known for his medallions, for his ivory figures, and for his statuary, as well. Besides these, he was also interested in pottery and designed a number of pieces that were made by the ceramics factory, Maison Vermeeren-Coché, in Brussels. Marcel Wolfers, son of the designer Philippe Wolfers, was one of De Rudder's pupils. [LD]

131 **Woman's Head** *circa* 1895
Glazed ceramic
29.0 x 20.9 (11½ x 8½)
Galerie L'Ecuyer, Brussels

This is among the best-known ceramics of De Rudder, who was primarily a sculptor. Possibly on commission, he modeled a number of portrait heads of children, in ceramic. *Woman's Head* was part of a series manufactured in the Vermeeren-Coché factory in Brussels, and there are several versions, which can be distinguished by the different glazes. Those made with white and golden glazes were the most popular.

JULIEN DILLENS 1849–1904

Dillens, who was born in Antwerp, studied at the Brussels Academy in the studio of Simonis. In 1877 he won the Prix de Rome for sculpture. He was the chairman-founder of the Brussels group L'Essor and became a professor of sculpture at the Brussels Academy of Art. In 1892, he was given ivory from the Congo to use in his work. From this supply he was able to produce the *Minerva* head, as well as other objects, which were shown at the Antwerp world exhibition of 1894. For the international exhibition at Tervuren in 1897, he made a polychromed sculpture group. He died in 1904 at St. Gilles in Brussels. [LD]

132 **Minerva** 1892
Ivory and gilt bronze
Height: 39.0 (15³/₈)
Galerie L'Ecuyer, Brussels
Reproduced in color on facing page

A new interest in ivory sculpture emerged in Belgium around 1892. There is a historical and practical reason for this phenomenon: in that year a great quantity of ivory from the Belgian Congo was made available to artists (*L'Indépendance Belge,* May 5, 1904). The result of this policy was abundantly illustrated in the international exhibitions in Antwerp in 1894 and in that held at Tervuren (Brussels) in 1897 (Tervuren, Koninklijk Museum voor Midden-Afrika, *Tervuren 1897,* by M. Luwel and M. Bruneel-Hye de Crom, 1967).

Dillens was one of the first artists to receive ivory for his work. Though the subject of *Minerva* is Symbolist, the style of the work announces the coming of Art Nouveau, particularly in the use of gold to emphasize the decorative aspect of the ivory.

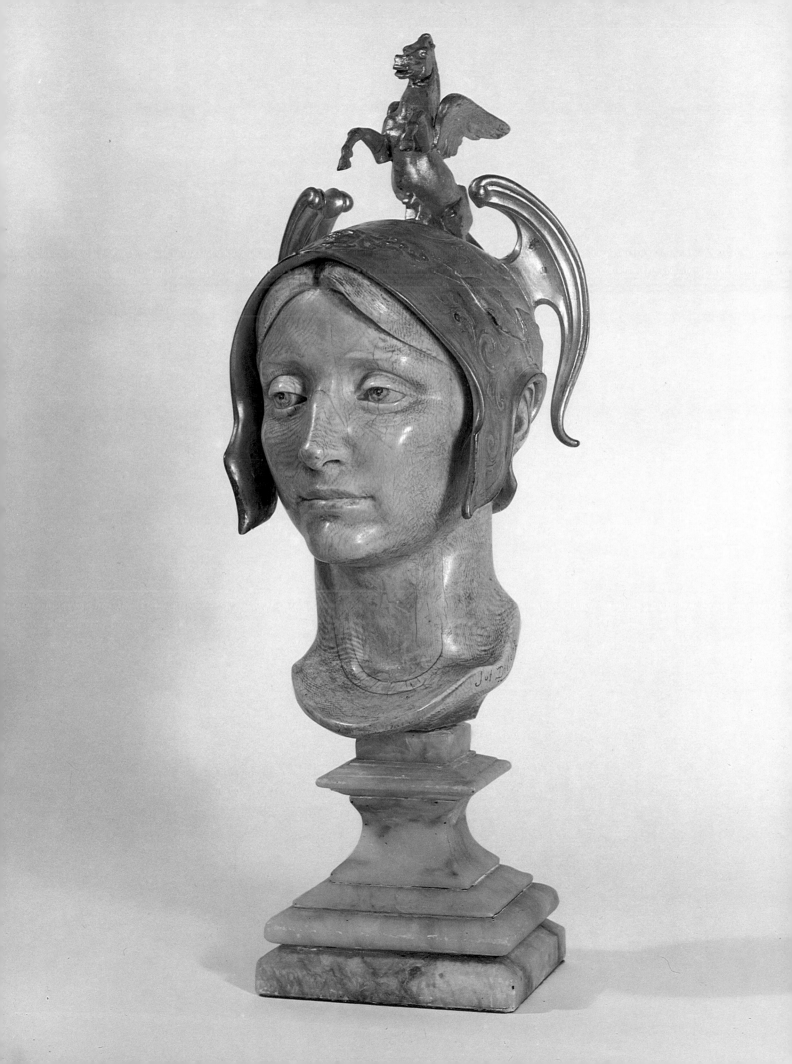

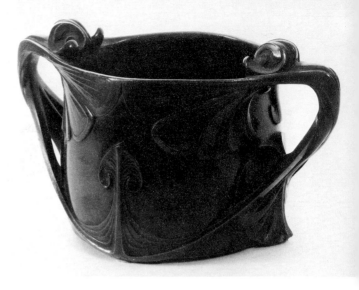

FERNAND DUBOIS
1861–1939

Born in Ronse, Dubois came to Brussels in 1877, in order to study physics at the university there. On the advice of Constantin Meunier, he began to work in the studio of the sculptor Charles van der Stappen. Two years after the founding of the École Professionelle d'Art Appliqué in Brussels, Dubois joined the faculty as a professor of design for jewelry and metal art. He specialized in engraving medals — of which he made about twenty — but his jewelry, candelabras, inkstands, and silver tea services are his best-known work. He showed both jewelry and silverwork at the Salons of La Libre Esthétique in 1894, 1895, 1897, and 1899. For the Tervuren exhibition of 1897, he made portraits, fans, paper cutters, and an ivory bridal chest. His friendship with Victor Horta resulted in a house designed by the architect for Dubois, on Avenue Brugman in Brussels, built between 1901 and 1906, as well as a villa at Sosoye, from the same years. [LD]

133 **Vase** *circa* 1900
Bronze
Height: 10.0 (4)
Galerie L'Ecuyer, Brussels
Illustrated above

The two handles of this vase, in the form of twisted stalks which run elegantly into the surface of the body, show how closely the designer was associated with the Art Nouveau love of twining, creeping, and growing things. Dubois' compositional insight and technical expertise are clearly apparent.

134 **Candelabra** *circa* 1899
Silver-plated bronze
Height: 52.5 (20³/4)
Musée Horta, Brussels
Illustrated on facing page

In this candelabra, one of the most important of all Art Nouveau motifs appears: nature in the form of a plant stalk, asymmetrically arranged to climb toward the buds above, is the basis of its design. The piece was first mentioned in *L'Art Décoratif* (1899, p. 32) and later in *Art et Décoration* (1902, p. 75, no. 12). It was exhibited in Turin in 1902 and in Houston and Chicago (*Art Nouveau Belgium-France*, 1976, cat. no. 297).

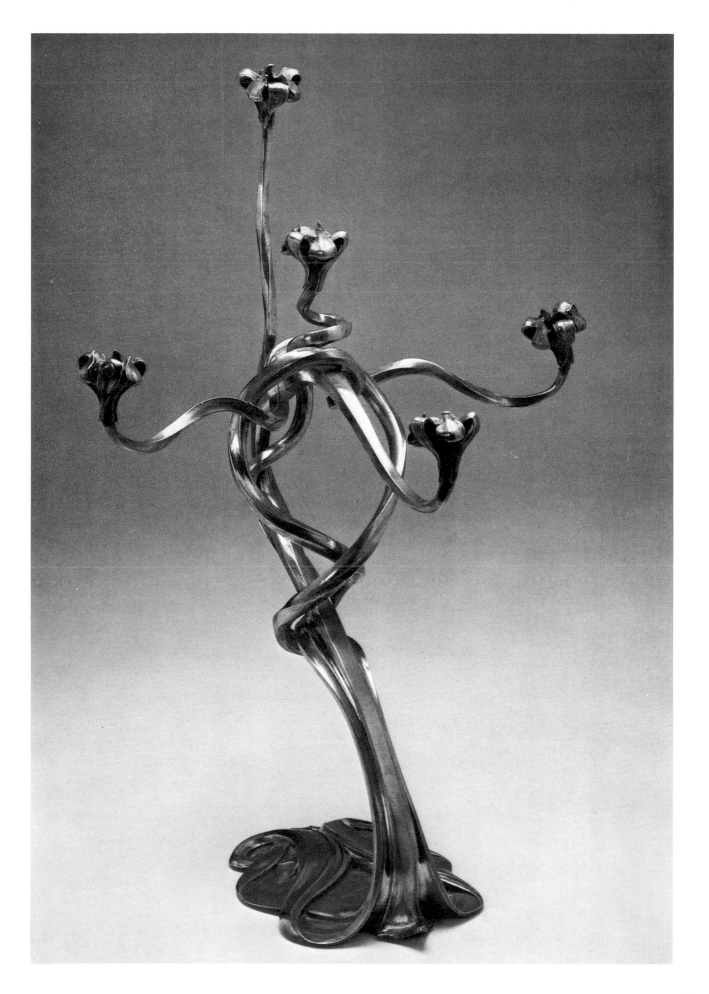

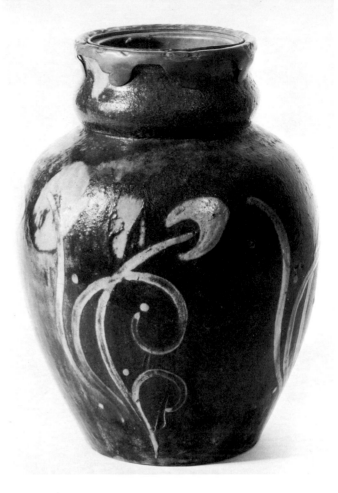

ALFRED WILLIAM FINCH
1854–1930

Biographical details of Alfred William Finch appear on page 100. For other works by this artist see cat. nos. 24, 25, 26, and 27.

135 **Flower Vase** *circa* 1895–1900
Glazed ceramic
Height: 30.0 (11³/₄)
Galerie L'Ecuyer, Brussels

This sandstone flower vase, decorated with a yellow-brown glaze, is typically Art Nouveau in the asymmetrical plant stem ornament that also adorns it. However, the flat, two-dimensional linearity of the plants has been particularly developed by Finch in his personal and subtly applied manner of ceramic design. Both this and the following piece were exhibited in Houston and Chicago (*Art Nouveau Belgium-France*, 1976, cat. nos. 305 and 304).

136 **Plate** *circa* 1895–1897
Glazed ceramic
Diameter: 25.0 (9⁷/₈)
Museum voor Sierkunst, Ghent

137 **Plate** *circa* 1895–1900
Glazed ceramic
Diameter: 35.8 (14¹/₈)
Galerie L'Ecuyer, Brussels

The whiplash ornament on the surface of this plate is the most famous of all Art Nouveau motifs, but here it has another meaning as well, its flexibility recalling the fact that Finch was first a painter, who converted to the making of ceramics during his membership in Les XX. He had a studio for experimenting with pottery, that was set up in the cellar of Henry van de Velde's Brussels house, Bloemenwerf. An attempt to discover new decorative forms is clearly visible in the ornamental use of crackled glaze on the plate. It was recently exhibited in *Art Nouveau uit het Museum voor Sierkunst te Gent* at the Provinciaal Begijnhof in Hasselt (1979, cat no. 31).

Finch's ceramic style developed in the mid-nineties, and this is a good example of the new, very simple, classic form that he adopted. He rejected the excesses of the nineteenth century and turned instead to the plain but elegant designs of the English Arts and Crafts Movement, which is suggested by the spiral form seen here. Finch's ceramics became quite well known around 1900, when they were sold by Henry van de Velde's arts and crafts shop in The Hague and at other places, as well. These lead glazes, in yellow, brown, and green, are characteristic of Finch's work.

PAUL HANKAR
1859–1901

Together with Victor Horta and Henry van de Velde, Paul Hankar was one of the most important Art Nouveau architects in Belgium. He was born in Frameries, but worked from 1878 to 1894 in Brussels for the architect Henri Beyaert, whose love for the Gothic and Flemish Renaissance styles clearly influenced his student. In the course of his career, Hankar first showed an inclination toward Viollet-le-Duc's Neo-Gothicism, and later for the newly-appreciated arts of Japan. His first commission was for a house in Brussels, which he designed in the Neo-Renaissance style with a traditional combination of bricks and sandstone. His own house, on the rue Defacqz in Brussels, was built in 1892–1893 and is very simple; the tendency toward the Neo-Renaissance style is still apparent, but it is also clear that the architect had searched for new solutions to the problems of construction, expressing his Orientalism in the polychromed and compartmentalized decoration of the façade. Hankar was always first a decorator and then an architect; he was less concerned with spatial unity than was Horta, considering the various parts of a building separately in his design. On the other hand, he attached a great deal of importance to the careful execution of the decoration, which he handled as isolated elements. Hankar's use of Orientalizing components was one of his most important contributions to Art Nouveau furniture and interiors. Particularly notable, too, are his broad curves and interesting asymmetrical constructions, both reminiscent of Serrurier-Bovy. When he died, in 1901, he left a group of remarkable sketches. Unfortunately, many of his buildings were destroyed by the extensive urban renovations made in Brussels after the Second World War. [LD]

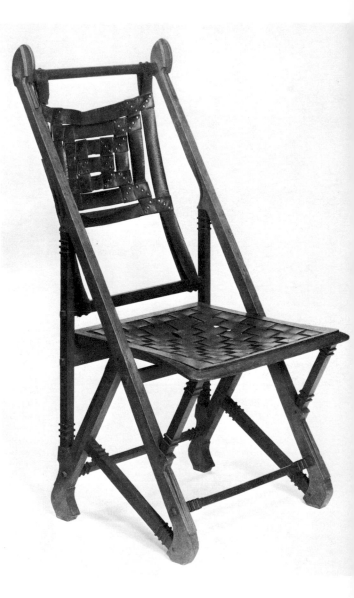

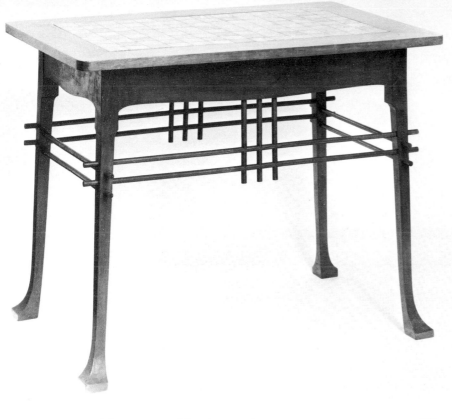

138 **Living Room Table** *circa* 1893
Mahogany
72.5 x 90.0 x 57.0 (28¹/₂ x 35¹/₂ x 22¹/₂)
Museum voor Sierkunst, Ghent
Illustrated above

139 **Chair** *circa* 1900
Oak and leather
114.0 x 33.0 x 29.0 (44⁷/₈ x 13 x 11¹/₂)
Museum voor Sierkunst, Ghent
Illustrated on facing page

The strong geometric quality of this table — which Hankar made for his own house on the rue Defacqz in Brussels — underlines the designer's special feeling for Japanese art. The polished squares of its surface and the delicate but disciplined interplay of the double rods running between the legs, show a particularly elegant manner of interpreting Oriental structure and composition. There is also a quality close to the simplicity of the English Arts and Crafts furniture makers, whose work Hankar so admired. Both Hankar and Serrurier-Bovy stand out from the other Art Nouveau artists in Belgium in their respect for simplicity, and a reticence about using flowery and complicated curves in their work. This piece was shown in Brussels and Düsseldorf (Design Center; Museum für Volk und Wirtschaft, *Meubelen uit België van Henry van de Velde tot Heden,* 1979, cat. no. 10) and Hasselt (Provinciaal Begijnhof, *Art Nouveau uit het Museum voor Sierkunst te Gent,* 1979, cat. no. 10).

This piece of furniture, designed for Philippe Wolfers' own villa in La Hulpe, shows Hankar's predilection for Oriental art and Neo-Gothic style. The general shape of the piece and the ornamental tracing on its plain surfaces, along with the ingenious plaiting of the leather straps on the backrest all suggest these two major sources of influence. This chair was shown in Houston and Chicago *(Art Nouveau Belgium-France,* 1976, cat. no. 374), and in the exhibitions in Brussels, Düsseldorf (cat. no. 11), and Hasselt (cat. no. 13; see our cat. no. 138).

VICTOR HORTA 1861–1947

Horta spent the years 1878–1880 in Paris, and subsequently studied architecture at the Brussels Academy. He was particularly interested in the structural theories of Viollet-le-Duc and in the new iron and glass construction of the Paris *Exposition Universelle* of 1889. His own greatly innovative work in architectural design in Brussels began with the house built in 1893 for his friend, the engineer Émile Tassel — a kind of architectural manifesto, in which Horta's original concepts of space, materials, and design were first expressed. It was this building that altered the development of Guimard's style. In the Hôtel Solvay, begun in 1894, Horta's principles of a totally unified design were further developed; every element — space, light, color, *boiserie,* metalwork, furniture, carpeting, wall patterns — is integrated into the whole. A third major commission was the new Maison du Peuple for the Belgian Workers Party — now destroyed — with its famous "wall of glass" which served as a symbol of the workers' new access to light and air. Horta was one of the most important creators of the Art Nouveau style; unfortunately, the disfavor into which this style fell in the twentieth century led him to destroy his vast archives in 1945. [MC]

140 **Salon Ensemble** *circa* 1894–1895
Oak
Table: 75.5 x 106.0 x 75.0
(29³/₄ x 41³/₄ x 29¹/₂)
Museum voor Sierkunst, Ghent
Illustrated on facing page, top

Horta's personal views on furniture design are fully demonstrated here in the pieces he designed for the Winssinger residence in Brussels. Like Hankar, the architectural components of Horta's work become part of his furniture, too. Open spaces function in furniture as they do in buildings: to create a unified sense of shape. His personal style of using ornamentation that is extremely subtle and graceful is very much a part of this table. The ensemble has been exhibited in Ghent (*Duizend jaar kunst en kultuur,* 1975, no. 891), as well as in the exhibitions at Brussels, Düsseldorf (cat. no. 18–19), and Hasselt (cat. no. 19). (See cat. no. 138.)

141 **Chair** *circa* 1898
Mahogany upholstered in velvet
85.5 x 40.0 x 46.0 (33⁵/₈ x 15³/₄ x 18¹/₈)
Museum voor Sierkunst, Ghent
Illustrated on facing page, bottom

This chair was designed by Victor Horta for his residence on the rue Americaine in Brussels, which is today the Horta Museum. The simple and logical construction of the piece is particularly striking, and the beautifully bowed stretchers of the chair are functional. Horta's choice of wood and material are nicely harmonious. This chair was exhibited in Brussels, Düsseldorf (cat. no. 17), and Hasselt (cat. no. 20). (See cat. no. 138.)

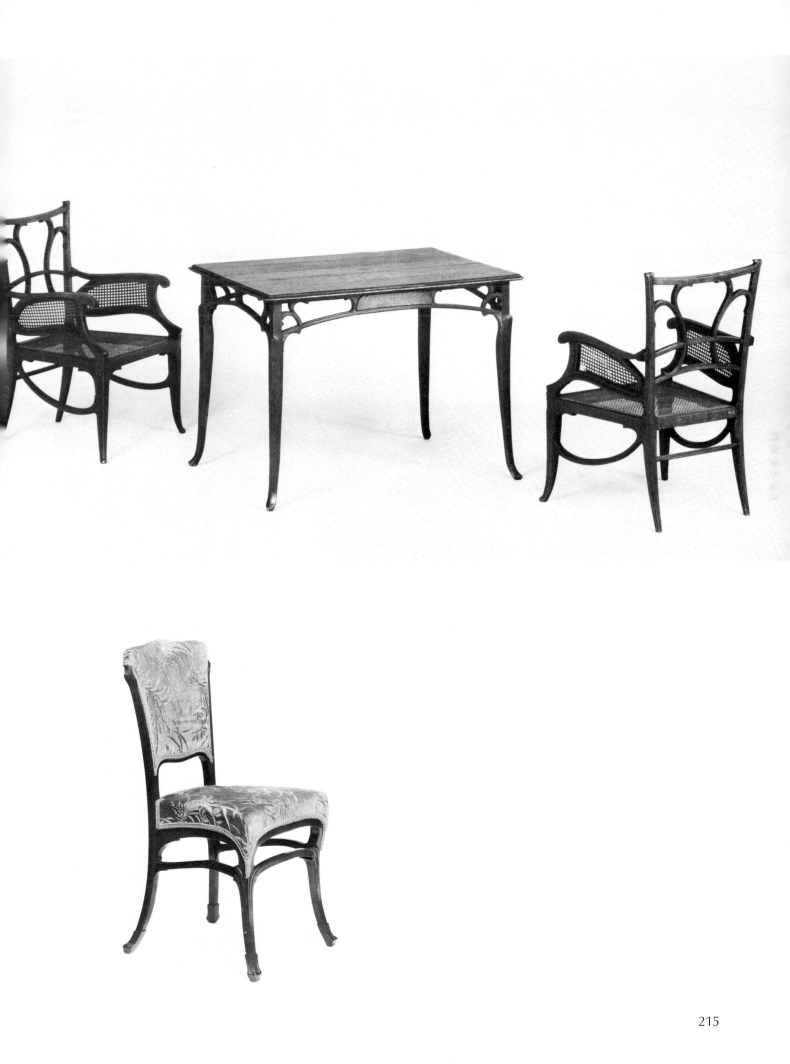

KERAMIS
Boch Frères

The ceramic firm of Boch Frères at La Louvière — also known under the name Kéramis — was founded in 1841 by a family of metallurgists from Lorraine who managed two ceramic factories, one in Luxembourg and one in the Saar. After the political separation of the Grand Duchy of Luxembourg from Belgium in 1839, the Belgian branch of the family set up a new factory at La Louvière. Decorated earthenware and stoneware were the specialties of the Kéramis pottery, but they also produced imitations of Delft and Sèvres china. Anna Boch, one of the director's daughters (see her portrait, cat. no. 88), was a member of Les XX and persuaded her colleague Willy Finch to work at Kéramis. She also produced a few designs for decorated pottery. [JW]

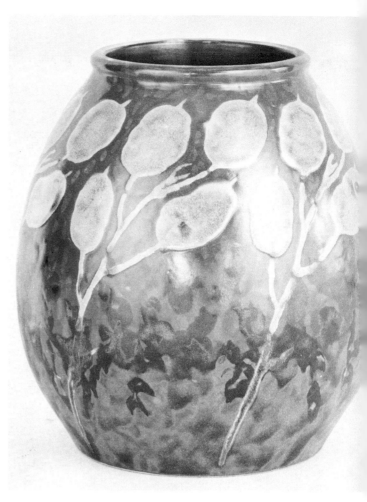

142 **Vase: "Monnaie du pape"** *circa* 1900
Glazed stoneware
Height: 17.4 (6⁷/₈)
Museum voor Sierkunst, Ghent

This vase, decorated in green and blue, with a mustard-yellow slip over a brown ground, shows the influence of A. W. Finch. Finch is known to have worked for Kéramis, and the tonalities of the glazes used here, as well as their flame-like character, are all suggestive of his style. The "monnaie du pape" (moon-wort) ornament is particularly subtle. This was recently shown in the *Art Nouveau Belgium-France* exhibition in Houston and Chicago (1976, cat. no. 394), and at the Provinciaal Begijnhof in Hasselt in *Art Nouveau uit het Museum voor Sierkunst te Gent* (1979, cat. no. 38).

GEORGES LEMMEN
1865–1916

Biographical details of Georges Lemmen appear on page 117. For other works by this artist see cat. nos. 46, 47, 48, 49, 50, and 118.

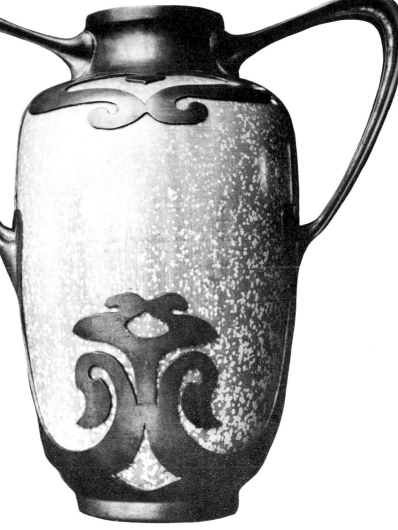

143 **Vase Decoration** 1894–1895
Pewter ornament on stoneware vase
Height: 31.0 (12¼)
*M. and Mme. Wittamer-De Camps,
Brussels*

This piece documents the collaboration between Lemmen, who began to work in decorative arts after 1890, and the noted French ceramicist Auguste Delaherche (1857–1940), who was one of the first decorative artists to show with Les XX. The pewter ornament on this Delaherche vase was designed by Lemmen. It was shown in Ostend in 1967 (Casino, *Europa 1900,* cat. no. 334).

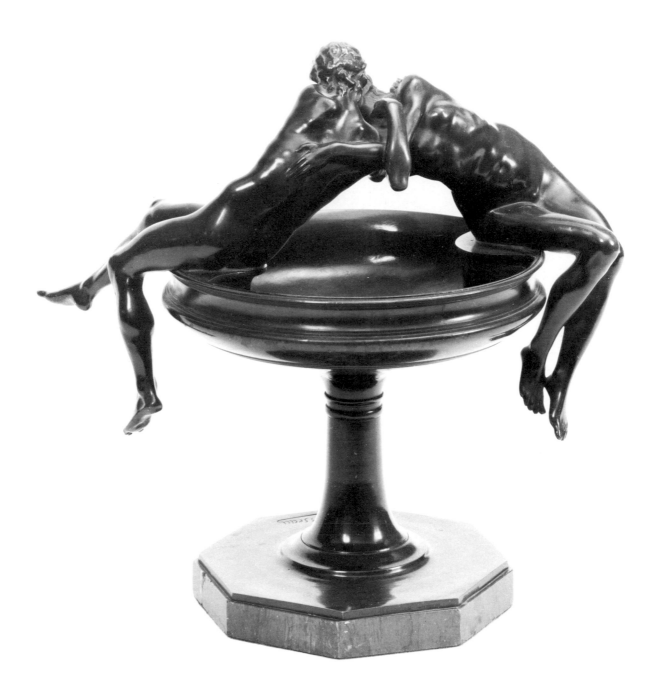

VICTOR ROUSSEAU
1865–1954

Victor Rousseau was the son of a stonemason from Féluy and he, himself, became a stoneworker on the construction of the Palais de Justice in Brussels, between 1877 and 1884. Later, he studied sculpture with Charles van der Stappen and, in 1890, won the coveted Godecharle Prize, which allowed him to travel in Italy, Greece, and France. From 1890 to 1910, Rousseau was a professor of sculpture at the Brussels Academy and, beginning in 1895, he showed his work regularly with La Libre Esthétique. He also showed with Pour l'Art and L'Art Idéaliste. Rousseau made paintings, watercolors, and drawings, but is best known for his small-scale figural sculpture. [JW]

144 **Coupe des Voluptés** *circa* 1897
Cup of Sensual Delights
Bronze
32.0 x 32.0 (12⁵/₈ x 12⁵/₈)
Galerie L'Ecuyer, Brussels

A great deal of Rousseau's work is made in marble, which he was able to work with exceptional feeling. This bronze cup, however, shows us a great deal about his artistic character, too. It is inspired by examples of classical antiquity, but also by the Symbolist movement of the late nineteenth century. Both elements contribute to its serene and intimate sensibilities. The opposition of the two entwined figures is handled adroitly and the flow of movement from one body to the other is barely arrested by their carefully balanced positions; light flows over the surfaces in a compositional structure of its own, enhancing the sensual quality of the subject.

GUSTAVE SERRURIER-BOVY
1858–1910

The son of a furniture-maker, Serrurier was born in Liège and studied architecture at the Academy there. After a trip to England to visit the Schools of Handicrafts, he came strongly under the influence of William Morris and his principles of making good design available to all, and was one of Morris' first disciples in Belgium — though he was quickly followed by Henry van de Velde. It was Van de Velde who persuaded Serrurier to exhibit his furniture designs at the Salons of La Libre Esthétique in 1894, 1895, and 1896, where they made a strong and favorable impression on the public. The English influence is clear in these works, with their unpainted wood and very minimal decoration. Serrurier, however, departs radically from his admiration for the Arts and Crafts movement in the asymmetry which is typical of his furniture and which bears witness to his appreciation for Japanese composition and occult balance. This is probably Serrurier's most important contribution to Art Nouveau, according to the historian Tschudi-Madsen, who also notes that the gently bowed trusses found in the designs of both Van de Velde and Serrurier are unique to their work. Sometimes the bent supports and accentuated right angles of Serrurier's constructions are only symbolic evidence of functional structure. He worked often in Hungarian oak, decorated in *vernis-cire*, but occasionally used mahogany, elm, lemon wood, or poplar, as well.

In 1884, Serrurier opened a store in Liège, where he sold the first imports on the Continent from Liberty's of London — the company largely responsible for the European craze for Oriental objects. In the same year, also in Liège, he began a furniture factory, which opened a branch in Brussels in 1897. New firms, manufacturing his furniture, were opened in 1899 in Paris and Liège, and the following year in Nice and The Hague. It was Serrurier who planned the important Colonial Hall for the international exhibition of 1897 at Tervuren, and the restaurant he designed was a tremendous success at the *Exposition Universelle* in Paris in 1900. He showed his work as well in the St. Louis exhibition of 1904 and at the international exhibition in Liège in 1905. Under the influence of Olbrich, and of the Viennese School, his work became more geometric and abstract around 1901. [LD]

145 **Flower Vase** *circa* 1902
Val-Saint-Lambert crystal, mounted in copper
Height: 40.0 (15³⁄₄)
Museum voor Sierkunst, Ghent

Serrurier-Bovy's visit to the 1901 exhibition, *Ein Dokument Deutscher Kunst*, at Darmstadt is clearly reflected here. The abstract element of his work increased soon afterwards and his bent lines were replaced by stronger, more constructive components. Sobriety dominates in this vase: three supports are decorated only by the punched-out squares in their lower portions, and six plain, horizontal bands hold the clear glass vase in place. The sculptural quality of the work looks ahead to some of the bolted, riveted, and welded sheet metal pieces of the next generation.

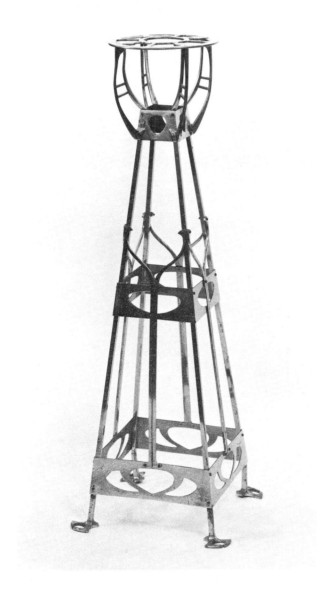

146 **Stand** *circa* 1895–1900
Copper
Height: 93.0 (36⁵/₈)
Galerie L'Ecuyer, Brussels
Illustrated left

This stand is constructed with four slightly spreading legs, which support a flat disc at their top. The straightforward clarity of form is in keeping with Serrurier-Bovy's statements about furniture design, and its architectural character is emphasized through the display of joins and the descriptive pattern of support. The almost severe aspect of the silhouette is diminished by the elegant shapes of its metal rods and the simple curved openings in the three tiers of bands which hold the structure together.

147 **Chambre d'artisan** *circa* 1895
An Artisan's Room
Oak and cane seating
Table: 75.4 x 140.0 x 79.0
(29³/₄ x 55¹/₈ x 31¹/₈)
Chairs: 94.0 x 47.0 x 47.0
(37 x 18¹/₂ x 18¹/₂)
Settee: 100.0 x 58.0 x 52.0
(39³/₈ x 22³/₄ x 20¹/₂)
Museum voor Sierkunst, Ghent
Illustrated on facing page

This suite of furniture was exhibited at the 1895 Salon of La Libre Esthétique, and an accompanying brochure by the artist explained, "It is generally, and nearly universally, believed that only the privileged classes are able to have a home that is furnished and decorated in good taste. A false notion has arisen that modest and simple people cannot, because of their scanty means, enjoy artistic pleasures, and that all aesthetic aspiration is impossible for them, if not actually forbidden." Above the furniture itself he wrote: "These pieces of furniture are based on simple and practical fundamentals, showing as little handwork as possible, but executed according to the true principles of furniture construction." Therein lay a great deal of Serrurier-Bovy's way of thinking about design: he made furniture that was aesthetically simple and justifiable, honest, and easily affordable for all. In that respect, he came very close to the English Arts and Crafts Movement, even without taking on its complete stock of formal elements. The group was exhibited at the Service Provincial des Affaires Culturelles in Liège in 1977; in the *Meubelen uit België van Henry van de Velde tot Heden* exhibition in Brussels and Düsseldorf in 1979 (cat. no. 6); and at the Provinciaal Begijnhof in Hasselt in 1979 (*Art Nouveau uit het Museum voor Sierkunst te Gent*, cat. no. 1).

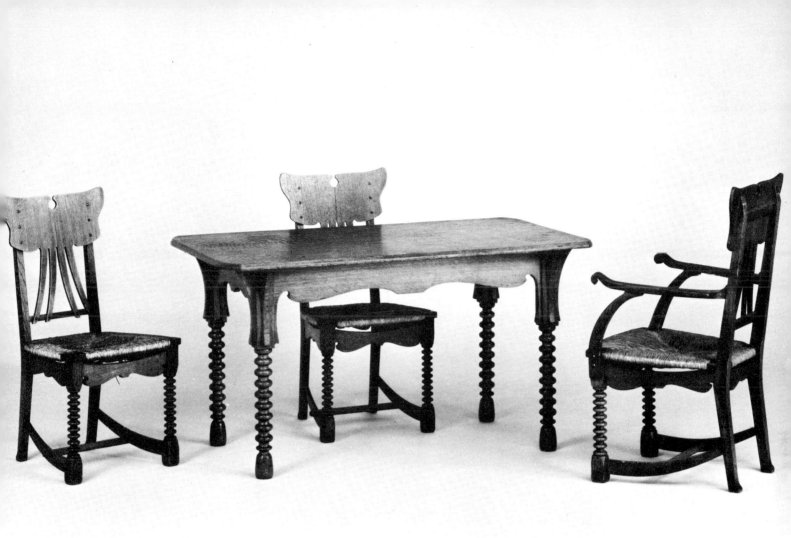

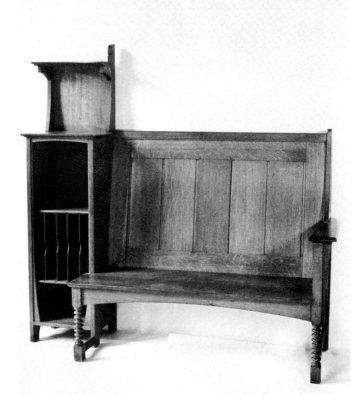

VAL-SAINT-LAMBERT
Henri and Désiré Muller

The Société Anonyme des Verrieries et Établissements du Val-Saint-Lambert was founded in 1826 in an old Cistercian abbey on the outskirts of Liège. It expanded very quickly and was soon internationally famous. One of the most creative periods for the establishment occurred between 1880 and 1914 when the Jemeppe section, founded by Léon Ledru, produced numerous pieces of unparalleled accomplishment. In 1906–1907, the brothers Henri and Désiré Muller came from Nancy to design glassware with etched decorations for the Val-Saint-Lambert works. Among the best designers for the company in the Art Nouveau period were Philippe Wolfers, Henry van de Velde, and Gustave Serrurier-Bovy. Between 1897 and 1903, Wolfers had eighteen vases made to his designs there, which were afterwards cast in bronze from the plaster model. These pieces were created in layers of colored crystal that Wolfers reworked with cameo ornamentation. Fourteen of these objects are mentioned in the *Catalogue des Exemplaires uniques,* which Wolfers published as a record of his work between 1894 and 1905. Orchids, cyclamen, and lilies are among the graceful plant forms that Wolfers used during his Art Nouveau period to accentuate the curved line and asymmetry of his design; this dynamic of growth and movement becomes even more obvious in his use of translucent materials, which also erase the distinctions between space and matter. Henry van de Velde made use of the high technical quality available at the Val-Saint-Lambert factories for a series of drinking glasses which he conceived between 1895 and 1905. Around the same time, he also had some stained glass designs carried out by Val-Saint-Lambert. The great chandelier planned for the Hôtel Solvay by Victor Horta was also made at the Val-Saint-Lambert crystal factory. Gustave Serrurier-Bovy's relations with the company are not well known, but he had one crystal vase made there that he mounted in copper. [LD]

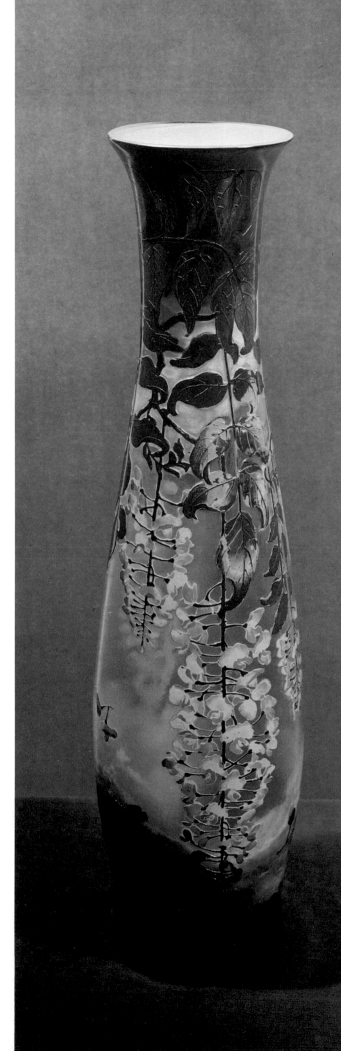

148 **Two Vases** *circa* 1906–1907
Etched glass
Height: 60.0 (23⁵/₈)
Galerie L'Ecuyer, Brussels
"Spring" reproduced in color on facing
page

Around 1906–1907, the brothers Henri and Désiré Muller, who had studied with the great glass designer Émile Gallé in Nancy, came to Val-Saint-Lambert to create a new style for the art glassworks. Earlier, they worked in Croismare and in Lunéville, both in France. During their stay in Liège, they made over four hundred designs for glassware. Their distinctive style is seen here; layers of colored glass are ornamented with designs etched in acid. The two vases are a pair, but have different decoration to suggest the two seasons of spring and autumn. The motif of the "Spring" vase is wisteria (*les glycines*) and that of the "Autumn" vase is umbels (*les ombelles*) — the botanical name for a common type of late summer wild flower.

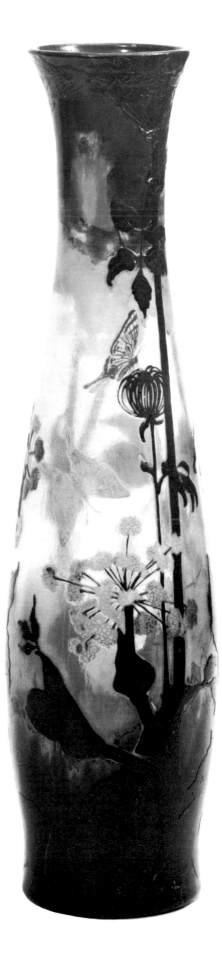

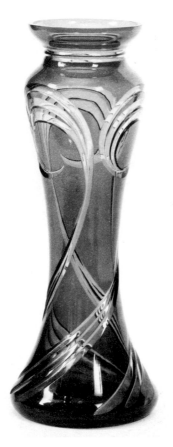

149 **Vase** *circa* 1902
Crystal with wheel-cut decoration
Height: 29.0 (11³⁄₈)
Galerie L'Ecuyer, Brussels

150 **Wineglass** *circa* 1898
Crystal with wheel-cut decoration
Height: 18.4 (7¹⁄₄)
Museum voor Sierkunst, Ghent

Henry van de Velde spent some time as a designer of art glass, working at the Val-Saint-Lambert firm and producing a group of vases having very finely detailed work. The decoration of the vase exhibited here was executed in the Van de Velde style in a deeply-cut pattern of interlaced swirling lines. The design follows the form of the vase, emphasizing the swelling and diminishing contours of its silhouette. This vase was exhibited in *Art Nouveau Belgium-France* (Houston, Chicago, 1976, no. 476). (See also J. Philippe, *Le Val-Saint-Lambert, ses cristalleries et l'art du verre en Belgique* [Liège, 1974], pp. 214–219, no. 152.)

The sinuous linear design of this wineglass is also attributed to Henry van de Velde. In the Paris review *L'Art Décoratif* for 1898, Van de Velde wrote: "The forms preferred by Val-St.-Lambert are sober, without useless decoration, in the Italian style; their beauty consists of a studied rapport between the cup and foot. The most beautiful glasses of Val-St.-Lambert are those which are also most reassuring to the eye; their strong outlines maintain the upward movement of the glass and underline its construction." This glass was exhibited in the *Art Nouveau Belgium-France* exhibition (1976, cat. no. 475).

**HENRY
VAN DE
VELDE**
1863–1957

Biographical details of Henry van de Velde appear on page 155. For other works by this artist see cat. nos. 102, 103, 104, 105, 170, 171, and 172.

151 **Side Chair** 1895
Oak and rush
Height: 94.0 (37)
The Museum of Modern Art, New York

In 1894 Van de Velde married Maria Sèthe, a pupil of Théo van Rysselberghe. For their new life together, he built the house which he called Bloemenwerf in Uccle, a suburb of Brussels. He designed the entire interior and all the furnishings as well, in a style of fresh simplicity that greatly impressed those who saw it: it was after a visit to the house that Samuel Bing commissioned Van de Velde to design the furnishings of four rooms for his new "Galerie Art Nouveau," which was to open in Paris late in 1895. This side chair is one of eight which, together with two armchairs, a child's high chair, a buffet, china cabinet, and table, were designed for the dining room in the new house. (See New York, Museum of Modern Art, *Art Nouveau: Art and Design at the Turn of the Century,* 1960–1961, cat. no. 286 and *Art Nouveau Belgium-France,* 1976, cat. no. 482.)

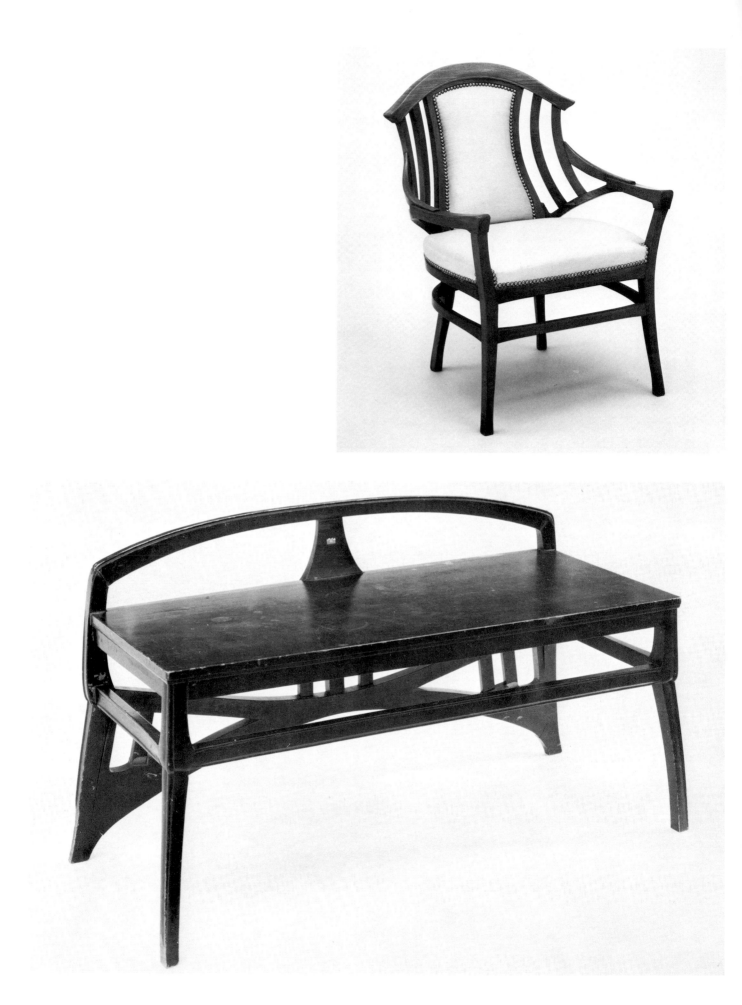

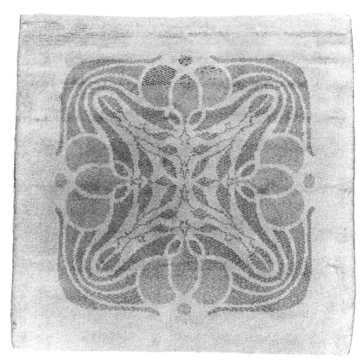

152 **Desk Chair** *circa* 1898–1899
Oak and fabric
Height: 85.7 (33³/₄)
The Museum of Modern Art, New York
Illustrated on facing page, top

The interest aroused by the furnishings of Bloemenwerf, and the renown brought by the interiors made for Bing's gallery in Paris propelled Van de Velde further into his newly chosen career as a designer of objects for use. In 1897 he founded a workshop in Ixelles in Brussels, where commissioned furniture was made, including this chair.

153 **Piano Bench** *circa* 1907
Black lacquered pine wood
61.0 x 110.0 x 46.0 (24 x 43¹/₄ x 18¹/₈)
Museum voor Sierkunst, Ghent
Illustrated on facing page, bottom

154 **Rug** *circa* 1902–1903
Wool
166.0 x 166.0 (65³/₈ x 65³/₈)
Museum voor Sierkunst, Ghent
Illustrated above

Van de Velde designed this piano bench for his Villa Hohe Pappeln in Weimar. The elegant effect of the piece resides solely in its formal qualities, for it is totally undecorated in the usual sense of the word. The structure is typical of Van de Velde's restrained Art Nouveau aesthetic, which kept within strict limits ranging from straight to gently curving lines. The basis of form is architectonal, as is usual in his work, but the play between straight and swelling line gives it a sensual quality as well. This work was exhibited in Brussels in 1970 (Galerie L'Ecuyer, *Henry van de Velde,* cat. no. 94); in Brussels and Düsseldorf in 1979 (Design Center; Museum für Volk und Wirtschaft, *Meubelen uit België van Henry van de Velde tot Heden,* cat. no. 15); and in Hasselt in 1979 (Provinciaal Begijnhof, *Art Nouveau uit het Museum voor Sierkunst te Gent,* cat. no. 21).

The artist designed this rug for the Esche factory in Chemnitz (now, as part of the German Democratic Republic, known as Karl-Marx-Stadt). The decorative scheme of the weaving serves as a guide to Van de Velde's basic conception of how to ornament an object; decoration was never to be simply applied to furniture or architecture, but had to be an essential part of the formal or functional qualities. In this rug, the decoration is limited to an abstract (though implicitly organic) linear pattern in the center. The restrained coloring — he uses only two tones, both pastel — gives the rug a serene quality, although the swelling forms of the ornament pattern are quite luxuriant. This work was shown in the Art Nouveau exhibition at Hasselt in 1979 (cat. no. 23).

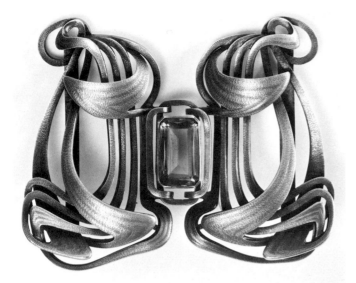

155 Belt Buckle *circa 1898*
Silver and amethyst
8.0 x 10.0 (3$^1/_8$ x 4)
Karl Ernst Osthaus Museum, Hagen
(loan from the Henri van de Velde Society)

Van de Velde designed his first silver work at the end of the nineties in Brussels. Most of the pieces are pendants, brooches, and belt buckles. Symmetry and linearity are the prevailing characteristics, and most of the work also contains precious colored stones. This buckle has been exhibited previously in Zurich and Hagen (*Henry van de Velde, Persönlichkeit und Werk,* 1958); Munich (*Henry van de Velde, Das Lebenswerk,* 1959); Stuttgart, (*Henry van de Velde zum 100 Geburtstag,* 1963); Otterlo (Rijksmuseum Kröller-Müller, 1964); Brussels (Galerie L'Ecuyer, *Henry van de Velde,* 1970); and Houston and Chicago (*Art Nouveau Belgium-France,* 1976, cat. no. 486).

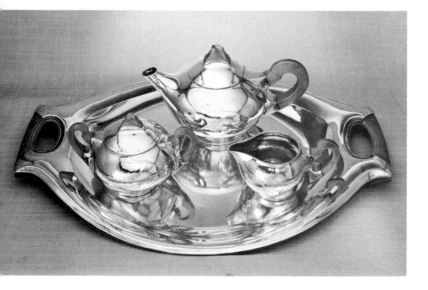

156 Tea Service *circa 1905*
Silver and wood
Teapot, height: 14.0 (5$^1/_2$)
Creamer, height: 7.0 (2$^3/_4$)
Sugar bowl, height: 9.7 (3$^7/_8$)
Tray: 49.0 x 33.0 (19$^1/_4$ x 13)
Karl Ernst Osthaus Museum, Hagen

This tea service, which is from the artist's own collection, was made during Van de Velde's German period. In 1900, he left Bloemenwerf, his Brussels home, for Berlin. Linear rhythms have been abandoned here for emphasis on an organic integration of form and ornament. Decorative embellishments carry over between the silver and wooden parts of the service. It was exhibited at Zurich and Hagen in the exhibition, *Henry van de Velde, Persönlichkeit und Werk,* in 1958.

PHILIPPE WOLFERS
1858–1929

When, at the age of seventeen, Philippe Wolfers began to work for his father Louis Wolfers, a master silversmith, the prevailing style was a neo-Louis XV Rococo manner, heavy with ornament. But following the international exhibitions in London (1862), Vienna (1873), and Paris (1889), the simple elegance of the arts of the Far East achieved recognition, and Wolfers' own work soon showed a stylistic evolution stemming from his admiration for Japanese form and decoration. In the nineties, nature also became an extremely important component of object ornamentation in Wolfers' repertory; many studies of fauna and flora were made for his later Art Nouveau creations. Wolfers was interested in a wide variety of expressive means with which he experimented in his crystal vases and particularly in the jewelry made in his own studio between 1890 and 1892. It is also his jewelry that best demonstrates the exquisite technique and matchless skill of Philippe Wolfers. He knew how to use the brilliance and depth of precious stones, the suppleness of precious metals, and the fluid quality of enamel — all of which permitted him a nearly infinite number of possibilities in design. This sensitivity made him perhaps the purest of all Art Nouveau decorative artists. But, in 1902, he gradually began to create more symmetrical designs and by 1905, most traces of Art Nouveau sinuosity were gone from his work.
[LD]

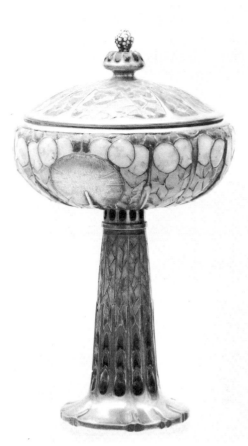

157 **Cup: "Monnaie du pape"** 1899
Silver, enamel, and marble
Height: 20.7 (8¹/₈)
Museum voor Sierkunst, Ghent

One of Philippe Wolfers' most marvelous creations in the Art Nouveau style is this cup in silver and translucent enamels, using the pale ovals of the plant called "monnaie du pape" (moonwort). He has joined the ornament to the underlying form in a very original way, using a cloisonné technique. The cup was made as one of a pair for the Neyt family and, although not signed, they are registered in Wolfers' own *Catalogue des exemplaires unique* (no. 155). They have been shown in a number of recent exhibitions: Brussels, Galerie L'Ecuyer, *Philippe Wolfers*, 1972 (cat. no. 8); Houston and Chicago, *Art Nouveau Belgium-France*, 1976 (cat. no. 513); Ghent, Museum voor Sierkunst, *Philippe Wolfers, juwelen, zilver, ivoor, kristal*, 1979 (cat. no. 20); and Hasselt, Provinciaal Begijnhof, *Art Nouveau uit het Museum voor Sierkunst te Gent*, 1979 (cat. no. 37).

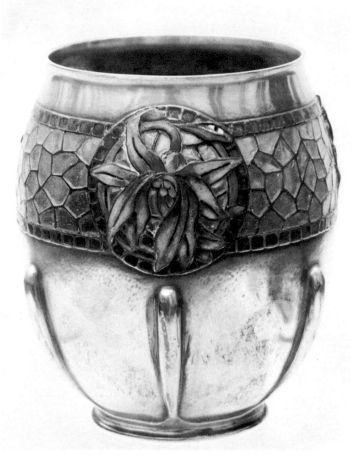

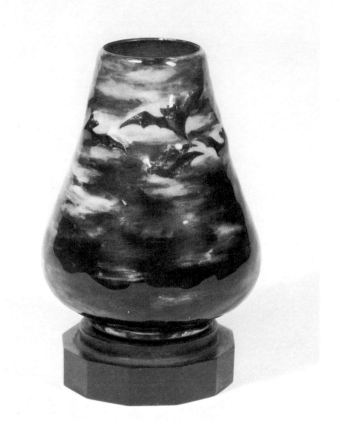

158 **Cup: "Magnolia"** 1899
Silver gilt, enamel, and marble
Height: 12.5 (4⅞)
Museum voor Sierkunst, Ghent

159 **Vase: "La Nuit"** 1898
Enamel on copper
Height: 13.0 (5⅛)
Galerie L'Ecuyer, Brussels

This cup, also one of a pair that was made in the same year as the "monnaie du pape" pieces, and for the same family, is characterized by a perfect harmony between structure and decoration. The motif of the magnolia blossom — in the medallion on the band that encircles the cup — seems to suggest that it is a swollen bud from which such a bloom would soon burst forth. The enamel work is carried out in a cloisonné form resembling stained glass. The pair was exhibited in the same exhibitions as the "monnaie du pape" cups (see cat. no. 157).

In this vase, Wolfers has invoked the mysteries of the night, showing fluttering bat wings against a dark blue background that also has passages suggesting clouds. The vase is the third of three vases that Wolfers made in this design.

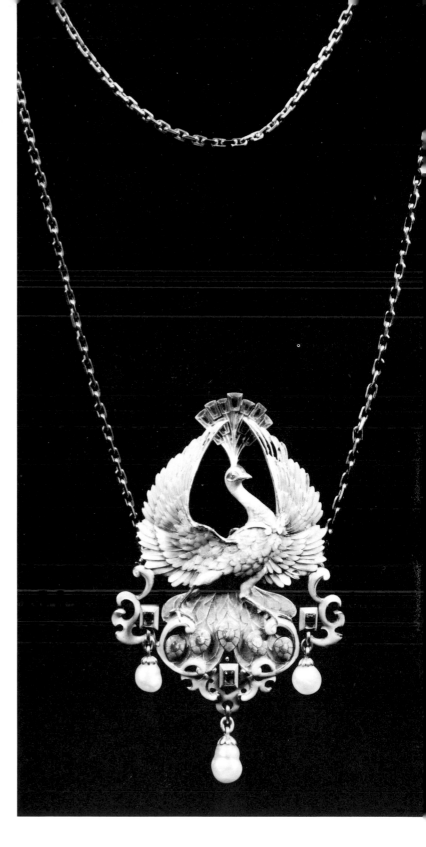

160 **Peacock Pendant** 1901
Gold, enamel, emeralds, and baroque
pearls
15.7 x 7.0 (6¼ x 2¾)
Francine Kerckx, Antwerp

Wolfers' jewels show off his special artistic and technical abilities
with great brilliance; the use of rich materials and glowing colors
in this piece is extraordinarily sumptuous. The peacock motif is a
favorite theme for the Art Nouveau period. This piece was ex-
hibited in Brussels (Hôtel Solvay, *Le Bijou 1900,* 1965, cat. no. 94);
Paris (Grand Palais, *Peintres de l'Imaginaire,* 1972, cat. no. 276);
Ostend (Casino, *Europa 1900,* 1967, cat. no. 287); Milan (Museo
Poldi Pezzoli, *Gioielli di Artisti Belgi dal 1900 al 1973,* 1973, cat.
no. 8); and Ghent (Museum voor Sierkunst, *Philippe Wolfers,
juwelen, zilver, ivoor, kristal,* 1979, cat. no. 50).

Architecture

JOSEPH BASCOURT
1863–1927

Bascourt studied architecture at the Antwerp Academy at night, working by day as a clerk and foreman for a brick mason. A prizewinning design in 1889 brought him attention, and his marriage to the daughter of an established architect brought him commissions from the wealthy circles of Antwerp. Many of the town houses he built for Antwerp merchants consisted of a mixture of historical styles, but Bascourt was one of the few Antwerp architects to develop an original and personal Art Nouveau style. [MC]

161 **Elevation of a House in Antwerp,
55 Avenue Cogels-Osy** *circa* 1900
Ink and wash on tracing paper
85.0 x 54.0 (33$^{1}/_{2}$ x 21$^{1}/_{4}$)
*Archives d'Architecture Moderne,
Brussels*

ERNEST BLEROT
1870–1957

Blérot was one of the most unusual and interesting of the architects who shaped Art Nouveau in Brussels. Between 1899 and 1901 he built a great many private houses, most notably the row of seventeen houses that lines an entire side of the rue Vanderschrick in St. Gilles, a residential section of Brussels. This series of façades is unique in the city for its great architectural variety and exceptional plastic articulation. From 1901 to 1908, Blérot worked on his own house, an important Art Nouveau monument in Brussels that was destroyed in 1962. [MC]

162 **Project for a Veranda at the Property of M. Desmet, 122 Avenue Louise** 1902
Pencil and watercolor on paper
81.0 x 128.0 (31$^7/_8$ x 50$^3/_8$)
Archives d'Architecture Moderne, Brussels
Detail illustrated on facing page

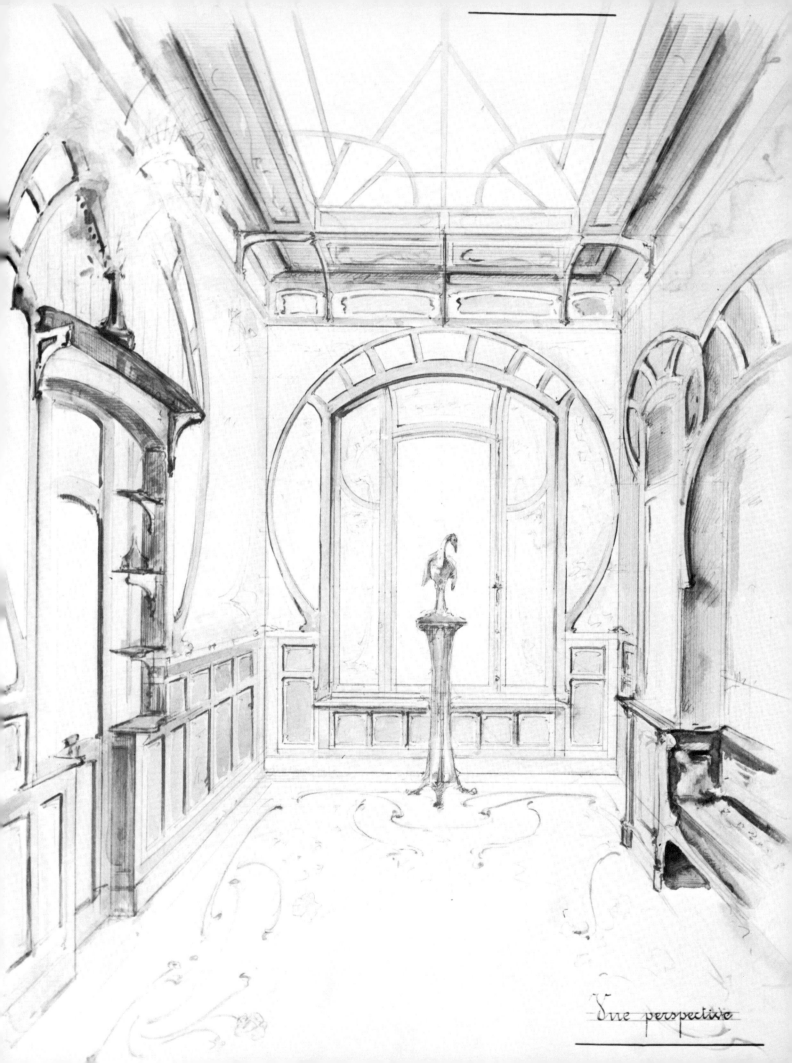

Une perspective

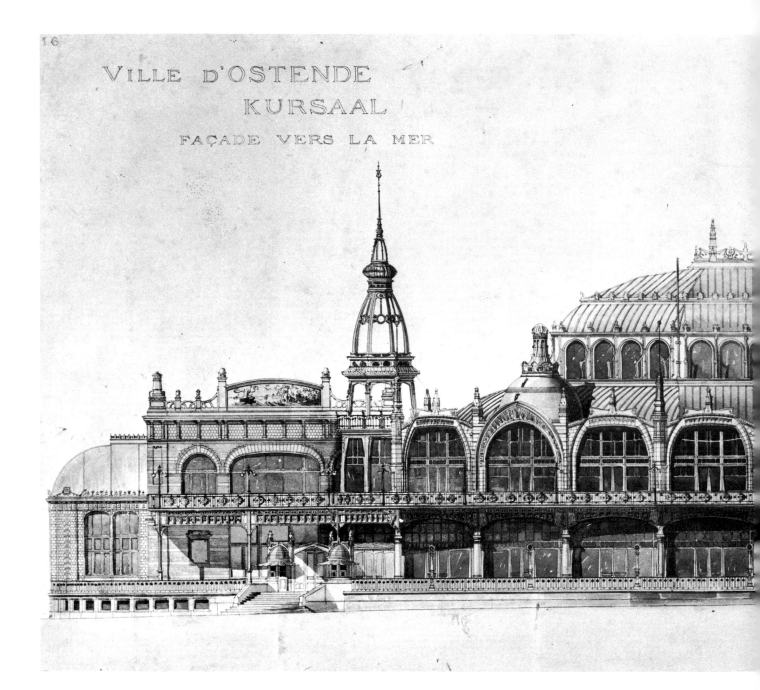

VILLE D'OSTENDE
KURSAAL
FAÇADE VERS LA MER

ALBAN CHAMBON
1847–1928

Chambon was born in France and studied at the École des Beaux-Arts in Paris, settling in Belgium in 1868. He is particularly known for his public buildings — among others, the Théâtre de la Bourse and the Hôtel Métropole in Brussels, several theatres in London, and the transformation of the Kursaal in Ostend. In his buildings, he regularly used stoneware and glazed brick, and exposed metal structures with cast-iron decorative motifs. King Leopold II gave him several commissions, including that of planning the Mont des Arts in Brussels. [MC]

163 **The Casino at Ostend: Elevation of the Seafront** 1903
Ink wash and gouache over print, mounted on board
51.0 x 115.0 (20 x 45¼)
Archives d'Architecture Moderne, Brussels

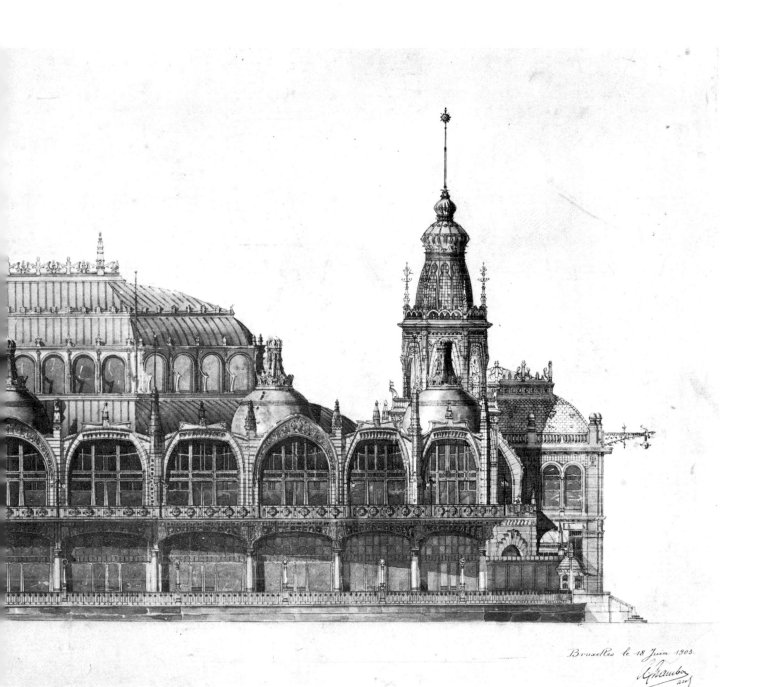

Bruxelles le 18 Juin 1903.

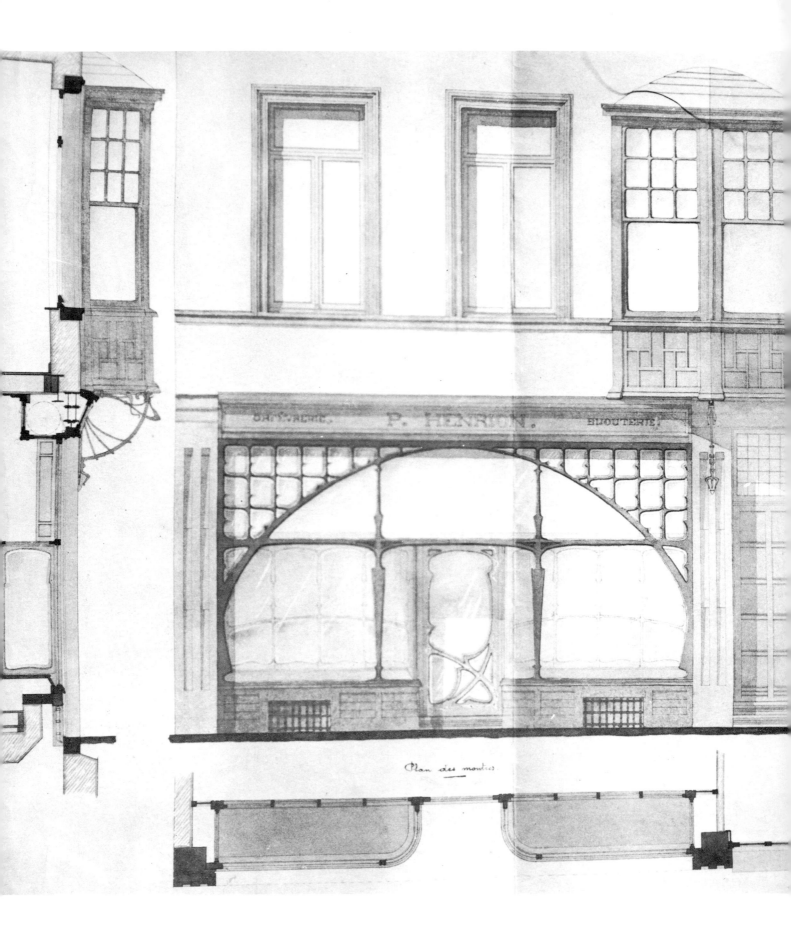

Plan des montres

PAUL HANKAR 1859–1901

Biographical details of Paul Hankar appear on page 212. For other works by this artist see cat. nos. 138 and 139.

164 **The Shopfront of the Paul Henrion Store, 9 rue Mathieu, Namur** 1896
Ink and watercolor on paper
68.0 x 70.0 (26³/₄ x 27¹/₂)
Musées Royaux d'Art et d'Histoire, Brussels
Illustrated on facing page

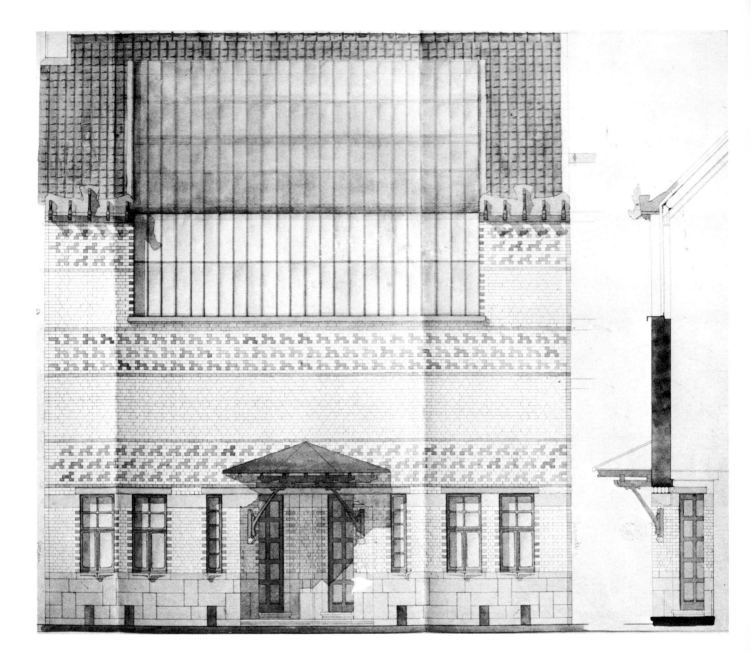

165 **The Façade of the Studio of the Painter Ciamberlani, 40 boulevard de la Cambre, Brussels** 1897
Ink and watercolor on paper
70.0 x 81.0 (27¹/₂ x 31³/₄)
Musées Royaux d'Art et d'Histoire, Brussels

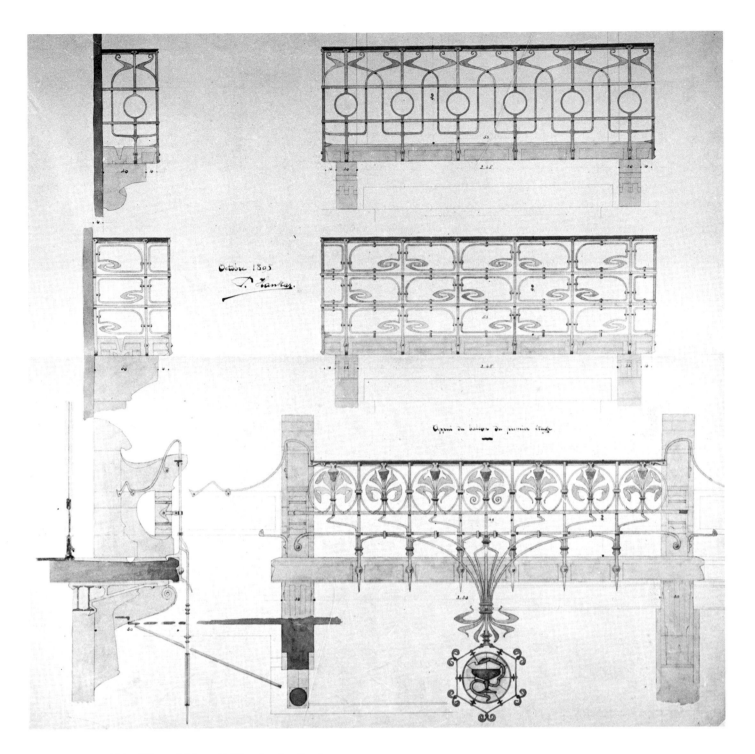

166 **Wrought Iron Grilles for the Peeters
Pharmacy, rue Lebeau, Brussels** 1895
Ink and watercolor on paper
70.0 x 70.0 (27$\frac{1}{2}$ x 27$\frac{1}{2}$)
*Musées Royaux d'Art et d'Histoire,
Brussels*

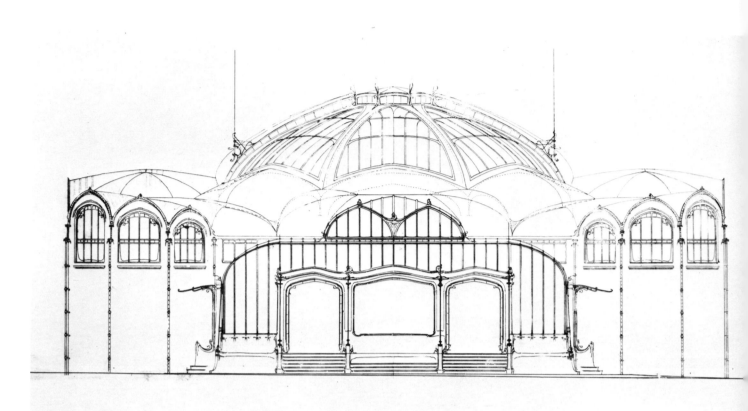

VICTOR HORTA 1861–1947 Biographical details of Victor Horta appear on page 214. For other works by this artist see cat. nos. 140 and 141.

167 **Study for the Pavilion of the Congo Free State at the 1900 Exposition Universelle, Paris** 1888–1889
Ink on tracing paper
69.0 x 129.0 (27^1/$_4$ x 50^3/$_4$)
Musée Horta, Brussels

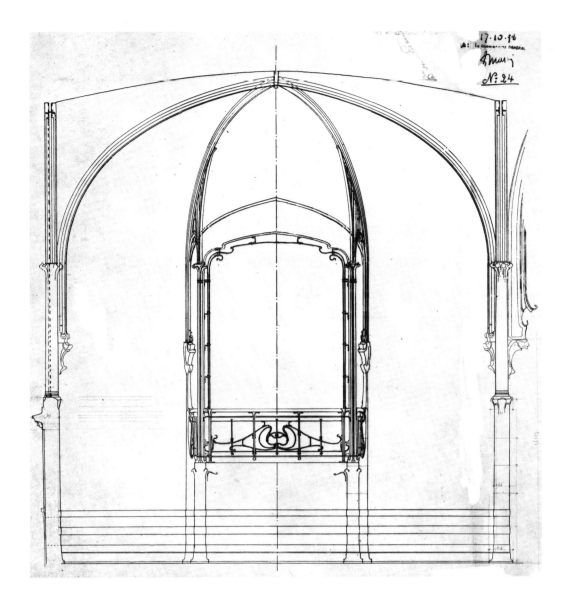

168 **Study for the Pavilion of the Congo
Free State at the 1900 Exposition
Universelle, Paris** 1888–1889
Ink on tracing paper
60.5 x 54.0 (23³/₄ x 21¹/₄)
Musée Horta, Brussels

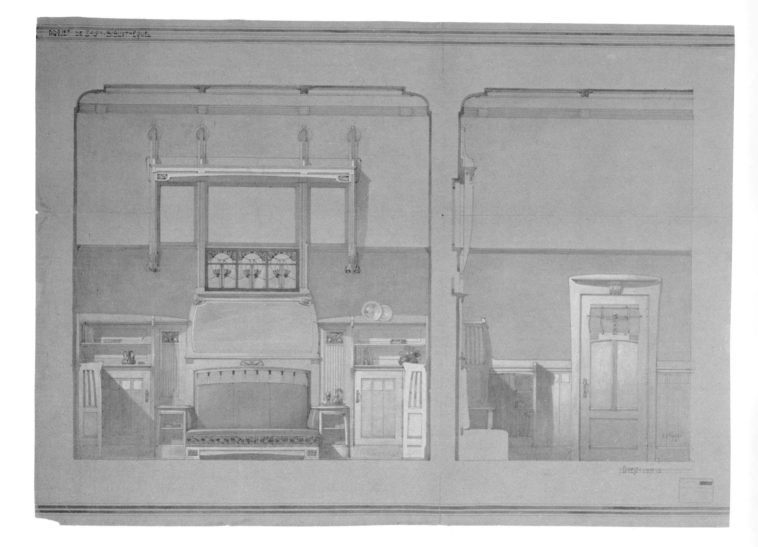

ANTOINE POMPE
1873–1980

Pompe was born in Brussels and studied at the Kunstgewerbeschule in Munich. He spent many years as a designer, engraver, and draftsman before producing his first work of architecture at age thirty-seven. His many designs for grillwork, flatware, and furniture during the years 1895–1905 were in the Art Nouveau style, but though very beautiful, they were never executed. In his architecture, done largely for a *petit bourgeois* clientele, Pompe was primarily influenced by English and German domestic architectural styles. [MC]

HENRY VAN DE VELDE
1863–1957

Biographical details of Henry van de Velde appear on page 155. For other works by this artist see cat. nos. 102, 103, 104, 105, 151, 152, 153, 154, 155, and 156.

169 **Project for a Room at the Turin Exhibition of 1902, Done for the Cabinet-Maker Hobé** *circa* 1901
Ink, watercolor, and gouache on paper
64.0 x 90.0 (25$\frac{1}{4}$ x 35$\frac{1}{2}$)
Archives d'Architecture Moderne, Brussels
Reproduced in color on facing page

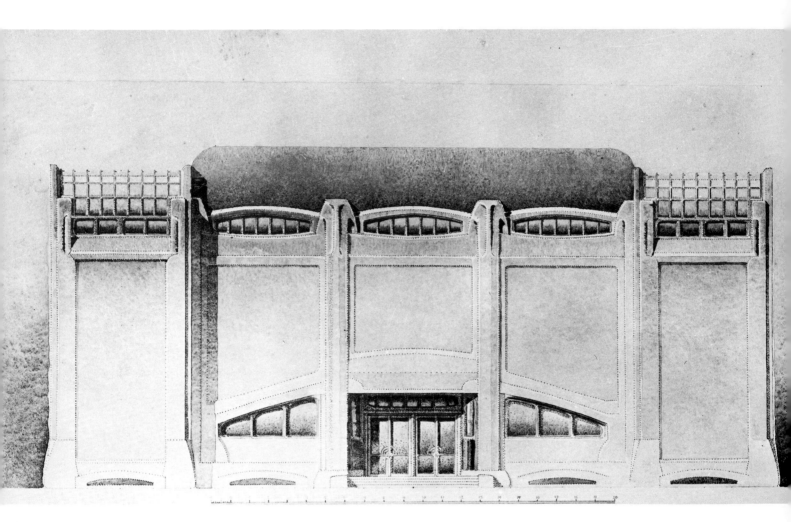

170 **Project for a Museum of Fine Arts at Weimar: Elevation of the Karlplatz Façade** 1903–1904
Watercolor on illustration board
51.0 x 72.5 (20 x 28¹/₂)
Archives Henry van de Velde, Brussels

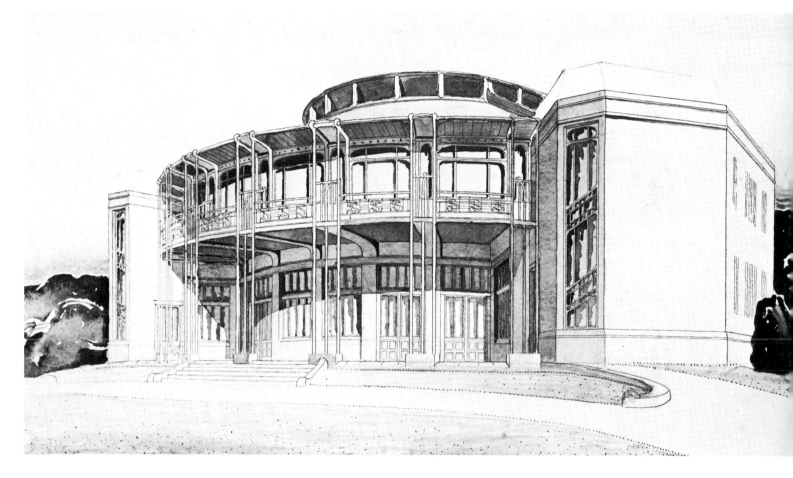

171 **Perspective Study for the Louise Dumont
 Theatre in Weimar** 1904–1905
 Watercolor on paper
 53.0 x 74.5 (20$^7/_8$ x 29$^1/_4$)
 Archives Henry van de Velde, Brussels

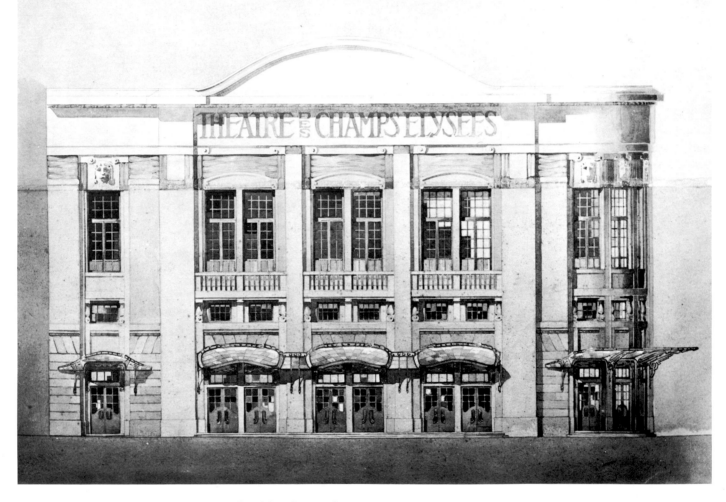

172 **Project for the Façade of the Théâtre des Champs-Elysées in Paris** 1910
Watercolor on cardboard
69.0 x 100.0 (27$^1/_4$ x 39$^3/_8$)
Archives Henry van de Velde, Brussels

Selected Bibliography

GENERAL Books, Journals, and Archives
Arranged alphabetically by author

L'Art Moderne (Brussels), 1881–1914.

Borsi, Franco. *Bruxelles 1900*. Brussels, 1974.

Borsi, Franco, and Wieser, H. *Bruxelles, Capitale de l'Art Nouveau*. Brussels, 1971.

Braet, H. *L'Accueil fait au Symbolisme en Belgique, 1885–1900*. Brussels, 1969.

Cassou, J.; Langui, E.; and Pevsner, N. *Gateway to the Twentieth Century*. New York, 1962.

Colin, P. *La Peinture Belge Depuis 1830*. Brussels, 1930.

Delevoy, R. L. *Symbolists and Symbolism*. New York, 1978.

de Mont, P. *De schilderkunst in Belgie van 1830 tot 1921*. The Hague, 1921.

Dortu, M. Grillaert, and Adhémar, J. *Toulouse Lautrec en Belgique*. Paris, 1955.

Dujardin, Jules. "Les Artistes Contemporains." *L'Art Flamand* 6 (Brussels, 1900).

Dumont, Georges H. *La vie quotidienne en Belgique sous la règne de Léopold II (1865–1939)*. Paris: Hachette, 1974.

Eemans, J. *La peinture moderne en Belgique*. Brussels, 1969.

Egbert, D. D. *Social Radicalism and the Arts*. New York, 1970.

Faider-Thomas, T. "Anna Boch." *Miscellanea Josef Duverger* 1 (Ghent, 1968), p. 406.

Fierens, Paul. *Essai sur l'Art Contemporain*. Paris, 1897.

Fontaine, A. *L'Art belge depuis 1830*. Paris, 1921.

Guerrand, R. R. *L'Art Nouveau en Europe*. Paris, 1965.

Haesaerts, Luc and Paul. "Flandre, essai sur l'art flamand depuis 1880." *L'Impressionisme* 1 (Paris, 1931).

Haesaerts, Paul. *Laethem-Saint-Martin: Le village élu de l'art flamand*. Brussels, 1965.

Haesaerts, Paul. *La peinture moderne en Flandres*. Brussels, 1960.

Herbert, E. W. *The Artist and Social Reform, France and Belgium 1885–1898*. New Haven, 1961.

La Jeune Belgique (Brussels), 1881–1894.

Jullian, Philippe. *Dreamers of Decadence: Symbolist Painters of the 1890s*. London, 1971.

Jullian, Philippe. *The Symbolists*. London, 1973.

Laughton, Bruce. "British and American Contributions to Les XX, 1884–1893." *Apollo* 86 (London, 1967), pp. 372–379.

Legrand, F.-C. *Symbolism in Belgium*. Brussels, 1972.

Lemonnier, C. *L'école belge de peinture 1830–1905*. Brussels, 1906.

Lemonnier, C., et al. *L'Art et la Vie en Belgique 1830–1905*. Brussels, 1921.

Lövgren, S. *The Genesis of Modernism — Seurat, Gauguin, Van Gogh and French Symbolism in the 1880s*. Bloomington, Indiana, 1971.

Madsen, S. Tschudi. *Sources of Art Nouveau*. Oslo, 1959.

Madsen, S. Tschudi. *L'Art Nouveau*. Paris, 1967.

Malhotra, R.; Rinkloff, M.; and Schälicke, B., eds. *Das frühe Plakat in Europa und den U. S. A. Frankreich und Belgien*, vol. 2. Berlin, 1977.

Maret, F. *Les Peintures luministes*. Brussels, 1944.

Matthews, A. J. *La Wallonie, 1886–1892: The Symbolist Movement in Belgium*. New York, 1947.

Maus, Madeleine Octave. *Trente années de lutte pour l'Art 1884–1914*. Brussels: L'Oiseau bleu, 1926.

Maus, Octave. Brussels, Musées Royaux des Beaux-Arts de Belgique. Archives de l'Art contemporain. Archives Octave Maus.

Milner, J. *Symbolists and Decadents*. New York, 1971.

Muther, Richard. *La Peinture Belge au XIXe Siècle*. Brussels, 1904.

Pincus-Witten, R. *Occult Symbolism in France: Joséphin Péladan and the Salons de la Rose + Croix*. New York, 1976.

Polak, B. H. *Het fin de siècle in de nederlandse schilderkunst: De Symbolistische beweging 1890–1900*. The Hague, 1955.

Rewald, John. *Post Impressionism: from Van Gogh to Gauguin*. New York, 1978.

Rheims, M. *The Flowering of Art Nouveau*. New York, [1966].

Roberts-Jones, Philippe. *Du Réalisme au Surréalisme: Peinture en Belgique de Joseph Stevens à Paul Delvaux*. Brussels, 1969.

Roelandts, Oscar. *Considérations sur l'Influence de l'art français en Belgique depuis 1832*. Mémoires de l'Académie Royale de Belgique 2nd Series, no. 4, facsimile 5. Brussels, 1941.

Schmutzler, R. *Art Nouveau*. New York, 1962.

Smeets, Albert. *Flemish Art from Ensor to Permeke*. Tielt/Utrecht, 1972.

La Société Nouvelle (Brussels), 1884–1896.

Sutter, J. *The Neo-Impressionists*. London, 1970.

van Beselaere, W. *De Vlaamse Schilderkunst van 1800–1950.* Brussels, 1961.

Van Nu en Straks (Brussels and Antwerp), 1892–1901.

van de Velde, Henry. Brussels. E.N.S.A.A.D. Archives de l'Association Henry van de Velde.

Verhaeren, Émile. Brussels. Bibliothèque Royale. Archives Émile Verhaeren.

La Wallonie (Liège), 1886–1892.

Warmoes, J. "Les XX et la littérature." *Cahiers Van de Velde,* no. 7 (Brussels, 1966), pp. 19–42.

Whitford, Frank. "From the Twenty to the Twenties: the Development of Modernism in Belgium." *Studio International* 188 (London, October 1974), pp. 124–127.

GENERAL Exhibition Catalogues

Arranged chronologically

——. Brussels. Salon des XX. Exhibition catalogues 1884–1893.

——. Brussels. Salon de La Libre Esthétique. Exhibition catalogues 1893–1914.

1920. Antwerp. Koninklijk Museum voor Schone Kunsten. *De Keurtentoonstelling van Belgische meesters (1830–1914).*

1923. Paris. Musée du Jeu de Paume. *Exposition de l'art belge ancien et moderne.*

1952. Zurich. Kunstgewerbemuseum. *Um 1900, Art Nouveau und Jugendstil.*

1957. Brussels. Palais des Beaux-Arts. *Le Mouvement Symboliste.*

1960–1961. Paris. Musée National d'Art Moderne. *Les Sources du XXᵉ siècle, les Arts en Europe de 1884 à 1914.*

1960–1961. New York. The Museum of Modern Art, et al. *Art Nouveau: Art and Design at the Turn of the Century.*

1962. Brussels. Musées Royaux des Beaux-Arts de Belgique. Otterlo. Rijksmuseum Kröller-Müller. *Le groupe des XX et son temps.* Catalogue by F.-C. Legrand.

1963–1964. Brussels. Musées Royaux des Beaux-Arts de Belgique. *Le courant réaliste en Belgique du XIXᵉ Siècle à nos jours.*

1964. Brussels. Musées Royaux des Beaux-Arts de Belgique. *La Part du rêve.*

1965. London. The Arts Council of Great Britain. *Autour de 1900 — l'art belge 1884–1900.*

1965. New Haven. Yale University Art Gallery. *Neo-Impressionists and Nabis in the Collection of A. G. Altschul.*

1965. Brussels. Musées Royaux des Beaux-Arts de Belgique. *Les jeux de la lumière dans la peinture belge: de Boulenger à Rik Wouters.*

1966. Brussels. Musées Royaux des Beaux-Arts de Belgique. *Évocation des XX et de La Libre Esthétique.*

1967. Ostend. Musée des Beaux-Arts. *Europa 1900: peintures, dessins, sculptures, bijoux.*

1967. Ostend Kursaal. *Europa 1900.*

1968. Brussels. Musées Royaux des Beaux-Arts de Belgique. *De l'allégorie au symbole.*

1968. London. Picadilly Gallery. *Les Salons de la Rose + Croix, 1892–1897.*

1968. New York. The Solomon R. Guggenheim Museum. *Neo-Impressionism.* Catalogue by Robert Herbert.

1968. Tucson. University of Arizona Art Gallery. *Homage to Seurat, Paintings, Watercolors and Drawings by the Followers of Seurat, Collected by Mr. and Mrs. W. J. Holliday.*

1969. Toronto. Art Gallery of Ontario. *The Sacred and Profane in Symbolist Art.*

1969. Brussels. Musées Royaux des Beaux-Arts de Belgique. *Peintres belges: Lumière française.*

1970. International Exhibitions Foundation. *La Belle Époque: Belgian Posters, Watercolors and Drawings from the Collection of L. Wittamer-De Camps.*

1970. Milan. Galeria del Levante. *Symbolism in Belgium.*

1970. London. Picadilly Gallery. *Belgian Drawings since 1870.*

1971. London. Royal Academy of Arts. *Ensor to Permeke: Nine Flemish Painters, 1880–1950.*

1971–1972. Brussels. Hôtel Van de Velde. *Brussels 1900: Capital of Art Nouveau.*

1972. Paris. Grand Palais. *Peintres de l'imaginaire: symbolistes et surréalistes belges.*

1974. Knokke. Casino. *Le Symbolisme en Belgique.*

1974. New York. The New York Cultural Center. Houston. Museum of Fine Arts. *Painters of the Mind's Eye: Belgian Symbolists and Surrealists.*

1975. Antwerp. Museum voor Schone Kunsten. *Als Ik Kan.*

1975. Brussels. Bibliothèque Royale. *L'Affiche belge 1892–1914.* Catalogue by Y. Oostens-Wittamer.

1975–1976. Rotterdam. Boymans Museum. Paris. Grand Palais, et al. *Le Symbolisme en Europe.*

1976. Houston. Rice Museum. Chicago. Art Institute. *Art Nouveau Belgium-France.*

1977. Brussels. Palais des Beaux-Arts. *Jugendstil.*

1977. Düsseldorf. Stadtische Kunsthalle. *Vom Licht zu Farbe: nach-impressionistische malerei zwischen 1886 und 1912.*

1978. Brussels. Palais des Beaux-Arts. *L'Art en Belgique 1880–1950: Hommage à Luc et Paul Haesaerts.*

1979. Hasselt. Provinciaal Begijnhof. *De Art Nouveau, verzameling vit het Museum voor Sierkunst te Gent.*

1979. Ghent. Museum voor Schone Kunsten. *Veertig kunstenaars rond Karel van de Woestijne.*

1979–1980. London. Royal Academy of Arts. *Post-Impressionism: Crosscurrents in European Painting.*

MONOGRAPHIC LITERATURE

Arranged alphabetically by artist; references within appear chronologically

**indicates publication includes extensive bibliography*

Jules van Biesbroeck

Milan. Pesaro Galeria. *Jules van Biesbroeck.* 1924.

Henri de Braekeleer

Van Zype, G. *Henri de Braekeleer.* Brussels/Paris, 1923.

de Ridder, A. *Henri de Braekeleer.* Brussels, 1931.

de Bom, E. *De Braekeleer en Antwerpen.* 1941.

Haesaerts, P. *Henri de Braekeleer.* Brussels, 1943.

Delen, H. *Henri de Braekeleer.* Antwerp, 1948.

Antwerp. Museum voor Schone Kunsten. *Rétrospective Henri de Braekeleer.* 1956.

Conrardy, C. *Henri de Braekeleer.* Monographies de l'Art belge. Brussels, 1957.

van Beselaere, W. "Henri de Braekeleer." *Apollo,* no. 105 (London, March 1977), pp. 203–206.

Émile Claus

Lemonnier, C. *Émile Claus.* Brussels, 1908.

Sauton, A. *Un Prince de Luminisme: Émile Claus.* Brussels, 1946.

Maret, F. *Émile Claus.* Monographies de l'Art belge. Antwerp, 1949.

Ghent. Museum voor Schone Kunsten. *Rétrospective Émile Claus.* 1974.

Gisbert Combaz

Capart, J., and Spruyt, A. "Gisbert Combaz." *Bulletin des Musées Royaux d'Art et d'Histoire* 3rd Series, no. 1 (Brussels, January–February 1941).

Adolphe Crespin

Maus, O., and Soulier, G. "L'Art décoratif en Belgique: M. Paul Hankar et Adolphe Crespin." *Art et Décoration* 1 (Paris, 1897), pp. 89–96.

William Degouve de Nuncques

Goffin, A. "William Degouve de Nuncques." *Art Flamand et Hollandais,* January 1914, pp. 9–29.

Haesaerts, L. and P. *William Degouve de Nuncques.* Brussels, 1935.

de Ridder, A. *William Degouve de Nuncques.* Monographies de l'Art belge. Brussels, 1957.

Stavelot. Musée de l'Ancien Abbaye. *Degouve de Nuncques.* 1963.

Jean Delville

Ciamberlani, A. "Notice sur Jean Delville." *Annuaire de l'Académie des Beaux-Arts (Brussels),* 1954.

Frangia, L. M. *Il Simbolismo di Jean Delville.* Bologna, 1978.

Julien Dillens

Brussels. Cercle Artistique et Littéraire. *Exposition rétrospective Julien Dillens et G. S. van Strydonck.* 1933.

Walens, A. *Julien Dillens.* Brussels, 1942.

Matthijs, G. M. *Julien Dillens Sculpteur 1894–1904.* Brussels, 1955.

James Ensor

New York. The Museum of Modern Art. *James Ensor.* 1951. Catalogue by Libby Tannenbaum.

Legrand, F.-C., ed. "Les lettres de James Ensor à Octave Maus." *Bulletin des Musées Royaux des Beaux-Arts de Belgique,* no. 1–2 (1966), pp. 17–54.

*Legrand, F.-C. *Ensor, cet Inconnu.* Brussels, 1971.

Stuttgart. Württembergerischen Kunstverein. *Ensor — ein Maler aus dem späten 19 Jahrhundert.* 1972.

Haesaerts, P. *James Ensor.* Brussels, 1973.

van Gindertael, Roger. *Ensor.* London, 1975.

*New York. The Solomon R. Guggenheim Museum. *Ensor.* 1976. Catalogue by David Farmer.

Ollinger-Zinque, Gisèle. *Ensor By Himself.* Brussels, 1976.

Lesko, D. "Ensor in His Milieu." *Artforum,* May 15, 1977, pp. 56–62.

Morrisey, Leslie. "James Ensor's Self-Portraits." *Arts* 54, no. 4 (December 1979), pp. 90–95.

Henri Evenepoel

Hellens, F. *Henri Evenepoel.* Monographies de l'Art belge. Antwerp, 1947.

Antwerp. Koninklijk Museum voor Schone Kunsten. *Rétrospective Henri Evenepoel.* 1953.

Chartrain-Hebbelinck, M.-J. "Lettres inédites de Henri Evenepoel." *Revue belge d'archéologie* 35, no. 3–4 (Brussels, 1966), pp. 221–222.

Chartrain-Hebbelinck, M.-J. "Evenepoel: a Belgian Precursor of Fauvism." *Apollo,* no. 94 (London, October 1971), pp. 293–297.

Hyslop, F. E., ed. *Henri Evenepoel à Paris: Lettres choisies.* Brussels, 1972.

*Brussels. Musées Royaux des Beaux-Arts de Belgique. *Hommage à Henri Evenepoel.* 1972.

Hyslop, F. E. *Henri Evenepoel: Belgian Painter in Paris.* University Park, Pennsylvania, 1975.

Émile Fabry

Woluwe-Saint-Pierre, Brussels, Hôtel Communal. *Rétrospective Émile Fabry. 1965–1966.*

Brussels. Galerie L'Ecuyer. *Hommage à Émile Fabry 1866–1965.* 1970.

Alfred William Finch

Paris. Galerie Bernheim Jeune. *A. Willy Finch, peinture et poterie.* 1912.

Brussels. Palais des Beaux-Arts. *Finlande, tradition et formes nouvelles: Tapis Rya et rétrospective A. W. Finch.* 1967. Catalogue by Bertel Hintze and Åke Gulin.

Léon Frédéric

Brussels. Palais des Beaux-Arts. *Rétrospective Léon Frédéric.* 1948.

Jottrand, L. *Léon Frédéric.* Monographies de l'Art belge. Antwerp, 1950.

Brussels. Musée "Hôtel Charlier." *Rétrospective Léon Frédéric.* 1973.

Paul Hankar

Conrardy, C., and Thibaut, A. *Paul Hankar.* Brussels, 1923.

de Mayer, C. *Paul Hankar.* Monographies de l'Art belge. Brussels, 1963.

Delevoy, R. L. "P. Hankar." *Encyclopedia of Modern Architecture* (London, 1963).

Victor Horta

Kaufmann, Edgar, jr. "224 Avenue Louise." *Interiors* 66, no. 7 (New York, February 1957), pp. 88–93.

Kaufmann, Edgar, jr. "Victor Horta." *Architects Yearbook,* no. 8 (1957), pp. 124–136.

Delevoy, R. L. *Victor Horta.* Monographies de l'Art belge. Brussels, 1959.

Delhaye, Jean. "L'oeuvre de Victor Horta." *Rythme,* no. 39 (Brussels, 1964).

Borsi, F., and Portoghesi, P. *Victor Horta.* Rome, 1969.

Paris. Musée des Arts Décoratifs. *Pionniers du XXᵉ siècle: Guimard, Horta, Van de Velde.* 1971.

Brussels. Musée Horta. *Horta.* 1973.

Eidelberg, M., and Henrion-Giele, S. "Horta and Bing: an Unwritten Episode of Art Nouveau." *Burlington Magazine* 119 (November 1977), pp. 747–752.

Borsi, F. *La Maison du Peuple — Sindicalismo Come arte.* Bari, 1978.

Fernand Khnopff

Dumont-Wilden, L. *Fernand Khnopff.* Brussels, 1907.

Eemans, N. *Fernand Khnopff.* Monographies de l'Art belge. Antwerp, 1950.

Legrand, F.-C. "Fernand Khnopff, Perfect Symbolist." *Apollo,* April 1967, pp. 278–287.

Morrisey, L. "Fernand Khnopff: The Iconography of Isolation and of the Aesthetic Woman." Ph.D. dissertation, University of Pittsburgh, 1974.

*Delevoy, R. L.; de Croës, C.; and Ollinger-Zinque, G. *Fernand Khnopff.* Brussels, 1979. Catalogue raisonné.

*Paris. Musée des Arts Décoratifs. Brussels. Palais des Beaux-Arts. Hamburg. Kunsthalle. *Fernand Khnopff.* 1979–1980.

Canning, S. "Fernand Khnopff and the Iconography of Silence." *Arts,* December 1979, pp. 170–176.

Howe, J. "The Sphinx and Other Egyptian Motifs in the Work of Fernand Khnopff: the Origins of *The Caresses.*" *Arts,* December 1979, pp. 158–169.

Eugène Laermans

Colin, P. *Eugène Laermans.* Brussels, 1929.

Maret, F. *Eugène Laermans.* Monographies de l'Art belge. Brussels, 1959.

de Ridder, A. *Eugeen Laermans.* Antwerp, 1950.

Georges Le Brun

Verviers. Société des Beaux-Arts. *Exposition Georges Le Brun.* 1920.

Desprechins, E. *Georges Le Brun, peintre de la Fagne.* Paris/Brussels, 1925.

Brussels. Musée d'Ixelles. *Georges Le Brun.* 1976.

Georges Lemmen

Nyns, H. *Georges Lemmen.* Monographies de l'Art belge. Antwerp, 1954.

Brussels. Bibliothèque Royale. *Georges Lemmen: dessins et estampes.* 1965.

Privat Livemont

Maus, O. "Privat Livemont." *Art et Décoration* 7 (Paris, 1900), pp. 55 and following.

Brussels. La Petite Galerie. *Rétrospective Privat Livemont.* 1941.

François Maréchal

Kunel, Maurice. *François Maréchal Aquafortiste.* Liège, 1931.

*Cologne. Belgisches Haus. *François Maréchal 1861–1945.* 1979.

Xavier Mellery

Lemonnier, C. "Xavier Mellery." *Gazette des Beaux-Arts,* May 1885, pp. 425–436.

Fierens, P. "Trois disparus: X. Mellery, F. Khnopff, A. Donnay." *La Renaissance de l'art* 1 (1922), pp. 95–97.

Goffin, A. *Xavier Mellery.* Brussels, 1925.

Potvin, J. *Xavier Mellery comme éducateur.* Brussels, 1925.

Van Zype, G. "Xavier Mellery." *Annuaire de l'Académie des Beaux-Arts* (Brussels), 1929, pp. 35–64.

Hellens, F. *Xavier Mellery.* Brussels, 1932.

Brussels. Palais des Beaux-Arts. *Rétrospective Xavier Mellery.* 1937.

Houbart-Wilkin, S. "La maison du peintre Mellery." *Bulletin des Musées Royaux des Beaux-Arts de Belgique* no. 1–2 (1964), pp. 27–41.

Constantin Meunier

Thierry, A., and van Dievoet, E. *Catalogue des oeuvres dessinées, peintes et sculptées de Constantin Meunier.* Louvain, 1909.

Christophe, L. *Musée Constantin Meunier.* Brussels, 1939.

Christophe, L. *Constantin Meunier.* Monographies de l'Art belge. Antwerp, 1947.

*Brussels. Musées Royaux des Beaux-Arts de Belgique. *Meunier — Minne.* 1969. Catalogue by Pierre Baudson.

George Minne

van Puyvelde, L. *George Minne.* Brussels, 1930.

Haesaerts, P. *George Minne, ou le repliement sur soi-même.* Antwerp, 1938.

de Ridder, A. *Minne.* Monographies de l'Art belge. Antwerp, 1947.

*Brussels. Musées Royaux des Beaux-Arts de Belgique. *Meunier — Minne.* 1969. Catalogue by Pierre Baudson.

Kultermann, U. "Fountain of Youth: the Folkwang fountain by George Minne." *Konsthistorisk Tidskrift* 46 (December 1977), pp. 144–152.

Constant Montald

van Herreweghe, G. *Le peintre idéaliste Constant Montald.* Ghent, 1954.

———. "Émile Verhaeren et Constant Montald." *La Nervie,* no. 5, special number (Brussels, May 1925).

Antoine Pompe

Brussels. Musée d'Ixelles. *Antoine Pompe et l'effort moderne en Belgique 1890–1940.* 1969.

Armand André-Louis Rassenfosse

Stavelot. Musée de l'Ancien Abbaye. *A. Rassenfosse et G. Serrurier-Bovy.* 1975.

Félicien Rops

Exteens, M. *L'oeuvre gravé et lithographié de Félicien Rops.* Paris, 1928.

Kunel, M. *Félicien Rops, sa vie, son oeuvre.* Brussels, 1943.

Pierard, L. *Félicien Rops.* Monographies de l'Art belge. Antwerp, 1949.

London. Picadilly Gallery. *Félicien Rops.* 1966.

New York. Associated American Artists. *Félicien Rops: A Major Exhibition of Etchings and Lithographs.* 1968.

Brison, C. *Pornocrates: an Introduction to the Life and Work of Félicien Rops.* London, 1969.

*Brussels. Musée d'Ixelles. *Félicien Rops.* 1969.

London. Arts Council of Great Britain. *Félicien Rops.* 1976–1977 (touring exhibition).

Holtzman, E. "Rops and Baudelaire: Evolution of a Frontispiece." *Art Journal* 38, no. 2 (Winter 1978–1979), pp. 102–106.

*Düsseldorf. Stadtische Kunsthalle. *Félicien Rops, Aquarelles, Zeichnungen, Druckgraphik.* 1979.

Victor Rousseau

Goffin, A. *V. Rousseau.* Brussels, 1932.

Dupierreux, R. *Victor Rousseau.* Monographies de l'Art belge. Antwerp, 1949.

Mons, Hainant Tourisme. *Victor Rousseau 1865–1965.* 1965.

Poirier, P. "Notice sur Victor Rousseau." *Annuaire de l'Académie Royale de Belgique* (Brussels), 1965.

Bougard, M. *Victor Rousseau, l'homme et l'oeuvre.* Charleroi, 1968.

Théo van Rysselberghe

Fierens, P. *Théo van Rysselberghe, avec une étude de Maurice Denis.* Brussels, 1937.

Maret, F. *Théo van Rysselberghe.* Monographies de l'Art belge. Antwerp, 1948.

*Ghent. Musée des Beaux-Arts. *Rétrospective Théo van Rysselberghe.* 1962.

Eeckhout, Paul, et al. "Van Rysselberghe et son temps." *Les Beaux-Arts,* special number (Brussels, 1962).

Chartrain-Hebbelinck, M.-J. "Théo van Rysselberghe: le groupe des XX et La Libre Esthétique." *Revue belge d'Archéologie* 34, nos. 1–2 (Brussels, 1965).

Chartrain-Hebbelinck, M.-J., ed. "Les lettres de Théo van Rysselberghe à Octave Maus." *Bulletin des Musées Royaux des Beaux-Arts de Belgique,* no. 1–2 (1966).

Valerius de Saedeleer

Milo, G. *Valerius de Saedeleer.* Brussels, 1934.

Walravens, J. *Valerius de Saedeleer.* Monographies de l'Art belge. Antwerp, 1949.

Aalst. Stedelijk Museum. *Tentoonstelling Valerius de Saedeleer.* 1967.

Gustave Serrurier-Bovy

van de Velde, H. "Un ingénieur-décorateur liègeois: M. G. Serrurier-Bovy." *Wallonia* 12 (Liège, 1902), pp. 285–296.

Watelet, J.-G. "Le décorateur Liègeois Gustave Serrurier-Bovy." *Cahiers Henry van de Velde,* no. 11 (Brussels, 1970), pp. 5–25.

Watelet, J.-G. *Gustave Serrurier-Bovy, architecte et décorateur 1858–1910.* Académie Royale de Belgique, Mémoires de la classe des Beaux-Arts 2nd Series, no. 14, facsimile 3. Brussels, 1974.

Stavelot. Musée de l'Ancien Abbaye. *A. Rassenfosse et G. Serrurier-Bovy.* 1975.

Heilbrunn, F. "Un mobilier de Serrurier-Bovy au Musée de Beauvais." *Revue du Louvre* 26, nos. 5–6 (Paris, 1976), pp. 438–442.

Liège. Service Provincial des Affaires Culturelles. *Serrurier-Bovy, architecte-décorateur.* 1977.

Jakob Smits

van den Bosch, E. *Jakob Smits.* Antwerp, 1930.

Haesaerts, P. *Jakob Smits.* Monographies de l'Art belge. Antwerp, 1948.

*Brussels. Musées Royaux des Beaux-Arts de Belgique. *Hommage à Jakob Smits.* 1971.

Léon Spilliaert

Edebau, F. *Léon Spilliaert.* Monographies de l'Art belge. Antwerp, 1950.

Brussels. Musée d'Ixelles, et al. *Léon Spilliaert.* 1961.

*Brussels. Musées Royaux des Beaux-Arts de Belgique. *Hommage à Léon Spilliaert.* 1972.

Washington, D. C. The Phillips Collection. *Léon Spilliaert.* 1980.

Henry van de Velde

Osthaus, K. E. *Van de Velde, Leben und Schoffen des Künstler.* Hagen, 1920.

Casteels, Maurice. *Henry van de Velde.* Brussels, 1932.

Zurich. Kunstgewerbe Museum. *Henry van de Velde 1863–1957, persönlichkeit und werk.* 1958.

Hagen. Karl Ernst Osthaus Museum. *Der junge Van de Velde und sein kreis.* 1959.

Teirlinck, Herman. *Henry van de Velde.* Monographies de l'Art belge. Brussels, 1959.

Casabella, no. 237 (March 1960). Van de Velde issue.

*Brussels. Palais des Beaux-Arts. *Henry van de Velde.* 1963.

Otterlo. Rijksmuseum Kröller-Müller. *Henry van de Velde.* 1964.

*Hammacher, A. M. *Le Monde de Henri van de Velde.* Antwerp, 1967.

Tannenbaum, L. "Van de Velde: a Reevaluation." *Art News Annual,* no. 34 (1968), pp. 134–147.

Brussels. Galerie L'Ecuyer. *Exposition Henry van de Velde.* 1970.

Paris. Musée des Arts Décoratifs. *Pionniers du XX^e siècle: Guimard, Horta, Van de Velde.* 1971.

Ollinger-Zinque, G. "La fille qui remaille ou la ravaudeuse." *Bulletin des Musées Royaux des Beaux-Arts de Belgique,* no. 22 (1973), pp. 165–169.

Eidelberg, M. "British Floral Designs and Continental Art Nouveau." *Connoisseur* 197 (February 1978), p. 123.

Guillaume Vogels

Brussels. Palais des Beaux-Arts. *Guillaume Vogels.* 1936.

Brussels. Musées Royaux des Beaux-Arts de Belgique. *Rétrospective Guillaume Vogels.* 1968.

Gustave van de Woestijne

van de Woestijne, Karel. *Gustave van de Woestijne.* Brussels, 1931.

Haesaerts, P. "Gustave van de Woestijne, of de meesters van Narcissus." *Beeldeude Kunst* 28, no. 3 (1942).

van Hecke, F. *Gustave van de Woestijne.* Monographies de l'Art belge. Antwerp, 1949.

Philippe Wolfers

Wolfers, M. *Philippe Wolfers, précurseur de l'Art Nouveau.* Brussels, 1965.

Ghent. Museum voor Sierkunst. *Philippe Wolfers: juwelen, zilver, ivoor, kristal.* 1979.

Index to Artists in the Catalogue

Numbers refer to catalogue entries

Index to Lenders

*Catalogue numbers in bold indicate works
reproduced in color*